Spatial Analysis and Social Spaces

Topoi
Berlin Studies of the Ancient World

Edited by
Excellence Cluster Topoi

Volume 18

De Gruyter

Spatial Analysis and Social Spaces

Interdisciplinary Approaches to the Interpretation of Prehistoric and Historic Built Environments

Edited by
Eleftheria Paliou
Undine Lieberwirth
Silvia Polla

London
2014

De Gruyter

ISBN 978-3-11-026594-1
e-ISBN 978-3-11-026643-6
ISSN 2191-5806

Library of Congress Cataloging-in-Publication Data

A CIP catalog record for this book has been applied for at the Library of Congress.

Bibliographic information published by the Deutsche Nationalbibliothek

The Deutsche Nationalbibliothek lists this publication in the Deutsche Nationalbibliografie; detailed bibliographic data are available in the Internet at http://dnb.dnb.de.

© 2014 Walter de Gruyter GmbH, Berlin/Boston

Typesetting: Dörlemann Satz GmbH & Co. KG, Lemförde
Printing and binding: Hubert & Co. GmbH & Co. KG, Göttingen
∞ Printed on acid-free paper

Printed in Germany

www.degruyter.com

Preface

The current volume is the product of an international meeting entitled "Spatial analysis in past built environments" which took place in the framework of the Excellence Cluster "Topoi: The formation and transformation of space and knowledge in ancient civilizations". Topoi is an interdisciplinary research network which is concerned with the study of the ancient world. It was launched in 2008 and is mainly represented by two universities and four research institutions based in Berlin: the Free University, the Humboldt University, the Berlin-Brandenburg Academy of Sciences and Humanities (BBAW), the Deutsches Archäologisches Institut (DAI), the Max Planck Institute (MPI) for the History of Science, and the Stiftung Preußischer Kulturbesitz (SPK). The cluster is part of the Excellence Initiative of the German federal and state government and involves the participation of more than 200 researchers from diverse disciplines, such as archaeology, geography, history, cultural studies, linguistics, philology, philosophy, theology, and history of science. To date, the network consists of about 50 research groups that investigate the interdependence of space and knowledge in the civilisations of the Mediterranean, the Ancient Near East, Black Sea and Eurasian steppe regions from the 6th millennium BC to around 500 AD. This research programme acknowledges and explores the important role of spaces, spatial systems and various types of space-related knowledge in the development of ancient cultures.

Since 2008 the Topoi Excellence Cluster has funded and organised at least one international conference or workshop each month, and has published selected contributions presented at these meetings in the "Topoi. Berlin Studies of the Ancient World" series. This series has proven extremely useful for compiling an up-to-date overview of the scientific results of the cluster, and reflects the breadth and multidisciplinary focus of research in Topoi. The present volume is also part of this publication scheme and is expected to contribute conceptually and methodologically to key research areas in the Topoi Excellence Cluster.

The editors would like to express their sincere gratitude to all the participants of the "Spatial analysis in past built environments" workshop and the contributors of this volume: Konstantinos Athanasiou, Gareth Beale, John Bintliff, Graeme Earl, Kevin Fisher, Piraye Hacıgüzeller, Bill Hillier, Quentin Letesson, Giles Morrow, Nils Müller-Scheeßel, Eleftheria Paliou, Konstantinos Papadopoulos, Laura Pecchioli, Sabine Reinhold, Benjamin Stangl, Hanna Stöger, Ulrich Thaler, Peter Trebsche, Akkelies Van Ness, Giorgio Verdiani, and David Wheatley. We are also very grateful to the anonymous reviewers of the volume for their critical and thoughtful comments on individual chapters and the book as a whole. Furthermore, special thanks go to Geoff Sammon, Carsten Schmieder, Vasko Demou and Rocco Steputat for their assistance in editing and proof-reading the final manuscript, and to all the students who helped during the days of the workshop. Hauke Ziemssen and Nadine

Riedl as members of the central administration of the Topoi Excellence Cluster have assisted the organisation of the workshop and the publication of the volume in many ways, and for this reason we are much indebted to them. Last but not least, we would like to thank Birgit Nennstiel for designing the cover of this volume.

This publication would not have been possible without the generous financial support of the Topoi Excellence Cluster, which fully funded the "Spatial analysis in past built environments" workshop and covered all the publishing costs of this volume.

Eleftheria Paliou, Undine Lieberwirth, Silvia Polla

Contents

Eleftheria Paliou

Introduction

1 The conception of this volume

In recent years a range of formal methods of spatial analysis have been developed for the study of human engagement, experience and socialisation within built space. Many, although not all, of these emanate from the fields of architectural and urban studies, and draw upon social theories of space that lay emphasis on the role of visibility, movement and accessibility in the built environment. Encouraged by the growing availability of computational methods in the last decade, these approaches have been gaining in popularity among researchers of prehistoric and historical built spaces, and have been given increasingly greater weight in archaeological interpretations. The conception of the two-day conference "Spatial analysis in past built spaces", which took place at the Topoi Building (Free University, Berlin) in April 2010, was inspired by these developments and the understanding that the study of the built environment is a multi-disciplinary endeavour. The workshop, therefore, aimed to bring together specialists in archaeology, social theory, architecture and urban planning, who sought to investigate social and cultural aspects of prehistoric and historical spaces using a variety of formal analytical approaches. In the call for papers special weight was laid on the concepts of human experience and movement in built environments and their social implications, while contributions discussing more recent computer-based methodologies were particularly encouraged. Furthermore, participants were asked to consider a number of general themes associated with the theory and practice of spatial analysis applications in archaeology: the ways in which these approaches can facilitate a better understanding of human engagement and socialisation in prehistoric and historical spaces; the potential of methodologies developed for the investigation of contemporary environments to be successfully applied in archaeological datasets; the research directions that are likely to prove more fruitful and the limitations of these approaches. A third of the scheduled conference time was dedicated to open discussion focusing on these and other issues raised during the conference, while a significant part of the second day of the workshop was allotted for "show and tell" demonstrations of software and analytical methods.

The Berlin meeting proved a successful and stimulating international event with participants from fifteen academic institutions representing a variety of interdisciplinary backgrounds, mainly in archaeology, social theory, urban planning and computer science. The current volume, which is a product of this meeting, comprises chapters corresponding to selected papers presented at the workshop, as well as three relevant contributions that were

solicited following the conception of this book. Spatial analysis in archaeology has a long history, and while many earlier edited volumes include works that examine social aspects of built space using analytical approaches (Samson 1990; Pearson and Richards 1994; Branigan 2002; Robertson et al. 2006; Owen and Preston 2009; Trebsche et al. 2010; Laurence and Newsome 2011, to name a few), the present collection of papers differs from previous publications in this field in three ways. Firstly, it consists of works in which quantitative intra-site analysis is an integral part of the interpretive process, as opposed to other volumes which are mostly concerned with non-quantitative analyses of past architectural remains. The formal methodologies presented here seek to describe various qualities of the built spaces under study in a rigorous way, so as to permit the comparison of different spatial forms and configurations and investigate social aspects of their transformation across space and time. Secondly, conforming to the call for papers of the Berlin meeting, the subsequent chapters address the more specific themes of human experience and behaviour in the built environment, focusing especially on the notions of visibility, movement and accessibility. The authors take the opportunity to associate these concepts with various social phenomena, ranging from social patterns embedded in a spatial configuration to power relationships and more subtle socio-symbolic meanings linked to the form and use of built space. Thirdly, reflecting again the intention of the Topoi workshop, this volume places particular emphasis on computational analytical techniques. Within archaeology, computer-based spatial analysis (for example GIS-based analysis) has been widely applied to the investigation of historical and prehistoric space, both domestic and ritual. Typically, however, the focus has been mainly on larger spatial scales and landscapes rather than urban spaces and buildings. This volume draws attention to more recent approaches to humanistic computing in a built context, such as isovist and visibility graph analysis, urban network analysis, GIS-based least-cost path analysis, agent-based approaches, and visibility analyses in 3D digital environments.

The basic premise that underlies this book is that formal spatial analyses and computational approaches can productively contribute to the identification and interpretation of social meanings, structures and processes mirrored in the material remains of the built environments that people used to inhabit in the past. The individual contributions sometimes have a primarily theoretical or methodological focus, while at other times they are more interested in discussing case studies where intra-site analysis offered valuable insights into the built spaces and societies under study. Below we discuss some common themes and wider issues on the theory, method and limitations of spatial analysis in built environments that, in our view, the chapters that follow bring to the forefront.

2 Quantifying spatial concepts

Common in all contributions is the acknowledgement that spatial analysis can assist social inferences in archaeological built contexts. There are many ways to study space, however, and despite the specific focus of this volume, the authors draw on a variety of theoretical and methodological perspectives mainly inspired by Space Syntax (Hillier and Hanson 1984), environment behaviour studies (Rapoport 1988; 1990), proxemics theory (Hall 1966), anthropological theory of the senses, as well as the works of Giddens (1984), Goffman (1963), Benedikt (1979) and Lynch (1960). Among these, Space Syntax is the major, although certainly not the sole, point of reference. Since the publication of the "Social logic of space" (Hillier and Hanson 1984) the idea that movement through space determines patterns of encounter and avoidance and hence shapes social relations has influenced archaeological thinking. To date, access and axial analysis, the two graph-based techniques that were introduced by Hillier and Hanson (1984) to explore the ways in which spatial configuration can facilitate or discourage human movement, co-presence and interaction, have been employed in numerous and culturally diverse prehistoric and historical environments situated mainly in Europe, the Near East and America.[1] These works indicate a long-lasting archaeological interest in premises and methods proposed by Space Syntax theory, despite the criticisms the latter has received (Leach 1978; Laurence 1987, p. 52–53; Osman and Suliman 1994). The continuing appeal of this particular paradigm is also due to the fact that over the years Space Syntax has been further developed and enriched with new concepts and techniques, which built upon the works of Benedikt (1979) and Watts and Strogatz (1998; Turner et al. 2001, p. 104), shifting the focus of analysis on the close link between visibility and movement. A detailed description of these approaches (e.g. isovist, visibility graph and agent-based analysis) is beyond the scope of this introduction, as they are thoroughly presented by Hillier in the first chapter of this book, and are employed in subsequent chapters by Letesson, Fisher, Hacıgüzeller and Thaler, Stöger and Van Nes.

Given the theme of the volume, the fact that Space Syntax is well represented should not come as a surprise. After all, it has from its inception been inextricably associated with quantitative analytical techniques. Other highly influential social theories that are often cited in archaeological works dealing with formal spatial analysis are not concerned with precise descriptions of space and quantified data. The works of Bourdieu (1977), Giddens (1984), and Foucault (1977) frequently form an initial theoretical basis in studies discussing the relationship between space and society. Nonetheless, they do not provide the analytical tools to interpret the material remains of built structures (Fisher 2009, p. 440; Smith 2011, p. 168). Smith (2011), for example, contrasts these theoretical approaches with what he

1 Archaeological works that use Space Syntax techniques are far too many to mention them all here. Some indicative examples are: Foster 1989; Bonanno et al. 1990; Fairglouch 1992; Gilchrist 1994; Ferguson 1996; Van Dyke 1999; Dawson 2002; Cutting 2003; Craane 2007; Fisher 2009.

terms "empirical urban theories", namely a body of theory with a greater empirical content that encompasses "social concepts concerning urbanism that have identifiable expressions in the archaeological record, along with methods for addressing those concepts" (Smith 2011, p. 171). We believe that these approaches could provide a valuable interpretive framework for the formal analysis of built spaces that archaeological practice brings to light.

From the empirical urban theories discussed by Smith, most pertinent to the theme of this volume, besides Space Syntax, are the works of Rapoport (1988; 1990), Hall (1960; 1966) and Lynch (1960), which aim to establish a direct link between human behavioural responses and the materiality of built environments. Whilst not all of these theoretical perspectives are inherently dependent on quantified data, the notions they propose often refer to measurable properties of space and, therefore, they could benefit by a more formal analytical examination. For instance, Rapoport's non-verbal communication approach has long been used by archaeologists (Sanders 1990; Moore 1996; Moore 2005; Michailidou 2001; Fisher 2009; Nevett 2009) to explore the relationship between repetitive cues in the built environment and expected social behaviour in given settings. Instead of merely relying on qualitative descriptions and observations of the spaces under investigation (focusing for example on the shape, size, colour and materials of built structures) such approaches could be further supported with quantitative data obtained in two and three dimensions (Fisher 2009, p. 445; Paliou, this volume). A similar observation can be made regarding works that build upon the urban theory of Kevin Lynch, which has inspired research in the field of Roman urbanism (Favro 1996; Haselberger 2000) and has met with great popularity in the discipline of urban studies. In his book "The Image of the City", Kevin Lynch identifies five distinct elements (paths, nodes, edges, districts, and landmarks) that affect human cognition and movement through a city. Works in the field of architectural computing (Conroy and Bafna 2003; Morello and Ratti 2009) have aimed recently to provide a quantifiable basis for Lynch's notions in two- and three-dimensional space. Such attempts indicate the potential of computational analysis to approach, in a new empirical way, fundamental theoretical concepts, which were not amenable to formal spatial analysis in the past. These promising developments have been made possible mainly due to technological advances in the area of humanistic computing that have occurred in the last decade.

3 Methodological themes and trends

Since the early 2000s there has been a remarkable increase in the amount of new computational tools and methods aimed at examining human movement and visibility in a built context. A number of free and open source software packages for the implementation of Space Syntax techniques have appeared, the most popular of which is UCL Depthmap, a spatial network analysis software created by A. Turner at University College London. Depthmap was initially intended for visibility graph analysis (Turner 2001), but over the years it

has been supplemented with additional routines for axial, convex space and agent-based analysis. In parallel with the appearance of software solutions specifically aimed at being employed in urban contexts, GIS packages have been enhanced with new analytical capabilities at the scale of building and settlements. The latest versions of ArcGIS software are not only able to represent 3D cityscapes, but they can also perform some basic visual analysis (calculation of sight lines) on building facades. At the same time procedures that have long been employed in the field of landscape studies, such as least-cost path calculations, have been utilised for the study of built space (Hacıgüzeller 2008; Hacıgüzeller and Thaler, this volume). Last but not least, one should add to the above the development of 3D visibility analyses which aim to examine human visual experience in digital spaces that represent more fully the qualities of real-world environments (Papadopoulos and Earl, this volume; Paliou, this volume). The wide availability of new analytical tools has brought to the forefront a number of issues associated with their use, some of which are tackled in the chapters that follow.

3.1 Topological vs. metric properties of space

One first issue concerns the existence of various methods for the analysis of human movement in a built environment, which, however, express distinctly different assumptions about how people find their way through urban space. Space Syntax applications are based on the tenet that spatial configuration is the main generator of human movement, especially at larger, non-local, spatial scales (Hillier et al. 1993; Hillier 2007, p. vii; Hillier et al. 2007). They focus, therefore, on the topological, geometrical properties of space and the notion of accessibility, which is defined as topological distance (i.e. the number of spaces needed to be traversed to reach a destination), while they underplay the metric qualities of built environments such as room size, length of street segments, and Euclidean distance. Remarkably different to Space Syntax is another popular trend in the analysis of human movement which accepts that mobile individuals are sensitive to metric properties of space (Ratti 2004; Montello 2007). The advocates of this tradition adopt a cost-benefit approach, which postulates that people primarily move in a way that enables them to conserve effort, time and expense. GIS raster-based least-cost path applications that have been widely used in the analysis of archaeological landscapes are founded on such assumptions. The application of similar methods at the level of building and settlements is relatively recent (Wu and Lock 2012; Hacıgüzeller and Thaler, this volume) and has provided an alternative to Space Syntax approaches, which have until now dominated archaeological analysis. The question that naturally arises at this point, namely which are the most appropriate tools to study human movement, has been intensively debated (Steadman 2004; Ratti 2004; Hillier and Penn 2004; Hillier 2007, p. vii) and has no simple answer, as it intertwines with complex and sometimes unresolved issues related to how factors such as human cognition, spatial scale

and individual differences influence mobility patterns. Works that seek to combine, compare and assess the suitability of different methodologies in a given context (Wu and Lock 2012; Hacıgüzeller and Thaler, this volume) have a valuable contribution to make in this respect.

While the aforementioned analytical tools are discussed later by the authors in great detail, it is noteworthy that a number of other relevant methodologies, which have been popular in the field of urban studies, are not represented in the volume. These include, for example, more sophisticated GIS-based urban networks analyses and agent-based models of pedestrian movement that do not conform to Space Syntax principles. Besides topological information, GIS-based spatial network analysis can incorporate a great amount of contextual information related to socio-economic data and the use of space, also taking into account factors such as the direction and cost (e.g. distance, time, energy) of movement in a street network (Conolly and Lake 2006, p. 236–238; Fischer 2003; Branting 2004). On the other hand, agent-based models (ABM) in a built enviroment aim to study human mobility at medium and small spatial scales from the bottom up by examining the non-linear formation of collective patterns of movement that emerge as a result of interactions among individuals. Such models could comprise agents with advanced cognitive abilities (e.g. memory, knowledge of the environment, clearly defined aims) and a well-defined course-determining mechanism involving goals, learned paths and destinations (e.g. Haklay et al. 2001; Kurose et al. 2001). ABMs of this kind follow a set of rules that are programmed by the user and should be distinguished from analyses implemented with Depthmap, where the behaviour and actions of agents are driven solely by the configurational properties of space (Turner and Penn 2002; Hacıgüzeller and Thaler, this volume; Van Nes, this volume; Stöger, this volume). Despite the fact that GIS-based spatial network analysis and ABMs can allow for numerous factors that influence the behaviour of mobile individuals, there have been until now only few applications of these methods in archaeological built environments (Branting 2004; Altaweel and Wu 2010). This is possibly due to their computational sophistication and their increased requirements for socio-economic data that are hard to obtain for prehistoric and historical societies.

3.2 Three-dimensional analysis

The new possibilities offered by analytical methods that expand in the third dimension is the second major theme that emerges in this volume. Most applications of spatial analysis depend upon two-dimensional plans that selectively capture only certain physical properties of real-world environments. Despite their abstract nature, such spatial representations have to date been integral for the analysis of human visual perception and movement in built space. Nonetheless, in recent years analytical tools that aim to explore the visual qualities of three-dimensional space have started to appear (Yang et al. 2007; Morello and Ratti 2009; Earl 2005; Paliou et al. 2011; Engel and Döllner 2009; Fisher-Gewirtzman et al.

2003; Paliou, this volume; Papadopoulos and Earl, this volume). These approaches have two main benefits: firstly, contrary to established spatial analyses that aim to examine planar spatial configurations, three-dimensional methods are applied to vertically arranged layouts, which according to environmental psychologists are likely to affect human spatial perception and the cognitive processes involved in way-finding (Montello 2007, p. iv–07); secondly, they can incorporate information on wall decoration, colour, texture and even intangible elements of built space such as illumination; elements of this kind can be linked with apparent and more subtle culturally specific socio-symbolic meanings that have been acknowledged as important by social anthropologists and archaeologists alike (Rapoport 1990, p. 106–107; Pearson and Richards 1994, p. 26). Due to their enhanced dimensionality, formal three-dimensional visual analyses can reveal spatial patterns that are essentially different from those highlighted by two-dimensional techniques. Arguably, to the degree that two- and three-dimensional methods focus on distinct physical properties of space, they could productively complement each other, leading potentially to more convincing and comprehensive interpretations that place equal weight on configurational and symbolic aspects of architectural environments.

4 Problems and limitations

The third issue that became evident during the Berlin meeting involves the limitations of formal analytical approaches that have been hinted at, if not explicitly discussed, by almost all authors. Perhaps the greatest difficulty in the application of quantitative techniques in past architectural environments is the incomplete state of archaeological spaces which – to use Hillier's words (Hillier, this volume) – makes analysis "more difficult by an order of magnitude". The successful implementation of quantitative processes requires a complete knowledge of the spatial properties or systems under examination, whether these are individual buildings, street networks or three-dimensional layouts. Nevertheless, historical and prehistoric built environments are hardly ever preserved in their entirety, and their internal arrangement is often insufficiently or poorly delineated; ambiguously defined architectural forms and spatial configurations could undermine the results of the analysis, which as a rule are sensitive to inaccurate numerical data. For archaeologists this situation poses a number of questions: can spatial analyses developed for modern environments be successfully applied in archaeological spaces? Should such approaches always aim to produce rigorous quantitative interpretations or could they also be used for qualitative insight into human phenomena, viz. as "tools to think with" (Cutting 2003)? In what ways do uncertainties in the archaeological record affect the results of the analysis and what are the best ways of dealing with ambiguous data in the context of quantitative research?

Such issues have mostly been discussed with regard to Space Syntax applications (Cutting 2003; Thaler 2005) amid concerns about poorly defined boundaries of rooms and

open spaces and a lack of knowledge regarding the missing upper storeys of excavated buildings. However, a similar scepticism is certainly justified for all applications of spatial analysis in archaeological built environments. The ever increasing number of works dealing with formal analytical approaches to ancient architecture, which are not solely restricted to exceptionally preserved sites, suggests that these methods are worthwhile, notwithstanding the problems frequently presented by archaeological datasets. That said, it has to be acknowledged that surviving building remains are frequently insufficient for the application of certain quantitative techniques and, like with all archaeological methods, some quantitative approaches are more suitable than others, depending on the specific research questions and problems presented in each context.

In a similar vein, different approaches for dealing with uncertain information in the archaeological record are adopted. Sometimes excavation evidence is used to infer some basic information about missing features, for instance the presence of an entrance, a room or an upper storey, which can be important for the successful implementation of certain quantitative methods (Cutting 2003, p. 16; Thaler 2005, p. 326; Hacıgüzeller and Thaler, this volume). At other times attempts are made to assess the ways in which incomplete data influence the outcomes of the analysis and suggested interpretations. To this end, the comparative examination of research results derived from the analysis of alternative spatial reconstructions could be helpful, as long as limited and informed hypotheses can be made about a finite number of plausible spatial forms and configurations (Clark 2007, p. 93; Paliou et al. 2011; Hacıgüzeller and Thaler, this volume). While sometimes the outcomes of this process are inconclusive, on many other occasions they suggest that the proposed interpretive statements are not affected by the type and level of uncertainty in the datasets examined.

Besides the problem of incomplete datasets, which is mostly relevant to archaeological research, another innate limitation of the analytical approaches discussed here is their emphasis on visual properties of space, which has as a consequence the prioritisation of vision to the detriment of the other senses (Wheatley, this volume; Papadopoulos and Earl, this volume). Environmental perception as well as human interaction and communication in built space involve the participation and synergy of vision, hearing, touch and smell, a fact that has been taken into consideration by environment-behaviour theorists (Rapoport 1990, p. 106; Hall 1966). Even so, formal analytical approaches to human experience and movement as a rule only examine visual aspects of built environments, while studies that seek to describe other sensory modalities, such as sound, using quantitative measures are admittedly few (Moore 2005; Paliou and Knight, in press). In this respect, analyses that consider more fully the synergistic relationship between the senses appear necessary and promising and should be encouraged (see also Wheatley, this volume). Ultimately, however, it has to be acknowledged that human experience cannot be solely reduced to a set of measurable spatial properties: there are a number of sensory impressions influencing human behavioural responses in built space that cannot be expressed in quantitative terms. Despite this

fact, the analytical methods presented here appear to capture certain spatial qualities that are relevant to how people respond and attribute meaning to their environment, and therefore, we believe they could make a valuable contribution to archaeological practice.

5 Outline of the volume

Many of the points mentioned above are elaborated in the subsequent chapters. The case studies discussed by the authors range chronologically from prehistoric to historical times. From a geographical point of view, they originate mainly from the area of the Mediterranean (Greece, Italy and Cyprus), which constitutes a particular focus of investigation for research groups in the Topoi Excellence Cluster. This is not to suggest that the applicability of the methods proposed is restricted only to the archaeology of Southern Europe. On the contrary, we would rather argue that similar spatial analyses could be employed to the study of various other cultures, to the degree that they encompass notions of socialisation and human-environment interaction that are pertinent to these societies. Turning now to the chapters, we will briefly describe their contents.

At the beginning of the volume Bill Hillier presents the theoretical propositions behind Space Syntax methods. He offers an overview of old and more recent Space Syntax techniques and discusses their contribution to the social analysis of urban spaces. Using examples of the application of access, axial, visibility graph and agent-based analysis performed mostly using UCL's Depthmap software, he aims to demonstrate the basic Space Syntax premise, which states that space is lawful and intrinsic rather than merely a background to social activity. In his discussion Hillier emphasizes the determining role of human experience in built space, and particularly visibility and movement, in the process of socialisation, explaining how individuals act as agents in the self-organisation of urban forms. Arguing that spatial configuration is both the product of physical-spatial laws and the agency of the human subjects, he seeks to reconcile a physical view with a phenomenological view of space. To support his arguments, Hillier gives examples of how Space Syntax analysis can elucidate the global and cultural processes that have led to the formation of modern cities (London, Tokyo, Nicosia).

Without doubt, one of the merits of Space Syntax techniques is their potential to contribute to diachronic and synchronic comparisons of spatial configuration. This potential is well demonstrated by Letesson, who uses access and visibility graph analysis to examine the concepts of invention, innovation and diffusion as expressed in Minoan Late Bronze Age buildings. In this way he identifies the existence of a genotype, namely an underlying set of principles which is common in domestic buildings as well as monumental and communal structures of the Neopalatial era. By applying the same methods of analysis to buildings dated to earlier periods he notices the existence of a clear shift in the architectural thinking of Minoan culture between the Middle Minoan and Neopalatial period.

Paliou discusses some of the cases where the relationship between visibility and social life in past urban spaces can be better understood with reference to a three-dimensional environment, giving examples which derive from a variety of different cultural contexts (Roman, Mesoamerican, Aegean Late Bronze Age, and Late Antique). She then presents methods of visibility analysis that can be employed in digital three-dimensional reconstructions of archaeological spaces. These methods are used to investigate in a formal analytical way the reception of wall paintings in Late Bronze Age Akrotiri (Thera) and aspects of human communication in the Late Antique church of San Vitale (Ravenna). Through the examination of these notably diverse case studies, Paliou highlights the potential of three-dimensional visibility analysis to empirically examine concepts linked mainly to Rapoport's Non-verbal communication approach and Space Syntax theory.

Wheatley reviews and responds to the theoretical criticism of visual analysis in archaeology, while attempting to encourage a convergence between landscape-scale and urban-scale studies of visual structure. His discussion mainly focuses on two criticisms which question the conceptual foundation of formal visibility studies and have given the impetus to much debate in the area of GIS research in archaeology: the first involves the postmodern stance which argues that the map-like view of space, which is the basis of most visual analyses, was not shared by other cultures in the past. The second criticism involves the claim that spatial analysis prioritises vision over other sensory modalities that are implicated in environmental perception and social interactions. Whilst Wheatley rejects the first claim, he acknowledges the validity of the second criticism. In the end he argues that proxemics research (Hall 1966) could offer a useful framework for the development of formal analytical methods which adopt a multi-sensory approach to the study of past built remains.

Papadopoulos and Earl examine further the potential of three-dimensional analysis in archaeological environments by demonstrating how intangible elements of architectural space, such as illumination, can be formally analysed with the use of 3D modelling software. They employ lighting analysis in typical Minoan spaces, e.g. tombs, domestic spaces and workshops, and discuss the potential influence of illumination in ritual practice, task performance and the use of space. Furthermore, by performing viewshed analysis in the same spaces, they explore the benefits of an enhanced approach to the study of visual space, maintaining that methodological integration could contribute to a more comprehensive understanding of prehistoric built space. In their concluding remarks they provide also examples of how visual analysis can stimulate discussion on a broader spectrum of senses, rather than merely vision.

In his study of monumental buildings in Late Bronze Age Cyprus, Fisher argues for the advantages of an integrative approach to theory as well as method. Drawing on the ideas of Giddens (1984), Goffman (1963), Hillier and Hanson (1984), Hall (1966), Rapoport (1990) and Lynch (1960), this approach recognises the agency of monumental buildings as well as the agency of their creators and inhabitants in the process of socialisation. Fisher incorporates the results of access and visual analysis in a wider theoretical discussion on how build-

ings communicate messages non-verbally, placing also particular emphasis on the role of furnishings and artefacts in built space; he concludes that, despite their similarities, monumental buildings in Cyprus were "personalised" through the idiosyncratic use of their architectural features, furnishings and artefacts, which determined daily human experience and the formation of individual and group identities.

Hacıgüzeller and Thaler pursue a comparative examination of topological and metric analyses of human movement in an attempt to evaluate the advantages, limitations and interpretive issues associated with the application of each method. They apply access, visibility graph, and agent-based analysis, as well as an innovative GIS metric approach, in order to examine diachronic changes in the spatial configuration of two Aegean Bronze Age buildings, Building A at Mallia (Crete) and the palace of Pylos (Messenia). The results of the different methods employed on most occasions correspond closely to each other and point to aspects of change and continuity in the case studies examined. Hacıgüzeller and Thaler in the end acknowledge the merits of each technique and the benefits of their combined application, while they make suggestions about how a multi-method approach could be best implemented in the future.

Bintliff argues for the usefulness of configurational analysis in the study of prehistoric and historical spaces, especially when used in combination with rich archaeological and literary evidence. He explores the theme of "communal values" through time by offering a brief overview of the evolution of house and town planning in the Greek city from the Iron Age to the Early Roman Era. He maintains that sociopolitical changes are manifested in the spatial organisation of houses, which he elaborates via the use of access diagrams. In this study textual sources, whenever available, are illuminating, and sometimes highlight the important role of elaborate furnishings and wall decorations in communicating messages of power, wealth and status, contradicting occasionally the impression given by spatial configuration alone.

Van Nes analyses the street network of Pompeii at the macro and micro scales, focusing on the topological relationship between private and public space. She explores various degrees of adjacency, permeability and intervisibility in the street network of the Roman town taking into account the visual relationship between windows and doors, the degree of constitutedness, entrance density, and the topological depth between private and public space. The results of these analyses suggest patterns of pedestrian movement through the street network and reveal relationships between building functions and the topological depth of street segments. According to Van Nes, macro and micro urban analyses offer important indications on street vitality, urban safety and social interaction in ancient street networks, as applies to modern environments.

Stöger's chapter examines the function of a Roman urban neighbourhood, Insula IV ii at Ostia, as lived space. By analysing the axial, convex and visual structure of the insula, she comes to the conclusion that its spatial configuration promotes human encounter by privileging integration rather than segregation. Furthermore, she argues that the integrating

capacity of the insula would have made it a "better and safer neighbourhood", which may explain its long period of occupation. Finally, Stöger acknowledges that Space Syntax is a useful "tool to think with", viz. a conceptual framework that inspires experimentation in the application of analytical methods as well as in the interpretation of results.

The chapters that follow, therefore, suggest that the application of formal analytical approaches to the study of built space within the realms of history and archaeology appears promising. Archaeological and historical research would clearly have a lot to gain from theoretical and methodological frameworks that aim to investigate human-environment relationships and social aspects of built space. The case studies examined by the authors demonstrate that these approaches can productively contribute to archaeological interpretations, especially when they are integrated with a more traditional analysis of material and literary evidence. Equally, we think that archaeological and historical approaches may have a distinct contribution to make to contemporary architectural and urban design theory, offering a wealth of material evidence against which urban concepts can be further examined and tested. Thus we hope that this volume will offer students, scholars and researchers a useful topical insight into the field of spatial analysis in historical and prehistoric built contexts, and will encourage further cross-disciplinary discussion and inter-disciplinary investigations to the study of past built spaces.

Bibliographical references

Altaweel, M., and Wu, Y. (2010)
"Route Selection and Pedestrian Traffic: Applying an Integrated Modeling Approach to Understanding Movement", in: *Structure and Dynamics: eJournal of Anthropological and Related Sciences*, 4 (2), http://escholarship.org/uc/item/6898p5vm (27 May 2012).

Benedikt, M. L. (1979)
"To Take Hold of Space: Isovists and Isovist Fields", in: *Environment and Planning B: Planning and Design*, 6, pp. 47–65.

Bonanno, A., Gouder. T., Malone, C., and Stoddart, S. (1990)
"Monuments in an Island Society: The Maltese Context", in: *World Archaeology*, 22 (2), pp. 190–205.

Bourdieu, P., (1977)
Outline of a Theory of Practice, Translated by Nice, R., Cambridge.

Branigan, K. (ed.) (2002)
Urbanism in the Aegean Bronze Age, Sheffield.

Branting, S. A. (2004)
Iron Age Pedestrians at Kerkenes Dağ: An Archaeological GIST Approach to Movement and Transportation, PhD Thesis, The State University of New York at Buffalo.

Craane, M. L. (2007)
"Analysing Medieval Urban Space; A Methodology", in: *Internet Archaeology*, http://intarch.ac.uk/journal/issue21/craane_index.html (28 May 2012).

Conolly, J., and Lake, M. (2006)
Geographical Information Systems in Archaeology, Cambridge.

Conroy Dalton, R., and Bafna, S. (2003)
"The Syntactical Image of the City: A Reciprocal Definition of Spatial Syntaxes", in: *Proceedings of the 4th International Space Syntax Symposium*, London, http://eprints.ucl.ac.uk/1104/1/SIC.pdf.pdf (28 May 2012).

Clark, D.L.C. (2007)
"Viewing the Liturgy: A Space Syntax Study of Changing Visibility and Accessibility in the Development of the Byzantine Church in Jordan", in: *World Archaeology*, 39, pp. 84–104.

Cutting, M. (2003)
"The Use of Spatial Analysis to Study Prehistoric Settlement Architecture", in: *Oxford Journal of Archaeology*, 21 (1), pp. 1–21.

Dawson, P.C. (2002)
"Space Syntax Analysis of Central Inuit Snow Houses", in: *Journal of Anthropological Archaeology*, 21(4), pp. 464–480.

Earl, G. P. (2005)
"Texture Viewsheds: Spatial Summaries of Built Archaeological Spaces Derived from Global Light Mapping", in: *Proceedings of the 11th International Conference on Virtual Systems and Multimedia, Ghent, Belgium, October 2005*, pp. 303–312.

Engel, J., and Döllner, J. (2009)
"Approaches Toward 3D Visual Analysis for Digital Landscapes and its Applications", in: Buhmann, Kieferle, Pietsch, Paar, and Kretzler (eds.), in: *Digital Design in Landscape Architecture 2009: Proceedings of Presented Papers, 21–23 May 2009*, pp. 33–41.

Fairclough, G. (1992)
"Meaningful Constructions: Spatial and Functional Analysis of Medieval Buildings", in: *Antiquity* 66, pp. 348–366.

Favro, D. (1996)
The Urban Image of Augustan Rome, Cambridge.

Ferguson, T. J. (1996)
"Historic Zuni Architecture and Society: An Archaeological Application of Space Syntax", in: *Anthropological Papers of the University of Arizona*, Tucson.

Fischer, M. M. (2003)
"GIS and Network Analysis", in: *Handbook 5 Transport Geography and Spatial Systems*. http://www.jyu.fi/ersa2003/cdrom/papers/433.pdf (27 May 2012).

Fisher, K. (2009)
"Placing Social Interaction: An Integrative Approach to Analyzing Past Built Environments", in: *Journal of Anthropological Archaeology*, 28, pp. 439–457.

Fisher-Gewirtzman, D., Burt, M., and Tzamir, Y. (2003)
"A 3-D Visual Method for Comparative Evaluation of Dense Built-up Environments", in: *Environment and Planning B: Planning and Design*, 30(4), pp. 575–587.

Foster, S. (1989)
"Analysis of Spatial Patterns in Buildings (Access Analysis) as an Insight into Social Structure: Examples from the Scottish Atlantic Iron Age", in: *Antiquity*, 63 (238), pp. 40–50.

Foucault, M. (1977)
Discipline and Punish: The Birth of the Prison. Translated by Sheridan, A. New York.

Giddens, A. (1984)
The Constitution of Society: Introduction of the Theory of Structuration, Berkeley.

Gilchrist, R. (1994)
Gender and Material Culture: The Archaeology of Religious Women, New York.

Goffman, E. (1963)
Behavior in Public Places: Notes on the Social Organization of Gatherings, New York.

Hacıgüzeller, P. (2008)
"Modelling Human Circulation in the Minoan Palace at Malia", in: Axel Posluschny, Karsten Lambers, and Irmela Herzog (eds.), *Layers of Perception: Proceedings of the 35th International Conference on Computer Applications and Quantitative Methods in Archaeology (CAA)*. Conference Berlin, 2–6 April 2005, pp. 336–341.

Haklay, M., O'Sullivan, D., Thurstain-Goodwin, M., and Schelhorn, T. (2001)
"'So Go Downtown': Simulating Pedestrian Movement in Town Centres", in: *Environment and Planning B: Planning and Design* 28, pp. 343–359.

Hall E.T. (1960)
The Silent Language, New York.

Hall, E., T. (1966)
The Hidden Dimension, New York.

Haselberger, L. (2000)
"Imaging Augustan Rome", in: *Journal of Roman Archaeology*, 13, pp. 515–528.

Hillier, B., and Hanson, J. (1984)
The Social Logic of Space, Cambridge.

Hillier, B., Penn, A., Hanson, J., Grajewski, T., and J. Xu. (1993)
"Natural Movement: Or, Configuration and Attraction in Urban Pedestrian Movement", in: *Environment and Planning B: Planning and Design*, 20, pp. 29–66.

Hillier, B. (2007)
Space Is the Machine: A Configurational Theory of Architecture. Space Syntax, London, UK. http://discovery.ucl.ac.uk/3881/1/SITM.pdf (28 May 2012).

Hillier, B., and Penn, A. (2004)
"Rejoinder to Carlo Ratti", in: *Environment and Planning B: Planning and Design*, 31(4), pp. 501–511.

Hillier, B., Turner, A., Yang, T., and Park, H. T. (2007)
"Metric and Topo-geometric Properties of Urban Street Networks: Some Convergences, Divergences and New Results", in: *Proceedings of the 6th International Space Syntax Symposium*, ITU, Istanbul, Turkey, 12–15 June 2007. http://eprints. ucl.ac.uk/3282/ (27 May 2012).

Kurose, S., Borges, A. W. J., and Timmermans, H. J. P. (2001)
"Classifying Pedestrian Shopping Behaviour According to Implied Heuristic Choice Rules", in: *Environment and Planning B: Planning and Design* 28(3), pp. 405–418.

Leach, E. (1978)
"Does Space Syntax Really 'Constitute the Social'?", in: D. Green, C. Haselgrove, and M. Spriggs (eds.), *Social Organization and Settlement: Contributions from Anthropology, Archaeology and Geography*, Oxford, BAR Int. Series (Suppl.) 47, pp. 385–401.

Lawrence, R. J. (1987)
Housing, Dwellings and Homes: Design Theory, Research and Practice, Chichester.

Lawrence, R., and Newsome, D.J. (eds.) (2011)
Rome, Ostia, Pompeii: Movement and Space, New York.

Lynch, K. (1960)
The Image of the City, Cambridge.

Michailidou, A. (2001)
Akrotiri Thiras: I meleti ton orofon sta ktiria tou oikismou, Athens.

Moore, J. D. (1996)
Architecture and Power in the Ancient Andes: The Archaeology of Public Buildings, Cambridge.

Moore, J. D. (2005)
Cultural Landscapes in the Ancient Andes: Archaeologies of Place, Gainesville.

Morello, E., and Ratti, C. (2009)
"A Digital Image of the City: 3D Isovists in Lynch's Urban Analysis", in: *Environment and Planning B: Planning and Design,* 36(5), pp. 837–853.

Montello, D. R. (2007)
"The Contribution of Space Syntax to a Comprehensive Theory of Environmental Psychology", in: A. S. Kubat, Ö. Ertekin, Y. Güney, and E. Eyüboğlu (eds.), *6th International Space Syntax Symposium Proceedings*. Istanbul, ITÜ Faculty of Architecture, pp. iv-1–iv-12, http:// www.geog.ucsb.edu/~montello/pubs/SpaceSyntax_invi ted.pdf (28 May 2012).

Nevett, L. (2009)
"Domestic Façades: A 'Feature' of the Urban Landscape of Greek poleis?", in: S. Owen and L. Preston (eds.), *Inside the City in the Greek World: Studies of Urbanism from the Bronze Age to the Hellenistic Period*, Oxford, pp. 118–130.

Osman, K. M., and Suliman, M. (1994)
"The Space Syntax Methodology: Fits and Misfits", in: *Architecture and Behaviour* 10(2), pp. 189–204.

Owen, S., and Preston L. (2009)
Inside the City in the Greek World: Studies of Urbanism from the Bronze Age to the Hellenistic Period, Oxford.

Paliou, E., Wheatley, D., and Earl, G. P. (2011)
"Three-dimensional Visibility Analysis of Architectural Spaces: Iconography and Visibility of the Wall Paintings of Xeste 3 (Late Bronze Age Akrotiri)", in: *Journal of Archaeological Science*, 38, pp. 375–386.

Paliou, E., and Knight D. J (in press)
"Mapping the Senses: Perceptual and Social Aspects of Late Antique Liturgy in San Vitale, Ravenna", in: F. Contreras, and J. Melero (eds.), in: *Proceedings of CAA 2010, Computer Applications and Quantitative Methods in Archaeology*, International Conference, Granada 6–9 April, 2010.

Pearson, M., and Richards, C.L. (1994)
Architecture and Order: Approaches to Social Space, London.

Rapoport, A. (1988)
"Levels of Meaning in the Built Environment", in: F. Poyatos (ed.), *Cross-cultural Perspectives in Nonverbal Communication*, Toronto, pp. 317–336.

Rapoport, A. (1990)
The Meaning of the Built Environment: A Nonverbal Communication Approach, Tucson.

Ratti, C., (2004)
"Space Syntax: Some Inconsistencies", in: *Environment and Planning B: Planning and Design*,31(4), pp. 487–499.

Robertson, E. C., Seibert, J. D., Fernandez, D. C., and Zender, M. U. (2006)
Space and Spatial Analysis in Archaeology, Calgary.

Samson, R. (ed.) (1990)
The Social Archaeology of Houses, Edinburgh.

Sanders, D. (1990)
"Behavioral Conventions and Archaeology: Methods for the Analysis of Ancient Architecture", in: S. Kent (ed.), *Domestic Architecture and the Use of Space: An Interdisciplinary Cross-cultural Study,* New York, pp. 43–72.

Smith, M. (2011)
"Empirical Urban Theory for Archaeologists", in: *Journal of Archaeological Method and Theory,* 18 (3), pp. 167–192.

Steadman, P. (2004)
"Guest Editorial: Developments in Space Syntax", in: *Environment and Planning B: Planning and design,* 31(4), pp. 483–486.

Thaler, U. (2005)
"Narrative and Syntax: New Perspectives on the Late Bronze Age Palace of Pylos, Greece", in: *Proceedings 5th International Space Syntax Symposium*, I, Delft, TU Delft, Faculty of Architecture, pp. 324–339, http://www.spacesyntax.tudelft.nl/media/longpapers2/ulrichth aler.pdf (28 May 2012).

Trebsche, N., Müller-Scheeßel, N., and Reinhold, S. (2010)
Der Gebaute Raum: Bausteine einer Architektursoziologie vormoderner Gesellschaften, Berlin.

Turner, A. (2001)
"Depthmap: A Program to Perform Visibility Graph Analysis", in: *Proceedings 3rd International Symposium on Space Syntax*, Georgia Institute of Technology, Atlanta, GA pp. 31.1–31.9, http://www.vr.ucl.ac.uk/publications/depthmap.pdf (28 May 2012).

Turner, A., Doxa, M., O' Sullivan, D., and Penn, A. (2001)
"From Isovists to Visibility Graphs: A Methodology for the Analysis of Architectural Space", in: *Environment and Planning B: Planning and Design*, 28, pp.103–121.

Turner, A., and Penn, A. (2002)
"Encoding Natural Movement as an Agent-based System: An Investigation into Human Pedestrian Behaviour in the Built Environment", in: *Environment and Planning B: Planning and Design*, 29(4), pp. 473–490.

Van Dyke, R. M. (1999)
"Space Syntax Analysis at the Chacoan Outlier of Guadalupe", *American Antiquity*, 64 (3), pp. 461–473.

Watts, D. J., and Strogatz, S. H. (1998)
"Collective Dynamics of 'Small-World' Networkers", in: *Nature*, 393, pp. 440–442.

Wu, M., and Lock, G. (2012)
"The Spatial Construct of Social Relationships: Human Interaction and Modeling Agency", in: A. Chrysanthi, P. Murrieta Flores, and C. Papadopoulos (eds.), *Thinking Beyond the Tool: Archaeological Computing and the Interpretive Process*, Oxford, pp. 88–102.

Yang, P. P. J., Putra, S., and Li, W. (2007)
"Viewsphere: A GIS-Based 3D Visibility Analysis for Urban Design Evaluation", in: *Environment and Planning B: Planning and Design*, 34(6), pp. 971–992.

Bill Hillier

Spatial analysis and cultural information:
the need for theory as well as method in space syntax analysis

Abstract

In this paper, some key space syntax techniques of analysis are presented and illustrated, and certain theoretical propositions linking space to society, resulting from the application of space syntax techniques, are explained. It is suggested that awareness of the theoretical propositions when the techniques are used can sometimes aid the archaeologist in the social interpretation of spatial patterns.

1 What space syntax is

Space syntax is a set of techniques for analysing spatial configuration, and a set of theories linking space and society. For the most part, it has been developed on the basis of here-and-now data which is, or can be, pretty complete. You can relate spatial configuration to where people are, how they move, how they adapt and decorate space, and how they talk about it. In archaeology you work with incomplete and often sporadic data, so analysis is more difficult by an order of magnitude.

So how can we proceed? I think the most useful thing I can do is to give, first, an overview of some of the techniques that are now available, and how they allow us to interpret spatial phenomena in social terms. But this will lead to two propositions which some may find initially strange. The first is that space is in itself lawful. The second is that it is through its lawfulness that space interacts with society. Because they may seem strange, I will try to demonstrate each of these propositions in as simple a way as I can, and show how spatial laws intervene in all aspects of our subject: the relations between physical objects and spaces, the effects of spaces on people, how we cognise space, and how and why societies order space in different ways. I will end by outlining a general theoretical model of the city, and show how it embodies these various types of law. It is this theoretical understanding of space which I believe will be most useful to archaeologists in seeking to extract cultural information from the material remains of buildings, settlements and areal spatial patterns.

2 How space syntax works

The techniques – and the theories – of space syntax are based on two key propositions. The first is that space is not a background to human activity, but intrinsic to it.

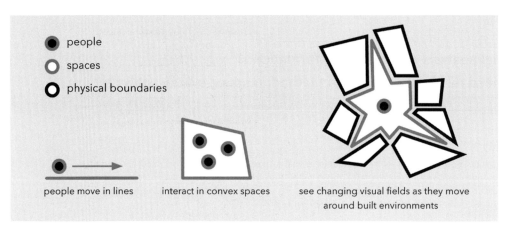

people
spaces
physical boundaries

people move in lines | interact in convex spaces | see changing visual fields as they move around built environments

Figure 1 | Space is intrinsic to human activity, not a background to it.

By this we mean that each kind of human activity has its own natural geometry (fig. 1). For example, movement is fundamentally linear and one-dimensional. Locally it leaves a linear trace, and globally we try to approximate lines when we navigate space towards a destination. Interaction, on the other hand, is fundamentally convex and two-dimensional. All participants in a spatial interaction, whether it is two people having a conversation or a lecturer addressing an audience, need to be *inter-visible*, and so occupy a space in which all points can be linearly connected to all others without going outside the space. Also, in general, when we see space, we see a *point isovist*, made up both of lines that radiate from us until they strike a boundary, and a largest convex element in which all points can see all others. This view of space as *intrinsic* to human activity is in contrast to our 'educated error' of seeing space as the background to objects, and so as the background to human behaviour (for a discussion of this, cf. Hillier 1996, p. 27–29).

The second proposition is that space is first and foremost *configurational*. By *configuration* we mean *simultaneously existing relations*. We can analyse the configurational properties of spatial complexes by examining the relations of each space to all others. Figure 2 shows a simple cellular spatial layout. It is striking that even at this simple level natural language offers no terms or concepts to describe the layout. Spatial configuration is, in effect, non-discursive: we act competently in spatial complexes, but we cannot make our competence explicit. This is because space and spatial relations are so fundamental to our ability to cognise the world around us, that, like the relational rules that govern language, they form part of the ideas we think *with*, rather than those we think *of* (Hillier 1996; Bloom et al. 1996; Lakoff and Johnson 1999).

If we are to talk about spatial configuration then, we need to *invent* ways to talk about it. How can this be done? We are all familiar with the theory of graphs as the theory of pure relations. A graph is a diagram of relations in which the things related are called *nodes*, or *vertices*, and represented as circles, and the relations are called *links* or *edges*, and repre-

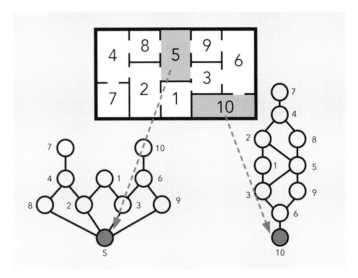

Figure 2 | Justified graphs from two difference spaces in a spatial layout, showing that the graph has very different properties when seen from different points of view.

sented as lines connecting the circles. In itself, a graph is not much clearer in representing spatial relations than the layout itself. However, in the case of space, we can visualise the relation of each space to all others through the *justified* graph, or *j-graph* (Hillier and Hanson 1984). A justified graph is where we pick a node and think of it as the *root* of the graph, and align the other nodes in layers above it according to the fewest other nodes we must pass through to get to that node from the root. This allows us to see some of the properties that we will seek to measure.

For example, it is easy to see that the left j-graph, drawn from space 5 in the layout (fig. 2), is shallow from the root, in that we do not need to pass through many intervening nodes to get to the other nodes. So we call it an *integrated* node, because it is on average close to other nodes. In contrast, the j-graph on the right, drawn from space 10 in the layout, is deep. We must pass through many more intervening nodes to go from the root to the other nodes. So we call it *segregated*, because it is on average not close to other nodes. This also affects the available *choice* of routes between the root and other spaces. Routes are of course shorter in the shallow graph, but there is also a choice of routes from the root to each space, and it is possible to go to each other space by a distinct route. In the deep graph there is only one route from the root to spaces 3, 9 and 1, and all must pass through space 6, while of the 5 routes from the root to space 7, 4 pass through space 5. These properties arise from the number of cycles, or rings, in the graph and where they are in relation to each node. If a graph is a pure tree, with no rings, then there is only one route between each pair of nodes, so we must always go the same way. How much choice of routes there is, and how many

routes pass through each space are both formal and potentially social questions we can pose of this layout.

So these two j-graphs look very different, and seem likely to have different functional potentials, even though they are of course the *same graph* looked at from different points of view. It is this property of space – of being different from different points of view – that buildings and cities exploit more than any other. As we will see, these differences are the key to the relation between spatial *form* and *function*. If we consider only the intrinsic properties of spaces, such as shape and size, then it is very difficult to find necessary relations to function, since, give or take the factors of size, most activities can be carried out in most spaces, and most spaces belong to a relatively small range of types, such as rooms and corridors. As soon as we add configurational properties, that is, the *extrinsic* properties of how each space relates to all the others, spaces become much more differentiated from each other, and their differing functional potentials become much clearer because configuration relates directly to potential movement patterns – and so co-presence – in each space.

This formulation allows us to redefine what we mean by a spatial system as a configuration. We may define it not in the usual way as a set of elements and relations, but as a *set of j-graphs* in which an *element is a position from which the whole system can be seen*, complete with its extrinsic as well as intrinsic properties. So we can think of a space in a building, or a street in a city as a point of view from which the whole system can be seen. This view of a system reconciles a *physical* view with a *phenomenological* view, in that the system is defined quite objectively and quantifiably, but at the same time it is defined as the set of different points of view from which the whole system can be seen. In such a system the primary properties of spaces are not intrinsic, but *extrinsic*: how each space relates numerically to all the others. The first quantitative step is then to represent the differences in these points of view numerically.

3 Numbers and colours

The integration value of a space can be calculated by treating it as the root of its j-graph, assigning a 'depth-value' of 1 to all spaces at the first level of depth, 2 to those on the second level, and so on till all spaces have been assigned their value, then summing the values to give the total depth of the system from that space. The total depth from space 5 in figure 2, for example, is 16, while for space 10 it is 30. To all intents and purposes, the total depth value is the integration value, but if systems with different numbers of spaces need to be compared, total depth must be subject to the normalisations set out in Hillier and Hanson (1984, Chapter 3) to take out the effects of the number of spaces on the measure. The integration value of a whole system will then be the mean of the integration values of its constituent spaces. Total depth is of course the mathematical measure of *closeness*, but the syntactic *integration* value is this plus the normalisations to take out the effects of size.

Measuring choice can also be best thought of on the basis of the j-graph. We assign a value of 1 to the root considered as an origin with respect to each other space considered as destination. We then assign a fraction to each space that lies on a simplest route to the destination at the first level of depth from the root, so if there are 3 we assign 1/3, then at the next level subdivide each fraction according to how many choices there are at that level, and continue through the levels until the fractions sum again to 1 at the destination. The sum of these fractions for each space for all origin destination pairs in the system will then be the choice value of the space. These choice values can be normalised by expressing each as a proportion of the total choice value in the system. The choice measure is closely comparable to mathematical *betweenness*, though calculated in a different way.

We can then make the patterns formed by these mathematical values intuitively clear by assigning colours to numbers, usually from red for most integrated through to blue for least (or light to dark grey if colour is not available). In this way we can *see* a mathematical structure in the configuration at a glance. We can also use both numbers and colours to show how culture manifests itself in the layout of space. For example in houses we usually find that a 'living room' or a 'kitchen' is not just a space with certain furnishings and implements, but also a certain *configurational position* in the house. These differences can be quantified by integration and choice analysis. By colouring up the integration values, for example, we can see that different functions have different degrees of integration into the layout as a whole, and where they are in relation to each other. Often these patterns are different across cultures. But within cultures we often find similar patterns even when the geometry of the houses is different (Hillier 1987; Hanson 1999). In effect, by defining space in terms of how all other spaces relate to it, and how it relates to all others, and exploring these relations across samples, we can find a clear and culturally variable *spatial meaning* to the idea of *function*. A *form-function* relation exists because function has been *realised spatially* through the positioning of the function in the layout as a whole.

By putting the various spaces or functions in order of integration, for example, we can construct an *inequality genotype*. To the degree that a sample of houses retains the *same* or a similar order, we can say that functions are being embedded into the spatial configuration of the house in a similar way. In other words, we are finding evidence of *cultural patterns* in the layout of the house itself. So *ideas* are seen to be objectively present in *things* as well as in minds. The *strength* of the genotype can be measured by the degree of isomorphism amongst the sequences in a sample. A strong genotype will indicate a strongly *rule-governed* environment, and vice versa. Inequality genotypes have recently been developed in several ways which may be of interest to archaeologists. Conroy-Dalton has developed a *graph matching* technique to explore how strong the genotypes are (Conroy-Dalton and Kirsan 2008). Kirsan has developed techniques for deriving information from incomplete data (Kirsan 2003). Monteiro has shown how the analysis can be applied to all household activities rather than simply spaces (reviewed in Hanson 1999).

4 Space types

Over and above these measures of configuration, it is also useful to see spaces as belonging to one of four configurational types: An *a*-space is a dead end. A *b*-space is on the way to a dead end, therefore you must return the same way. A *c*-space is at least 2-connected and lies on at least one ring and has one alternative way back, whereas a *d*-space is more than 2-connected, lies on at least two rings and has more than one alternative way back.

Although these definitions are applied to individual spaces, they are configurational in the sense that they are defined by the way the space fits into its surrounding context. An *a*-space is defined by being part of an *a*-complex, a *b*-space by being part of a *b*-complex, and so on. It is because they are configurational in this way that the space-types relate strongly to the two generic things that people do in space: moving and occupying, and how they relate. For example, because an *a*-space is a dead end, it offers no potential for movement and thus is suitable only for occupation. A *b*-space controls movement to an *a*-space or dead-end complex, and so lends itself to forms of occupancy which reflect the control of movement, and to forms of movement where returning the same way is useful rather than problematic (it would be undesirable in a gallery or museum, for example). A *c*-space creates a sequence which can return to an origin by a different path, and so lends itself to forms of occupation where continuous circulation through spaces without repetition is required. A *d*-space generates route choices, but also focuses movement from other spaces on to itself, and so is useful for forms of occupancy which benefit from the presence of movement, for example a communal space of some kind.

In the house whose graph is shown in figure 3, all space types are represented, and each relates to a certain type of function. One of the *a*-spaces is a 'best' room used only for the formal reception of guests, and the other is the office of the male house owner. The single *b*-space controls access to the office, and is used for interaction with business associates. The *c*-spaces are the vestibule of the formal entrance connecting to the best space and the corridor connecting it to the rest of the spaces, and also the ring of spaces for female domestic functions attached to the *salle commune*. The *d*-spaces are – apart from the outside, which is the root of the graph – the vestibule of the informal everyday entrance and the *salle commune* itself, the centre of everyday interaction. In each case the space type seems appropriate to its function.

The space types relate closely to how integration and segregation are created in layouts. In general, segregation is created by *b*- and *c*-spaces, since these create the necessity to pass through spaces to get to others, while integration is created by *a*- and *d*-spaces, which do not create this necessity. Thus a street network formed by outward facing buildings is essentially a mix of *a*- and *d*-spaces, a gallery or museum will be largely composed of *c*- and *d*-spaces to avoid having to retrace steps, with the mix determining how much choice and compulsory sequencing there is in the layout. Every layout in the form of a tree (as houses in some cultures are) will be made up only of *a*- and *b*-spaces. This will have the effect that

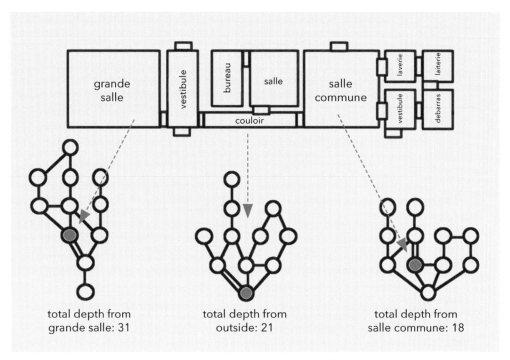

Figure 3 | Space types in the graph of a French farmhouse, taken from Hillier et al. 1987.

there is exactly and only one route from each space in the layout to every other. The mix of space types will then strongly affect the social functioning of the layout and its constituent spaces, and thus will be culturally informative.

5 Visual integration

So far we have considered configuration only in terms of relations amongst well-defined spatial elements such as rooms. Many spatial systems, from open-plan layouts in buildings to street systems in cities, do not have such easily definable spatial elements. However, reflecting the fact that different human activities have different natural geometries, space syntax as a set of techniques is about applying configurational analysis to many different representations of space, from such empirically defined elements as rooms, through to formal geometrical elements such as point, lines and convex spaces. All have different potentials for capturing some aspect of the space-function relation.

One of the most powerful techniques is based on points, and known as *visual integration* analysis. This is carried out using the DepthMap software (developed by Turner 2001, available through www.spacesyntax.com) by creating a uniform grid in all the space

to be analysed, as fine as we like, and then drawing the visual field from the central point in each grid square. We then carry out integration analysis on these overlapping shapes, colouring up as before. The j-graphs are of course now hidden, but they still underlie the analysis. The resulting pattern of visual integration says not simply how much you can see from each point, but how difficult it is to get to see all the space in the layout from each point in terms of the number of visual steps that must be taken. This technique has turned out to be particularly useful where movement is exploratory and impromptu, and therefore two-dimensional, as it is in a department store or museum, rather than linear and directed, as it tends to be in urban space (see below). It can be applied at two levels: knee level for where you can move; and eye level for what you can see. The relation between the two is often vital to understanding how space works. It can also be applied three-dimensionally, either for a single floor, or across floors. The analysis makes a much finer pattern of differentiation between the different points that make up the layout than line- or room-based analysis.

Let me give an example of where this technique can also help us understand museums and galleries, where movement can often be exploratory, rather than following a set route. On the left of figure 4, we see traces of 100 people entering the Tate Britain Gallery, as it was in 1996, and moving and viewing for ten minutes. On the right is a visual integration analysis. It is not difficult to see that the two patterns strongly resemble each other, not in all detail, but pretty well. Visitors seem to be using the visual structure of the gallery as their main navigational aid, so that more visually integrated spaces have more movement passing through them. We can test this statistically by simply correlating observed movement rates with spatial values for the space at the level of the rooms. We find a correlation of just under 70% (r-square .68) between the mean visual integration values of the rooms and the logarithm of movement. This is very unexpected. It suggests that the way in which we intuitively read the layout visually is actually having the most powerful influence on the pattern of movement (Hillier et al. 1996; Hillier and Tzortzi 2006).

Once we have such an analysis, bringing to light a clear relation between the spatial form of the building and the key aspect of how it functions, we have a powerful design tool, since we can then use the analysis to explore the effect of changes by simply drawing the plan and re-analysing. This study was in fact part of the remodelling of the gallery carried out in the late nineties, and is now being used for planning a further extension. Turner has also developed 'intelligent' agent-based techniques, available in the DepthMap software, in which what is learnt by studying movement is built into the agents as knowledge. Spatially intelligent agents in this sense are now being used on real design projects (see www.spacesyntax.com).

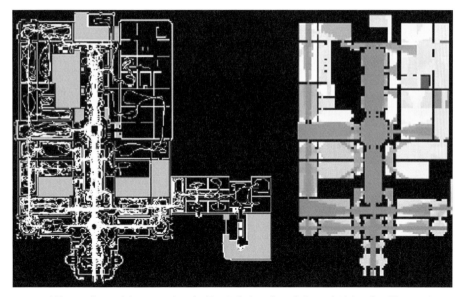

Figure 4 | Traces of 100 visitors entering the Tate Britain gallery (left), and (right) visual integration from dark for strong to light for weak.

6 Some theoretical implications

This then is how space syntax works as a technique. Now let us look at some theoretical implications of what we have said. By analysing space rigorously, and observing human activity carefully, we have already shown that space and social activity relate in two ways. Through its inequality genotype, the spatial layout of, say, a house can reflect and embody an existing social pattern, because space was laid out and categorised to give reality to culturally given domestic norms, thereby reinforcing and reproducing them through a pattern of integration. Hence we can perpetuate things about ourselves and our cultures by building them into space, thus making them seem inevitable and natural. We can call this the *conservative* use of space, since space is being used to reflect and so reproduce a given social pattern. But space can also *shape* potential social patterns, as in the case of Tate Britain, since by shaping movement, space also creates new patterns of co-presence in space, and thus new potential encounters. In Tate Britain this happened in a particularly interesting way, since the pattern of choice in the gallery means that people who were co-present in space when entering the gallery could first split apart by taking different routes, then re-encounter, and perhaps recognise, each other, perhaps moving in opposite directions. This could then be repeated to create a pattern of re-encounter we called 'churning'. Where space creates new patterns of co-presence then, we can call it the *generative* use of space, since space is being used to create the potentials for new co-presence and potentially for new social relations.

The distinction between the conservative and generative use of space is foundational to how people, individually and collectively, make space into the social thing that it is. To understand how it does this, we must first show that it mirrors a no less fundamental distinction in the social fabric, and one found, as far as I can see, in any society. To explain this, we can begin with a hardware-software distinction. In the house, the spatial and physical structure is the hardware and the concealed cultural rules that shape its emergent form the software. As with the house and the gallery, buildings as spatial forms vary on the continuum from the *conservative* at one pole, meaning a high ratio of rules to events, and thus little randomness, to the *generative* at the other pole, meaning a low ratio of rules to events, so more randomness We intuit this as the distinction between formal and informal. In a conservative environment, there are more rules to follow, in a generative environment fewer.

We can make a parallel distinction about human society. In society, human encounter is the hardware – the space-time events – and social rules and conventions are the software. Again it varies on a formal-informal dimension. Formal encounters mean a high ratio of rules to events, and the limiting case is a ritual, where everything that happens reproduces a given form and given social relations in a given order. In this way, it reproduces existing relations and so conserves them. Informal encounters mean a low ratio of rules to events. The limiting case is a 'party', where the general rule is "let everyone talk to everyone else", hence it is generative of new social relations and transformative of existing ones. Everyday life combines both, but can be more or less 'ritualised'. Usually in different phases of life we use more or less ritualised models according to the social situation we are in: the more asymmetric the encounter, or the greater the social distance, the more it will tend to have a higher ratio of rules to events. We behave more politely when relations are seen to be asymmetric.

We can call a low ratio of rules to events a *short model*, since we can write down the rules in a short sequence of symbols and use them to govern a large number of events, and a high ratio a *long model*, since we require a long sequence of symbols to govern a small number of events. So a party is a short model event, with a ritual being a long model. The length of model used in different situations is a pervasive feature of social life. For example, a group of peers working together on a daily basis will develop what linguists call a short code, that is an informal and economical mode of communication. Their behaviour will then tend to be morphogenetic, and lead to new outcomes that do not already exist. Similarly, we find that highly asymmetric relations in domestic life tend to generate a long model which affects how space is divided by boundaries, as well as how people behave towards each other. Such behaviours are conservative in that they reproduce existing patterns. This distinction is also a structural feature of society. In all societies we can distinguish the proportion of human effort and resource that goes into the biological survival of individuals, and the proportion that goes into biologically pointless activities which serve to reproduce social relations. Economic anthropologists used to contrast this as the *replace-*

ment fund and the *ceremonial fund* (Wolf 1966) and enquire into how much time different societies spent on each.

However, in general two things will vary systematically: replacement fund activities will tend to have a shorter recursion period, involve a great deal of everyday activity, and bring together a local group and use a short model, that is a low ratio of rules to events; while ceremonial activities will tend to have a longer recursion period, take the form of special events rather than everyday activity, involve a wider group of people and use a longer model, that is a higher ratio of rules to events. More generally we can say that the shortness of the model is inverse to distance, and vice versa, that is to the probability of encounter. Indeed, we can say that one of the aims of ceremonial life is to make things happen across distances, and so bring together what would otherwise be separated. We find this equally pervasively in our own lives. For example, we eat every day informally with our spatial group, whatever that might be. But every now and then we have a dinner party, which brings people together across distances, and uses a longer model for the dinner itself – better wine, more elaborate cooking and so on. Conversely, the closer you live to other people, the easier it is to invite them to an informal event.

Thus long and short models are not only common to space and behaviour, but also link space and behaviour, and do so in a structural way. In saying that where we find asymmetric local relations we use longer models we are simply saying that here the distance is in the software rather than the hardware – so 'social distance' is software distance, and physical distance is hardware distance. Therefore space and social relations not only share common ground, they are also intimately and dynamically related in social life. In general this would lead us to expect that increasing spatial integration would lead to shorter models, except insofar as asymmetric relations are realised locally, in which case we would expect longer models. Conversely, we would expect living under more dispersed conditions, as in suburbs for example, to be associated with longer models, as indeed seems to be the case: suburban life is more rule governed. Whole lifestyle choices then seem to engage this distinction. I will soon show how this lawful relation between space and society features in the ways in which cities in different cultures acquire their different types of spatial patterning, but first I must demonstrate other kinds of law that intervene in the processes whereby cities emerge from collective human activity.

7 A spatial law

The first type of law we must consider is the most basic: laws governing how spatial configuration emerges in the first place from the placing of physical objects in space. Many would be sceptical about the possibility of spatial laws because space seems to acquire its forms and structures only through the way we deploy physical objects which partition space. How can a dependent variable be lawful? In fact, the primary form of lawfulness in

space is exactly about this. Configuration emerges in space precisely through the ways in which we place physical objects within it.

We can find out that this is the case by configurational analysis of the effect of placing objects in space. We quickly bring that to light when we place an object in space, with configurational properties emerging in the ambient space of the object, varying with the location and shape of the object. An understanding of these laws is indispensable to an understanding of how the pattern of space in settlements and cities emerges from the aggregation of buildings. It is also indispensable to understanding human spatial cognition. I will argue that we learn to intuit laws of real space in much the same way that we learn to intuit physical laws – cognitive scientists call it intuitive physics – so that we can crumple up a ball of paper and throw it so that its parabola leads it to land in a waste-paper basket. We learn these laws by manipulating space.

Let us begin with an example. A group of people is sitting in armchairs in my daughter's flat. My two year old grandson comes into the room with two balloons attached to weights by two pieces of string about two and a half feet long, so that the balloons are at about head height for the people sitting. Looking mischievous, he places the balloons in the centre of the space defined by the armchairs. After a minute or two, thinking he has lost interest, one of the adults moves the balloons from the centre of the space to the edge. My grandson, looking even more mischievous, walks over to the balloons and places them back in the centre of the room. Everyone understands intuitively what is going on, including you. But what is actually happening? What my grandson knows is that by placing an object in the centre of a space, it creates more obstruction from all points to all others in that space than if the object is placed anywhere else. In this way, he seeks to draw attention to himself, so that people will interact with him rather than each other.

In fact, this simple story shows three key things about human spatial cognition, even at an early age. First, his understanding is clearly configurational – he is working with a pattern, not a thing. Second, his understanding is allocentric as well as egocentric, meaning that he understands the relations amongst other points of view, as well as the relations to others from his own egocentric point of view. Both of these are of profound importance in understanding how people cognise space. But from our point of view today, there is a third implication of even greater importance. What he does reflects a simple mathematical law: that when you move an object from corner to centre and consider its effects from all points to all others – we might call them allocentric effects – then inter-visibility from all points to all others is significantly reduced, and the mean metric distance by shortest paths from all points to all others increases (that is, metric integration decreases). These effects are shown in figure 5 (left and right), in which the degree of visual and metric integration of each pixel is indexed from light for high through to dark for low. These are laws which I believe we know intuitively, but not I think formally. As I suspect these laws may be part of the spatial foundations of architecture, we should look at them closely and understand how they work.

Figure 5 | Moving an object from corner to centre decreases inter-visibility (left: light means less visual distance to all other points, and dark more) and increases the mean length of trips (right: light is less metric distance, and dark more).

The same laws apply to changing the shape of the object, as in figure 6. An elongated object will decrease total inter-visibility and increase total distance from all points to all others compared to a square one of equal area.

Figure 6 | Changing the shape of an object from square to rectangular decreases inter-visibility and increases mean trip length. Again, light means less visual distance (left) and metric distance (right).

Why does this happen? Consider the spatial property of inter-visibility, which is a con-figurational property in the sense that it deals with the simultaneous relations of each space to all others, and so is not the same as simple visibility. Suppose, then, that we have a rectangular space, as in figure 7, made up of 8 unpartitioned sub-spaces, each of which has a human individual sitting in the centre. We want to partition somewhere along its length. We are interested in retaining as much inter-visibility as we can. Does it make any differ-ence where we place the partition? In terms of total area, of course, it makes no difference, since wherever we place the partition, the total area will remain the same. We might expect that the same would be true of inter-visibility. But it isn't. As we move the partition from centre to edge the number of people who can see each other increases.

Why? Because the number of people who can see each other in an open space is most simply expressed as the square of the number of people – as in n people can see n others, so total inter-visibility is $n \times n$. So with the partition placed centrally, we have twice the square

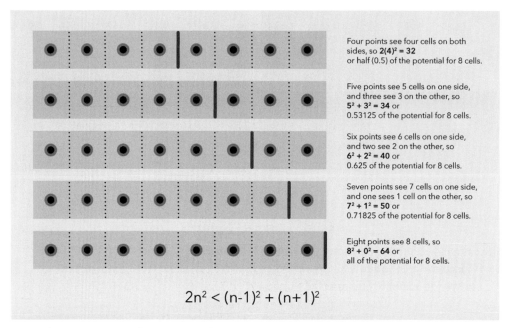

Four points see four cells on both sides, so **2(4)² = 32** or half (0.5) of the potential for 8 cells.

Five points see 5 cells on one side, and three see 3 on the other, so **5² + 3² = 34** or 0.53125 of the potential for 8 cells.

Six points see 6 cells on one side, and two see 2 on the other, so **6² + 2² = 40** or 0.625 of the potential for 8 cells.

Seven points see 7 cells on one side, and one sees 1 cell on the other, so **7² + 1² = 50** or 0.71825 of the potential for 8 cells.

Eight points see 8 cells, so **8² + 0² = 64** or all of the potential for 8 cells.

$$2n^2 < (n-1)^2 + (n+1)^2$$

Figure 7 | Moving a partition from centre to edge increases total inter-visibility.

of two equal numbers. And as we move the partition one step towards one of the edges, we have the square of a larger number plus the square of a proportionately smaller number. Mathematically this will always be a larger number than twice the square. All we need to know in effect is that this twice the square of a number, n, will be a smaller number than $(n - 1)^2 + (n + 1)^2$:

$$2n^2 < (n - x)^2 + (n + x)^2 \tag{1}$$

This means that a large space and a small space have greater inter-visibility than two equal-sized spaces. This may be why in buildings a large space and a small space feel bigger than two equal-sized spaces, even though the total area is equal, why in cities a short and long line seem longer than two equal lines, and perhaps even why a long and a short time interval seem longer than two intervals broken in the middle. Our understanding of space and time seems to be configurational in this sense.

The same laws apply to metric distances from all points to all others: more centrally placed or elongated obstacles increase metric distances more than peripherally placed or square ones. One consequence of this is for the mean length of trip (or metric integration) from all points to all others in different types of grid, holding ground coverage of blocks, and therefore total travellable distance in the space, constant. In the four grids shown in figure 8, dark grey in the open space means short mean trip length to other points through to light grey for longer trips.

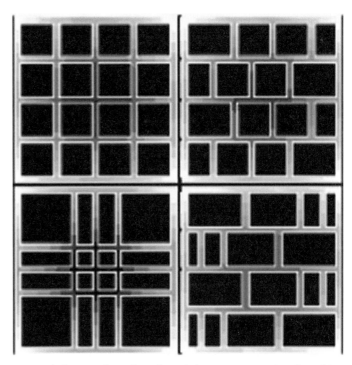

Figure 8 | Changing the scaling of a grid changes mean trip length. In this case, for graphical clarity, dark means less metric distance from each point to all others. The mean distances for each system are: top left 2.53, top right 2.59, bottom right 2.71, bottom left 2.42.

Compared with the regular orthogonal grid top left, interference in linearity on the right increases mean trip length. But more strikingly, if we reduce the size of central blocks and compensate by increasing the size of peripheral blocks, we reduce mean trip length compared to the regular grid. This is in fact a very common pattern found in towns and cities, with small blocks in centres, local or global, and larger blocks away from centres. So again we find a mathematical law underlying an empirical phenomenon.

8 How does this spatial law relate to urban space?

How we place and shape objects in space then determines the emergent configurational properties of that space. But what kind of block placing and shaping makes space urban? On the left of figure 9, we aggregate buildings in an approximately urban way, with linear relations between spaces, so that we can see where we are going as well as where we are. On the right we retain the identical blocks but move them slightly to break linear connections between the spaces. If we then analyse metric and visual distances within the two

Figure 9 | Two slightly different arrangements of identical blocks, with strong linear relations between spaces on the left and weak on the right.

complexes, we find that all to all metric distances (not shown) increase in the right-hand case, so trips are on average longer, but the effect is slight compared to the effect on all to all visual distances, which change dramatically (shown in figure 10).

Figure 10 | Visual integration analysis (light is high, and so low visual distances from all points to all others) showing how the non-urban layout on the right loses both integration and structure through the slight block changes.

Showing visual integration, as in figure 10 – light means less visual distance – we see that the left case identifies a kind of main street with side and back streets, so an urban type structure has emerged. But the right case has lost both structure and degree of inter-visibility. Even though the changes are minor, it feels like a labyrinth. We can see where we are but not where we might be. The effect on computer agents moving around the system is striking, if obvious. In figure 11 we move 10,000 computer agents with forward vision in the space, again using the software by Alasdair Turner (2001). The agents randomly select a target within their field of vision, move 3 pixels in that direction, then stop and repeat the pro-

Figure 11 | Traces of 10,000 forward looking agents moving nearly randomly.

cess. On the left, the traces of agent movement 'find' the structure of visual integration. On the right, they wander everywhere and tend to become trapped in fatter spaces. This is an effect purely of the configuration, since everything else is identical.

But what about human beings? Human beings do not of course move randomly, but purposefully, and successful navigation in an unfamiliar environment would seem to depend on how good a picture of the whole pattern we can get from seeing it from a succession of points within it. One way we might plausibly measure this property is by correlating the size of the visual field we can see from each point with the visual integration value (its visual distance from all others), so in effect measuring the relation between a *local* property that we can see from each point, and a *non-local* one that we cannot see.

In space syntax this is called the *intelligibility* of the system. The r^2 for the 'intelligible' layout on the left is 0.714, while for the right case it is 0.267. Defined this way, the intelligibility of a spatial network depends almost entirely on its linear structure. Both field studies (Hillier et al. 1987) and experiments (Conroy-Dalton 2001) suggest that this does work for humans.

For example, Conroy Dalton took a linearised 'urban' type network (fig. 12, left) and asked subjects to navigate in a 3D immersive world from left edge to 'town square' and back. As the traces show, they manage to find reasonable routes. But she then moved the (identical) blocks slightly to break the linear structure and reduce intelligibility (fig. 12, right), and repeated the experiment. The subjects found the modified layout labyrinthine and many wandered all over the system trying to perform the same way-finding task.

9 How then do urban patterns arise?

The intelligibility of space seems, in effect, to be largely dependent on linear organisation. As we aggregate objects in space, linking spaces linearly in a space becoming densely filled

Figure 12 | Trace of human agents trying to navigate from edge to centre in an intelligible (left) and unintelligible (right) layout.

seems to be the only way to avoid creating a labyrinth. How then does this kind of structure arise? We need to know a second kind of law, this time governing how aggregating cells in partially randomised systems can lead without design to the emergence of certain key features of urban spatial patterns. We can understand this by noting first that the basic form of most cities is one of discrete groups of contiguous buildings, or 'blocks', usually outward facing, defining a network of linear spaces linking the buildings, and asking how this can arise from an aggregative process.

If we take cell dyads (fig. 13, top left), representing buildings linked by entrances to a bit of open space, and aggregate them randomly, apart from employing a rule that each dyad joins its bit of open space cell to one already in the system (forbidding vertex joins for the buildings, since no one joins buildings corner to corner), a pattern of buildings and spaces emerges with the topology of a city – outward facing blocks defining a linking network of linear space – but with nothing like its geometry, in spite of being constructed on a regular grid (Hillier and Hanson 1984). The 'blocks', and therefore the spaces, are the wrong shape. Where then does the characteristic urban geometry come from?

The answer lies of course in our first type of spatial law and its implications for linearity. Thus, if we modify our aggregative process by requiring those adding cells to the system to avoid blocking a longer local line if they can block a shorter one (fig. 14, left), we find a much more urban type layout emerges, approximating the mix of long and short lines we

Figure 13 | Aggregating dyads of open and closed cells by a restricted random process.

find in real systems and emulating certain structural features (Hillier 2002). With the contrary rule – always block long lines (fig. 14, right) – we construct a labyrinth in which lines are of much more even length. So urban space networks seem to be shaped in some degree by a combination of spatial laws and human agency, with the human agents implementing, and hence in a sense knowing, the spatial laws.

The importance to archaeology of understanding how complex spatial patterns can arise without design from a partially randomised system could sometimes be considerable. It is as true of the forms of seemingly complex buildings as it is of settlement forms. Even a simple process of aggregation governed only by a rule about how many faces of each cell must be left free for light and air generates different emergent shapes under aggregation. For example, 2-connected will tend to a street or courtyard pattern, while 3-connected generates a complex built form with a network of differently sized courtyards – a form that is found again and again in the archaeological record. If we also include rules about the permeability of cells to each other, even more complex forms can arise without design.

For example, in figure 15, we start with a single cell with a single entrance, then add cells full-facewise, but otherwise randomly, each time creating a permeability from the new cell to the existing cell which it adjoins, and adding a second permeability to the outside. Where cell adjacencies arise randomly, say to close a courtyard, no permeability is added. The emergent pattern is again a network of courtyards, but now with an internal spatial

Figure 14 | A layout generated by a 'conserve longer lines' rule (left) and one generated by the inverse rule.

Figure 15 | Formal, spatial and functional patterns emerging in a cellular aggregate.

structure resulting from the accumulation of permeabilities. This will then in itself have a structure in the form of a pattern of line integration, which in turn will shape the pattern of movement and co-presence. So we see that, as with settlements, spatial and functional properties can emerge without design in built forms being generated through a partially randomised aggregation process.

10 The geometry of cities

So what of real cities? What can we learn of the spatial and social structures of cities, and the relations between them? We can begin by looking very carefully at the geometrical and metric properties of two relatively unplanned cities which have no common history: London and Tokyo. Figure 16 shows an arbitrarily selected part of the street network of each in the form of least (or 'axial') line maps, made up of the fewest and longest lines which pass through all the space of the system and make all connections – maps shown to be objective in Turner et al. 2005, in spite of challenges. Least line maps for a larger number of cities have already brought to light some remarkable consistencies. Most strikingly, at all scales, from the local area to the whole city, and for both 'organic' and 'geometric' cities, we find least line maps are made up of a very small number of long lines and a very large number of short lines, so much so that in terms of the line length distributions in their least line maps cities have scale-free properties (Hillier 2002; Carvalho and Penn 2004). Practically speaking, we also find that wherever we are, we are not far from a line much longer than the one we are on. Formally, it means that these often haphazard urban growths have acquired some mathematical structure. This poses a puzzle. How can mathematically well-formed networks emerge from decades or centuries of activity by innumerable uncoordinated agents acting in very different social, economic and cultural situations and working with very different, and highly variable, geometries?

However, this is not all we find. If we look carefully at the two maps in figure 16, we begin to see geometrical as well as metric consistencies. For example, in both cases, the eye intuitively picks out *line continuities,* formed by series of nearly straight end-line to end-line connections. If we move along one of these lines, another is very likely to be found at the end of the line, and then another. This happens at all scales, but at each scale the lines are locally longer than lines which lack this kind of angular connection. It can be said that, in both cases, probabilistically, the longer the line, the more likely it is to end in a nearly straight connection to another line.

In both maps, the eye will also note a large number of shorter lines, often with near right-angle connections, forming more grid-like local patterns. Again, if one such line is found, then it is likely that there will be several others in the immediate neighbourhood. We can also say that the shorter the line, the more likely it is to end or intersect in a right angle or near right angle. These are the opposite properties to those we find in formal cities, like

Figure 16 | Arbitrarily selected part of the street network of Tokyo (left) and London (right) in the form of least line maps.

Brasilia or pre-Columbian Teotihuacan, where the longest lines end at right angles to key structures.

Thus organic grids tend to have a kind of informal geometry. They are more regular than they appear at first sight. There is, in effect, a hidden geometry in organic cities: they are quite grid-like, in spite of seeming irregular (Hillier 1999). We can call them *deformed grids*. At the same time, geometric grids are not so regular. Lines are of very different lengths and connectivities, because many are *interrupted*, either by buildings or other artefacts. We can perhaps speak of two kinds of grid: *deformed grids* and *interrupted grids* (Hillier 1996). More importantly, all kinds of grids seem to take a dual form, in the shape of a foreground grid with one set of geometrical and metric properties and a background grid with another.

11 Cities as configurations

Yet cities which we expect to be different turn out to have even more striking properties in common when we examine them as configurations using space syntax techniques. Here we can again make use of the Depthmap software. This allows us to begin with the street segment between junctions as our unit of analysis and examine patterns of *integration* and *choice* using three different measures of distance – least length (metric), fewest turns (topological) and least angle change (geometric), applied at different radii, defined in the same three ways as distance. This gives a powerful family of quantitative techniques for examining spatial structure in cities and its relation to functional patterns.

Using DepthMap it was possible not only to confirm what had been known since Hillier et al. (1993), that the correlation between grid configuration and movement densities

40 BILL HILLIER

showed a surprising regularity, but also that the strongest correlations were found when configuration was analysed using least angle change measures, leaving little doubt that people, whether walking or driving, work out routes using a geometric mental model of the grid (Hillier and Iida 2005). The consistency with which the correlation has appeared in different studies, and emerged as the strongest variable in multivariate studies of the influences on movement patterns, confirms that the relation between grid structure and movement – and so co-presence – is a powerful probabilistic law.

DepthMap has also been used to show common global structures in cities, even when they have had no common history or mutual influence. For example, the *integration core* of a city often forms a pattern we call a *deformed wheel*, with a hub, spokes and rim forming the main structure of public space, and the residential areas in the interstices of the wheel. This first came to light in the study of small towns in the South of France, and we found the same pattern in London's urban areas with her 'urban villages' at the hub. However, it was something of a surprise to find the pattern approximated in very large cities such as London (with a relatively weak rim), and Tokyo (with much stronger, and multiple rims). When we examine cities using the *choice* measure we find a network across the whole grid, closely following the *foreground network* we identified geometrically (fig. 17).

Examining the pattern of centres and sub-centres in relation to these networks at all scales (using the radius restricted measure to examine local properties) leads directly and unmistakeably to a new spatial definition of the city as a foreground network of linked centres at all scales, set into a background network of primarily residential space. This is created by a clear process. The grid configuration emerges from the step by step addition of buildings and urban blocks to the city, the configuration then shapes the pattern of movement, and land use patterns follow grid induced movement, creating, with feedback and multiplier effects, the functional duality of the city as a direct outcome of the spatial duality.

It is also a socio-cultural duality. We showed earlier that space itself has dual potentials, in that we can use space generatively to create new co-presence that is not part of existing social relations, or we can use space conservatively to control co-presence in the image of an existing social order, and so help to reproduce that order. But both arise from the basic thing that space does: shape a pattern of movement and co-presence. In cities space is used in both generative and conservative modes, the former, driven by micro-economic activity, to create the foreground grid, the latter, driven by residential culture, to create the background grid. So in the dual city we see an emergent spatialised sociology, as well as a structure-function relation.

We can illustrate this most clearly in a city with more than one culture (now unfortunately divided): Nicosia (fig. 18). Top right is the Turkish quarter, bottom left the Greek quarter. Their line geometry is different. In the Turkish quarter, lines are shorter, their angles of incidence have a different range, and there is much less tendency for lines to pass through each other. Integration analysis highlights even more how different the areas are.

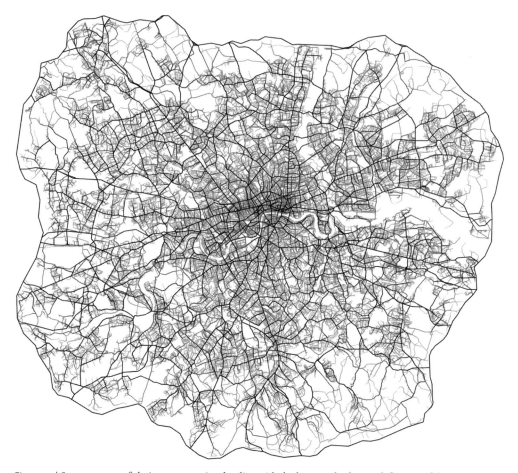

Figure 17 | Segment map of choice at unrestricted radius with the least angle change definition of distance for London within the M25. The measure identifies the foreground network of linked centres set into the background network of mainly residential space.

Syntactically, the Turkish area is much less integrated than the Greek area. We can also show that it is less intelligible, and has less synergy between the local and global aspects of space. Yet in spite of these strong cultural differences in the tissue of space, we still find that Nicosia as a whole is held together by a clear foreground grid with a 'deformed wheel' structure.

Understanding how both networks emerge at once is the key to understanding how the space of cities is created. Cities are in effect generated by a dual process: a public space process, driven largely by micro-economic factors which are invariant and tend to give cities similar global structure, and a background residential space process, which is driven by cultural factors and thus tends to make cities locally different from each other. The two processes are driven by the same underlying laws being used in two different ways: in

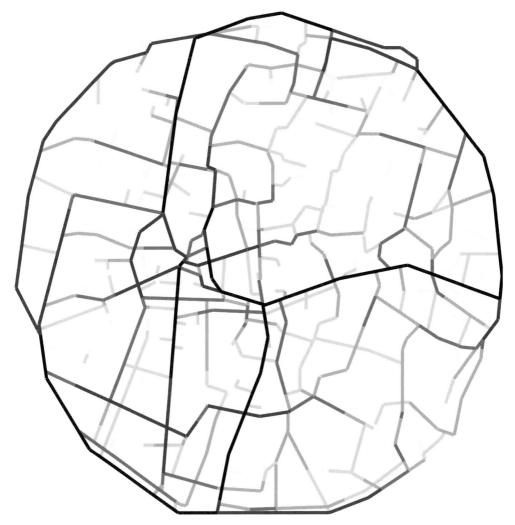

Figure 18 | Segment map show integration at unrestricted radius with the least angle change definition of distance for Nicosia within the walls (dark: strong/light: weak). In spite of the strong spatial difference in the background network, the system is structured by a deformed wheel core.

one, to generate the most public space in which movement and co-presence are maximised; in the other to generate residential space which is more controlled and modulated according to the needs of culture. This is the *generic* form that cities have taken since this structure first emerged, and it is of great interest to space syntax theory to know from archaeologists where and when this dual spatial and functional form first appeared – we believe in post-Ubaid Mesopotamia, perhaps in Uruk – but others may know better.

However, this is the city-creating process that eventually turns collections of buildings into living cities. It shows a process of self-organisation which at once involves laws, but is

run by people taking decisions – about building, moving, assigning land uses, modifying space, and so on. Both in the growth of the city as an emergent spatial pattern and in the way in which movement sets in motion the processes whereby the spatial pattern comes to life, decisions by human cognitive agents require some allocentric picture of the organisation of the grid, at least at a localised level. The emergence of structure and the structure-function relation both depend on the spatial cognition of knowing human subjects. It shows how cities tend to acquire similar global forms through micro-economic activity which is both universal and globalising, and dissimilar local background forms through cultural factors which are both differentiated and localised. We should see the urban grid not as an inert background to activity, but as a historical record of a city-creating process, with universal as well as idiosyncratic aspects. Archaeologists need to be aware of this.

We can also learn from this another fundamental property of cities which is of relevance to archaeologists. Cities appear to us as patterns of activity related to patterns of space. This is how the task of design is presented to the designer: how a specific pattern of activity is to be related to a specific pattern of space. Yet theoretically cities are not like that, and this is not how they become as they are. Space is created not directly by the interrelated demands of specific activity patterns, but indirectly by the different demands that *kinds* of activity place on the movement and co-presence that is created by space. The basic differentiation between the micro-economic and cultural aspects of activity have already been shown to be of this kind. The relation between activity and space in cities is *generic*, not *specific*. This is why the new patterns of activity that constantly evolve as society changes so often fit effortlessly into old patterns of space. However much society changes, there is always likely to be a range of activity with different demands on movement and co-presence, from those that need co-presence through to those that do not, and each will find its appropriate locus in the range of spaces available, provided that it is sufficiently rich.

12 A theoretical reflection

Hence we can see that organic cities come to be what they are – seamless networks of busy and quiet zones, often in close proximity to each other – in two dynamically interlinked stages: how buildings aggregate to create urban type space patterns; and how by shaping movement and co-presence these space patterns then set in motion the chain of events which create the sense of well-ordered diversity that good cities provide. Objective spatial laws are decisive in both phases, in that the creation of space from buildings happens as it does through these laws, and the effect of spatial configuration on movement is also lawful. However, as we have seen, both types of law only appear in the process through the agency of individual human beings, whether they are taking decisions on the growth or modification of the physical city, or making decisions about how to move through the grid. This is

why we say that before cities are social products, they are human products. They reflect how our minds read their ambient space and use it to guide both their actions and their bodies in space. Moreover, insofar as cities are human products, they tend to be universal, and insofar as they are products of culture, they tend to be differentiated. The individuality of cities arises because both of these are partial orderings against a random background, so that a large number of idiosyncratic facts also shape cities.

So a science of the city does not mean setting aside the human individual and the human subject. We cannot give an account of the city without an account of the human subject, because cities self-organise and the human individual is the agent of self-organisation. Even though physical-spatial laws are involved, they enter the process through the human subject. In this sense the syntactic theory of the city combines a phenomenological view of space with a science of space (Hillier 2005). We must do this because cities are human products in a very strong sense. In their very form and function they reflect what we are and how we can be. Perhaps this is why cities are the greatest artefact.

13 A meta-theoretical reflection

How then does this approach to space fit into others? We must be blunt: it is a different paradigm. We must be clear how. There are, in our time, more approaches to space than you can shake a stick at. I reviewed many of them in Hillier (2008). Yet all share a paradigmatic agreement on three things: first, that space is not of interest in itself, but only insofar as it is shaped by human agency; second, that space does nothing to us; it has no agency in itself, and can only receive the imprint of society, not put its own imprint on society; and third, space certainly can't have its own laws – that would mean going back to the too awful sixties and the – long since abandoned – 'quantitative revolution'.

I have shown the contrary for all three propositions: firstly that, seen as configuration, space is of independent interest and responds to human agency in systematic and analysable ways – in spite of the apparent paradox that space seems to be dependent on its creation and on the deployment of objects – partitions, buildings, and so on; secondly, that space does have agency: as configuration it shapes emergent collective movement flows and therefore human co-presence. In my view this is what space does, and all it does, and everything else it seems to do passes through this basic relation – which is intuitively obvious, mathematically necessary and empirically the case; and thirdly that space is after all subject to laws which apply to it quite specifically and to nothing else.

There are in effect three types of law: type 1: laws of space itself, governing the emergence of spatial complexes with well-defined properties of various kinds; type 2: laws from space to people, primarily, the lawful relation between spatial configuration and human movement and co-presence; and type 3: laws from people to space – for example, the laws that govern the ways in which micro-economic activity and residence have differential

effects on urban patterns. I hope that I have given clear and unambiguous examples of each type of law in operation and shown a clear and credible mechanism for how each law works. It is knowledge of these laws which I believe can and should inform the process of making social and cultural inferences from spatial remains.

Bibliographical references

Bloom, P., Petersen, M., Nadel, L., and Garrett, M. (1996)
Language and Space, Cambridge, MA.

Carvalho, R., and Penn, A. (2004)
"Scaling and Universality in the Micro-Structure of Urban Space", in: *Physica A* 332, pp. 539–547.

Conroy-Dalton, R. (2001)
Spatial Navigation in Immersive Virtual Environments, Bartlett School of Graduate Studies, University of London (PhD thesis, not published).

Conroy-Dalton, R., and Kirsan, C. (2008)
"Small Graph Matching and Building Genotypes", in: *Environment and Planning B: Planning and Design* 35, 5, pp. 810–830.

Hanson, J. (1999)
Decoding Homes and Houses, Cambridge, MA.

Hillier, B., and Hanson, J. (1984)
The Social Logic of Space, Cambridge, MA.

Hillier, B., Hanson, J., and Graham, H. (1987)
"Ideas Are in Things: An Application of the Space Syntax Method to Discovering House Genotypes", in: *Environment and Planning B: Planning and Design* 14, pp. 363–385.

Hillier, B., Burdett, R., Peponis, J., and Penn, A. (1987)
"Creating Life: Or Does Architecture Determine Anything", in: *Architecture and Behaviour* 3, 3, pp. 233–250.

Hillier, B. (1996)
Space is the Machine, Cambridge, MA.

Hillier, B., Major, M., Desyllas, J., Karimi, K., Campos, B., and Stonor, T. (1996)
Tate Gallery Millbank: A Study of the Existing Layout and the New Masterplan Proposal, UCL eprints, http://eprints.ucl.ac.uk/932/ (20 September 2013).

Hillier, B. (2002)
A Theory of The City as Object: How the Social Construction of Urban Space is Mediated by Spatial Laws, Urban Design International 7, pp. 181–203.

Hillier, B., Penn, A., Hanson, J., Grajewski, T., and Xu, J. (1993)
"Natural Movement: Or Configuration and Attraction in Urban Pedestrian Movement", in: *Environment and Planning B: Planning and Design* 20, pp. 29–66.

Hillier, B. (2005)
"Between Social Physics and Phenomenology", in: *Proceedings of the Fifth Space Syntax Symposium*, Delft.

Hillier, B., and Iida, S. (2005)
"Network and Psychological Effects in Urban Movement", in: Cohn, A.G., and Mark, D.M. (eds.), *Spatial Information Theory: COSIT 2005, Lecture Notes in Computer Science 3693*, Berlin, pp. 475–490.

Hillier, B., and Tzortzi, K. (2006)
"Space Syntax: The Language of Museum Space", in: MacDonald, S. (ed.) *A Companion to Museum Studies*, Wiley-Blackwell, pp. 282–301.

Hillier, B. (2008)
"Space and Spatiality: What the Built Environment Needs From Social Theory", in: *Building Research and Information* 36, 3, pp. 216–230.

Kirsan, C. (2003)
"Detective Work With a Deficient Sample: Syntactic Analysis of the Houses of Conflict", in: Hanson, J. (ed.), *Proceedings of the Fourth Space Syntax Symposium*, London.

Lakoff, G., and Johnson, M. (1999)
Philosophy in the Flesh, Basic Books, New York.

Turner, A. (2001)
"DepthMap: A Program to Perform Visibility Graph Analysis", in: *Proceedings of the Third Space Syntax Symposium*, Atlanta.

Turner, A., Penn, A., and Hillier, B. (2005)
"An Algorithmic Definition of the Axial Map", in: *Environment and Planning B: Planning and Design* 32, 3, pp. 425–444.

Wolf, E. (1966)
Peasants, Prentice Hall, New Jersey.

Quentin Letesson

From building to architecture:
The rise of configurational thinking in Bronze Age Crete[1]

Abstract

This paper is based on the identification – through space syntax analysis of Neopalatial architecture (Late Bronze Age Crete, c. 1600–1425 BC) – of a large number of topological and quantitative recurrences within the Minoan architectural landscape. These findings allow us to recognize a genotype (i.e. an underlying set of principles) that permeated the Minoan built environment, forming a continuum between domestic buildings (houses) and monumental and communal structures (such as the so-called 'palaces'). Using the Neopalatial genotype as a starting point and extending the space syntax analysis to earlier built forms, this paper aims at investigating the development of Minoan architectural language. This research establishes that, at the end of the Middle Minoan Period – if not earlier – a seemingly conscious concern about structure, i.e. spatial configuration, manifested itself, contributing to a shift from vernacular building to 'theoretical' architecture. Bearing that in mind, this paper intends to further investigate processes of invention, innovation and diffusion across different scales within Minoan architectural tradition.

1 Introduction

The Neopalatial period (ca. 1600–1425 BC), often considered the golden age of Minoan civilization, witnessed the development of an elaborate architectural repertoire that spread throughout the island and had repercussions many miles away from its shores (Driessen 1989–1990; Shaw 2009). This 'Neopalatial Style' is characterized by the extensive use of specific architectural features, including timber construction, ashlar walls, cut stone door jambs, pier-and-door partitions, etc. Simultaneously, certain room types – and in particular the so-called 'lustral basins' and 'Minoan halls' – were widely represented in buildings of various size and architectural elaboration. Some of these features preexisted, others were new, but their large-scale distribution is what really sets this 'Neopalatial Style' apart: they occur all over Crete first, in the Cyclades and on the Greek mainland afterwards.

Although it would be a mistake not to consider these formal properties as an integral part of Neopalatial architecture, it would be even more misleading to take them as its essential constituents. Neopalatial architectural language definitely had a vocabulary of its own, but what truly distinguishes it are its grammatical rules. In earlier work I attempted to high-

1 This paper was originally presented at the 16th annual conference of the European Association of Archaeologists (1–5 September 2010, The Hague) in a session dedicated to space syntax. These researches were made possible thanks to the support of the Fonds National de la Recherche Scientifique (F.R.S.-FNRS). I am very much indebted to Charlotte Langohr, Jan Driessen and Simon Jusseret for their constructive critiques, comments and suggestions.

light the configurational properties of Neopalatial architecture,[2] and space syntax provided the theoretical framework and tools to achieve this goal (cf. Hillier, this volume). Building on pioneer work by Preziosi and Palyvou on formal and circulatory patterns in Minoan architecture (Preziosi 1983; Palyvou 1987), some 70 buildings were analysed, from modest houses to monumental 'palaces' (Letesson 2009).

Despite the great formal diversity of the corpus, all the buildings share common structural properties. Some were elementary, such as the strong demarcation between the exterior world and the internal domain of a building, others were much more elaborate, including the integration inequality genotype of the so-called 'palaces' (see below). Furthermore, it is necessary to underline that, to some extent, Neopalatial architecture shows strong formal links with Prepalatial and Protopalatial building traditions, while structurally it appears extremely innovative. Consequently, several new spatial patterns clearly depart from more traditional ways of organizing space. I will come back to some of these issues, but first I will briefly address the concept of vernacular architecture.

2 Vernacular architecture

Traditionally, in architectural studies, the vernacular character is considered to be the exact opposite of polite, or "High Style" architecture. It is stated that "polite architecture [...] is typically designed and built by professionals following national or international styles, often using exotic materials and adventurous techniques to achieve aesthetically pleasing results. It undergoes significant change through time, and is most often studied chronologically. Vernacular architecture, on the other hand, is generally built by amateurs, often the people who will use it, guided by local conventions, using locally available materials and traditional techniques. Basically conservative, it changes relatively little through time, but lends itself to study by region."(McEnroe 1990, p. 195).

Even if studies of vernacular architecture represent a non-negligible contribution to the discussion of the built environment, the very use of the term 'vernacular' has rightly been criticized in recent years. Blier pointed out: "vernacular, like other building taxonomies, reveals as much about modern (largely Western) classification values as about the salient issues addressed by the structures themselves. Among other things, the prominence of binary oppositions posited *vis-à-vis* 'vernacular' versus 'polite' architecture [...] reveals the enduring nature of Western dualistic thinking." (Blier 2008, p. 231).

Starting with Forde's major book, *Habitat, Economy, and Society* (Forde 1934), and reinforced by an ever-increasing number of case studies and theoretical debates, the idea that buildings, whatever their level of complexity, are shaped fundamentally by human deci-

2 In space syntax, 'configuration' refers to a set of interdependent relations in which each is determined by its relation to all the others (Hillier 1996, p. 35; cf. also Hillier, this volume).

sions is now well anchored. This contributed to downplaying – without negating – issues of shelter, as well as contextual factors like climate, topography and available materials as the most salient determinants of building form (Glassie 2000, p. 91–94).

In a similar vein, Glassie raised an interesting question: "If every building is a cultural fact, the consequence of a collision between intentions and conditions, if differences of culture and circumstances adequately account for differences among buildings, the question is why we persist in calling some of them vernacular" (Glassie 2000, p. 20). In his view, calling buildings 'vernacular' is a way of highlighting their cultural and contingent nature, so that the term 'vernacular' is one of the tools that can be used when we wish to crack architectural objects open and learn their meanings (Glassie 2000, p. 21). Glassie also noted that what makes vernacular architecture is first and foremost the cultural congruity in design, construction and use (Glassie 2000, p. 46). This specific understanding of the concept is essential in itself and central to the present argument. It also finds a stimulating echo in the difference between building and architecture underlined by Hillier in *Space is the Machine* (Hillier 1996).

3 Building vs. architecture

In its theoretical preliminaries, the book opens with the question "what architecture adds to building" (Hillier 1996, p. 15–53). Focusing on what buildings – and more generally built environments – are, Hillier elaborates on how they take part in the 'transmission of culture through artefacts' (Hillier 1996, p. 42–43, n. 20). At the centre of the argument lies the concept of the non-discursivity of configuration,[3] the fact that in all areas where we use rule systems to behave in ways which are recognizable as social, some hidden structures we think with (i.e. unconscious configurational rules) seem to prevail. This corresponds to 'social knowledge', the purpose of which is "to create, order and make intelligible the spatio-temporal events through which we recognize the presence of culture in everyday life." (Hillier 1996, p. 40). This type of knowledge is normative in the sense that it creates society through habits of doing and practices hiding the abstract principles that bring spatio-temporal phenomena together into meaningful patterns. Social knowledge is about how to behave in the world, but there is also knowledge that seeks to understand the world, that is to say analytic or scientific knowledge. In social knowledge we unconsciously follow the underlying rules and therefore behave appropriately; in analytic knowledge we bring these abstract structures into our awareness to examine them critically and, if necessary, to reconstitute them (Hillier 1996, p. 41).

3 'Non-discursive' in the sense that we do not know how to talk about it (Hillier 1996, p. 38; cf. also Hillier, this volume).

Social knowledge plays a decisive role in the shaping of built space. Spatial and formal patterns that are created through buildings and settlements often correspond to intricate codes that govern, for example, which types of space there are, the way they are connected and sequenced, what activities take place together in them and which ones have to be separated, what categories of persons have access to them and their respective rights, how they are decorated and furnished, what types of objects are expected in them, and so on. These patterns vary from one cultural group to the other, but usually members of the group handle these spatial codes without thinking of them and even without being aware of them until they are challenged or until they are confronted to another form of patterning in another culture (Hillier 1996, p. 43). It is by means of this significant underpinning by non-discursive configurationality that buildings become parts of the 'transmission of culture through artefacts'. For example, we can think consciously of a prison as a physical object and have a mental image of it and we can think of its parts as physical or spatial parts, like cells, entrance gate or exercise yard. But if we think of a prison as a whole entity it will be through the unconscious intermediary of configuration, in the sense that "when we think of a particular kind of building, we are not only conscious of an image of an object, but at the same time of the complex of spatial relations that such a building entails" (Hillier 1996, p. 43). In the case of the prison, this complex of spatial relations is related to the coexistence, within the same compound, of radically different categories of users (inmates, wardens and visitors) requiring radically different modes of movement and occupation.

Thus it appears that it is essentially through unconscious principles and codes that the raw materials of space and form are given social meanings in the built environment. Nevertheless, it is not because buildings are instances of the transmission of culture through artefacts that buildings of the same type and culture will be identical to each other. As was already mentioned, Neopalatial Cretan architecture, like many other examples of vernacular architecture, is a combination of an underlying common structure (i.e. a genotype) and a surface variety or heterogeneity of physical expressions (i.e. the phenotypes). This is because vernacular builders use rule sets that are tacit and taken for granted, ideas they think with rather than of.[4] These ideas "specify not the specific but the generic, so that vernacular designer may use the rules as the basis of a certain restrained creativity in interpreting the rules in novel ways" (Hillier 1996, p. 45). This accounts for the diversity within the architectural corpus of a given culture. On the other hand, the house built by a builder sharing the culture of a community comes out right because it draws on the normative rules of a shared social knowledge. In that case, there is, as Glassie pointed out, cultural congruity in design, construction, and use.

If the act of building is intimately related to the unconscious reproduction of abstract principles and culturally sanctioned codes and their materialization in the spatial and physical forms of the built environment, architecture must be something more. According

4 This corresponds to Henry Glassie's 'architectural competence' (Hillier 1996, p. 44).

to Hillier, there is architecture when "the configurational aspects of form and space, through which buildings become cultural and social objects, are treated not as unconscious rules to be followed, but are raised to the level of conscious, comparative thought, and in this way made part of the object of creative attention" (Hillier 1996, p. 45–46). Therefore, architecture happens when there is a shift from social knowledge to analytic or theoretical knowledge during the creation of a built form. It means that, at some point during the creative process, an intellectual choice amongst the range of possibilities takes place and leads to a successful accomplishment that goes beyond cultural reproduction. Therefore, the reflective thought generates invention or at least innovation at the level of the underlying structure of the built form. In summary, the preconditions for architecture are: 1) analytical knowledge in action and 2) invention at the level of the genotype.

It thus goes without saying that architecture does not necessarily depend on architects but can exist within the context of what we would normally call the vernacular. This does not mean that the innovative production of buildings which are phenotypically individual within the vernacular should be thought of as architecture (Hillier 1996, p. 47). Indeed, as mentioned, phenotypical heterogeneity is the normal product of the unconscious materialization of culturally constrained codes. The designer of a building truly turns it into architecture when he or she takes into consideration possibilities that are not contained in contemporary cultural knowledge but which are at the same time within the field of what is architecturally possible.

This is, I believe, exactly what happened at the beginning of the Late Bronze Age in Crete or perhaps, as we shall see, even earlier, at some point during the Middle Bronze Age. Nevertheless, even if we acknowledge this difference between building and architecture, there is no clear-cut limit to be drawn. Either can become the other at any moment. Broadly speaking, in the evolution of building, there are two ways in which things are done: in obedience to a tradition, or in pursuit of innovation. "Building contains architecture to the degree that there is non-discursive invention, and architecture becomes building to the degree that there is not. Vernacular innovation is therefore included within architecture, but the reduplication of vernacular forms is not. Architecture is therefore not simply what is done but how it is done" (Hillier 1996, p. 49).[5] Indeed, the boundary between the vernacular and architecture is constantly shifting. Usually, it is concomitant to the greatest changes that reflective thought transcends vernacular tradition and leads to architectural invention[6] which, eventually, will be the cornerstone of a new vernacular language.

5 "The bringing of the non-discursive, configuration dimension of built form from cultural reproduction to reflective awareness and abstract exploration of possibility is at once a passage from the normative to the analytic and from the cultural bound to the universal, the latter meaning that all possibilities are open rather than simply the permutations and phenotypical innovations that are sanctioned by the vernacular." (Hillier 1996, p. 49).
6 On this concept of invention being related to contextual changes, see also van der Leeuw: "Once certain solutions have been found, the sheer complexity of the network and of the instantiation procedures favours the con-

It is also worth noting that, in vernacular tradition, form, spatial and functional patterns are known in advance and only need to be recreated, but architecture, because of its very nature, uncouples these features of the building from their reliance on social knowledge. Therefore, the form-function relationship – and above all its social outcomes – becomes uncertain. Recently, this idea was explored in the context of the new spatial patterning of the Neopalatial period and its potential social consequences (Letesson and Driessen 2008).

4 Invention, innovation, and tradition

The foregoing discussion about what architecture really is raised the question of the relation between tradition and innovation, but it still requires more thorough consideration. First of all, there is a difference between invention and innovation. In a paper devoted to understanding the concepts of invention and innovation through network analysis, van der Leeuw defined the former as a local process: "Only those agents that are immediately connected to the inventor(s) are involved and the process is therefore one that plays out in a relatively limited number of dimensions comprising the immediate articulation of the know-how of the inventor(s) with the other agents in their material world" (van der Leeuw 2008, p. 242). Usually, innovation takes place on a different scale. It is the process by which an invention is adopted and spreads throughout a population. Therefore, it involves a much larger network of agents (van der Leeuw 2008, p. 225 and 242–243). Van der Leeuw's core argument is that, by understanding the structure and the dynamics of the complete network (objects and things, human and non-human agents) involved in the processes of invention and innovation, it is possible to grasp and conceive them properly (van der Leeuw 2008, p. 229–230). Furthermore, according to Roux, invention is more of a cognitive phenomenon, whereas innovation is better considered a historical phenomenon (Roux 2010). Inventors are skilled individuals whose expertise and cognitive abilities allow them to develop exploratory behaviour. Therefore, by going beyond the cultural representations associated with their ways of doing things, they are able to 'force' the technical system and its associated identity (Roux 2010). She also underlined the fact that in the process of innovation, what is chosen is usually the context of production rather than the technique itself (Roux 2010).

Returning to Hillier's distinction between building and architecture, it can be said that architecture happens when there is *invention* at the level of the genotype. This usually leads to *innovation*, that is to say, the diffusion and adoption of the new principles on a larger scale. Eventually, this innovation process – being widely distributed, digested and culturally sanctioned – establishes the foundations of a new vernacular tradition. As was mentioned

tinued use of these 'solutions' over the invention of new ones as long as the context is the same" (van der Leeuw 2008, p. 236).

above, it is therefore quite tricky to draw a precise line between architectural invention, consecutive innovation and the emergence of a new vernacular tradition. A real understanding of these processes requires a detailed analysis of all the agents involved – human or non-human – and an assessment of their complex relational patterns. This paper is a first attempt to lay solid bases for further investigation of the development of the Minoan built environment. Our starting point revolves around the understanding of the emergence of the 'Neopalatial Style' and of its proliferation.

5 Neopalatial architectural genotype

At the beginning of the 90s, Driessen was the first to comment on the emergence of a new architectural language in the Neopalatial period and its proliferation throughout the island of Crete (Driessen 1989–1990). At the time, the so-called 'palaces' were seen as the probable birthplace of these innovations (pier-and-door partitions, lustral basins, Minoan halls, masons' marks, real ashlar masonry, etc.), which is why the term 'palatial style' was coined to identify this assemblage.[7] His study mainly focused on the new built forms and architectural features, realizing at the same time that something more essential was at stake at a deeper, structural level, especially when comparing Pre- and Protopalatial buildings with Neopalatial ones (Driessen 1989–1990, p. 8).

The same year, McEnroe published a paper about the significance of local styles in Minoan vernacular architecture (McEnroe 1990). Without denying the existence of the Neopalatial style and its proliferation, it offered a very interesting perspective on local expressions of an overall tradition. This paper contributed to including a focus on local factors (available materials, topography, etc.) and expertise in the debate about the Neopalatial style. From the 90s onwards, in a very elementary form, the idea of various phenotypic expressions of an underlying genotype was already in the air. In Minoan studies, this concept was first promoted in 1983 by Preziosi in his seminal book *Minoan Architectural Design* (Preziosi 1983).[8] Adopting a semiotic approach to built form, he was the first to go behind the lexicon of Minoan architecture in search of its underlying spatial logic: "[...] what distinguishes this architectural corpus are the patterns of association and relationship which it manifests, rather than a material homogeneity of formation." (Preziosi 1983, p. 200).[9] Even

7 Recently, this interpretation has been rightly challenged (Schoep 2002; 2004; 2006; 2010), see below.

8 Most of the ideas developed in this book were first explored in Preziosi's first book: The Semiotics of the Built Environment: an Introduction to Architectonic Analyses, 1979.

9 "Possibly one of the most important discoveries in connection with the study of Minoan architecture has been the fact that (A) all of the cellular configurations found in the corpus can be seen as simple variants of a small set of basic conformations and proportions, and that (B) this limited set of forms reveals an internally coherent orderliness: the set of forms, in other words, comprises a system in its own right, in opposition to systems of other corpora" (Preziosi 1983, p. 200).

if his book did not get the reception that it deserved, a whole generation of scholars interested in Minoan architecture was directly or indirectly influenced by his writings.[10]

Furthermore, starting with Graham, the use of a systematic measuring unit and the existence of complex and well thought-out planning processes were studied and highlighted in Minoan architectural studies (Graham 1960; Cherry 1983; Preziosi 1983, p. 319–478 and 481–482; Schmid 1985; Hitchcock 1997; Preziosi 2003; Bianco 2003).[11] The design of Minoan built forms – or of some of their parts – was also closely related to topographical or celestial features (Shaw 1973; Preziosi 1983, p. 501–508; Driessen and Sakellarakis 1997, p. 72–73; Goodison 2001; Goodison 2004; Letesson and Vansteenhuyse 2006). Broadly speaking, there is general agreement about the existence of a high degree of elaboration within Minoan architecture, especially where the Neopalatial period is concerned.

The main goal of the research that constituted the basis of the present argument was twofold: a concern about overcoming the traditional focus on prestige architecture by integrating buildings of various size and elaboration within the corpus under study and an attempt to understand the underlying logic structuring its formal heterogeneity. Space syntax, by transforming every building – whatever its size – into a set of comparable data (i.e. j-graphs, visual maps and numerical values)[12] in which relational patterns amongst spaces are the essential factor, offered the perfect analytical methodology and theoretical framework.[13] Using space syntax to study Cretan Neopalatial architecture permitted the emphasis of a large number of topological and quantitative recurrences. These features are so often repeated between Minoan buildings that they allow the recognition of a genotype – an underlying set of principles – that permeate the Minoan built environment and form a continuum between houses and 'palaces' (Letesson 2009).

Among the numerous properties of this Neopalatial genotype (Letesson 2009, p. 321–368), only two are dealt with in this paper, since they reflect a drastic change from the earlier situation. There is indeed a stronger concern about the creation of a clear demarcation between inside and outside and a shift from an agglutinative mode to an articulated mode of organizing space (fig.1).

The former manifests itself in many ways, but the massive use of external transition spaces (vestibules, corridors, porticoes) is definitely its better crystallization. This suggests

10 Driessen 1989–1990; McEnroe 1990; Palyvou 1987; Sanders 1988; Hitchcock 2000.

11 The principle of a basic measuring unit is widely accepted, but its exact value is controversial, to say the least.

12 In the following figures the visual integration plan (in its HH version) was made on Depthmap (with a color scale ranging from red – high visual integration – to blue – low visual integration, cf. Turner 2001; 2004). Numerical values (such as RRA, control value, difference factor, and indexes of distributivity and asymmetry) as well as other visual maps (step depth, control, and controllability) associated with over 70 Neopalatial buildings can be found in Letesson 2009, p. 376–466.

13 This paper does not present an in-depth assessment of this theoretical and methodological framework. The reader can nonetheless find a detailed overview here (Hillier, this volume; cf. also Letesson 2009, p. 5–18; Ostwald 2011); for a critical examination, cf. also Hacıgüzeller and Thaler, this volume.

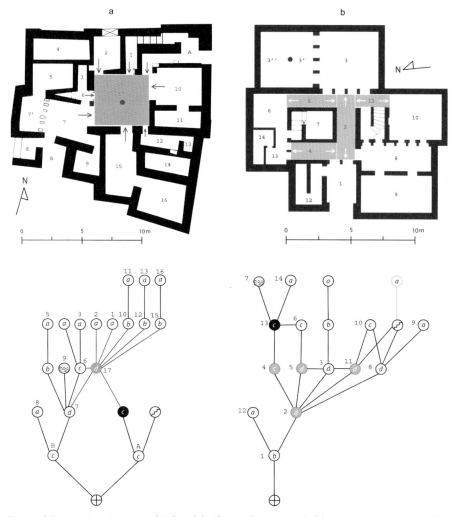

Figure 1 | Houses Zeta-Beta (a) and Delta-Alpha (b) – Malia – Survival of the agglutinative mode (a) VS proper articulated mode (b).

a growing concern about undesirable intrusions.[14] It not only implies an attempt to reduce the permeability of a building, but also acts as an efficient signal, a way of underlining the shift from the external world to the internal domain. The very existence of such

14 This may be linked to a space syntax concept called 'transpatial solidarity'. Hillier and Hanson 1984, p. 145: "A solidarity will be transpatial to the extent that it [...] emphasizes the discreteness of the interior by strong control of the boundary. [...] The essence of a transpatial solidarity lies in the local reproduction of a structure recognizably identical to that of other members of the group. Such a solidarity requires the segregating effect of the boundary to preserve interior structure from uncontrolled incursion. Solidarity means in this case the reproduction of an identical pattern by individuals who remain spatially separated from each other, as well as from the surrounding world."

external transition spaces emphasizes the fact that the contacts between the inside and outside of Neopalatial buildings were potentially so frequent and/or necessary that they needed to be strictly monitored. Indeed, they suggest frequent, planned encounters that formed integral parts of the social dynamics, tightly controlled and channelled through space. Pre- and Protopalatial structures mostly lack such spaces because encounters within them were probably between residents only (Sanders 1990).[15] When we add to this the fact that Neopalatial buildings often had more than one entrance and most of them were in fact either preceded or followed by external spaces of transition, the indications that different categories of visitors frequented the interior of structures become even more persuasive.

In Pre- and Protopalatial periods, houses mostly follow an agglutinative configuration, whereas in Neopalatial Crete the massive introduction of internal spaces of transition created articulated plans that categorized people and their activities more strictly and efficiently. The articulation therefore resulted in a spatial segmentation which is often considered to be concomitant with socio-political complexity, related to age, gender, status or other differentiations (Kent 1990). Generally, this articulated mode of organizing space revolves around a particular space, the integration and visual controllability of which are extremely high, if not the highest, within the building (room 5 in fig. 2b). These spaces were labelled 'poles of convergence' (Letesson 2009, p. 350), partly because most of the trajectories that crisscross a building had to pass through them.[16] This probably implies that they were rooms to which people (or a selection of specific people) had equal access and equal rights. They were spaces fit for local interactions depending on spatial proximity, activities occurring at the same place by a gathering of people in space, such as a communal meal, a particular ritual performance, or hosting visitors. In Minoan studies, such 'poles of convergence' have usually been labelled as hosting/reception zones or more simply as the 'functional centre' of a building. Very frequently the particular function of such spaces is difficult to assess, and it is quite possible that they were essentially multi-functional, notably because everybody could relatively easily gain access to them (see for example Shaw and Shaw 1996, p. 366–367). From a syntactical point of view, their essential feature is that they formed the main internal arena for encounters and co-presence in Neopalatial architecture.[17] This becomes the more evident when comparing them with other spaces that were

15 'Residents' are those whose identity as individuals is embedded in the spatial layout of a building and who therefore have some degree of control of space and privileged access to it. 'Visitors', on the other hand, are those who lack control over a particular building. Their access to space is usually temporary, subordinated to the control by the residents, with their social identity generally manifesting itself collectively (Hillier 1996, p. 251; cf. also Hillier and Hanson 1984, p. 147).

16 In a ringy j-graph, a 'pole of convergence' is a cell which is in a dominant position on a ring or through which several rings pass. In a tree-like configuration, a 'pole of convergence' is generally formed by a symmetrical disposition of cells subordinated to a pivotal space (Letesson 2009, p. 350).

17 The 'poles of convergence' illustrate perfectly the concept of 'spatial solidarity'. Hillier and Hanson 1984, p. 145: "[...] a spatial solidarity [...] builds links with other members of the group not by analogy or isolation – as

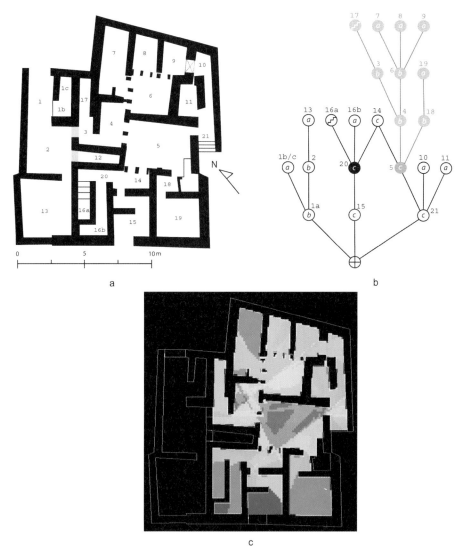

Figure 2 | Building 5 – Palaikastro – Plan (a), j-graph (b) and visual integration (c).

not accessible for all the members of the residential group and obviously even less for potential visitors, or with spaces that were more closely associated with particular activities to the exclusion of others, such as storerooms, workshops, etc. In terms of space syntax analysis, the latter usually develop in tree-like and linear arrangements (rooms 3, 4, 6–9,

transpatial solidarity does – but by contiguity and encounter. [...] Encounters have to be generated, not limited, and this implies the weakening of restrictions at and within the boundary. A spatial solidarity would be undermined, not strengthened, by isolation".

and 17–19 in fig. 2b), a type of spatial configuration which easily frames, distinguishes and articulates circulations and categories of people and activities in patterns of avoidance or controlled encounter.

This articulated mode of organizing space found its best expression in the configuration of the so-called 'palaces': multiple external transition spaces forming several external rings culminating in the central court, the pole of convergence *par excellence* (fig. 3).[18] Beyond the central court, the spaces essentially formed tree-like linear sequences. In space syntax, ringy systems are often associated with encounters between residents or between residents and visitors, whereas tree-like sequences tend to categorize, articulate and frame people (mainly residents) and their respective behaviour, i.e. private, gender-related or

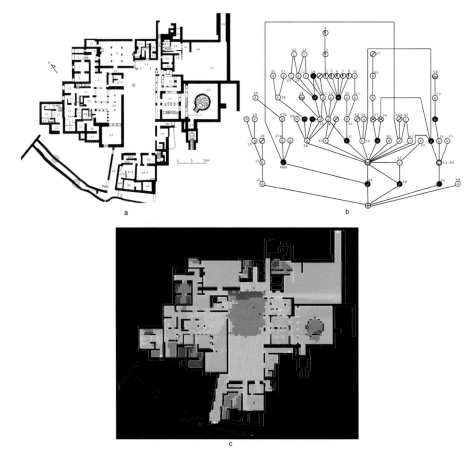

Figure 3 | 'Palace' – Zakros (2nd phase) – Plan (a), j-graph (b) and visual integration (c).

18 Here it is worth noting that, in terms of synchrony (Hillier 1996, p. 232–233; Letesson 2009, p. 351), the investment of so much space in an open air cell is most certainly of great importance (cf. for example Letesson and Driessen 2008; Palyvou 2002).

specialized activities (Hillier and Hanson 1984, p. 166–167). What is also surprising is that in all 'palaces' – as in several domestic structures – similar spaces show similar degrees of spatial connections (i.e. of integration value). There is in fact a hierarchical order, an integration inequality genotype (Hillier 1996, p. 36–37 and 249; cf. also Hillier, this volume), starting with the Central Court – as the space with most connections – via the Minoan hall and different types of storage spaces to finally the lustral basins – as the most segregated space with only a single connection. It is because of this panel of recurrences that the 'palaces' can be regarded as strong programme buildings (Hillier 1996, p. 250–255; Letesson 2009, p. 354–355), that is to say buildings "in which it is not the layout that generates the movement pattern but the programme operating within the layout [...]: its aim is to reinforce certain categoric identities and create strongly controlled interfaces between them" (Hillier 1996, p. 252).

6 The rise of configurational thinking?

Despite the fact that we know a lot more about Neopalatial architecture than about built forms in Pre-, Proto- or Postpalatial Crete, it is nonetheless clear that the former shows some radically different properties at the level of the genotype. These were properties that, added to new architectural features evoked earlier on, contributed to distinguishing the Neopalatial built environment from what existed before and after.[19] Either before or just at the dawn of the Late Bronze Age, invention took place at the level of the genotype, transcending the culturally sanctioned built form and giving birth to architecture *per se*.

Nevertheless, the overall adoption of these new principles during the Neopalatial period happened on a much larger scale than the local dimension considered typical of the invention process (van der Leeuw 2008, p. 242). It also undoubtedly involved a much larger number of agents than the skilled individual whose conceptual and practical breakthroughs are often associated with the concept of invention (Roux 2010). Bearing this in mind, it has to be acknowledged that the proliferation of the Neopalatial style is somewhere in between innovation (i.e. the progressive adoption of the new set of principles) and the development of a new vernacular tradition (i.e. the definitive integration of these principles within the boundaries of social knowledge).

This raises several questions that are probably all related: when, where, why and how did this invention happen? Moreover, it would be interesting to know why and how this local invention triggered off a wave of innovation. Furthermore, the shift from the proliferation of the new principles to their adoption in a vernacular tradition would also need to be put in its geographical (where?) and chronological (when?) contexts. Of course, this constitutes a challenging area of investigation which demands a much larger and more in-depth

19 For a recent general study on Minoan architecture cf. McEnroe (2010).

approach. Nevertheless, some lines of thought can already be put forward as stepping stones for further study.

The major obstacle in the search for invention within the Minoan building tradition is the incomplete state of our data for the stages that precede and follow the Neopalatial period. Architectural remains dating to these periods are less common, and usually their preservation is not sufficient for space syntax analysis to be conducted properly.[20] Furthermore, in order to be able to grasp variations at the level of the genotype within a building tradition and to recognize these as symptomatic, the analyst needs to study a representative sample. Therefore, by studying the Pre-, Proto- and Postpalatial buildings that are sufficiently preserved, a comparative set has been constituted. Even though this study is still in progress, some preliminary observations can be of some help for the present argument.

In different recent studies, Schoep has investigated further several aspects of social and political organization in Middle Minoan Crete (Schoep 2002; 2004; 2006; 2010a). She rightly criticized the traditional focus on palatial central authority as the main agent of innovation and change[21] and argued that this conception was mainly biased by an idea of diachronic homogeneity, the LM II–III palace of Knossos and its associated centralized power being somewhat blindly used as a model for considering the EM III-MM II court-centred buildings (Schoep 2004, p. 244–245; Schoep 2006, p. 38–39; cf. also Dabney 1995, p. 43).[22] Her main argument is that processes of emulation and competition between different elite groups were the driving forces of the changes that characterize the Middle Minoan period. The MM II town of Malia is central to her argument. Indeed, this site revealed some of the best preserved and published Middle Minoan buildings as well as a considerable amount of material (Poursat 1978; Poursat 1992; Poursat 1996; Poursat and Knappett 2005; Schoep 2002, p. 107–111; Schoep 2010a, p. 71–78, for a recent overview of Malia, cf. Driessen 2010b). In summary, she stressed that the recurrent distribution of similar material assemblages (as well as their associated practices like craft specialization, administration and religious or ideological activities) within different architectural units (Quartier Mu, Villa Alpha, Magasins Dessenne, etc.) pointed to the existence of different social groups – first labelled 'faction' (Schoep 2002, p. 115–120) and then 'elite' (Schoep 2004; Schoep 2006; Schoep 2010) – coexisting within the Protopalatial town. Relations amongst these groups

20 Usually in the case of buildings of which the upper floor(s) are missing it is recommended that the precise location of staircases is known for space syntax analysis to be conducted properly (Cutting 2003, p. 18). It is also worth noting that some reticence about the existence of fully developed upper floors in domestic architecture was expressed by several scholars who are more prone to admit the existence of roof terraces instead (Hallager 1990; Driessen 2005).

21 This traditional view is crystallized in Cherry's seminal article Polities and Palaces: Some Problems in Minoan State Formation (Cherry 1986).

22 It is also worth noting that this analogy could well be doubly doubtful. In LM II-LM IIIA2 Early, Knossos had without a doubt an island-wide administrative, economic and ideological influence. Nevertheless, that does not preclude the existence of regional groups (Chania, Agia Triada, Phaistos) which had the desire and the means to defend their relative political and cultural autonomy from the LM II onwards (Langohr 2009, p. 194–195).

"based on affiliation rather than class" would have been characterized by processes of emulation, competition and collaboration in the search for social and material resources (Schoep 2002, p. 118). According to Schoep, the existence of these different groups within the town of Malia should be related to its great – and relatively sudden – expansion at the beginning of MM IB (Schoep 2004, p. 262; cf. also Poursat 1987, p. 465). It is generally admitted that, in a process of nucleation, groups came to the settlement and the plain of Malia from elsewhere (Driessen 2001; Schoep 2002). Such a gathering of various groups with different origins "could provide a context for persistent and ongoing factionalism" (Schoep 2004, p. 262; cf. also Preucel 2000, p. 73). On a larger scale and on the basis of settlement patterns and density as well as their respective chronological development, Schoep hypothesized the existence of a "patchwork of large, medium and small polities" with "a marked asymmetry in [their] power relations" (Schoep 2010a, p. 69–70). This power imbalance would have been mediated by the forging of alliances and therefore would have had an important influence on the local elites and their access to non-local resources, thus affecting "the production and consumption of elite culture on the one hand and the dynamics between different elite groups on the other" (Schoep 2010a, p. 70). Recently, Driessen also devoted a paper to social organization and especially to the 'house' concept (Driessen 2010a).[23] A 'house' is defined as a corporate group which would have been the primary unit of production and consumption within Minoan society and would have defined itself essentially through its locus-boundness and intergenerationality (Pullen 2010, p. 7; Driessen 2010a, p. 41). In other words, 'houses' are social groups of variable size that are practically and symbolically centred on an estate (building or other). This spatial anchorage and the actions involved in its preservation participate in perpetuating group identity and serve "to configure [its] status vis-à-vis other houses within the larger society" (Gillespie 2000, p. 2). The way in which 'houses' and elite groups relate to each other has not yet been explored in Minoan studies, but the two concepts are compatible and could be characterized by a difference of scale,[24] keeping in mind that the 'house' can be considered "an institution that used multiple strategies to recruit members whose everyday practices integrated kinship, economics, religion and politics (Gillespie 2000, p. 15). The main interest of the 'house' concept for the present discussion is its focus on the "intimate personal relation between buildings and people" (Driessen 2010a, p. 40).[25]

With these concepts and the characteristics of MM II Malia in mind, invention in Minoan building tradition can be reconsidered. In the investigation of the first appearance of the so-called 'palatial' architectural features, Schoep underlined that there was almost no evidence to suggest that the origins of the 'Neopalatial Style' can be traced back to the early

23 For a thorough definition and detailed investigation of this Levi-Straussian concept and its evolution and characteristics, cf. Joyce and Gillespie (2000).
24 With, for example, a 'house' being constituted by higher and lower status individuals (Driessen, pers. comm.).
25 This idea that people invest in space that, in turn, frames the people is of course central in space syntax.

court buildings at Knossos, Phaistos or Malia (Schoep 2004, p. 245–255; Schoep 2006, p. 39–41). On the contrary, it is in the MM II settlement of the latter that several buildings testified to the existence of a new vocabulary displaying specific features of Late Bronze Age architecture (Schoep 2002, p. 107–111; Schoep 2004, p. 255–261; Schoep 2006, p. 41–42). The innovations included techniques (ashlar masonry, column bases), new architectural modules (such as the Minoan hall, the lustral basin and blocks of magazines equipped with collecting gutters) and new materials (sandstone for walls and white limestone and con-glomerate for column bases). Furthermore, elsewhere on the island, there is, for the time being, little evidence for architectural innovations in the Middle Minoan Period apart from Malia (Schoep 2004, p. 259–261).[26] Nevertheless, we have to acknowledge the fragmentary nature of our data in contrast to the exceptional preservation of the MM II town of Malia,[27] as exemplified by *Quartier Mu*, central to Schoep's argument (Schoep 2002, p. 111–117; Schoep 2004, p. 256–259; Schoep 2010a, p. 74–78; for a detailed description, cf. Poursat 1992).[28]

Within this complex, Building A is the structure of the MM II town that displays the greatest architectural elaboration by far – with the notable exception of the Crypte Hypo-style and probably the partly excavated Magasins Dessenne (Schoep 2010a, p. 77).[29] Indeed, formally speaking, Building A is extremely innovative and could have featured the first prototypes of the Minoan hall and lustral basin in close association (rooms I1-I13-I13a and I4 respectively – cf. Driessen 1982, p. 54–55; Schoep 2004, p. 257; cf. also Shaw 2011, p. 148–153). Furthermore, structurally its configuration clearly departs from the spatial pat-terning typical of the Pre- and Protopalatial periods.[30] If one takes a closer look at Building A with the Neopalatial genotype in mind, some similarities are striking, and it becomes even clearer if the two phases of the building are compared (figures 4 and 5). Indeed, in its second phase (fig. 5), several characteristics stand out: multiple entrances usually associ-ated with external transition spaces (III15, Ib, I22, IIId, IIIe), complex ringy system with a typical pole of convergence (cells I13-I13a) in a dominating position, and tree-like arrange-

26 The northwestern part of the Monastiraki site, characterized by architecture of an official nature, may well be an exception. Even if this building is only partly excavated and not as well preserved as Quartier Mu, it nonetheless testifies to the existence of an elaborate architectural language (possible Minoan hall with a column base in worked stone, door-opening with stone threshold and abutments) elsewhere on the island and perhaps even before the Malian MM II phase (Kanta 2006; Como, Kanta and Marazzi 2009, p. 227).

27 It is therefore more than probable that the emergence of innovations in MM architecture also took place else-where than in Malia, the architectural remains found beneath the Domestic Quarter at the palace of Knossos being an excellent example (Evans 1930, p. 324–96, and esp. p. 359–61; Shaw 2011). Unfortunately, such remains are scanty and usually badly preserved.

28 The so-called 'maisons-ateliers' already have their own volume in Études Crétoises (Poursat 1996), but the architecture of Quartier Mu still awaits a final publication. Cf. also Hacıgüzeller and Thaler, this volume.

29 The architectural complex labelled 'Magasins Dessenne' was presumably constituted by two different build-ings, probably of a domestic nature (Treuil 1999; van Effenterre 1980, p. 197–200). Recent cleaning operations and associated architectural studies nonetheless tend to prove that the complex was actually a single building with two architectural phases (Devolder, forthcoming).

30 On Building A, cf. Hacıgüzeller and Thaler, this volume, for a detailed configurational analysis.

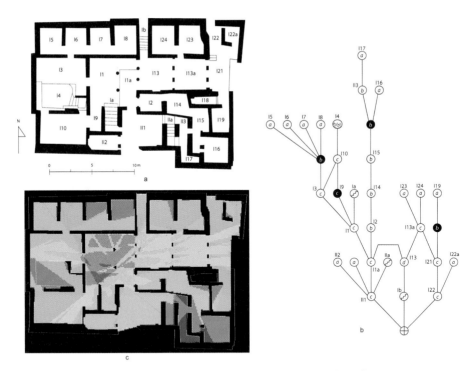

Figure 4 | Quartier Mu – Building A – 1st phase – Plan (a), j-graph (b) and visual integration (c).

ment of spaces beyond the distributed parts of the complex. A very good example of the symmetrical pattern of the latter is found in the more systematic organization of storage spaces along a corridor giving access to them (Poursat 1992; van Effenterre 1980, p. 179–180), which prefigures one of the most typical spatial configurations of storerooms in the Neopalatial period (Begg 1975, p. 19–21; Christakis 2008; Treuil 1996).[31] Add to these symptomatic configurational features some of the first documented uses of architectural techniques such as pier-and-door partitions (polythyron), cut stone door jambs, ashlar masonry, usually considered characteristic of the Neopalatial period, along with the embryonic versions of a lustral basin and a Minoan hall, and it does seem attractive to consider Building A of *Quartier Mu* as an appropriate background for invention within Minoan building tradition. Moreover, the articulated nature of the configuration of Building A strongly contrasts with the simple agglutinative structure of the MMIA/B houses that existed south of the 'palace' (Driessen 2010b, p. 560). However, it has to be admitted that, to a certain extent, because of its exceptional conservation, *Quartier Mu* might be somewhat artificially singled out. Indeed, the existence of buildings with similar elaboration else-

31 The same type of storage spaces is also attested in the Magasins Dessenne, the Crypte Hypostyle and in the east wing of the court building or 'palace' (Schoep 2004, p. 259).

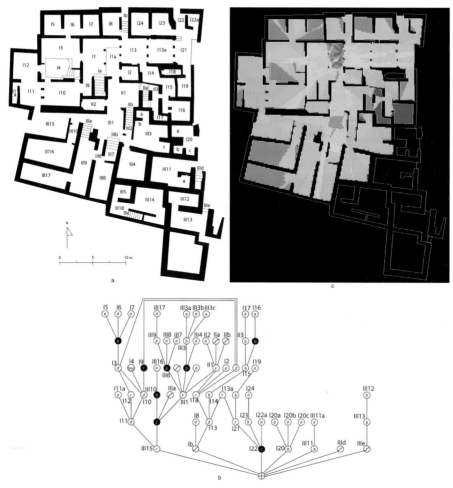

Figure 5 | Quartier Mu – Building A – 2nd phase – Plan (a), j-graph (b) and visual integration (c).

where during the end of the Middle Bronze Age cannot be ruled out.[32] For example, it has been argued that a similar plan may have existed in the Throne Room area at Knossos as early as the MM I–II period (Mirié 1979; Niemeier 1987; Dickinson 1994, p. 149–150). This hypothesis is a matter of debate and is strongly criticized by Schoep, who considered that these attempts to put the origins of the Throne Room in the Protopalatial period are clearly influenced by "the desire to project back later functional and architectural elements" and are contradictory to more recent stratigraphical and architectural investigations (Schoep 2004, p. 249, see also Macdonald 2002, p. 42). It is also interesting to note that Building B (Poursat 1992, p. 24–31), built slightly later than A (Driessen 2010b, p. 562), shows a much

32 Cf. n. 26–27 above.

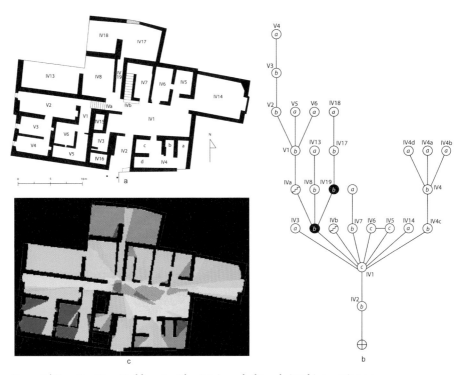

Figure 6 | Quartier Mu – Building B – Plan (a), j-graph (b) and visual integration (c).

more agglutinative arrangement, with many rooms opening directly onto space IV1 (fig. 6). The latter, the central hub of the building, is the most integrated space, has high visual controllability and lies on a limited internal ring (with spaces IV6 and IV5). Beyond this ring, all spaces are organized in linear sequences. This gives the impression of being a more functional building, mostly dedicated to storage, with IV1 acting as a controlling point for taking goods in or out.[33] Nevertheless, since the entire west part of the ground floor is gone, we need to be particularly cautious with remarks on configuration. Furthermore, the presence of a paved vestibule with a bench (IV2) and some finds of really good quality in the destruction layers in the basement-like spaces to the west (Poursat 1992, p. 29) could potentially suggest a different reconstruction of Building B.

On present evidence, MM II Malia in general and Building A of *Quartier Mu* in particular may have been one of the cradles of architectural invention within Minoan building tradition. This could thus contribute to answering the 'where' and 'when' questions. But

33 This close association between a more 'prestigious' and a fairly 'functional' building was identified as a recurrent architectural pattern in Minoan architecture, especially in the Neopalatial period, with Tylissos (buildings A and B) and Knossos (Little Palace and Unexplored Mansion) being the most famous examples (Preziosi 1983, p. 72; Poblome and Dumon 1987–1988; Hitchock and Preziosi 1997).

what about the 'why' and 'how'? Before tackling these issues, it is worth remembering that the Protopalatial period (especially MM IIB and MM III) also witnesses the appearance of terracotta house models (Schoep 1994; Schoep 2004, p. 262), some of which, like that found in Archanes (Lembessi 1976), were extremely detailed, mapping circulatory patterns that became typical of the so-called "Neopalatial style" (Palyvou 1987, p. 196). As was pointed out by Glassie, plans are indications of cultural distance: "The amount of detail on a plan is an exact measure of the differences that separate those who conjoin in a building project" (Glassie 2000, p. 45). House models such as that of Archanes could betray the existence of individuals whose chief function was to design new types of buildings and give indications about how to build them.[34] This could then attest a break in the full congruity between design, construction, and use in that some specialized agents may have been in charge of the design and planning, whereas construction and use remained with unspecialized individuals, probably the future inhabitants of the building. Some of these matters will be dealt with when considering the innovation process, but the reasons why and the ways in which invention happened in MM II Malia should first be considered.

Schoep related the application of what she coined 'innovative architecture' in elite residences to the deployment of conspicuous consumption, an important strategy in elite competition (Schoep 2004, p. 262). It is, however, difficult to determine if conspicuous consumption in the built environment should be held responsible for invention *per se* or more simply for the small-scale proliferation of these new ideas – and thus innovation – within the MM II town. It is nonetheless a possibility that a specific elite group, in an attempt to make itself distinct, set a wave of innovation in motion by initiating the creation and enhancement of several building features and spatial patterns, for example in *Quartier Mu*. The conscious modification of the traditional genotype of the built form (i.e. invention) illustrated in the latter could, however, betray something more fundamental. What clearly stands out from the configuration of *Quartier Mu* is a redefinition of the interfaces, a term that, in space syntax, defines the relational patterns between the two categories of users of a building, the residents and the visitors (Hillier 1996, p. 251).[35] Indeed, the spatial organization of Building A shows strong articulation: many rooms are separated by transition spaces and tend to be clustered in sectors (magazines to the North and South, ceremonial and hosting areas in the middle, basement storage in the south-east: Poursat 1992, p. 31–47, fig. 40).[36] A concern for efficiency could account for this situation, but this type of segmentation is often related to increasing socio-political complexity (Kent 1990). Space is segmented in that rooms hosting compatible and/or complementary activities are clustered, while some specific rooms (or sets of rooms) are kept apart from each other to avoid interference between activities and practices considered irreconcilable. The high segmentation

34 For an exhaustive discussion of house models in antiquity, cf. Muller (1998).
35 Cf. also n. 15 above.
36 This is what Hacıgüzeller and Thaler (this volume) call 'compartmentalisation'.

of Building A therefore betrays the existence of more complicated interfaces than what usually exists in the agglutinative mode of organization space recurrent in the Pre- and Protopalatial periods.[37] This is exactly what Schoep noted when acknowledging that the "innovative architectural features not only marked wealth and status, but also, through their deployment in various internal and external locations, functioned to include and exclude different groups of people" (Schoep 2004, p. 262). She established a close connection between these new spatial patterns and the staging of gatherings and/or ceremonial activities (Schoep 2004, p. 262–263; cf. also Letesson and Driessen 2008). Apart from their form (embryonic Minoan hall), the syntactical properties of the arrangement of spaces I1a-I13-I13a make it the perfect candidate for a hosting/gathering area, a true pole of convergence (fig. 5). Indeed, these spaces are syntactically and visually integrated, while room I13a, in particular, is situated in a dominant position on an external ring, a property that is usually associated with the mediation between the interior and the exterior of a building (and therefore between residents and visitors: Hillier and Hanson 1984, p. 158–159; cf. also Letesson 2009, p. 347).[38]

Thus, besides external gathering areas that have a long history in Minoan Crete, in funerary contexts (Branigan 1993; Branigan 1998; Hamilakis 1998; Murphy 1998), natural places such as caves, hilltops and mountain peaks (Haggis 1999, p. 73–79; Tomkins, forthcoming), and settlements (Driessen 2004; Murphy 2010; Todaro 2012; Tomkins 2007, p. 187–190; Tomkins 2012; Tomkins and Schoep 2010, p. 73–74), with the central part of Building A, the fabric of the built form itself revolves around a gathering space.[39] Apart from its configurational properties and spatial features, the central part of Building A also revealed a large amount of fine tableware with the largest concentration of drinking vessels in polythyron I13 (Poursat and Knappett 2005, p. 199; Schoep 2010a, p. 77). *Quartier Mu* could very well be the first known example of the clear absorption within the built environment of gathering practices and commensal activities traditionally associated with the exterior world (Letesson and Driessen 2008, p. 210).[40] This "appropriation of the commu-

37 This corresponds to what Dabney labelled a switch from an undifferentiated to a differentiated disposition of space in non-palatial buildings (Dabney 1995, p. 46).

38 The same probably goes for rooms III1 and especially II1, which was the major entrance during the first phase of the building. Both of these spaces also formed a kind of buffer zone between the north and south parts of Building A during its second phase and certainly had a pivotal role in the distribution of the circulation, both horizontal and vertical, by means of the surrounding staircases (IIa, IIb, IIIa and IIIb).

39 At the same time, it seems that the central court of Knossos, Phaistos and Malia was not fully circumscribed (Schoep 2004, p. 252–255; Schoep 2006, p. 41, n. 45) and that the south wings were built later during the Neopalatial period (cf. also Letesson and Vansteenhuyse 2006, p. 108–110).

40 Even if Schoep underlined that those ceremonies have left few or no traces (Schoep 2010, p. 77), the new spatial syntax of their architectural settings might well be the best testimony of their existence. These smaller-scale gatherings hosted by specific elite groups were certainly of a different nature than the events happening within the court building, which probably involved the community at large. "This seems to mark an important change from previous periods when the court building may have been the primary arena for social interaction between different groups" (Schoep 2004, p. 264).

nal" (Tomkins and Schoep 2010, p. 76) can be explained by a growing concern about the control of such events that could promote "a feeling of group identity amongst those who were invited inside" and be manipulated as a "strategy of exclusion marking the lesser status of those excluded" (Schoep 2004, p. 263). It is difficult to decide if the new interfaces crystallized by this architecture involved either competing elite groups (inner/real and sub/aspiring-elite: Schoep 2010a, p. 74–78), different components of a 'house' that can be quite heterogeneous, being characterized by the fact that there is no typical form of affiliation to it (Driessen 2010a, p. 41; Gillespie 2000, p. 7), or more simply a combination of both with a privileged social group and its affiliates or dependents. One thing is certain, though: this invention at the level of the spatial structure echoed a significant change in the social matrix. To summarize, it seems that the relations amongst competitive social groups within the same town led to the need for new social and cultural arenas and therefore for new spatial arrangements materializing them. The contacts between those different groups and sub-groups intensified, and consequently, better controlled and segmented built forms arose, while some groups probably used these architectural innovations to advertise their social superiority and establish their political power.

If the previous discussion can contribute to clarifying the reasons why invention happened, it does not say much about the ways in which it was made possible. First of all, we have to take into account the fact that architectural invention took place in a "wider context of technological innovations in MM II, including the use of the potter's wheel and an elaborate administrative system" (Schoep 2004, p. 264). The town of Malia in MM II, with its numerous traces of specialized crafts in many buildings (Schoep 2002, p. 115–116), gives the impression of a hive of artisanal and industrial activities. In this context, the competition between workshops and/or craftsmen affiliated or offering their services to rival social groups could have been really high. One can easily imagine that these talented individuals were vying in skill and daring with each other, relentlessly exploring new ways of making things, addressing new challenges to the technological system and, eventually, profoundly improving the know-how of their time. Furthermore, it is generally accepted that long-distance exchange and contacts were relatively frequent in MM II and were certainly not only related to the involvement of a palatial authority (Schoep 2006, p. 48–49). As it was already the case in the Prepalatial period (Tomkins and Schoep 2010, p. 70), independent agents were in contact with the Cyclades, Egypt and the Near East. Consequently, external influences had a clear impact on Crete with the selective adoption of technologies borrowed from the East during EM III-MM II and probably mobilized by competing elite groups to establish their claim for power and affirm their superiority (see Schoep 2006, p. 52–57 for a detailed examination). These eastern technologies made their way into many aspects of material production, and buildings were not an exception. Apart from more architectural innovations (use of ashlar masonry, orthostats and column base), it has been suggested that the Minoan hall and lustral basin could have been of Egyptian inspiration (Graham 1977, p. 124–125; Driessen 1982, p. 55; Schoep 2006,

p. 55–56).[41] In Malia, imports – whether foreign or Cretan – are more common in MM II than in any other phase of the settlement's history (Driessen 2010b, p. 561). If we take into account this atmosphere of technical emulation and eastern influence, *Quartier Mu* with its *maisons-ateliers*, the production of which it was probably closely overseeing (Poursat 1996; Schoep 2010b, p. 121), and its Egyptianizing items (Poursat 1992, p. 26; Schoep 2002, p. 118–119) could definitely be a privileged backdrop for architectural invention.

For the time being, this specific role of *Quartier Mu* in the process of architectural invention within Minoan building tradition should be considered a working hypothesis and needs to be tested on the basis of other evidence. For example, some Early Bronze Age (MM I/Prepalatial) buildings often considered unusual, such as the oval structure at Chamaizi (fig. 7, cf. Davaras 1972; Davaras 1992; Lenuzza 2011) and the large building at Agia Photia (fig. 8, cf. Tsipopoulou 1988; Tsipopoulou 1992),[42] already showed a configuration that in some aspects remind us of *Quartier Mu* and the future Neopalatial genotype (external distributed part and internal tree-like sequences with the pole of convergence, a large central space in a dominant position on an external ring, as liminal cell and buffer zone). The existence of such spatially elaborated buildings in the Prepalatial period showing configurational properties that seem to presage the later genotype proves that the social evolution of the Middle Bronze Age is certainly not a total departure from what happened in the Early Minoan period (Tomkins and Schoep 2010, p. 68).[43] Of course, throughout history such configuration is recurrent in many vernacular traditions (cf. for example the Kuanyama kraal of the Ambo Tribe: Hillier and Hanson 1984, p. 163–167) and should not be considered to be too symptomatic. The conjunction of many more recurrent factors is needed for a definite genotype to be established. Furthermore, during the same period, more modest domestic structures, such as *Block B* in Myrtos Fournou Koriphi (fig. 9, cf. Warren 1972; Whitelaw 1983; Sanders 1984; Sanders 1990), have nothing to do with this type of configuration and testify to the classical agglutinative way of organizing spaces. Nevertheless, this remark proves that a systematic structural study of the whole Minoan built environment is needed in order to have a better understanding of its evolution and revolution.

41 Following the same line of thought, the introduction of three-dimensional terracotta house models in MM II could point towards a Near Eastern or Egyptian influence (Schoep 1994, p. 198).

42 It is also worth noting that a substantial amount of the material found in the Agia Photia cemetery is compatible with a Cycladic source of manufacture and therefore attested to the existence of contacts between the Cyclades and the north coast of Crete (Day, Wilson and Kiriatzi 1998). Furthermore, it is not impossible that these links to the Cyclades might be indicative of the origin of the local community in historical terms (Day, Wilson and Kiriatzi 1998, p. 147). Bearing that in mind, we have to continue to be aware that external influences may well have played a decisive role in the elaboration of the large building at Agia Photia.

43 Even if distinct social groups might well have been slightly more homogeneous, apart from each other, in smaller settlements with only episodic and brief trading contacts, and even if social competition mainly took place in different arenas (the highly visible forms of burial, for example), these buildings could attest to a more segmented and articulated use of space, also revealing an "appropriation of the communal" by some dominant groups that was already underway (Tomkins and Schoep 2010, p. 76).

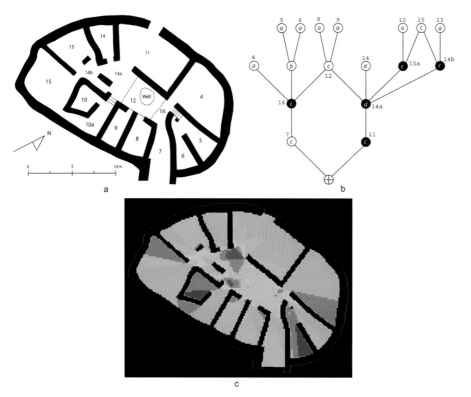

Figure 7 | Chamaizi – Plan (a), j-graph (b) and visual integration (c).

After examining the process of invention in the context of MM II Malia and *Quartier Mu* particularly, the widespread proliferation of these new principles remains to be addressed. Radiating from its birthplace, this innovation happened at different scales with variable intensity, throughout Crete first and in the Cyclades and mainland Greece afterwards (Shaw 2009, p. 169–178). Traditionally, the direction of the influence has always been considered to go from the 'palaces' to other buildings (Driessen 1989–1990). It is now felt more likely that burgeoning features of the Neopalatial genotype first appeared outside the court-centred buildings.[44] Their proliferation over the island in the Late Bronze Age has been interpreted differently (for references see Schoep 1999, p. 202, n. 3). One hypothesis – closely related to the direction of influence traditionally mentioned – considers that the large-scale distribution of the 'palatial' features reveals an integrated political landscape centred on Knossos, with lower order centres repeating, on a less grandiose scale, the func-

44 This does not preclude the fact that the evolution of these new architectural techniques and spatial patterns might have been punctuated by developments originating in the court-centred building and in non-palatial buildings.

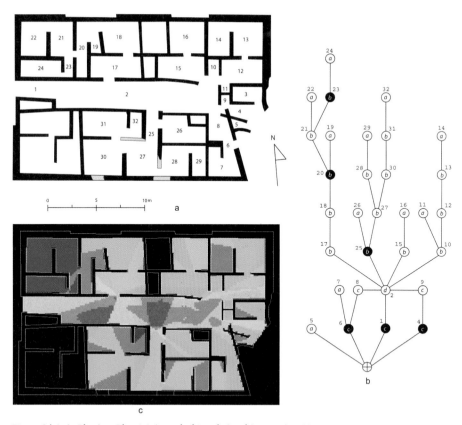

Figure 8 | Agia Photia – Plan (a), j-graph (b) and visual integration (c).

tions exerted by the capital. A second school of thought explains this proliferation as resulting from interaction and emulation between independent peer polities (Hamilakis 2002). Whatever its reasons, this phenomenon certainly followed complex trajectories and developed through different scales that all deserve thorough consideration if we wish to be able to understand this wave of innovation properly. The circumstances that favoured the proliferation and the means of propagation have to be considered from the settlement level to an island-wide perspective and even further away with the Minoanizing architectural features attested overseas. Usually such a phenomenon is considered from a top-down angle but, in the case of the widespread adoption of an invention which is first and foremost a local process, it seems more sensible to reverse the perspective by adopting a bottom-up approach.

Where the settlement level is concerned, we should again return to the MM II town of Malia. The situation of the Middle Bronze Age town was probably rather similar to what Cunningham has identified for Palaikastro, where the street grid was first laid out in MM II (Cunningham 2001, p. 79; MacGillivray and Driessen 1990, p. 390–401; MacGillivray and Sackett 2010, p. 574). Even if some architectural remains are as old as EM II (van Effenterre

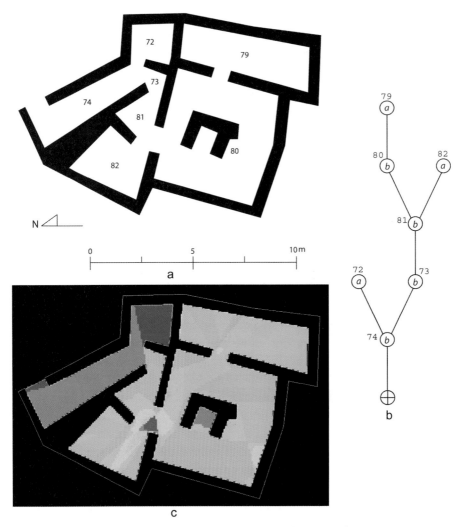

Figure 9 | Myrtos Fournou Koriphi – Block B – Plan (a), j-graph (b) and visual integration (c).

1980, p. 29–30 and 155–156), it is only in MM IA that a coherent street system was laid out around building blocks (van Effenterre 1980, p. 261; Driessen 2010b, p. 560).[45] If the configurational features mentioned above are added to these urban characteristics, Malia seems to display significant signs of stress incurred when population density and settlement size approach a certain threshold of tolerance involving frequency of interaction and

45 It is also possible that, at the time, an enclosure wall protected the town. The latter is attested at several points, but its line cannot be followed everywhere (van Effenterre 1980, p. 22 and 265–267; Deshayes and Dessenne 1959, p. 4–5; Driessen 2010b, p. 560).

difficulty of communication (Fletcher 1995, p. 69–162). Cunningham also identifies different features that all point to the presence of such a problem at Palaikastro: placement of central rooms away from the street, serial segregation of internal spaces, street system facilitating large scale communication, and use of more durable materials (such as ashlar: Cunningham 2001, p. 82).[46] It does seem that the two towns were in a very similar situation. If we can admit that the birth of new architectural features and spatial patterning was influenced by the attempt by certain groups to raise themselves above others and to create appropriate arenas for promoting and maintaining their superiority, we cannot exclude the major impact of the spatial response to social stress. In practical terms, even if the social group in charge of *Quartier Mu* initiated a new spatial vocabulary in a context of conspicuous consumption and inclusion/exclusion practices in Building A (Schoep 2004), this does not prove that it was more due to elite competition than to social stress. In fact, it makes a lot more sense to allow for both processes to be involved in the birth of new spatial requirements and therefore architectural forms. As Cunningham pointed out: "One of the predicted responses [to social stress] has to do with the need to project a unifying social message. This can perhaps be seen on an individual scale with the use of a common repertoire of elite signifiers" (Cunningham 2001, p. 82).[47] Of course, the same goes for the adoption within the town of Malia of these new features: other social groups, in other buildings, were probably not only imitating the elite behaviour taking place in Building A (Schoep 2006, p. 58), but were also simply affected by the same social stress with the same consequences: stronger articulation of the configuration, allowing better control of access and categorization of internal spaces. This probably resulted in more complex and controlled interfaces with different types of users having different rights according to their social status, age, gender, etc. It is also worth noting that similar social contexts could cause rather different spatial responses at a variable pace. Furthermore, some spatial responses chosen by a community could well be completely rejected by another, as attested by the fate of the Minoan hall in area 6/block M in Palaikastro (Driessen 1999; Knappett and Cunningham 2012, p. 12–15), which would give its preference to more local forms (e.g. the so-called Palaikastro halls: Driessen 1989–1990, p. 14; Driessen 1999). It is also worth mentioning that, in the process of innovation, it is very often the context of the invention which is chosen rather than the technique itself (Roux 2010). This means that, in the case of MM II Malia, for example, social groups may have wanted to imitate the general model of inclusive/exclusive practices of Building A in *Quartier Mu* and not specifically the articulated plan that materialized them. This accounts for some variability in their own buildings that were not aping

46 In his analysis, Cunningham made use of several space syntax concepts for approaching both the urban layout and the buildings' configuration (Cunningham 2001, p. 79–81).

47 One of the other responses is the creation or enhancement of monumental public buildings which likewise provide a clear isovistic message across the increasingly large and complex interaction-communication field (Fletcher 1995, p. 134–151). The progressive investment in the court-centred building of Malia from MM II to its heyday in the Neopalatial period is probably good testimony to this process (cf. for example Schoep 2006, p. 58).

spatial configuration and architectural features *stricto sensu*. Hence, while investigating the diffusion and adoption of new architectural principles and patterns, we have to remain open to the existence of complementary, divergent or reactionary dynamics. Of course, this applies to the whole scale-spectrum.

Locally, growing social stress could well help to explain the diffusion of the new architectural principles, but on a larger scale some other processes are more than certain to have been at stake. When considering the island level, it is good to bear in mind that the two schools of thought mentioned might not be as contradictory as it seems at first sight. Indeed, even if the existence of a more politically integrated landscape with some centres extending their control over neighbouring polities is accepted for the Protopalatial period (Tomkins and Schoep 2010, p. 73), this does not preclude the existence of emulation between different centres or even between smaller polities within the authority of the same centre. It also seems clear that "the scale and complexity of a center (size of main settlement, number of large complexes, social hierarchy, competition, etc.), and its access to interregional networks have an influence on the originality and complexity of elite culture." (Schoep 2010, p. 78). In the literature, instead of the centre imposing its cultural norms onto its subordinate settlements (which of course probably happened for some aspects and in specific periods), the emulation process is often related to smaller settlements adopting (import) or adapting (local production) aspects of the elite culture of larger polities. Well-known examples of this are the settlements of Myrtos-Pyrgos and Monastiraki and their relation respectively with Malia and Phaistos, as attested by their adoption and use of writing and administration as well as their production and consumption of fine tableware (Knappett 1999; Kanta 1999; for other examples cf. Schoep 2010, p. 78–79). As was already stated, these processes of emulation, adoption and adaptation can follow complex dynamics. The adoption of some cultural traits does not guarantee that one social group would borrow the full cultural package of another. Moreover, over time, the channels of influence can change direction or simply flow from another source. For example, we may wonder why Myrtos-Pyrgos, usually considered to be within the cultural influence of Malia in the Protopalatial period, looks so Knossian, architecturally speaking, in the Neopalatial period, especially where its main building is concerned (amongst other features, we can note the presence of gypsum dadoes, a gypsum bench with triglyphs, special attention given to colour alternation, a stairwell with balustrade and columns, etc.: Driessen 1989–1990, p. 15; Chlouveraki 2006, p. 288–293). The emulation processes aside, some other factors could have played a decisive role in the diffusion of the new spatial patterns and architectural features. In his description of the Minoan 'house', Driessen emphasized that 'multilocal house groups' could have existed, "dispersed over a series of even nonadjacent communities, and thus contributing to a social and symbolic landscape that exists within and through the identifiable settlement network" (Driessen 2010a, p. 55). He stresses that this could contribute to explaining "the progressive dispersal of seal types from the core area to surrounding villages during the late Prepalatial and early Protopalatial

period" and even in outlying areas on the island, if not beyond, at a later date (Driessen 2010a, p. 56, n. 22–24). This could also, at least in part, account for the wave of architectural innovation on the island and perhaps overseas. Various groups stemming from the same 'house' but geographically apart from each other could have therefore stimulated and taken part in the mobility of architectural technology to create similar adequate – in the sense that they would have materialized the same social interfaces – buildings at various points on the island. Similarly, Driessen recently associated several mason's marks found in court-centred buildings with the work and presence of different 'house' groups within these communal centres (Driessen, forthcoming).[48]

Besides the reasons why this wave of innovation took place, the agents that conveyed the new principles have to be briefly considered. Buildings are the settings of daily life, they are at the same time the materialization of cultural norms and the arenas where the latter are maintained, negotiated and reproduced. Because of this specific nature, they are more prone to conservatism than other aspects of material culture. This could of course account for the time lapse that separates the birth of architecture in MM II (presumably in built environments like *Quartier Mu* at Malia) from the progressive diffusion of the new principles and their crystallization in the form of a new vernacular tradition, probably at some point during the Neopalatial period. Of course, in these processes and their relatively long time-span, the vectors of diffusion also have to be taken into consideration. The hypothetical existence of 'specialized supervisors' (Shaw 2009, p. 168) was related to the innovation process that characterized the Neopalatial period. Itinerant builders with a high level of expertise were put forward as a way of explaining how the 'Neopalatial style' spread throughout Crete and especially to remote and small-sized settlements (Driessen 1989–1990, p. 17–22; Shaw 2009, p. 166–169). Unfortunately, as Shaw puts it: "Without adequate contemporary records, our understanding of the organization of the builders and their relationships to those in charge of the building, whether patrons, administrators or experienced supervisors, is limited to reasoned speculation" (Shaw 2009, p. 166). Likewise, house models might also have served as diffusion devices: they could have been carried along by travelling craftsmen to promote their work and abilities, sent towards some subordinate settlement by a larger centre to sustain a political message, or kept as a token of affiliation and/or remembrance by a 'house' group away from its focal place.

Most of the above mentioned processes probably played a role on a larger scale in the diffusion of this 'Neopalatial style' in the Cyclades and even the Greek mainland (for various examples, cf. Shaw 2009, p. 169–178; Palyvou 2005, p. 179–188). A detailed investigation of the architectural minoanization of the Aegean is beyond the scope of this paper.

48 This idea of mason's marks being associated with different groups is not new, but usually they are linked with gangs of workmen responsible for completing adjacent projects within the court-centred buildings (Begg 2004a, p. 20 and n. 166 for a historiographical approach to this idea; Begg 2004b, p. 221; more generally on mason's marks, cf. Shaw 2009, p. 76–79).

Nevertheless, some general remarks can be made. At the beginning of the Late Bronze Age, Cretan elite culture was probably well known in the Aegean and mobilized by foreign elite groups to establish their own superiority. However, it is also possible that, during the Neopalatial period, some 'house' groups left Crete under the pressure of increasing rivalries between 'houses' (Driessen 2010a, p. 55). These settlers could have been forced to leave their focal place but kept the firm intention of re-creating it somewhere else (or at least of importing some of its features as symbolic links with the ancestral 'house'). All these phenomena could have taken part in the widespread diffusion of the new Neopalatial vernacular tradition overseas. As for the lower scales of diffusion, we need to remember that these processes usually follow complex dynamics, with an intricate interplay of external influence and local tradition, adoption and adaptation, resistance and affiliation.

7 Postscript

In the light of this research, it appears that the so-called 'Neopalatial Style' in Minoan architecture has to be considered a phenomenon which developed from progressive innovation (i.e. adoption of new principles) to the emergence of a new vernacular tradition (i.e. new principles becoming cultural standards). Invention (i.e. creation of new principles) certainly happened before the beginning of the Neopalatial period – perhaps notably in MM II *Quartier Mu*, as tentatively suggested here – and may have been influenced by the long-term maturation, adaptation and transformation of even earlier architectural developments. As Glassie stated: "No building is entirely new. If it were, it would be utterly incomprehensible. [...] No matter how grandiose and revolutionary the creation, there must be some tradition, some presence of the common and continuous – of the qualities called 'folk' – or people would not be able to understand it or use it. In their mixing of the old and the new, all buildings are vernacular, the products of real people in real situations" (Glassie 2000, p. 70).

This paper does not present a definitive picture of the evolution of Minoan architectural language. Some questions were tackled, others were raised, but most importantly, a new way of considering the evolution of the built form in Minoan Crete was advocated, a way that does not only focus on architectural forms and functions but gives a central place to the analysis of configuration, the structure of space. Through its application to several key buildings in Minoan architectural history, it can already be realized that space syntax, with its invaluable potential for comparative analysis, definitely constitutes a powerful tool for investigating concepts of invention, innovation and diffusion. This paper should hence be considered as a first step to a much needed diachronic and systematic structural approach to the Minoan built environment.

Some remarks and perspectives for further research may be offered in conclusion. In this paper, quite traditionally, buildings were mainly approached as products, as definite

architectural forms. Nevertheless, we must be aware that this pre-eminence of form over process, clearly dominant in Western thought, may not be the most efficient paradigm to deal with the evolution of built structures. Indeed, architecture comprises at once process (acts) and results (products), but as Blier noted, buildings are first and foremost living organisms (Blier 1987, p. 2; cf. also Hillier 1996, p. 17–20).[49] They "have life-histories, which consist in the unfolding of their relations with both human and non-human components of their environments" (Ingold 2000, p. 187). Hillier concurs when he writes: "The built environment is, apart from society itself, the largest and most complex artefact that human beings make. Its complexity and its scale emerge together, because, like society, a built environment is not so much a thing as a process of spatio-temporal aggregation subject to continual change and carried out by innumerable agencies over a long period of time" (Hillier 1996, p. 92). Therefore building is an ongoing process: "It does not begin here, with a pre-formed plan, and end there, with a finished artefact. The 'final form' is but a fleeting moment in the life of any feature, when it is matched to a human purpose, likewise cut out from the flow of intentional activity" (Ingold 2000, p. 188). This shift in perspective from products to process corresponds to what van der Leeuw labels a shift from a static to a dynamic world view, a perspective where one does not study 'what is' but 'what happens', not entities but processes, where change is assumed and stability needs to be explained rather than vice versa (van der Leeuw 2008, p. 226). Van der Leeuw also considers this dynamic world view to be 'non-linear' in that it turns its back on linear causalities, acknowledging unexpected behaviour as happening in otherwise regular processes. "Moreover, from this perspective, similar causes can have widely divergent effects, but very different causes can, under certain circumstances, also have convergent effects" (van der Leeuw 2008, p. 226). In such a non-linear dynamic approach, discontinuity and bifurcation are seen as intrinsic properties of complex human systems, whose resilience and continued existence depend as much on innovative behaviour as they do on replication (van der Leeuw 2008, p. 227). Such an approach could turn out to be particularly well adapted to the study of the evolution of the Minoan built environment (for a similar plea, see Driessen 2010a, especially p. 43–46). Unfortunately, the state of preservation of our data is a major issue. Remains of Minoan buildings are usually in a rather bad state, and even when they are not, documenting their modifications in plan and structure is far from easy. Nevertheless, special attention given to architectural phases and, more precisely, a diachronic approach to change in built forms is necessary to study building biographies (Herva 2005, p. 220–221), and therefore, the development of an architectural language.

Moreover, understanding the life histories of buildings also requires a thorough consideration of all the human and non-human components of their environments. With this in mind, the shift from building to architecture as acknowledged here for Minoan Crete

49 On this subject, cf. the very interesting paper by Herva on foundation deposits in Minoan buildings (Herva 2005).

would also gain by being tackled in the context of the overall change in the Neopalatial period that Knappett recently documented, essentially in the production, distribution and consumption of various goods (Knappett 2011, p. 106–122). If invention at the level of the genotype happened at some point at the end of the Protopalatial period, it may have triggered a cascade of innovation that would have had repercussions way beyond the built form. As van der Leeuw puts it: "[...] in every tradition, ultimately ideas, tools and know-how become closely aligned and intertwined into a system in which changes in one domain immediately require changes in many others" (van der Leeuw 2009, p. 245). The concept of 'agent-artefact space' developed by Lane is also very informative in this matter (Lane et al. 2009). It conveys the sense in which a given technology consists of a set of knowledge distributed across various entities – be they agents or artefacts – with various kinds of interconnections (Knappett 2011, p. 156). In such a model, for an innovation to take hold – i.e. for an isolated invention to spread across the network space – there has to be some kind of alteration of that space, which may be physical or conceptual.[50] In this sense, the emergence of configurational thinking and the birth of architecture *per se* in Minoan Crete certainly played a major role in shaping what is often considered its Golden Age: the Neopalatial period.

50 "The space is dynamic because not only can its structural properties be the very source of invention and creativity, its structures are also subsequently altered by such change. As more artefact types are created, so are new kinds of agents; and these in turn may create new interconnections that in turn spawn yet further problems requiring solutions. As the agent-artefact space changes and grows, more kinds of attributions and exaptations are enabled, leading to more innovation" (Knappett 2011, p. 156).

Bibliographical references

Begg, Ian (1975)
Minoan Storerooms in the Late Bronze Age, University of Toronto (PhD thesis, unpublished).

Begg, Ian (2004a)
"An Archaeology of Palatial Mason's Marks on Crete", in: Ann Chapin (ed.), *Charis. Essays in Honor of S.A. Immerwahr* (Hesperia Supplement 33), Princeton, pp. 1–25.

Begg, Ian (2004b)
"An Interpretation of Mason's Marks at Knossos", in: Gerald Cadogan, Eleni Hatzaki, and Andonis Vasilikis (eds.), *Knossos: Palace, City, State. Proceedings of the Conference in Herakleion organised by the British School at Athens and the 23rd Ephoreia of Prehistoric and Classical Antiquities of Herakleion, November 2000, for the Centenary of Sir Arthur Evans' Excavations at Knossos*, British School at Athens Studies 12, London, pp. 219–223.

Bianco, Giulina (2003)
"Two Different Building Modules of Measurement at Kommos – A Neopalatial Module in Building T and Postpalatial Module in Building P", in: Karin P. Foster and Robert Laffineur (eds.), *Metron. Measuring the Aegean Bronze Age* (Aegaeum. Annales d'archéologie égéenne de l'Université de Liège et UT-PASP 24), Liège, Austin, pp. 415–420.

Blier, Suzanne P. (1987)
The Anatomy of Architecture. Ontology and Metaphor in Batammaliba Architectural Expression, Cambridge.

Blier, Suzanne P. (2008)
"Vernacular Architecture", in: Christopher Tilley, Webb Keane, Susanne Kuechler-Fogden, Mike Rowlands, and Patricia Spyer (eds.), *Handbook of Material Culture*, London, pp. 230–253.

Branigan, Keith (1993)
Dancing with Death: Life and Death in Southern Crete, c. 3000–2000 BC, Amsterdam.

Branigan, Keith (1998)
"The Nearness of You: Proximity and Distance in Early Minoan Funerary Landscapes", in: Keith Branigan (ed.), *Cemetery and Society in the Aegean Bronze Age*, Amsterdam, pp. 13–26.

Cherry, John F. (1983)
"Putting the Best Foot Forward", in: *Antiquity* 57, pp. 52–56.

Cherry, John F. (1986)
"Polities and Palaces: Some Problems in Minoan State Formation", in: Colin Renfrew and John Cherry (eds.), *Peer Polity Interaction and Socio-Political Change*, Cambridge, pp. 19–45.

Chlouveraki, Stella (2006)
Gypsum in Minoan Architecture: Exploitation, Utilisation and Weathering of a Prestige Stone, University College London (PhD thesis).

Christakis, Kostandinos S. (2008)
The Politics of Storage: Storage and Socio-Political Complexity in Neopalatial Crete, Prehistory Monographs 25, Philadelphia.

Como, Maria Teresa, Kanta, Athanasia, and Marazzi, Massimiliano (2009)
"The Architectural Investigation of the Protopalatial Site of Monastiraki, Crete", in: Martin Bachmann (ed.), *Bautechnik im antiken und vorantiken Kleinasien*, BYZAS 9, Istanbul, pp. 225–241.

Cunningham, Tim (2001)
"Variations on a Theme: Divergence in Settlement Patterns and Spatial Organization in the Far East of Crete during the Proto- and Neopalatial Periods", in: Keith Branigan (ed.), *Urbanism in the Aegean Bronze Age*, Sheffield Studies in Aegean Archaeology 4, London, New York, pp. 72–86.

Cutting, Marion (2003)
"The Use of Spatial Analysis to Study Prehistoric Settlement Architecture", in: *Oxford Journal of Archaeology* 22, 1, pp. 1–21.

Dabney, Mary K. (1995)
"The Later Stages of State Formation in Palatial Crete", in: Robert Laffineur and Wolf-Dietrich Niemeier (eds.), *Politeia. Society and State in the Aegean Bronze Age. Proceedings of the 5th International Aegean Conference held at the University of Heidelberg, Archäologisches Institut, 10–13 April 1994* (Aegaeum. Annales d'archéologie égéenne de l'Université de Liège et UT-PASP 12), Liège, Austin, pp. 43–47.

Davaras, Costis (1972)
"The Oval House at Chamaizi Reconsidered", in: *Archaiologika Analekta ex Athenon* V, 2, pp. 283–288.

Davaras, Costis (1992)
"Chamaizi", in: Wilson J. Myers, Eleanor E. Myers, and Gerald Cadogan (eds.), *The Aerial Atlas of Ancient Crete*, Berkeley, Los Angeles, pp. 78–81.

Day, Peter M., Wilson, David E., and Kiriatzi, Evangelia (1998)
"Pots, Labels and People: Burying Ethnicity in the Cemetery at Aghia Photia, Siteias", in: Keith Branigan (ed.), *Cemetery and Society in the Aegean Bronze Age*, Sheffield, pp. 133–149.

Deshayes, Jean, and Dessenne, André (1959)
Fouilles exécutées à Mallia. Exploration des maisons et quartiers d'habitation (1948–1954), II (Études crétoises XI), Paris.

Devolder, Maud, Déderix, Sylviane, and Fadin, Lionel (forthcoming)
"Recherches aux 'Magasins Dessenne' à Malia", in: *Bulletin de Correspondance Hellénique* 137.2.

Dickinson, Oliver T.P.K. (1994)
The Aegean Bronze Age, Cambridge.

Driessen, Jan (1982)
"The Minoan Hall in Domestic Architecture on Crete: To Be in Vogue in Late Minoan IA?", in: *Acta Archaeologica Lovaniensia* 21, pp. 27–92.

Driessen, Jan (1989–1990)
"The Proliferation of Minoan Palatial Architectural Style (I) Crete", in: *Acta Archaeologica Lovaniensia* 28–29, pp. 3–23.

Driessen, Jan (1999)
"The Dismantling of a Minoan Hall at Palaikastro (Knossian Go Home?)", in: Philip P. Betancourt, Vassos Karageorgis, Robert Laffineur, and Wolf-Dietrich Niemeier (eds.), *Meletemata. Studies in Aegean Archaeology Presented to Malcom H. Wiener as he Enters his 65th Birthday* (Aegaeum. Annales d'archéologie égéenne de l'Université de Liège et UT-PASP 20), Liège, Austin, pp. 227–236.

Driessen, Jan (2001)
"History and Hierarchy. Preliminary Observations on the Settlement Pattern in Minoan Crete", in: Keith Branigan (ed.), *Urbanism in the Aegean Bronze Age* (Sheffield Studies in Aegean Archaeology 4), London, New York, pp. 51–71.

Driessen, Jan (2004)
"The Central Court of the Palace at Knossos", in: Gerald Cadogan, Eleni Hatzaki, and Andonis Vasilikis (eds.), *Knossos: Palace, City, State. Proceedings of the Conference in Herakleion organised by the British School at Athens and the 23rd Ephoreia of Prehistoric and Classical Antiquities of Herakleion, in November 2000, for the Centenary of Sir Arthur Evans' Excavations at Knossos* (British School at Athens Studies 12), London, pp. 75–82.

Driessen, Jan (2005)
"On the Use of Upper Floors in Minoan Neopalatial Architecture", in: Isabelle Bradfer-Burdet, Béatrice Detournay, and Robert Laffineur (eds.), KRHS TEXNITHS. *L'artisan crétois. Recueil d'articles en l'honneur de Jean-Claude Poursat, publié à l'occasion des 40 ans de la découverte du Quartier Mu* (Aegaeum. Annales d'archéologie égéenne de l'Université de Liège et UT-PASP 26), Liège, Austin, pp. 83–88.

Driessen, Jan (2010a)
"Spirit of Place. Minoan Houses as Major Actors", in: Daniel J. Pullen (ed.), *Political Economies of the Aegean Bronze Age. Papers from the Langford Conference, Florida State University, Tallahassee, 22–24 February 2007*, Oxford, Oakville, pp. 35–65.

Driessen, Jan (2010b)
"Malia", in: Eric H. Cline (ed.), *The Oxford Handbook of the Bronze Age Aegean (ca. 3000–1000 BC)*, Oxford, pp. 556–570.

Driessen, Jan (forthcoming)
"Beyond the Collective. The Minoan Palace in Action", in: Maria Relaki and Iannis Papadatos (eds.), *Studies in Honour of Keith Branigan. Proceedings of the Symposium held at Sheffield University in January 2010*.

Driessen, Jan, and Iannis Sakellarakis (1997)
"The Vathypethro-Complex. Some Observations on its Architectural History and Function", in: Robin Hägg (ed.), *The Function of the Minoan Villa. Proceedings of the Eighth International Symposium at the Swedish Institute at Athens, 6–8 June 1992*, Stockholm, pp. 63–77.

Fletcher, Roland (1995)
The Limits of Settlement Growth. A Theoretical Outline, Cambridge.

Forde, Daryll (1934)
Habitat, Economy, and Society, London.

Gillespie, Susan D. (2000)
"Beyond Kinship. An Introduction", in: Rosemary A. Joyce and Susan D. Gillespie (eds.), *Beyond Kinship: Social and Material Reproduction in House Societies*, Philadelphia, pp. 1–21.

Glassie, Henry (2000)
Vernacular Architecture, Bloomington.

Goodison, Lucy (2001)
"From Tholos to Throne Room: Perceptions of the Sun in Minoan Ritual", in: Robert Laffineur and Robin Hägg (eds.), *Potnia. Deities and Religion in the Aegean Bronze Age* (Aegaeum. Annales d'archéologie égéenne de l'Université de Liège et UT-PASP 22), Liège, Austin, pp. 77–89.

Goodison, Lucy (2004)
"From Tholos Tomb to Throne Room: Some Considerations of Dawn Light and Directionality in Minoan Buildings", in: Gerald Cadogan, Eleni Hatzaki, and Andonis Vasilikis (eds.), *Knossos: Palace, City, State. Proceedings of the Conference in Herakleion Organised by the British School at Athens and the 23rd Ephoreia of Prehistoric and Classical Antiquities of Herakleion, in November 2000, for the Centenary of Sir Arthur Evans' Excavations at Knossos* (British School at Athens Studies 12), London, pp. 339–50.

Graham, James W. (1960)
"The Minoan Unit of Length and Minoan Palace Planning", in: *American Journal of Archaeology* 64, pp. 335–41.

Graham, James W. (1977)
"Bathrooms and Lustral Chambers", in: Konrad H. Kinzl (ed.), *Greece and the Eastern Mediterranean in Ancient History and Prehistory: Studies Presented to Fritz Schachermeyr on the Occasion of his Eightieth Birthday*, Berlin, pp. 110–125.

Haggis, Donald C. (1999)
"Staple Finance, Peak Sanctuaries, and Economic Complexity in Late Prepalatial Crete", in: Angelos Chaniotis (ed.), *From Minoan Farmers to Roman Traders: Sidelights on the Economy of Ancient Crete*, Stuttgart, pp. 53–86.

Hallager, Erik (1990)
"Upper Floors in LM I Houses", in: Pascal Darcque and René Treuil (eds.), *L'habitat égéen préhistorique. Actes de la Table Ronde internationale organisée par le Centre National de la Recherche Scientifique, l'Université de Paris I et l'École Française d'Athènes (Athènes, 23–25 juin 1987)* (BCH suppl. XIX), Athens, Paris, pp. 281–292.

Hamilakis, Yiannis (1998)
"Eating the Dead: Mortuary Feasting and the Politics of Memory in Aegean Bronze Age Societies", in: Keith Branigan (ed.), *Cemetery and Society in the Aegean Bronze Age*, Amsterdam, pp. 115–32.

Hamilakis, Yiannis (2002)
"Too Many Chiefs?: Factional Competition in Neopalatial Crete", in: Jan Driessen, Ilse Schoep, and Robert Laffineur (eds.), *Monuments of Minos. Rethinking the Minoan Palaces* (Aegaeum. Annales d'archéologie égéenne de l'Université de Liège et UT-PASP 23), Liège, Austin, pp. 179–199.

Herva, Vesa-Pekka (2005)
"The Life of Buildings: Minoan Building Deposits in an Ecological Perspective", in: *Oxford Journal of Archaeology* 24, 3, pp. 215–227.

Hillier, Bill (1996)
Space is the Machine. A Configurational Theory of Architecture, Cambridge.

Hillier, Bill, and Hanson, Julienne (1984)
The Social Logic of Space, Cambridge.

Hitchcock, Louise (1997)
"The Best Laid Plans Go Astray: Modular (Ir)regularities in the 'Residential Quarters' at Phaistos", in: Philip Betancourt and Robert Laffineur (eds.), TEXNH. *Craftsmen, Craftswomen and Craftsmanship in the Aegean Bronze Age* (Aegeum. Annales d'archéologie égéenne de l'Université de Liège et UT-PASP 16), Liège, pp. 243–250.

Hitchcock, Louise (2000)
Minoan Architecture. A Contextual Analysis (Studies in Mediterranean Archaeology and Literature 155), Jönsered.

Hitchcock, Louise, and Preziosi, Donald (1997)
"The Knossos Unexplored Mansion and the 'Villa-Annex Complex'", in: Robin Hägg (ed.) *The Function of the Minoan Villa. Proceedings of the Eighth International Symposium at the Swedish Institute at Athens, 6–8 June 1992*, Stockholm, pp. 51–62.

Ingold, Tim (2000)
The Perception of the Environment. Essays in Livelihood, Dwelling and Skills, London.

Joyce, Rosemary A., and Gillespie, Susan D. (eds.) (2000)
Beyond Kinship: Social and Material Reproduction in House Societies, Philadelphia.

Kanta, Athanasia (1999)
"Monastiraki and Phaistos, Elements of Protopalatial History", in: Philip P. Betancourt, Vassos Karageorgis, Robert Laffineur, and Wolf-Dietrich Niemeier (eds.), *Meletemata. Studies in Aegean Archaeology Presented to Malcom H. Wiener as he Enters his 65th Birthday* (Aegaeum. Annales d'archéologie égéenne de l'Université de Liège et UT-PASP 20), Liège, Austin, pp. 387–393.

Kanta, Athanasia (2006)
"Monastiraki, a Minoan Palatial Centre in the Valley of Amari, Crete", in: Anastasia Kanta and Massimiliano Marazzi (eds.), *Monastiraki 1. Missione Monastiraki, Campagne 2002/2004*, Naples.

Kent, Suzan (1990)
"A Cross-Cultural Study of Segmentation, Architecture, and the Use of Space", in: Suzan Kent (ed.), *Domestic Architecture and the Use of Space. An Interdisciplinary Cross Cultural Study*, Cambridge, pp. 127–152.

Knappett, Carl (1999)
"Assessing a Polity in Protopalatial Crete: The Malia-Lasithi State", in: *American Journal of Archaeology* 103, 4, pp. 615–639.

Knappett, Carl (2011)
An Archaeology of Interaction: Network Perspectives on Material Culture and Society, Oxford.

Knappett, Carl, and Tim Cunningham (2012)
Palaikastro Block M. The Proto- and Neopalatial Town (BSA Supplementary Volumes 47), Athens.

Lane, David, van der Leeuw, Sander, Pumain, Denise, and West, Geoffrey (eds.) (2009)
Complexity Perspectives in Innovation and Social Change, New York.

Langohr, Charlotte (2009)
PERIFEREIA. *Étude régionale de la Crète aux Minoen Récent II–IIIB (1450–1200 av. J.-C.). 1. La Crète centrale et occidentale* (Aegis 2), Louvain-la-Neuve.

Lembessi, Angeliki (1976)
"Ο οίκίσκος των Αρχανων", in: *Archaeologikis Ephemeris*, pp. 12–43.

Lenuzza, Valeria (2011)
"'The Whole is a freak': A Reassessment of the Spatial Organization of the Oval House At Cha-maizi, Siteia", in: Glowacki, Kevin T. and Vogeikoff-Brogan, Natalia (eds.), *Stega. The Archaeol-ogy of Houses and Households in Ancient Crete* (Hesperia Supplement 44), Princeton, pp. 59–70.

Letesson, Quentin (2009)
Du phénotype au génotype: analyse de la syntaxe spatiale en architecture minoenne (MMIIIB-LMIB) (Aegis 2), Louvain-la-Neuve.

Letesson, Quentin, and Vansteenhuyse, Klaas (2006)
"Towards an Archaeology of Perception. 'Looking' at the Minoan Palaces", in: *Journal of Medi-terranean Archaeology* 19, 1, pp. 91–119.

Letesson, Quentin, and Driessen, Jan (2008)
"From 'Party' to 'Ritual' to 'Ruin': The Spatial Context of Feasting", in: Louise Hitchcock, Robert Laffineur, and Janice Crowley (eds.), *DAIS. The Aegean Feast* (Aegaeum 29), Liège, Austin, pp. 207–215.

MacDonald, Colin F. (2002)
"The Neopalatial Palace of Knossos", in: Jan Driessen, Ilse Schoep, and Robert Laffineur (eds.), *Monuments of Minos. Rethinking the Minoan Palaces* (Aegaeum. Annales d'archéologie égéenne de l'Université de Liège et UT-PASP 23), Liège, Austin, pp. 35–55.

MacDonald, Colin F., Hallager, Erik, and Niemeier, Wolf-Dietrich (eds.) (2009)
The Minoans in the Central, Eastern and Northern Aegean – New Evidence (Monographs of the Danish Institute at Athens 8), Athens.

MacGillivray, Joseph A., and Driessen Jan (1990)
"Minoan Settlement at Palaikastro", in: Pascal Darcque and René Treuil (eds.), *L'habitat égéen préhistorique. Actes de la Table Ronde internationale organisée par le Centre National de la Recherche Scientifique, l'Université de Paris I et l'École Française d'Athènes, Athènes, 23–25 juin 1987*, (Bulletin de Correspondance Hellénique supplément XIX), Athens, Paris, pp. 395–412.

MacGillivray, Joseph A., and Sackett, Hugh L. (2010)
"Palaikastro", in: Eric H. Cline (ed.), *The Oxford Handbook of the Bronze Age Aegean (ca. 3000–1000 BC)*, Oxford, pp. 571–581.

McEnroe, John (1990)
"The Significance of Local Styles in Minoan Vernacular Architecture", in: Pascal Darcque and René Treuil (eds.), *L'habitat égéen préhistorique. Actes de la Table Ronde internationale organisée par le Centre National de la Recherche Scientifique, l'Université de Paris I et l'École Fran-çaise d'Athènes (Athènes, 23–25 juin 1987)* (BCH suppl. XIX), Athens, Paris, pp. 195–202.

McEnroe, John (2010)
Architecture of Minoan Crete. Constructing Identity in the Aegean Bronze Age, Austin.

Mirié, Sieglinde (1979)
Das Thronraumareal des Palastes von Knossos: Versuch einer Neuinterpretation seiner Entstehung und seiner Funktion (Saarbrücker Beiträge zur Altertumskunde 26), Bonn.

Müller, Béatrice (2001)
"'Maquettes architecturales' de l'Antiquité. Regards croisés (Proche-Orient, Égypte, Chypre, bassin égéen et Grèce, du Néolithique à l'époque hellénistique)", Actes du Colloque de Strasbourg, 3–5 décembre 1998, Paris.

Murphy, Joanne (1998)
"Ideologies, Rites and Rituals: A View of Prepalatial Minoan Tholoi", in: Keith Branigan (ed.), *Cemetery and Society in the Aegean Bronze Age*, Amsterdam, pp. 27–40.

Murphy, Joanne (2010)
"Political Economies in Ritual: A Comparative Study of the Rise of the State in Pre- and Protopalatial Knossos and Phaistos", in: Daniel J. Pullen (ed.), *Political Economies of the Aegean Bronze Age. Papers from the Langford Conference, Florida State University, Tallahassee, 22–24 February 2007*, Oxford, Oakville, pp. 112–126.

Niemeier, Wolf-Dietrich (1987)
"On the Function of the 'Throne Room' in the Palace at Knossos", in: Robin Hägg and Nanno Marinatos (eds.), *The Function of the Minoan Palaces. Proceedings of the Fourth International Symposium at the Swedish Institute in Athens, 10–16 June, 1984*, 4, XXXV, Stockholm, pp. 163–168.

Ostwald, Michael (2011)
"The Mathematics of Spatial Configuration: Revisiting, Revising and Critiquing Justified Plan Graph Theory", in: *Nexus Network Journal* 13.2, pp. 445–470.

Palyvou, Clairy (1987)
"Circulatory Patterns in Minoan Architecture" in: Robin Hägg and Nanno Marinatos (eds.), *The Function of the Minoan Palaces. Proceedings of the Fourth International Symposium at the Swedish Institute in Athens, 10–16 June, 1984*, 4, XXXV, Stockholm, pp. 195–203.

Palyvou, Clairy (2002)
"Central Courts: The Supremacy of the Void", in: Jan Driessen, Ilse Schoep, and Robert Laffineur (eds.), *Monuments of Minos. Rethinking the Minoan Palaces* (Aegaeum. Annales d'archéologie égéenne de l'Université de Liège et UT-PASP 23), Liège, Austin, pp. 167–178.

Palyvou, Clairy (2005)
Akrotiri Thera. An Architecture of Affluence 3,500 Years Old, Philadelphia.

Preucel, Robert W. (2000)
"Making Pueblo Communities: Architectural Discourse at Kotyiti, New Mexico", in: Marcello A. Canuto and Jason Yaeger (eds.), *The Archaeology of Communities. A New World Perspective*, London, New York, pp. 58–77.

Poblome, Jeroen, and Christine Dumon (1987–1988)
"A Minoan Building Program? Some Comments on the Unexplored Mansion at Knossos", in: *Acta Archaeologica Lovaniensia* 26–27, pp. 69–79.

Poursat, Jean-Claude (1978)
Fouilles exécutées à Mallia. Le Quartier Mu I (Ètudes Crétoises XXIII), Paris.

Poursat, Jean-Claude (1987)
"Town and Palace at Malia in the Protopalatial Period", in: Robin Hägg and Nanno Marinatos (eds.), *The Function of the Minoan Palaces. Proceedings of the Fourth International Symposium at the Swedish Institute in Athens, 10–16 June, 1984*, 4, XXXV), Stockholm, pp. 75–76.

Poursat, Jean-Claude (1992)
Guide de Malia au temps des premiers palais. Le Quartier Mu (École française d'Athènes. Sites et monuments VIII), Paris.

Poursat, Jean-Claude (1996)
Fouilles exécutées à Malia. Le Quartier Mu III. Artisans minoens: les maisons-ateliers du quartier Mu (Études Crétoises XXXII), Paris.

Poursat, Jean-Claude, and Knappett, Carl (2005)
Fouilles exécutées à Malia. Le Quartier Mu IV. La poterie du Minoen Moyen II: production et utilisation (Études Crétoises XXXIII), Paris.

Preziosi, Donald (1979)
The Semiotics of the Built Environment: An Introduction to Architectonic Analyses, Bloomington, London.

Preziosi, Donald (1983)
Minoan Architectural Design. Formation and Signification (Approaches to Semiotics 63), Berlin, New York.

Preziosi, Donald (2003)
"What Does a Module Mean?", in: Karin P. Foster and Robert Laffineur (eds.), *Metron. Measuring the Aegean Bronze Age* (Aegaeum. Annales d'archéologie égéenne de l'Université de Liège et UT-PASP 24), Liège, Austin, pp. 233–237.

Pullen, Daniel J. (2010)
"Introduction: Political Economies of the Aegean Bronze Age", in: Daniel J. Pullen (ed.), *Political Economies of the Aegean Bronze Age*, Oxford, Oakville, pp. 1–10.

Roux, Valentine (2010)
"Technologie et cognition", in: *L'archéologie en mouvement: hommes, objets et temporalités (CNRS/INSHS), Paris 23–25 June 2010*, http://webcast.in2p3.fr/2010/archeomouv/index.php?video=roux.ram (29 February 2010).

Sanders, Donald H. (1984)
Behavior and the Built Environment: An Interpretive Model for the Analysis of the Architecture in an Archaeological Context and Its Testing on Material from the Aegean Bronze Age Site of Myrtos, Crete, (Ph.D. thesis, unpublished).

Sanders, Donald H. (1988)
"Architecture, the Neglected Artifact", in: Elizabeth B. French and Diane E.H. Wardle (eds.), *Problems in Greek Prehistory. Papers presented at the Centenary Conference of the British School of Archaeology at Athens, Manchester April 1986*, Bristol, pp. 489–499.

Sanders, Donald H. (1990)
"Behavioral Conventions and Archaeology: Methods for the Analysis of Ancient Architecture", in: Suzan Kent (ed.), *Domestic Architecture and the Use of Space. An Interdisciplinary Cross-Cultural Study (New Directions in Archaeology)*, Cambridge, pp. 43–72.

Schoep, Ilse (1994)
"Home Sweet Home. Some Comments on the So-called House Models from the Prehellenic Aegean", in: *Opuscula Atheniensa* 20, pp. 189–210.

Schoep, Ilse (1999)
"Tablets and Territories? Reconstructing Late Minoan IB Political Geography through Undeciphered Documents", in: *American Journal of Archaeology* 103, pp. 201–221.

Schoep, Ilse (2002)
"Social and Political Organisation on Crete in the Proto-Palatial Period: The Case of Malia in MMII", in: *Journal of Mediterranean Archaeology* 15, 2, pp. 102–25.

Schoep, Ilse (2004)
"Assessing the Role of Architecture in Conspicuous Consumption in the Middle Minoan I–II Periods", in: *Oxford Journal of Archaeology* 23, 3, pp. 243–269.

Schoep, Ilse (2006)
"Looking Beyond the First Palaces: Elites and the Agency of Power in EMIII-MMII Crete", in: *American Journal of Archaeology* 110, pp. 37–64.

Schoep, Ilse (2010a)
"Making Elites: Political Economy and Elite Culture(s) in Middle Minoan Crete", in: Daniel J. Pullen (ed.), *Political Economies of the Aegean Bronze Age. Papers from the Langford Conference, Florida State University, Tallahassee, 22–24 February 2007*, Oxford, Oakville, pp. 66–85.

Schoep, Ilse (2010b)
"Middle Bronze Age. Crete", in: Eric H. Cline (ed.), *The Oxford Handbook of the Bronze Age Aegean (ca. 3000–1000 BC)*, Oxford, pp. 113–125.

Shaw, Joseph W. (1973)
"The Orientation of the Minoan Palaces", in: *Antichità cretesi. Studi in onore di Doro Levi. Cronache di archeologia* 12, pp. 47–59.

Shaw, Joseph W. (2009)
Minoan Architecture: Materials and Techniques (Studi di archeologia cretese VII), Padua.

Shaw, Joseph W. (2011)
"Tracing the Ancestry of the Minoan Hall System", in: *Annual of the British School at Athens* 106, pp. 141–165.

Shaw, Joseph W., and Shaw, Maria C. (eds.) (1996)
Kommos I. The Kommos Region and Houses of the Minoan Town. Part 2. The Minoan Hilltop and Hillside Houses, Princeton.

Schmid, Martin (1985)
"Esquisse du tracé d'un ensemble architectural de l'époque minoenne: Malia, le Quartier Mu", in: *Le dessin d'architecture dans les sociétés antiques. Actes du Colloque de Strasbourg 26–28 janvier 1984 (Université des sciences humaines de Strasbourg. Travaux du centre de recherche sur le Proche Orient et la Grèce antiques 8)*, Leiden, pp. 63–73.

Todaro, Simona (2012)
"Craft Production and Social Practices at Prepalatial Phaistos: The Background to the First 'Palace'", in: Ilse Schoep, Peter Tomkins, and Jan Driessen (eds.), *Back to the Beginning. Reassessing Social and Political Complexity on Crete during the Early and Middle Bronze Age*, Oxford, Oakville, pp. 195–235.

Tomkins, Peter, and Schoep, Ilse (2010)
"Early Bronze Age. Crete", in: Eric H. Cline (ed.), *The Oxford Handbook of the Bronze Age Aegean (ca. 3000–1000 BC)*, Oxford, pp. 66–82.

Tomkins, Peter (2007)
"Communality and Competition: The Social Life of Food and Containers at Aceramic and Early Neolithic Knossos, Crete", in: Christopher Mee and Josette Renard (eds.), *Cooking Up the Past: Food and Culinary Practices in the Neolithic and Bronze Age Aegean*, Oxford, pp. 174–199.

Tomkins, Peter (2012)
"Behind the Horizon: Reconsidering the Genesis and Function of the 'First Palace' at Knossos (Final Neolithic IV-Middle Minoan IB)", in: Ilse Schoep, Peter Tomkins, and Jan Driessen (eds.), *Back to the Beginning. Reassessing Social and Political Complexity on Crete during the Early and Middle Bronze Age*, Oxford, Oakville, pp. 32–80.

Tomkins, Peter (forthcoming)
"Landscapes of Identity, Ritual and Memory: Reconsidering the Use of Caves on Crete during the Neolithic and Early Bronze Age", in: Moyes Holley (ed.), *Journeys into the Dark Zone*, Colorado.

Treuil, René (1996)
"De la cigale à la fourmi: les origines des magasins à vivres dans le monde égéen", in: *Topoi 6*, pp. 71–83.

Treuil, René (1999)
"Les 'Maisons Dessenne' à Malia", in: Philip P. Betancourt, Vassos Karagheorgis, Robert Laffineur, and Wolf-Dietrich Niemeier (eds.), *Meletemata. Studies in Aegean Archaeology Presented to Malcom H. Wiener as he Enters his 65th Birthday* (Aegaeum. Annales d'archéologie égéenne de l'Université de Liège et UT-PASP 20) Liège, Austin, pp. 841–845.

Tsipopoulou, Metaxia (1988)
"Αγία Φοτιά Σητείας: Το Νέο Εύρημα", in: Elizabeth B. French, and Diane E. H. Wardle (eds.), *Problems in Greek Prehistory. Papers Presented at the Centenary Conference of the British School of Archaeology at Athens, Manchester April 1986*, Bristol, pp. 31–47.

Tsipopoulou, Metaxia (1992)
"Ayia Photia", in: Wilson J. Myers, Eleanor E. Myers, and Gerald Cadogan (eds.), *The Aerial Atlas of Ancient Crete*, Berkeley, Los Angeles: pp. 66–69.

Tuner, Alan (2001)
"Depthmap. A Program to Perform Visibility Graph Analysis", in: John Peponis, Jean Wineman, and Sonit Bafna (eds.), *Proceedings of the 3rd International Symposium on Space Syntax*, Atlanta, 31.1–31.9.

Turner, Alan (2004)
Depthmap 4 – A Researcher's Handbook, London. (http://discovery.ucl.ac.uk/2651/)

Van der Leeuw, Sander E. (2008)
"Agency, Networks, Past and Future", in: Carl Knappett and Lambros Malafouris (eds.), *Material Agency. Towards a Non-Anthropocentric Approach*, New York, pp. 217–247.

Van Effenterre, Henry (1980)
Le palais de Mallia et la cité minoenne. Étude de synthèse, Rome.

Warren, Peter (1972)
Myrtos. An Early Bronze Age Settlement in Crete (Annual of the British School at Athens Supplementary Volume 7), London.

Whitelaw, Todd M. (1983)
"The Settlement at Fournou Korifi, Myrtos and Aspects of Early Minoan Social Organization", in: Olga Krzyszkowska and Lucy Nixon (eds.), *Minoan Society. Proceedings of the Cambridge Colloquium 1981*, Bristol, pp. 323–345.

Eleftheria Paliou

Visibility analysis in 3D built spaces:
a new dimension to the understanding of social space

Abstract

The existence of a close link between visibility in built space and social life has repeatedly been acknowledged by social theories and has concerned a great number of studies on modern and past built environments. Archaeologists aiming to explore this relationship in a formal way have traditionally been employing one- or two-dimensional visibility analysis techniques using ground plans or sections of the spaces under examination. While these methods have considerably enriched archaeological interpretive schemes, this chapter discusses a number of cases (Roman, Mesoamerican, Aegean Late Bronze Age, and Byzantine urban spaces), where social aspects of visibility in built settings can be better understood with reference to a three-dimensional environment. It then describes briefly two applications of the recently proposed computational methods of visibility analysis in three-dimensional digital spaces, and argues that these methodologies have the potential to contribute new approaches to the examination of built environments.

1 Introduction

Visibility is a very popular concept within those bodies of theory that seek to link social relations and human action in urban space to the materiality of the built environment, such as environment-behaviour theory (Rapoport 1990), space syntax (Hillier and Hanson 1984), and reception theory (Lynch 1960). These conceptual approaches, which have been recently classed together under the term "empirical urban theory" (Smith 2011), have appealed to some archaeologists, as they are associated with notions that have identifiable manifestations in the archaeological record, and are susceptible to a formal examination via spatial analysis. In recent years many works have drawn on empirical urban theories to interpret past built spaces using various two-dimensional visual analysis techniques, which rely upon the construction of lines of sight on building plans and sections. The role of these methods in the proposed interpretative schemes is often considered essential, nonetheless, it is frequently acknowledged that two-dimensional analyses describe inadequately the visual properties of three-dimensional space (Moore 1996, p. 227; Fisher 2009, p. 451). The implications of this fact are fairly obvious: since people in the past engaged with three-dimensional architectural environments, certain social meanings encoded in built settings will remain undetected when space is being studied in two dimensions.

This chapter aims to discuss some of the cases where relationships between visibility and social life in past urban spaces can be better understood with reference to a three-dimensional environment. In this discussion special emphasis is given to theoretical concepts associated with Rapoport's Nonverbal Communication approach and the application

of more recent space syntax methods, namely isovist and visibility graph analysis. The archaeological examples used to support the argument belong to very different cultural contexts: Roman, Mesoamerican, and Aegean Late Bronze Age urban spaces, as well as Late Antique churches. Finally, this paper briefly describes two applications of the recently proposed computational methods of visibility analysis in three-dimensional spaces and argues that these methodologies have the potential to contribute new approaches to the examination of built environments, enhancing the interpretive schemes used in archaeological social analysis.

2 The visibility of built forms

2.1 Environment-behaviour theory and the Nonverbal Communication approach

The relationship between space and social life has concerned a large theoretical corpus that has significantly influenced archaeological investigations over the years. Among these works environment/behaviour theory, and especially Rapoport's Nonverbal Communication approach, proves particularly useful for the interpretation of archaeological remains (Michailidou 2001; Fisher 2009; Fisher, this volume; Thaler 2009), not least because it seeks to infer social meanings embodied in built space in a way that is "relatively direct and simple" (Rapoport 1990, p. 10). The Nonverbal Communication approach argues that urban spaces communicate a variety of latent messages by providing cues, visual, olfactory, and acoustic (Rapoport 1990, p. 106–107), which relate to identity, status, wealth and power, but also to expected behaviour, accessibility and other information that make human co-action possible (Rapoport 1990, p. 221). Within this conceptual framework the role of visual cues is especially stressed and their symbolic function is witnessed in numerous different ways: in the shape, size, scale, colour and materials of built structures, and in spatial relationships, e.g. prominence, centrality versus periphery, exposed versus hidden (Rapoport 1990, p. 107). For instance, a built structure of special significance (a public ritual space, a monument, an elite building) could be easily identified within its architectural context because of its larger size, its central, exposed or prominent location, and its distinct architectural features (construction materials used, decorative elements, distinctive architectural forms and furnishings). Social actors can read, interpret and associate these characteristics with particular uses of space and expected modes of social behaviour, while frequently they consciously manipulate the appearance of built environments to promote their interests. Although Rapoport (1990) refers mainly to modern built spaces, the notion that social meanings are communicated via visual cues such as those described above has always been accepted by archaeologists.

Whilst in prehistoric environments the existence of a close link between visibility in built space and social life is merely being assumed or inferred from an incomplete archae-

ological record, in historical cityscapes, such as that of ancient Rome, this relationship is clearly evidenced in surviving written sources. For example, Wallace-Hadrill (1988, p. 46), in a paper discussing social aspects of Roman houses, mentions two characteristic passages which suggest that visual access from public spaces to a private residence, successively occupied by Livius Drusus (*tribune* of the *plebeians* in 91 BC) and Cicero, was not only desirable, but also requested and planned:

> A public figure went home not so much to shield himself from the public gaze, as to present himself to it in the best light. Two passages may illustrate Roman sensibilities on this point. One records an exchange between Livius Drusus, tribunus plebis in 91, and the architect in charge of building his house on the slope of the Palatine overlooking the forum: when the architect promised him to make it "completely private and free from being overlooked by anyone", Livius replied, "No, you should apply your skills to arranging my house so that whatever I do should be visible to everybody." (Vell. Pat. Ii. 14.3). ... his successor in the same property, Cicero, felt no differently: "My house stands in full view of virtually the whole city" (Wallace-Hadrill 1988, p. 46)

These quotes offer a valuable insight into some of the intentions that guided choices on the location, form and structure of buildings in ancient Rome. More importantly for the current discussion, they suggest that certain notions of "public" or "private" in the Roman cityscape could be better examined in three-dimensional space rather than with two-dimensional plans. In this case it would be important to know, for instance, whether and which parts of the façade, the back spaces or architectural decoration of a building (e.g. painted and relief decoration) could be seen from public areas of the Roman city. Furthermore, one might like to know which buildings are more visible from certain parts of the cityscape or which structures can be seen with more ease in a given built district.

Similarly, in the case of Mayan architecture human experience in 3D space is considered crucial for understanding socio-symbolic aspects of built space that may have shaped human movement and action in the past. Hohmann-Vogrin (2005, p. 287) observes that the use of a ground plan alone is insufficient for appreciating experience in Mayan sites, where movement was apparently guided by the altitude of monumental structures that could be seen from a distance. Moreover, she argues that visual and physical access in these spaces would have implicitly expressed important social symbolisms:

> Maya sites are like landscapes, resembling mountains, hills, valleys and planes. Open spaces are constituted by plazas, courtyards, terraces and platforms on different levels, while interior space is relatively limited. In some cases access to higher levels was obviously restricted ... Step by step, terraces and platforms become smaller. Sights and views are determined by the altitude of the respective terrace or platform. On the lowest level, the view is limited by walls and platforms taller than the viewer, at least in the smaller courtyards. The field of vision is widened by access to higher levels. On the highest level – presumably never reached by the average person – the view becomes unlimited, so to

speak. Here, social hierarchy is demonstrated literally. This is both functional and symbolic. (Hohmann-Vogrin 2005, p. 285)

In recent years advances in the discipline of urban studies and the increasing availability of computing power have enabled the development of computational analysis methods which aim to quantify aspects of visual experience in built environments. Such approaches seek to permit the comparative investigation of urban configurations, and to examine the social dimensions of their transformation through space and time. Established visual analysis methods, such as axial[1], isovist or visibility graph analysis (Bintliff, Fisher, Hacıgüzeller and Thaler, Hillier, Letesson, Stöger: cf. this volume), cannot be used, however, for the investigation of visibility in 3D cityscapes. These one- and two-dimensional techniques aim to define the visible space between walls that offers possibilities for movement, and were created to underpin different theoretical and empirical considerations than those described above. Thus, they do not take into account the three-dimensional topography of a cityscape or the vertical dimensions of built structures. On the other hand, archaeologists in the past have attempted to develop methods that are more suitable for examining human visual experience in 3D space. For instance, in his analytical approach to Andean architecture Moore (1996) places great emphasis on the vertical dimension of monumental buildings. In order to investigate the visual impact of public built structures he introduced methods of analysis that aimed to quantify the impression of "monumentality" induced to a viewer from different viewpoints[2]; he created isovistas, namely contour maps that define locations in space at which the visual impact of a monument as seen from selected angles of view changes significantly (fig. 1). For the creation of these maps only the highest point of the target structure is taken into account. Moore (1996, p. 227–228) admits that, although sufficient for his analysis, his measures are crude, and suggests that the application of computer-assisted design and Geographic Information Systems (GIS)[3] could offer fuller reconstructions of architectural spaces and potentially more subtle recognitions of constructed patterns. The recent development of fully three-dimensional visual analysis techniques reflects similar considerations.

1 In many recent space syntax studies axial lines are referred to as "lines-of-sight" (Turner 2003, p. 661).
2 These methods were later used by Letesson and Vansteenhuyse (2006) in the context of Minoan palatial architecture.
3 More recent versions of commercial GIS software (e.g. ArcGIS 10) provide the tools for some basic forms of visibility analysis on building facades, such as line of sight calculations. This analysis can determine whether a line of sight will be obstructed by a building or not. However, more sophisticated types of visibility analysis, e.g. viewshed calculations that can determine how much of a façade could be visible from a given location, cannot currently be performed with commercial GIS software.

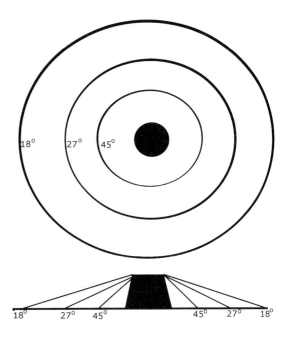

Figure 1 | Example of unobstructed isovistas that mark three different visual thresholds, e.g. those locations where the monument occupies 18, 27, and 45 degrees above the horizontal line of vision (based on Moore 1996, figure 3.7).

2.2 Computational approaches to visibility analysis in 3D spaces: The visibility of Theran murals in the townscape of Late Bronze Age Akrotiri

Visibility analysis in fully 3D spaces[4] (Earl 2005; Paliou and Wheatley 2007; Paliou et al. 2011; Paliou 2011; Paliou and Knight, in press; Papadopoulos and Earl, this volume; Earl et al., forthcoming) has been applied in archaeological studies with the aim of permitting the quantitative description of views perceived in visually complex 3D environments by a human observer on the ground. By coupling common 3D modelling and GIS functionalities, this approach manages to quantify visual access to vertical built features (e.g. facades, masonry, mural painting) in architecturally intricate built contexts, such as those often encountered in real world environments. In this respect it is especially well-suited for the formal examination of concepts associated with Rapoport's Nonverbal Communication approach, and conforms well to the line of enquiry outlined above. It has to be noted that in many situations estimating in a formal way the communicative potential of 3D built features can be fairly straightforward. Fisher (2009, p. 445; this volume), for example, has argued that ashlar masonry in Late Bronze Age Cyprus formed an integral part of the identities of the elite, and was strategically used in socio-politically or ideologically important

4 Fully 3D are those digital spaces with three independent x, y and z axes. These should be distinguished from digital models that, although they appear to be 3D, do not have an independent z axis, for example traditional digital elevation models (DEMs), where height is merely an attribute of a set of x, y coordinates (2.5 D models).

contexts. To demonstrate his point he quantifies the presence of ashlar masonry in LBA rooms by calculating their *ashlar elaboration scores*: he first divides the length of the wall(s) constructed of ashlar blocks by the total wall length of the room, and subsequently multiplies the outcome by a value that defines the degree of elaboration for the observed type of ashlar masonry *(elaboration multiplier)*. Nonetheless, when it comes to exploring visual access to vertical built features within complex architectural contexts, the use of more sophisticated spatial representations and analytical processes is necessary.

One of the first applications of visibility analysis in 3D spaces aimed to explore aspects of the visual experience of Theran murals in the Late Bronze Age town of Akrotiri (Thera, Greece: Paliou 2009; Paliou 2011), which was buried by an immense volcanic eruption in prehistory. Akrotiri (fig. 2) is famous for the lavish wall decorations that embellished many of its public and domestic buildings. The Theran murals, like the site itself, are exceptionally well preserved, and are among the best studied finds of Aegean Bronze Age painting. Since their discovery the wall paintings of Akrotiri have fuelled intense debates regarding their uses and intended purposes, with some scholars maintaining that their themes suggest a primary religious/ritual function (e.g. Marinatos 1984; Morgan 1998), while others argue that they had a predominantly secular/social content (e.g. Schachermeyer 1978; Televantou 1994; Doumas 2005). Despite the difficulties involved in interpreting the exact themes of Theran murals, it is reasonably safe to assume that they were elite architectural features, since figurative wall painting in the Late Bronze Age Aegean is linked with palatial architecture and the most elaborate buildings discovered (Boulotis 1992; Chapin 2004; Gates 2004).

It has long been suggested that the unprecedented number of wall paintings found in Theran domestic spaces may have been associated to strategies of social competition among town dwellers who acquired wealth in a relatively short time, due to trade and seafaring activities (Doumas 1992, p. 29; Schachermeyr 1978; Boulotis 1992, p. 89). Nevertheless, most discussion on the visual consumption of wall paintings has concentrated on the practices (ritual, dining etc.) that took place in the decorated rooms (Michailidou 2001; Boulotis 2005; Chapin 2004), mainly during formal occasions, while the possible latent messages of the paintings in more mundane everyday situations have remained less well studied. For instance, it has been suggested that in Akrotiri wall paintings adorning first floor rooms in domestic buildings could have been visible to a passer-by outside the buildings through the open windows (Doumas 2005). If this was true, murals could have been used to mark the houses of those having or aspiring to a high social position and would have communicated messages of status not just to the few people allowed into these rooms on certain formal occasions, but to any individual traversing the prehistoric settlement in the course of everyday life. The possibility to see the paintings also from outside the buildings would perhaps explain why mural decoration was so abundant in Akrotiri. However, appreciating how murals decorating first floor rooms may have been received by those crossing the public open spaces presents a number of challenges: the wall paintings used to

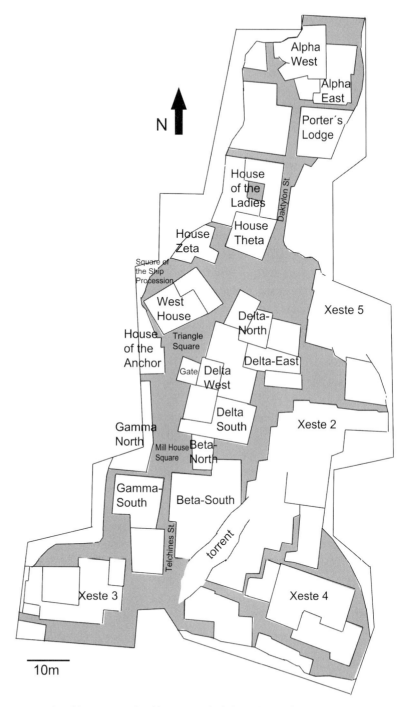

Figure 2 | Building units and public spaces (shaded) at Akrotiri (based on Palyvou 2005, fig. 27).

decorate walls that have nowadays collapsed and could have only been partially seen through wooden window frames, which have disintegrated, as suggested by imprints left in the thin volcanic ash (Palyvou 1999, p. 406–407).

Computational visibility analysis was employed in this case to formally assess the communicative potential of wall paintings in the townscape of Akrotiri. Room B1 of Beta South, Room 5 of the West House, and the first-floor room above the Gate at Delta West (fig.2) were chosen as case studies, since these spaces could be reconstructed with a relatively high degree of certainty and were distinguished by typical features of Theran architecture, (e.g. large horizontal windows, pier-and-window partitions, painted friezes). The procedure of analysis, which has been described in detail elsewhere (Paliou 2009; Paliou et al. 2011), required as a first step the creation of 3D digital reconstructions[5] (fig. 3) of the spaces under study using information provided by the building remains, the excavation process (imprints of wooden window frames and lattices in the volcanic ash) and the restored wall paintings, which indicated the dimensions of collapsed walls. Then the visible area of each painted surface from a large number of defined viewpoints was recorded in the virtual environment, using point-source illumination; this method permits the easy extraction, further analysis and remapping of visual data derived from a 3D model. Such an approach is based on the analogue production of isovist in a digital environment by illuminating a 3D model with a single light source that emits light in all directions (cf. also Benedikt 1979); in this case, illuminated and non-illuminated areas of the model correspond to visible and non-visible surfaces as seen from the location of the light source respectively (Paliou et al. 2011).

Viewer locations at the public open spaces outside the reconstructed buildings were identified by sampling space at equal intervals (20 cm by 20 cm) using a grid (fig. 4). Subsequently, a simple script was used to animate the light source over each one of the observer locations in succession at the eye level of a standing observer (1.55 m). Information on the illumination (visibility) of painted surfaces for each viewing location was then extracted in a raster format (fig. 5), to be further analysed and mapped in a GIS[6] environment using a series of scripts and batch processes (Paliou et al. 2011). This procedure produced maps which showed the amount of the visible area of a targeted painted wall that could potentially be seen from each viewing location (fig. 6). One basic benefit of this method of analysis is that by constraining the light rays within certain angular ranges it can also establish how much of the painted surface could have been observed with relative ease (fig. 6 b, d, f). In this case the painted areas visible within an angular range of up to 25 degrees above eye level were also recorded, viz. the surfaces that could be seen with eye rotation and with no need for additional upward head movements (Higuchi 1983,

5 All 3D models discussed in this paper were created with various versions of AutoCAD and 3Ds Max software.
6 GIS analysis was performed with ArcGIS.

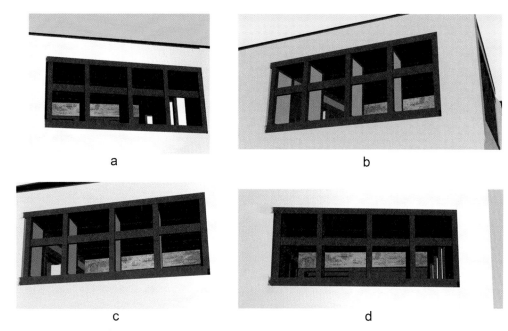

Figure 3 | 3D model of Room 5 (first floor) of the West House. a,b,c,d: Views from the public open space outside the building (Paliou 2011, fig. 3). Created by E. Paliou.

p. 40; Paliou 2011, fig. 6). Within this visual range the communicative potential of the paintings is relatively high, as pedestrians walking in a densely built and possibly populated environment are more likely to encounter the painted walls naturally and with ease, without making particular visual effort or interrupting their movement (Paliou 2011, p. 254).

By applying the above analytical methods, changes in the visual experience of someone moving through the public spaces of the settlement were systematically recorded and analysed, and important spatial relationships, which were not immediately perceivable simply by walking through the digital reconstruction, became apparent. An important conclusion was that a large number of the paintings could have been exposed to the viewer from many locations outside the buildings. The precise themes would not have always been intelligible.[7] Nonetheless, the mere awareness of lavish wall decoration would have been enough to convey latent social messages of status and power to those encountering the paintings,

7 The intelligibility of the themes would have also been affected by lighting conditions, the colour of painted elements and the distance of the paintings to the observer. Although lighting conditions in the Theran houses are hard to reproduce with scientific accuracy (Paliou 2009, p. 87), it makes sense to suggest that rooms with a small area (approx. 4 × 4 m) and large or multiple windows piercing the greater part of their outer walls would have been fairly well illuminated for most part of the day (cf. Doumas 2005).

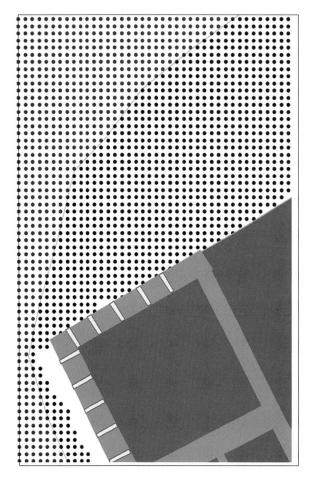

Figure 4 | The grid of viewpoints at the open public space outside the West House (Paliou 2011, fig. 5a).

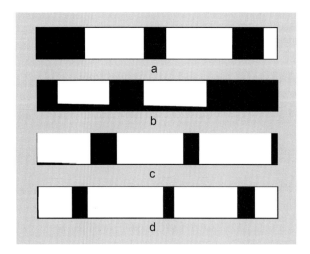

a

b

c

d

Figure 5 | Textures (viewsheds) of the south frieze of the Miniature Fresco (Room 5, West House) with information on the visibility of the painted wall surface for four different viewpoints (white/visible-black/non-visible): a, b, c, d correspond to fig. 3a, 3b, 3c, 3d respectively (Paliou 2011, fig. 4).

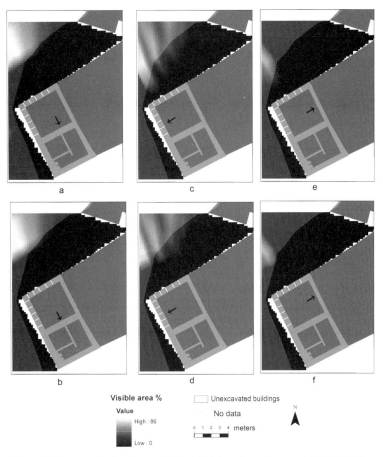

Figure 6 | Changes in visual access to the Miniature fresco from outside the West House (Paliou 2011, fig. 9) – a, b: The visible area of the south frieze from the square without (a) and with angular restrictions (b). c, d: The visible area of the west frieze from the square without (c) and with angular restrictions (d). e, f: The visible area of the east frieze from the square without (e) and with angular restrictions (f). The arrow points to the position of the fresco under study.

and on some occasions to trigger memories of the social events that took place in the decorated rooms. Furthermore, the systematic visibility recording and mapping for virtually all locations outside the buildings highlighted certain necessary and less obvious spatial conditions permitting the visibility of the wall paintings from the street network. The results showed that pedestrians would have to be located in most cases at least three and sometimes four metres away from the walls of a building embellished with murals to be able to observe the painted surfaces. Since main roads in Akrotiri are usually up to 2 m. wide, this suggested that the visibility of wall decoration from public open spaces was possible to a great extent due to the existence of the so-called squares (fig. 2), the relatively wide open-

ings in the street network. Such spaces distinguish this Cycladic town from other more densely built contemporary Aegean urban settlements (Palyvou 2005, p. 29); visual access to first floor rooms in towns that lacked similar openings would have been impossible or rare. In this respect one could argue that it was the particular urban layout of Akrotiri that permitted the visibility of mural decoration from outside the buildings, enhancing in this way the communicative potential of the murals. Hence, the spatial configuration of the prehistoric settlement might have encouraged the surprisingly wide production of wall decoration, as much as social conditions (Paliou 2011).

The case study of Akrotiri is perhaps characteristic of the problems associated with exploring communicative aspects of built features in architecturally complex spaces, and how these may be solved using methods of visibility analysis in fully 3D digital environments. A similar approach could prove beneficial in other cases, viz. for examining the visual impact of built features in Roman or Mesoamerican societies, providing that the suggested methods and interpretive schemes are employed in a context-specific way. The remainder of this paper argues for the benefits of using three-dimensional visibility analysis within theoretical frameworks that place primary emphasis on the social significance of the open space delineated by walls and buildings. The focus will be upon isovist and visibility graph analysis, two techniques that were added to the set of Space Syntax methods almost a decade ago with the aim of identifying patterns of co-presence in the built environment, and of investigating the ways in which spatial configuration encourages movement, social encounters and interaction.

3 The visibility of space between walls

3.1 Space syntax methods: isovist and visibility graph analysis

Isovist analysis was introduced in the field of urban studies in 1979 by Benedikt, who originally defined *the isovist* as the set of all points visible from a vantage point in space, namely as a three-dimensional entity (Benedikt 1979, p. 49). Benedikt (1979; see also Benedikt and Burnham 1985) argued that certain isovist measures, such as area, perimeter, occlusivity, variance, skewness and circularity, influence the formation of human spatial perceptions and behaviours related to the concepts of privacy, surveillance, prominence, visual access and exposure. He therefore proposed ways of calculating, mapping and analysing these isovist qualities. In his analysis he considered for the sake of simplicity the isovist as a horizontal two-dimensional plane at the eye level of the observer (Benedikt 1979, p. 52). More recently, Turner et al. (2001) drew on the theoretical framework developed by Benedikt, as well as on social theories of networks, such as those proposed by Hillier and Hanson (1984) and Watts and Strogatz (1998), to analyse the spatial configuration of built spaces using visibility graphs (Hillier, this volume).

The applications of isovist and Visibility Graph Analysis in archaeology are underlain by the notion that human perception and communication in built spaces often reflect important aspects of social organization and cultural behaviour (cf. Taft 1998; Moore 1996; Clark 2007). One of the few works that discuss the use of these methods in ecclesiastical space was carried out by Clark (2007), who, following the work of Franz and Wiener (2005), used isovist measures to study the spatial configuration of Byzantine churches in Jordan. Clark considered *isovist spaciousness* (area), *openness* (isovist perimeter2/area) and *complexity* (area/isovist perimeter2) calculated from the altar, the assembly, the ambo and from the seat of the presiding cleric for six distinct church types (Clark 2007). He then performed Visibility Graph Analysis for the same spaces and compared the various levels of visual integration that possibly signify changes in liturgical rites and the relationships between the assembly and the clergy over time (Clark 2007, p. 102).

Clark's work is interesting because it draws attention to symbolic aspects of the spatial organization of congregations during liturgical rites. His analytical approach would appear insufficient, however, if it was to be used for studying certain common types of Byzantine ecclesiastical space. For instance, in some Late Antique churches a part of the congregation would have been situated in second storey galleries, known as *gynaecium* or *matroneum*, and hence would have observed the unfolding ritual events from above. According to written sources referring mainly to Constantinopolitan liturgical rites (Taft 1998), these spaces would have been occupied by women. In fact the same sources suggest that as a rule male and female members of the congregation would have been allocated separate spaces during the liturgy: men would have been situated in the main nave area and perhaps in one of the side aisles, while women, in addition to the second storey galleries, would have occupied one or maybe both lateral spaces of the ground floor, when these were not used by men. Examining the differences in the visual perception of male and female participants could enlighten aspects of interaction among the members of the congregation during the liturgy and highlight certain cultural behaviours in the context of formal settings. Still, the visual experience of the female participants at the *matroneum*, who would have been looking down to observe the ritual activities on the ground floor, cannot be effectively explored with two-dimensional methods of analysis, since these only take into account a single horizontal slice of space at the eye level of the observer.

3.2 Visibility and co-presence during the liturgy in San Vitale, Ravenna

Three-dimensional visibility analysis offers new possibilities for exploring perceptual and social aspects in ecclesiastical space. The method was employed to investigate visual patterns in the still extant 6th century church of San Vitale in Ravenna (Paliou and Knight, in press). San Vitale is an octagonal domed church, with a main nave area and side ambulatory aisles on the ground floor as well as second storey galleries (fig. 7a). There are no sur-

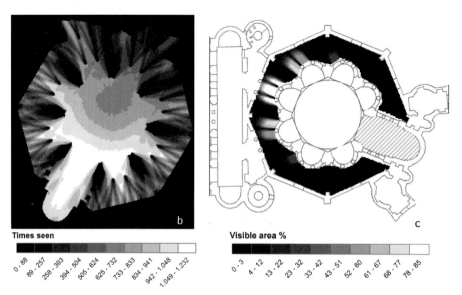

Figure 7 | a) A 3D model of San Vitale (created by I. Giannakopoulou, modified by E. Paliou, based on Deichmann 1989); the sampled area (10,270 viewpoints – sampling every 20 cm) at the *matroneum* is indicated in white. b) Times seen map of the ground floor from the *matroneum*. c) Visible area (%) of the chancel (hatched) from the *matroneum*.

viving written sources informing us about the spatial organization of the congregation in this church; nevertheless, the architectural similarities of San Vitale to contemporary Constantinopolitan churches suggest conceptual trade with the Byzantine capital (Grossmann 1973; Krautheimer 1986; Deichmann 1989; Knight 2010), and possibly a similar use of the second storey galleries as a place for women.[8] Within this context visual access from the galleries to the ground floor can be thoroughly examined in three-dimensional space, as demonstrated previously: first, by defining observer locations in the *matroneum* in equal

8 The spatial separation of male and female members in the Constantinopolitan congregations has been discussed in detail by Mainstone (1988) and Taft (1998).

intervals (one every 20 cm, fig. 7a), then recording the ground floor area that can be seen from each observer location, and finally analysing information incorporated in binary viewsheds[9] using a GIS. In this case, the final output of the analysis was "times seen" maps (fig. 7b), namely raster images composed by summing up binary viewsheds, which describe how many times different areas of the ground floor are sighted from the *matroneum*.

This process allowed quantitative comparisons of the visual experience of men and women in church space. The visual access to the liturgical foci from the ground floor was examined with visual connectivity maps created using Depthmap (fig. 8). These revealed that the chancel area, the main focus of attention during the liturgy, is visible on average from 12,623 locations on the ground floor.[10] On the other hand, the "times seen" map describing the visibility of the same area from the galleries showed that it can be visually accessed only from 1,026 locations on average (out of 10,270 viewpoints defined by a grid of 20 cm intervals: fig. 7a,b). This map also suggests the relatively restricted visual access from the galleries towards the main nave area, where men would have been located. Fig 7c shows that the locations in the galleries which can see a significant part of the area of the chancel (more than 20 %) are rather few (1,643 out of a total of 10,270). It follows then that female members of the congregation had somewhat limited visual access to the performance of the ritual compared with those situated on the ground floor. If women, in addition to the galleries, occupied the aisles flanking the nave (left or right), as applies to the sixth century liturgy at Constantinople (Taft 1998, p. 36–39), then they would still have been situated on the least visually integrated areas of the ground floor (as suggested by Visibility Graph analysis in fig. 9). Visual access from the nave area to these spaces (and vice versa) would have, therefore, been restricted.

On the other hand, it is also important to note that some locations in the *matroneum* would have offered special and literally transcendental views from above (Paliou and Knight, in press) (fig. 10). The few worshippers located in these areas would have perhaps the most advantageous visual access during the service, as they would have been able to observe clearly both the unfolding events on the ground floor, and a large number of congregation members in the nave area at the same time. Still, the locations in the galleries offering such views are limited (fig. 7c); the results of the analysis (fig. 7, 8, 9) mainly suggest restricted visual connectivity between the areas allocated to women and the chancel area, as well as the main nave area occupied by men. Such visual restrictions, which concern locations in church space designated for the female rather than the male participants, are imbued with symbolic meaning. If the liturgical rites in Ravenna are associated with similar social and religious behaviours as those documented for Constantinopolitan

9 Maps that show visible and non-visible areas (fig. 5, fig. 10).
10 The viewer locations on the ground floor were defined by a grid of 20 cm intervals.

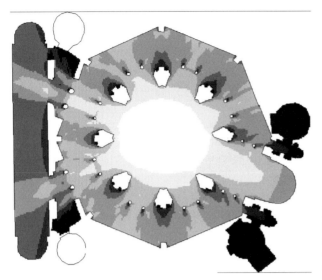

Figure 8 | Visual connectivity for the ground floor (grid spacing 20 cm; created with DepthMap). White: high visual connectivity (max. 18,479), black: low visual connectivity (min. 127).

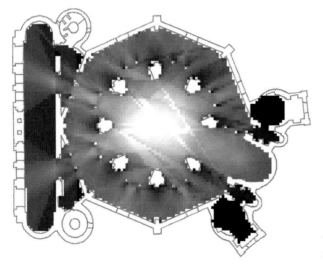

Figure 9 | Visual Integration (HH, white values-high/black-low) for the ground floor of San Vitale.

churches[11] in the 6th century (Taft 1998, p. 87), the separation of the sexes in church space in this particular way may suggest the ranking of women after men during the liturgy, and the intention to discourage communication between male and female congregation members, probably aiming to protect women from "inappropriate" and "dangerous" male behaviour (Taft 1998, p. 82–87; Paliou and Knight 2011, in press).

11 The degree to which similar social and religious behaviour characterizes the liturgical traditions of Ravenna and Constantinople in the 6th century is debatable due to the lack of sufficient textual evidence and, therefore, one should be cautious when making such an assumption.

Figure 10 | Visible area of the ground floor from the *matroneum* measured from a position opposite the chancel (white = visible, black = non-visible).

The analysis described above looked into only certain aspects of visual communication in San Vitale that were affected by the occlussive effects of architecture. In a similar way the visibility of other architectural features (e.g. relief decoration, mosaics, the altar etc) can be explored. It should be emphasised that the results of three-dimensional analytical approaches of this kind, as applies to landscape and two-dimensional architectural visibility analyses, suggest solely what could potentially be seen in space, as opposed to what one would actually see: visual access in the church during the liturgy may or may not have been further restricted by factors of more transient nature, such as the bodies of individuals that would have partaken in the liturgy, artificial or natural illumination, screens and curtains (Taft 1998, p. 49) etc. Nonetheless, the visual properties of architectural configuration were permanent and would have determined to a great extent visual experience during the ritual. The case-study of San Vitale aimed mainly to demonstrate that aspects of visual communication in three-dimensional space are quantifiable and potentially suggestive of social perceptions and behaviours.

4 Conclusions and discussion

Methods of visibility analysis in three-dimensional built environments are able to produce new types of spatial patterns that take into fuller account the geometric properties of architectural space and the physiology of the human visual system. This chapter provided some examples of how these new types of mapping can be interpreted within social theories that

lay emphasis upon symbolic aspects of visibility in space. The 3D methods described above can be used to analyse visual properties of the open space between walls, as well as visual characteristics of built forms. Environment-behaviour studies and Rapoport's Non-Verbal Communication approach, which seek to examine the ways in which messages of social status, identity and power are encoded and conveyed via visual cues, could benefit from such approaches; maps showing changes in the visibility of a target feature through space (fig. 6, fig. 7c) can help establish the likelihood that this object will be encountered by a mobile individual. Furthermore, such maps could facilitate a better understanding of how landmarks and prominent architectural features could have influenced human movement patterns in built space and vice versa. When attempting to tackle problems of this nature, however, one should always bear in mind that the intelligibility of objects in built environments depends on many factors: for example, the comprehensibility of the theme in a mural painting scene could be affected by lighting conditions (Paliou 2011; Papadopoulos and Earl, this volume), the colour of painted elements and their distance to the viewer. Such factors should be considered when trying to assess the communicative potential of architectural features.[12] Papadopoulos and Earl in this volume offer some good examples of how different aspects of visibility in the built environment can be approached with a combination of formal 3D visual analyses.

Furthermore, as was demonstrated by the case study of San Vitale, the 3D analytical methods proposed in this chapter can also be used to examine the visibility of space between walls that is associated with social interactions. Encounters and movement in formal settings, such as ritual spaces, follow a set of rules that reflect, produce and reproduce social relations and order (cf. also Hillier, this volume). As applies to some types of Byzantine ecclesiastical space, visibility relationships that trigger and shape human interactions cannot always be reduced to two dimensions. Maps such as those presented in Figure 7b are complementary to visual connectivity maps produced with Depthmap (fig. 8) and are expected to be useful additional tools for understanding visibility patterns in built environments. Moreover, it is also noteworthy that maps summarizing visual properties of space can be fused with audibility maps (Paliou and Knight, in press) and produce analytical products that suggest the blending of the senses as advocated by anthropological theorists (cf. also Wheatley, this volume).

Ultimately, a number of other concepts used in urban analysis could be examined and described in quantitative terms with the methods presented here. The notion of "monumentality" that is discussed by Moore (1996) in his work on Andean architecture could be associated with a more refined analytical process, which takes into account the precise form of buildings under study. Furthermore, certain notions of what Lynch has termed "imageability" (Lynch 1960), namely "that quality in a physical object which gives it a high probabil-

12 See footnote 7.

ity of evoking a strong image in any given observer" (Lynch 1960, p. 9), could be explored quantitatively by comparing, for example, the degree to which different building facades are exposed to an observer situated in a given built context.

It goes without saying that the visualisation of archaeological spaces in 3D is not always possible with the same degree of success or certainty: archaeological remains are often hard to interpret in 3D based on surviving evidence, and every attempt to reconstruct an archaeological environment has to cope with data quality issues. Still, in recent years archaeologists have systematically tried to address the problems involved in 3D reconstruction of past environments, and formal ways for dealing with uncertainty in these contexts have been proposed (Paliou 2009; Paliou et al. 2011; Earl et al., forthcoming); methods that have long been known in the field of GIS-based landscape analysis, such as probability or fuzzy mapping, have been employed to incorporate uncertainty in the results of 3D visibility analysis, and identify those occasions where interpretive statements can be made with greater confidence (Paliou et al. 2011). The further development of computational tools that acknowledge and seek to consider the special needs of archaeological data is a worthwhile direction of research that promises to offer new possibilities for the social analysis of past built environments.

Acknowledgements:I am very grateful to Topoi Excellence Cluster for funding the "Spatial analysis and social spaces" workshop and the publication of this volume, as well as to the co-organisers of the workshop, Undine Lieberwirth and Silvia Polla. Also many thanks go to David Knight for his advice on the case study of San Vitale and Gianna Yannakopoulou, who made available the San Vitale 3D model.

Bibliographical references

Benedikt, M. L. (1979)
"To Take Hold of Space: Isovists and Isovist Fields", in: *Environment and Planning B: Planning and Design* 6, pp. 47–65.

Benedikt, M., and Burnham, A. C. (1985)
"Perceiving Architectural Space: From Optic Arrays to Isovists", in: W. Warren, H. and E. R. Shaw (eds.), *Persistence and Change – Proceedings of the first International Conference on Event Perception*, Hillsdale, NJ, pp. 103–114.

Boulotis, C. (1992)
"Provlimata tis Aigaiakis zografikis kai oi toichografies tou Akrotiriou", in: Doumas, C. (ed.), *Akrotiri Thiras: Eikosi chronia erevnas (1967–1987). Simperasmata-Provlimata-Prooptikes*, Athens, pp. 81–93.

Boulotis, C. (2005)
"Aspects of Religious Expression at Akrotiri", in: *Periodical Publication of the Society for the Promotion of Studies on Prehistoric Thera* 3, pp. 20–75.

Chapin, A. P. (2004)
"Power, Privilege and Landscape in Minoan Art", in: A. Chapin (ed.), *Charis: Essays in Honor of Sara A. Immerwahr* [*Hesperia Supplement 33*], New Jersey, The American School of Classical Studies at Athens, pp. 47–64.

Clark, D. L. C. (2007)
"Viewing the Liturgy: A Space Syntax Study of Changing Visibility and Accessibility in the Development of the Byzantine Church in Jordan", in: *World Archaeology* 39, pp. 84–104.

Deichmann, F. W. (1989)
Ravenna, Haupstadt des spätantiken Abendlandes, vol. III. Stuttgart.

Doumas, C. (1992)
The Wall-paintings of Thera, Athens, The Thera Foundation.

Doumas, C. (2005)
"La Répartition Topographique des Fresques dans les Bâtiments d'Akrotiri à Théra", in: I. Bradfer-Burdet, B. Detournay, and R. Laffineur (eds.), *Kris Technitis: L' Artisan Crétois. Recueil d'articles en l' honneur de Jean-Claude Poursat, publié à l'occasion de 40 ans de la découverte du Quartier Mu*, Liège, pp. 73–81.

Earl, G. P. (2005)
"Texture Viewsheds: Spatial Summaries of Built Archaeological Spaces Derived from Global Light Mapping." in: *Proceedings of the 11th International Conference on Virtual Systems and Multimedia, October 2005*, Ghent, Belgium, pp. 303–312.

Earl, G., Porcelli, V., Papadopoulos, C., Beale, G., Harrison, M., Pagi, H., and Keay, S. (forthcoming)
"Formal and Informal Analysis of Rendered Space: The Basilica Portuense", in: A. Bevan and M. Lake (eds.), *Computational Approaches to Archaeological Spaces*.

Fisher, K. (2009)
"Placing Social Interaction: An Integrative Approach to Analyzing Past Built Environments", in: *Journal of Anthropological Archaeology* 28, pp. 439–457.

Franz, G., and Wiener, J. M. (2005)
"Exploring Isovist-Based Correlates of Spatial Behavior and Experience", in: A. Ness (ed.), *Proceedings of the 5th International Symposium on Space Syntax*, Delft, pp. 503–517.

Gates, C. (2004)
"The Adoption of Pictorial Imagery in Minoan Wall Painting: A Comparative Perspective", in: A. Chapin (ed.), *Charis: Essays in Honor of Sara A. Immerwahr* [*Hesperia Supplement 33*], New Jersey, The American School of Classical Studies at Athens, pp. 27–46.

Grossmann, P. (1973)
S. Michele in Africisco zu Ravenna, DAI Rom, Mainz a. Rhein.

Higuchi, T. (1983)
The Visual and Spatial Structure of Landscapes, Cambridge, MA.

Hillier, B., and Hanson, J. (1984)
The Social Logic of Space, Cambridge, UK.

Hohmann-Vogrin, A. (2005)
"Space Syntax in Maya Architecture.", in: A. Ness (ed.), *Proceedings of the 5th International Symposium on Space Syntax*, Delft, pp. 279–292.

Knight, D. J. (2010)
The Archaeoacoustics of San Vitale, Ravenna, University of Southampton, M. Phil thesis, available at http://eprints.soton.ac.uk/ (22 September 2012).

Krautheimer, R. (1986)
Early Christian and Byzantine Architecture, (revised by Curcic, S.), London.

Letesson, Q., and Vansteenhuyse, K. (2006)
"Towards an Archaeology of Perception: 'Looking' at the Minoan Palaces", in: *Journal of Mediterranean Archaeology* 19, pp. 91–119.

Lynch, K. (1960)
The Image of the City, Cambridge, MA.

Mainstone, R.J. (1988)
Hagia Sophia: Architecture, Structure and Liturgy of Justinian's Great Church, New York.

Marinatos, N. (1984)
Art and Religion in Thera: Reconstructing a Bronze Age Society, Athens.

Michailidou, A. (2001)
Akrotiri Thiras: I meleti ton orofon sta ktiria tou oikismou, Athens.

Moore, D., J. (1996)
Architecture and Power in the Ancient Andes – The Archaeology of Public Buildings, Cambridge, UK.

Morgan, L. (1988)
The Miniature Wall Paintings of Thera: A Study in Aegean Culture and Iconography, Cambridge, UK.

Paliou, E. (2009)
The Visual Consumption of Mural Painting in Late Bronze Age Akrotiri (Thera, Greece): A Computational Approach to Visibility Analysis in Three-Dimensional Built Environments, University of Southampton (PhD thesis, unpublished).

Paliou, E. (2011)
"The Communicative Potential of Theran Murals in Late Bronze Age Akrotiri: Applying Viewshed Analysis in 3D Townscapes", in: *Oxford Journal of Archaeology*, August 2011, pp. 30–33.

Paliou, E., and Knight D. J (in press)
"Mapping the Senses: Perceptual and Social Aspects of Late Antique Liturgy in San Vitale, Ravenna", in: F. Contreras and J. Melero (eds.), *Proceedings of CAA 2010, Computer Applications and Quantitative Methods in Archaeology, International Conference, Granada, 6–9 April 2010*.

Paliou, E., and Wheatley, D. (2007)
"Integrating Spatial Analysis and 3D Modelling Approaches to the Study of Visual Space: Late Bronze Age Akrotiri", in: A. Figueiredo and G. L. Velho (eds.), *The World is in Your Eyes – Proceedings of the XXXIIIrd Computer Applications in Archaeology Conference, 21–24 March 2005 (Tomar, Portugal)*, Tomar, pp. 307–312.

Paliou, E., Wheatley, D., and Earl, G. P. (2011)
"Three-Dimensional Visibility Analysis of Architectural Spaces: Iconography and Visibility of the Wall Paintings of Xeste 3 (Late Bronze Age Akrotiri)", in: *Journal of Archaeological Science* 38, 2, pp. 375–386.

Palyvou, C. (1999)
Akrotiri Thiras: I oikodomiki techni, Athens.

Palyvou, C. (2005)
Akrotiri Thera: An Architecture of Affluence 3,500 Years Old, Philadelphia, Pennsylvania.

Rapoport, A. (1990)
The Meaning of the Built Environment. A Nonverbal Communication Approach. With a New Epilogue by the Author, Tucson, Arizona.

Schachermeyr, F. (1978)
"Akrotiri: First Maritime Republic?", in: C. Doumas (ed.), *Thera and the Aegean World I. Papers Presented at the Second International Scientific Congress, Santorini, Greece, August 1978*, London, pp. 423–428.

Smith, M. (2011)
"Empirical Urban Theory for Archaeologists", in: *Journal of Archaeological Method and Theory*, 18 (3), pp. 167–192.

Taft, R. F. (1998)
"Women at Church in Byzantium: Where, When and Why", in: *Dumbarton Oaks Papers* 52, pp. 27–87.

Televantou, C. (1994)
Akrotiri Thiras: Oi toichografies tis Dytikis Oikias, Athens.

Thaler, U. (2009)
Architektur der Macht – Macht der Architektur: Mykenische Paläste als Dokument und Gestaltungsrahmen frühgeschichtlicher Sozialordnung, University of Heidelberg, PhD thesis (unpublished).

Turner, A., Doxa, M., O' Sullivan, D., Penn, A. (2001)
"From Isovists to Visibility Graphs: A Methodology for the Analysis of Architectural Space", in: *Environment and Planning B: Planning and Design* 28, pp. 103–121.

Turner, A. (2003)
"Analysing the Visual Dynamics of Spatial Morphology", in: *Environment and Planning B: Planning and Design* 30, pp. 657–676.

Wallace-Hadrill, A. (1988)
"The Social Structure of the Roman House", in: *Papers of the British School at Rome* 56, pp. 43–97.

Watts, D., J., and Strogatz, S. H. (1998)
"Collective Dynamics of 'Small-World' Networks", in: *Nature* 393, pp. 440–442.

Wheatley, D., and Gillings, M. (2002)
Spatial Technology and Archaeology: The Archaeological Applications of GIS, London.

David Wheatley

Connecting landscapes with built environments: visibility analysis, scale and the senses

This paper reviews some of the main theoretical critiques of spatial technological approaches to the past, particularly of visibility analysis. It considers the extent to which methodologies for both the built environment and for wider landscapes might either reject or respond to these issues, considering in particular (a) the claim that such work is based on a culturally-specific concept of space (the map) that is unlikely to have been shared by other cultures in the past and (b) the accusation that analysis of visual structure perpetuates a western bias towards vision over the other senses and 'privileges' the visual over other aspects of perception and bodily engagement. The paper concludes that, although much of this critique can be contested or moderated in various ways, we should accept that vision is not easily separable from other senses. To respond to this challenge, it is suggested that we should seek a framework to understand the link between space and all the senses while at the same time seeking to bring together the traditions of spatial analysis for landscape archaeology and the built environment. One possible way forward may be to combine the sensory/spatial framework used by proxemics for smaller scales with that defined by Higuchi for landscapes because they share some useful concepts. It is hoped that responding positively in this way to postprocessual critique may ultimately enrich formal methods of understanding ancient urban environments and landscapes.

1 Formal visibility analysis in archaeology

Archaeological studies of the built environment have long shared with landscape-scale studies an interest in the visual structure of space, although these two scales of analysis have generally followed parallel methodological developments: landscape studies have evolved paper-based methods into GIS-based 'viewshed' analysis, while studies of built environments have developed methods based on 'isovists' or axial graph analysis (Hillier, this volume). These traditions of research share a number of methodological and theoretical aspects, but interestingly, while landscape-scale work has increasingly evoked specific theoretical criticism, work on the built environment has largely avoided such issues. If the positive trend towards convergence between landscape-scale and urban-scale studies of visual structure is to continue, therefore, it may be useful to review some of the theoretical concerns that have been raised and to explore how both approaches might respond to them.

Spatial technologies are now well established in archaeological practice both for the management of archaeological remains and also as a platform for spatial analysis, while Geographic Information Systems (GIS) are now so established within archaeological practice that their use barely warrants specific mention. Their application to archaeology has been the subject of numerous papers and edited volumes (Westcott and Brandon 2000; Aldenderfer and Maschner 1996; Maschner 1996; Lock 2000; Lock and Stanèiè 1995; Gillings et al. 1999; García Sanjuan and Wheatley 2002; Grau Mira 2006; Johnson and North 1997) and at least three books (Wheatley and Gillings 2002; Connolly and Lake 2006; Chapman 2006). Initially seen as a tool with which to implement statistical models of site locations (Carr 1985; Kvamme 1983; Kvamme 1989) or to re-cast functional-processual approaches to space such as site catchment analysis (Hunt 1992; Gaffney and Stančič 1991), spatial computation has rapidly become the platform of choice for an array of inter-site spatial analyses and formal approaches to landscape archaeology.

In the last decade or so, advocates of spatial technological approaches to archaeological landscapes have attempted to broaden the theoretical basis of their work at the same time as expanding its methodological sophistication, and in doing so have drawn on a range of both processual and postprocessual theoretical ideas. As part of this, particular attention has focused on the analysis of the visual structure of archaeological landscapes (Gillings and Wheatley 2001; Wheatley and Gillings 2000). Llobera (1996; 1999), for example, has espoused an approach that draws on the ecological psychology of Gibson (1979) in the analysis of later prehistoric linear ditches in Wessex, and has subsequently broadened the conceptual basis of visibility analysis with the notion of the 'visualscape' (Llobera 2003), while Wheatley and Gillings (2000) have sought to re-situate visibility analysis as a human-centred methodology and incorporate aspects of the approach to landscape advocated by Higuchi (1988). Visibility analysis has now been used to analyse different aspects of many prehistoric landscapes, including the locations of 'cup and ring' petroglyph panels in the Kilmartin region of northwest Scotland (Gaffney et al. 1996), the ritual landscape around Stonehenge (Exon et al. 2000), the settings of passage graves, 'tertres tumulaire' and 'allées coudées' of Brittany (Roughley 2004), the locations of Hungarian tells (Trick 2004) and the distribution of Neolithic and Calcolithic tombs in the eastern Sierra Morena, Andalusia (García Sanjuan et al. 2006). Influenced by the phenomenological approach of Tilley (1994) and Thomas (1991; 1996; 1999), among others, it has also been deployed in parallel with non-computational methods, as in Cummings and Whittle's (2004) work on the landscape setting of megalithic monuments in Wales.

Computational analysis of visibility has a similarly long history in the analysis of the built environment, with methods based on 'isovists' (Batty 2001; Benedikt 1979) having clear parallels with 'viewshed' analysis, while line-of-sight analyses are a major component of approaches based on Space Syntax (Hillier and Hanson 1984; Hillier, this volume), where they are often referred to as Visibility Graph Analysis (Turner et al. 2001) and have been used to investigate past as well as contemporary spaces (Clark 2007; Stavroulaki and

Peponis 2005). These two traditions of visibility analysis within landscape archaeology and the built environment are perhaps now beginning to converge, as in the deployment of three-dimensional approaches to visibility that have been used to analyse the positioning and iconography of Theran frescoes (Paliou 2009; Paliou and Wheatley 2007; Paliou et al. 2011; Paliou, this volume; Papadopoulos and Earl, this volume), work which draws heavily on traditions of research both in architecture and landscape archaeology.

2 Critiques of spatial technological approaches

Perhaps as a result of its origins within functional-processual archaeology and the subsequent attempts to broaden the theoretical basis of the approach, the use of spatial technologies within landscape archaeology has attracted a more sustained attack from postprocessual or postmodern theorists within the discipline, with particular attention devoted to the development and use of formal methods for the analysis of visual structure in ancient landscapes. The nature of the critique that has been levelled against visibility analysis (and, more broadly, against the application of GIS to archaeology) is both complex and inhomogeneous, and it mirrors the wider schism that has emerged within archaeological theory over the last three decades between, on the one hand, scientific approaches to archaeological analysis (broadly processual, neo-processual or cognitivist) and on the other hand a range of theoretical positions generally referred to as 'postprocessual', which include post-structuralism, phenomenology, feminism and postmodernism. The latter are clearly diverse and not always compatible with each other, but it is reasonable to continue to regard them as, in some sense, a single school of thought, as they generally share the aim of revising or refuting one or more of the basic tenets of enlightenment philosophy and Cartesian thought on which 'scientific' approaches are based (cf. for example Hodder 2001; Johnson 1999; Jones 2001; Trigger 1989).

Without becoming embroiled in a broader theoretical debate that is well beyond the scope of this volume (and is, anyway, rather less bipartisan than it was a decade or so ago), two aspects of the critique levelled at spatial visibility analysis may be worthy of a considered response because they ask interesting questions about how we might go about understanding the spatial configuration of cultural remains from the past. The first arises from a widespread postmodern concern with the contextual nature of human experience, from which perspective the map-like, geometric idea of space that underpins formal spatial analysis is argued to be problematic because it is a modern, western construct that we cannot assume is/was shared by other cultures at other times. The second critique (which emerges largely from a phenomenological perspective) holds that an understanding of human experience should begin with corporeal engagement with the world, and that formal methods of visibility that separate out vision as a separate field of analysis artificially 'privilege' the visual over other aspects of bodily engagement, notably the other senses.

3 The map as a culturally-specific 'way of seeing'

The first of these holds that computational approaches and formal spatial analyses are irredeemably built upon on an historically-specific concept of space – the map – which constitutes a specific way of 'looking at the world', one which is contested by, for example, phenomenological (e.g. Tilley 1994) and feminist (e.g. Gidlow 2000; Haraway 1991) theorists.

For Thomas, for example, "the distribution map, the air photo, the satellite image, the Geographic Information System, are all distinctively specular. They all present a picture of past landscapes which the inhabitant would hardly recognise" and spatial technologies "attempt to lay the world bare ... like a corpse under the pathologist's knife" (1993, p. 25). He has also argued that this feminises and objectifies the landscape and that this way of looking constitutes an example of 'the male gaze'. Relating the map perspective of spatial technologies to Haraway's (1991, p. 678) notion of a "god trick", he later claims that "such a sexualised way of looking is particularly troubling since we habitually make use of a series of spatial technologies (GIS, satellite imagery, air photography) which seek to lay bare and penetrate the land" (2001, p. 169).

It is, of course, debatable whether map-like spatial abstraction constitutes a specifically male way of imagining the world, as some feminist theorists have suggested, and even more questionable that it follows that 'scientific' spatial analysis should be regarded as some kind of landscape pornography (as Thomas appears to suggest). It is also not entirely clear that Haraway intended the 'god trick' quote to refer literally to maps in this way: the term actually emerges from a far wider discussion of situated knowledge and the limits of objectivity that is part of a much wider and more nuanced discourse on building a new kind of (feminist) science:

> Vision is the technological feast becomes unregulated gluttony; all perspective gives way to infinitely mobile vision, which no longer seems just mythically about the god-trick of seeing everything from nowhere, but to have put the myth into ordinary practice. And like the god-trick, this eye fucks the world to make techno-monsters. (Haraway 1991, p. 678)

Nevertheless, there is no doubt that the perspective of GIS (and maps and orthophotography) is a very particular spatial abstraction that is – as has been claimed – a way of imagining space as if looking down from above, although, contrary to Thomas' claim (following Cosgrove 1984) that this modern idea of landscape emerges with the adoption of linear perspective in art, it is an abstraction that eschews any representation of perspective. While accepting this, however, the assumption that inhabitants of past landscapes would "hardly recognise" a top-down, map-like representation of the world is contestable. There are actually many reasons to suspect that many non-western, non-modern cultures are and were capable of this kind of spatial abstraction, not least that maps themselves have a surprisingly long history (Harley and Woodward 1987). The capacity to represent space in this way is evident from Babylonian clay tablets, several of which far more clearly show map-like

Figure 1 | Two examples of 'map-like' thinking in very different cultures. Left shows a late Babylonian Clay tablet now in the British Museum BM92687 (Photo: The British Museum, used with permission), the right image shows the Hummingbird geoglyph, Nazca Peru, 400–650AD (Photograph: St-Amant made available under Creative Commons License v 3.0, Wikipedia – CC-BY-SA-3.0)

representations of geographic space. These include the late Babylonian 'map of the world' in the British Museum (BM92687) discussed by, for example, Horowitz (1998), which appears to present a mixture of Babylonian cosmology and geography as a map (fig. 1, left). Perhaps the clearest example of a Babylonian map is from Nuzi (near Kirkuk, Iran), dating to around 2400 BC. This appears to be a map of the region near Yorghan Tepe (ancient Ga-Sur), but regardless of its geographic attribution it is pretty unambiguously a map of a wide geographic area, bounded by ranges of hills and bisected by a river – possibly the Euphrates – which appears to flow into a delta, then into a lake or sea.

One widely cited candidate for the 'earliest map' was found by Mellaart (1967) at Çatalhüyük, and probably dates from around 6200 BC. It is a painted mural that has previously been interpreted as a plan of around 80 houses and which, if accepted as a map, would show that map-like thinking considerably pre-dated writing. Meece (2006), however, has recently convincingly contested its interpretation as a map and argued that true mapmaking arises only within highly organised, bureaucratic societies. While this may be true of a very formal kind of mapmaking, however, map-like thinking by societies without writing systems is in evidence in the archaeology of some landscapes themselves, perhaps most clearly in the geoglyphs of the Nasca plain, Peru, which include complex geometric figures and animal forms whose shapes cannot be appreciated from the ground (fig. 1, right). These are now generally interpreted as pathways and sacred spaces (Aveni 2000; Grün et al. 2003) but regardless of their specific interpretation, they again testify to an ability to imagine the world from above without the need to literally see it and also to a capacity to 'map out' figures and shapes using complex spatial abstraction that is akin to map-making.

There are good reasons, then, not to uncritically accept the assertion that non-western, non-modern cultures cannot or could not engage in this kind of spatial abstraction. There is also a grave danger that, in seeking to deconstruct specifically modern, western European, ways of thinking, we may end up denying other cultures abilities that we take for granted of ourselves. Ascribing this particular imaginative capacity to the Nasca people has in fact proved so difficult for some 'theorists' that they have found it necessary to ascribe the Nasca geoglyphs to visiting aliens (von Däniken 1998) rather than to acknowledge the sophisticated spatial abilities of native cultures, and it seems possible that the same error is repeated in Thomas' and others' critique, albeit with very different motives. An alternative view would be that the ability to think in a 'map-like' way is one of many cognitive abilities that all humans possess, although it may be expressed in different ways and to different degrees, depending on the environmental, historical and cultural context in which people live out their lives. This does not, of course, deny that cultural differences exist in the ways that this ability is deployed, or even that the way these abilities are deployed may emerge in historically specific contexts and therefore may work either to reinforce or to challenge certain ways of thinking (such as those described by feminist theorists).

Ultimately, however, the argument that the historically-situated nature of map-like thinking somehow invalidates formal spatial analysis and should cause us to move away from maps, plans, orthophotography and GIS is a specious one. Whether or not we adopt the (cognitivist) position that map-like thinking is an innate human ability or the (postmodernist) position that it is a historically-specific 'way of seeing', the spatial organisation of things within a map-like framework exists empirically and can be represented and measured in that way. Analysis of these empirical observations and regularities contributes to our understanding of spatial organisation and behaviour. Where patterns related to visibility and intervisibility occur, such as in communications networks, cities or ritual landscapes, we can document and quantify these regularities as 'visual structure', using graphical methods and statistics. 'Visual structure' is a useful concept because it separates the empirical documentation and quantification of such patterns and regularities from their meaning and interpretation. The question as to *why* a series of prehistoric tombs, for example, exhibit patterns of visibility or intervisibility is the ultimate purpose of this kind of research, but before we can begin to answer that question we need to show empirically *that* they exhibit a pattern, and perhaps explore how strong that pattern is. Spatial methods such as 'cumulative viewshed analysis' and 'visibility graph analysis' work because visual structure within landscapes and the built environment has emerged from patterns of human behaviour and meaningful human actions. Crucially, that pattern-formation occurs *whether or not* those people and communities share the same concept of space that contemporary cartography or GIS uses. To suggest that use of a contemporary spatial framework invalidates formal visibility analysis is therefore the equivalent of declaring that archaeological interpretations that draw on Frankfurt School philosophy are invalid because we have no evidence for Neolithic people reading English translations of Heidegger.

This critique does, however, have a more positive contribution to make in that it draws attention to the conventions that spatial analysis and GIS use, some of which have become so habitual that we can begin to consider them 'natural' rather than historically-specific. These range from obvious conventions such as the colours and line-styles used for features on maps through 'craft traditions' such as the colour palettes ascribed to elevation models and even to the basic conventions of maps (north is up and the geometry is represented as from above) that we rarely even consider to be conventions. There is a benefit in being forced to confront the culturally specific way we represent space because it reminds us that there are *other* ways we might choose to do so, and so facilitates the development of new conventions that may open the way to new ways of thinking. One of these new ways is facilitated by the widespread availability of computational methods to represent three dimensional or alternative spatial realities. This is sometimes eschewed as unnecessary, or dismissed as 'technological fetishism' (Huggett 2004) meaning that we do it just because we can, but this is to underestimate the significance of exploring new ways to represent spaces. Rigid abstractions of spaces such as we habitually use in maps, plans and GIS do guide the way that we think about space, and the ability to present results in other forms – which might include transformed spaces, three-dimensional perspective drawings, virtual and augmented realities – is therefore liberating and potentially transformative.

4 Visualism and archaeology of the senses

The second critique that has been levelled against spatial analysis of visual structure is that it artificially 'privileges' the visual over other senses, a position which is contrasted with 'archaeologies of the body' or of the senses (e.g. Hamilakis et al. 2002; Skeates 2010), whose goal is to write more holistic accounts of sensory engagements in the past. Frieman and Gillings, for example, claim that those developing visibility studies "have sought to capture and communicate the visual essence of a place or encounter" through ever more complex (view) 'sheds' so that "the shed is increasingly regarded as a valid proxy for perception and visibility a synonym for sensory engagement" (2007, p. 4–5). Taking the position that human perception can only be understood through corporeal engagement, they argue that vision is only one "sensory modality out of many ... from the variety and flow of sensory engagement that characterises the human sensorium" and that a more holistic approach is needed in which "having successfully extracted vision from the sensorium we need to rise to the challenge of putting it back" (2007, p. 5–6). They repeat Ingold's (2000, p. 281–285) argument that the practice of ordering sensory modalities does not help this goal and that "... the tendency to reify sight as the principal or dominant sense has also provoked comment, in particular accusations of the uncritical and often unthinking visualism".

To some extent, this critique is built on a 'straw man' because little (if any) of the work on visibility analysis makes the claim that it 'represents' or is a 'proxy for' human percep-

tion as a whole. Most visibility studies clearly understand visibility as only one component of perceptual experience, and they elect to analyse vision either because they find empirical evidence for visual structure within landscapes or the built environment, or because it is more amenable to formal analysis than other sensory modalities, which – at worst – leaves them open to accusations of reductionism or laziness. Nonetheless, it is not unreasonable to question the way in which computational approaches to the sensory structuring of built spaces and landscapes have been dominated by analysis of vision. It is undeniable that, with the exception of a few examples of research into the rôle of sound (such as Mlekuz 2004; Watson and Keating 1999) and occasional attempts to reproduce smells for tourist attractions (Dann and Jacobsen 2003), formal approaches to sensory experience have tended to analyse visual structure rather than auditory, haptic or olfactory patterns, or the ways in which these senses may interact (cf. Papadopoulos and Earl, this volume). It seems entirely plausible that the relative importance given to the visual as a 'dominant' sense is a culturally-specific tendency that has emerged within a particular historical context, and that the perceptual experiences of people in past communities may have been – as some ethnologies suggest – rather different.

Although it is certainly true, however, that "this tendency to elevate vision above all the other sensory modalities has come under sustained attack as part of a broader questioning of the Enlightenment project and its legacy, vision being strongly associated with objective science and Cartesian rationality" (Frieman and Gillings 2007, p. 7), it is also worth at least considering the possibility that the 'dominance' of vision is *not* just a historical way of thinking but perhaps – as has been argued above for map-like thinking – something that the human brain is inherently predisposed towards. Evidence that vision might be a 'dominant' sense (at least in some rather limited ways) can certainly be found in the way that the senses interact, and can be supported empirically by psychological studies. One familiar example is the 'ventriloquist effect' by which speech that is accompanied by a simultaneous visual stimulus from a different spatial location is perceived as coming from the position of the visual stimulus (Bertelson and Aschersleben 1998). In slightly different form, this is also evident in the McGurk effect (McGurk and MacDonald 1976), a robust perceptual effect in which subjects are simultaneously shown a video recording of one phoneme (such as 'ga') which has been dubbed over with the sound of a different phoneme (such as 'da'). Subjects consistently report that they perceive the phoneme indicated by the visual stimulus rather than the actual auditory stimulus, and that their auditory perception changes when the conflicting visual stimulus is introduced, suggesting that (at least in this context) the brain tends to 'resolve' conflicts between sound and vision by privileging the visual. Similar evidence also exists for perception that involves visual and haptic senses: experimental evidence suggests that when two objects of equal weight but different sizes are handled, the (visually) largest is usually also perceived to be the heaviest (Flanagan and Beltzner 2000), while Botvinick and Cohen (1998) have shown how subjects report 'feeling' sensations when they see a convincing model of their hand being touched.

While these examples suggest that visual stimuli are sometimes 'privileged' in sensory processing within the human brain, perhaps more interestingly they also show how the senses are not as separate as we might imagine. If we really wish to understand how the senses relate to one another, therefore, we might also give some consideration to *synaesthesia,* the condition by which stimulation of one sensory modality is perceived through another. Although research into synaesthesia has quite a long history (e.g. Galton 1880; Wheeler and Cutsforth 1922; Nielsen 1947), it is not until relatively recently that psychological and cognitive research has established that it has a neurological basis (Simner 2010). Methods such as fMRI (functional Magnetic Resonance Imaging) have shown how, in many synaesthetes, neuronal activity associated with one 'concurrent' sensual modality is activated by inputs from another 'inducer' modality, resulting in genuinely synaesthetic perception in the subject. This can take many forms, and is not restricted to single inducer → concurrent connections. Some of the better documented examples involve 'grapheme → colour' synaesthesia, in which numbers are perceived as particular colours and which may be caused by interaction ('cross wiring') in the fusiform gyrus between an area associated with grapheme processing and area V4 (Ramachandran and Hubbard 2001a; Brang et al. 2010a). Other well-documented examples relate to 'tone → colour' synaesthesia, in which subjects experience colours in response to different musical notes (cf., for example, Crisinel and Spence 2010; Brougher and Mattis 2005; Beaumont 2004). It may also be the case that synaesthesia – perhaps in less acute forms – is far more common than has been realised within human populations. Recent estimates suggest that around 1 in 23 people are synaesthetes (Simner et al. 2006), and some have even argued that all humans are born as synaesthetes but that most of us subsequently lose this experience (Cohen Kadosh et al. 2009; Simner et al. 2009). There is also some evidence that it is more prevalent in some sub-populations (notably artists, musicians and poets) than in the general population (Domino 1989), and some have speculated that there may be a connection between synaesthesia and the origins and structure of language (Ramachandran and Hubbard 2001b; Simner 2007). Of particular relevance in this context is recent work on 'space → time' synaesthesia, which suggests both that this variant is surprisingly common (perhaps more than 2.2 % of the population) and that it may be related in some way to a widespread human ability to learn mappings between arbitrary spatial forms (such as circles) and temporal sequences (Brang et al. 2010b).

So if we cannot even rigidly separate the senses at a neurological level, we can probably conclude that phenomenology and 'science' are in substantial agreement that the senses are more closely interrelated than has previously been accepted (Stein and Meredith 1993), even if there may be some grounds for suggesting that the basic cognitive makeup of human beings may sometimes tend to 'privilege' the visual over other senses. We should therefore acknowledge that the predominance of studies of visibility may indeed be problematic because – with some minor reservations – we cannot assume that humans are 'naturally' visual creatures or that vision is (at least in any simple way) the dominant sensory

modality. A more interesting line of investigation would therefore lead to the development of methods for exploring how the senses may be related to one another in the structuring of space.

5 Scale and the senses

If we largely reject the first accusation that formal spatial analysis is fundamentally flawed because of its use of a historically-situated notion of space, but accept that there is merit in the critique that undue weight has been given to vision to the detriment of a more holistic understanding of sensory engagement, then we need to consider how to begin to establish a theoretical framework that facilitates further development of formal analysis while also allowing us to accommodate a wider consideration of the sensory relationship between space and perception.

This is not simply a case of proposing more methods and case studies, or just broadening the scope of formal analysis to include the exploration of spatial patterns relating to the other senses instead of (or in addition to) vision. Although it may be methodologically challenging in some instances, methods do exist for working with sounds, smells and other sensory modalities. Rather, what is needed is a theoretical basis within which to think about spatial relationships between or merging of sensory modalities. Ideally, this framework should also be relevant both to the built environment and wider landscapes, so as to continue the process of bridging these two disciplinary traditions. To do this, it may be beneficial to refocus the debate onto how the senses operate together during corporeal engagement with the world to generate an experience of place, and how this might translate into spatial patterns in both the built environment and the wider landscape.

In the context of relatively small scales such as might be relevant to the organisation of rooms, households and urban settings, we might turn to what the anthropologist Edward T. Hall termed 'proxemics' (Hall 1966) and which he defined as "the study of how man unconsciously structures microspace – the distance between men in the conduct of daily transactions, the organization of space in the houses and buildings, and ultimately the layout of towns". Establishing the now classic definitions of 'intimate', 'personal', 'social' and 'public' spaces, defined as egocentric 'bubbles' around human subjects (cf. fig. 2), proxemics demonstrated how social interactions are regulated by social norms related to these zones, and posited the existence of culturally-moderated but innate distance-related behaviours in humans. Perhaps surprisingly, in view of its potential utility as a means of understanding the organisation of the built environment, Lawrence and Low were forced to conclude by 1990 that "proxemics research in anthropology has been limited" (1990, p. 478) and more generally that "in spite of occasional forays into psychological treatments of human interactions with the built environment, anthropological inquiries into perception and language have not been pursued by later researchers, nor has the development of proxemics

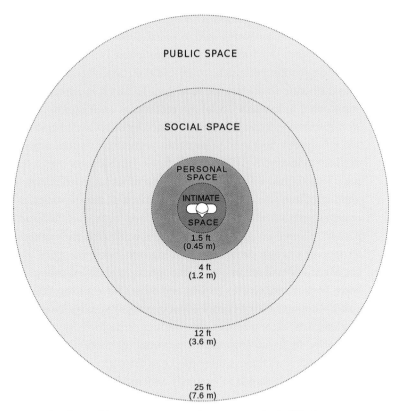

Figure 2 | Hall's (1966) proxemics spaces shown as 'reaction bubbles' (source: Wikimedia Commons).

research been fully explored" (1990, p. 481). With few exceptions (such as Moore 1996), there has been little subsequent attempt to develop proxemic methods within the context of archaeological landscapes or built environments, and postmodern critiques of 'scientific' approaches to the body have tended to follow more phenomenological – and less quantifiable – approaches, with critics such as Farnell arguing that "proxemic zones of space are empty of the dynamically embodied action that structures their meaning" (1999, p. 351).

If we accept, however, that formal approaches to sensory engagement with the senses are useful (because 'visual structure' can be empirically documented, so it is likely that other 'sensory spatial structure' may also be documented), then proxemics does appear to offer a useful basis for beginning to move beyond spatial methods that are based solely on vision. This is because it recognises the extent to which *spatial scale* largely controls which senses are implicated in different kinds of social interactions. To put this another way, different spatial scales tend to *afford* different sensory engagements that we can, admittedly rather crudely, characterise by the different balance of senses that are implicated in such interactions.

Proxemic methods allow us to recognise – and potentially model – the ways in which different senses are implicated in social interactions at different spatial scales. Social interactions within the 'intimate' space immediately surrounding a person are largely defined by the deployment of touch, smell and even taste (in *very* intimate interactions) and to some extent hearing in preference to vision. In fact it is common for vision to be intentionally suppressed in intimate social interactions by seeking low-light conditions or closing eyes. Non-intimate intrusions into this space by other social actors (such as greeting kisses, or grooming activities) tend to be tightly regulated by social norms, and unlicensed intrusion can lead to instinctively hostile reactions. Interactions within 'personal space' are characterised by a slightly different combination of visual (particularly 'reading' facial expressions, although these are subject to cultural variation), aural (particularly conversation) and haptic engagement that often takes quite ritualised forms such as handshakes. There is still a component of smell involved, which is often controlled with deodorants and perfumes in contemporary western contexts. Intruding into 'personal space' is, again, closely regulated by social and cultural norms, and although it generally extends around a metre or two from the body, Watson and Graves (1966) and others have shown that this distance also varies with cultural context so that failure of social actors to conform to each other's social expectations can lead to profound misunderstandings. From this, we might expect that spaces designed or evolved to favour intimate or personal interactions will show particular characteristics with respect to all these senses (perhaps through controlled levels of light, smell and so on), and it may be possible to quantify and model these aspects of the built environment in order to infer the likely uses or meanings of different configurations of space. 'Social space' is the zone within which interactions take place between the majority of social actors representing activities such as familial interactions and social negotiations with friends or strangers. Because of the increased distance, these interactions are largely dominated by aural (speech) and visual (gesture, posture and body language) sensory modalities with far less involvement of the other senses. The same applies to 'public' space, which characterises even larger-scale social interactions that often involve many social actors (performances, lectures and speeches, for example). Between them, these various proxemics zones account for distances from around a metre or so away from an individual to perhaps 10 m or so although, again, it is reasonable to expect these distances to vary with cultural and historical context.

Beyond this distance, however, proxemics begins to have less to offer. Social interactions over longer distances are – if we exclude technologies such as telephones – rare, and we must therefore consider the way in which other aspects of the world may be perceived by human actors. The 'sense of a place' clearly involves all the senses in a way that a proxemics model may assist with – the experience of being somewhere might incorporate, for example, the feel of the wind on a face, the smell of the soil, the sound of birdsong and the texture of the light. With increasing distance, however, our experience of a place becomes increasingly a function of sound and vision, and ultimately only vision before – at extreme

distances – we cease to have any sensory experience at all. It is here that the ideas of Higuchi (1988) may be most useful because they provide a framework within which to think about extending proxemics zones out into the wider landscape. This is easiest to explain by reference to the classification of zones within a wooded landscape (1988, p. 12–20), which Higuchi defines in terms of how the senses are implicated in their experience. Thus, he defines a 'short' zone within which each of the trees is recognisable as an individual entity, with leaves and branches. The sound of the rustling leaves and even the smell of the blossom or pollen may be involved in perception at this range, which he suggests extends to a distance equivalent to around 60 times the height of the dominant tree species. Beyond this range he defines a 'medium' zone, within which trees become textural units. The treetops are visible, but not details of individual trees. Significantly, only vision is implicated in the experience of this area of landscape, with mist and haze playing a part in how they are perceived. Beyond a distance equivalent to around 1100 times the height of the dominant species (but depending on the weather) is the 'long' distance landscape in which even the contours of the treetops are no longer perceived. It is possible to perceive (visually) that this part of the landscape is wooded, but not much more, and depth variation within the zone is no longer perceived, so that it can appear flat, like a painted background.

The strength of Higuchi's simple idea is that these landscape zones – like proxemic zones – are defined both by their relationship to the perceiver, the sensory interactions that are possible at different distances, but also by the relationship *between* perceiver and landscape. These are not abstract spaces which are devoid of cultural meaning or significance, but rather they are what Gibson (1977) would term 'affordances' – they relate solely neither to the subject nor to their environment but to the relationship between them. They therefore offer the possibility of methodological application because they can be modelled and so are amenable to the development of robust, formal methods, while they remain at the same time deeply relational and contextual. What Higuchi's zones afford, say, to the Japanese tradition of landscape design is different from what they afforded to eighteenth century English landscape architecture, just as differences in social norms between cultures mean that proxemic zones afford different social interactions in different cultural contexts.

6 Conclusions

This essay is not intended as a concrete proposal for new methods of investigation for either landscape archaeology or the built environment, or as a rallying call to one or other kind of theory. Rather, it is intended as a review of some relevant theoretical discussions about vision/senses/space with the hope that the discussion will firstly facilitate a considered response to the critique that has been levelled at formal visibility analysis, and secondly begin to develop a more coherent, shared understanding of space that might underpin the development of common approaches within the previously divergent disciplinary tradi-

tions of landscape archaeology and studies of the built environment. Some of the points raised as objections to the use of formal methods for visibility analysis – notably the post-modernist argument about 'map-like' understandings of space – can be rejected, while other aspects of the critique, particularly the accusation that the predominance of visibility-oriented studies has led us to systematically under-research other sensory modalities, should be broadly accepted and even welcomed.

As a response, it has been argued that we look to use the similarities between pro-xemics and Higuchi's notion of sensually-defined landscape zones, each of which was conceived for a different scale of analysis, in order to establish a more seamless understanding of the relationship between sensory engagement and space which has the potential to bridge the disciplinary divide between 'landscape' and 'built environment'. There are, of course, real differences between sensory engagement in the built environment and with wider landscapes: the first deals, in general, with scales of analysis similar to that of pro-xemics, so that new approaches and methods should perhaps show much greater consideration of other sensory modalities, particularly in thinking about how buildings, rooms and cities may be structured around complex combinations of senses. At the wider scale of landscape and regional studies, there seems a greater rationale for continuing to investigate vision as the main sensory modality which may structure and organise space in the past because – at least at scales of interaction above several kilometres – vision is the only form of sensory engagement afforded by the landscape at that scale. Of course, it should still be possible to integrate closer zones (such as Higuchi's 'near' landscape) in which other senses play a role, and to explore how – for example – the threshold between the 'hearing' zone and the 'seeing' zone may have been critical in setting out and organising settlements or ritual landscapes.

Bibliographical references

Aldenfelder, M., and Maschner, H. D. G. (eds.) (1996)
Anthropology, Space and Geographic Information Systems, New York.

Aveni, A. F. (2000)
Between the Lines: The Mystery of the Giant Ground Drawings of Ancient Nasca, Peru, Austin, Texas.

Batty, M. (2001)
"Exploring Isovist Fields: Space and Shape in Architectural and Urban Morphology", in: *Environment and Planning B: Planning and Design* 28, pp. 123–150.

Beaumont, C. M. (2004)
Musical Synaesthesia in Synaesthetes and Its Manifestation as a Wider Phenomenon [Online]. Sheffield.

Benedikt, M. L. (1979)
"To Take Hold of Space: Isovists and Isovist Fields", in: *Environment and Planning B: Planning and Design* 6, pp. 47–65.

Bertelson, P., and Aschersleben, G. (1998)
"Automatic Visual Bias of Perceived Auditory Location", in: *Psychonomic Bulletin and Review* 5, pp. 482–489.

Botvinick, M., and Cohen, J. (1998)
"Rubber Hands 'Feel' Touch that Eyes See", in: *Nature*, 756.

Brang, D., Hubbard, E. M., Coulson, S., Huang, M., and Ramachandran, V. S. (2010a)
"Magnetoencephalography Reveals Early Activation of V4 in Grapheme-Color Synesthesia", in: *NeuroImage* 53, pp. 268–274.

Brang, D., Teuscher, U., Ramachandran, V. S., and Coulson, S. (2010b)
"Temporal Sequences, Synesthetic Mappings, and Cultural Biases: The Geography of Time", in: *Consciousness and Cognition* 19, pp. 311–320.

Brougher, K., and Mattis, O. (2005)
Visual Music: Synaesthesia in Art and Music Since 1900, London.

Carr, C. (ed.) (1985)
For Concordance in Archaeological Analysis: Bridging Data Structure, Quantitative Technique, and Theory, Kansas City.

Chapman, H. (2006)
Landscape Archaeology and GIS, Stroud.

Clark, D. L. C. (2007)
"Viewing the Liturgy: A Space Syntax Study of Changing Visibility and Accessibility in the Development of the Byzantine Church in Jordan", in: *World Archaeology* 39, pp. 84–104.

Cohen Kadosh, R., Henik, A., and Walsh, V. (2009)
"Synaesthesia: Learned or Lost?" in: *Developmental Science* 12, pp. 484–491.

Connolly, J., and Lake, M. (2006)
Geographical Information Systems in Archaeology, Cambridge.

Cosgrove, D. (1984)
Social Formation and Symbolic Landscape, London.

Crisinel, A. S., and Spence, C. (2010)
"As Bitter As a Trombone: Synesthetic Correspondences in Nonsynesthetes Between Tastes/Flavors and Musical Notes", in: *Attention, Perception and Psychophysics* 72, pp. 1994–2002.

Cummings, V., and Whittle, A. W. R. (2004)
Places of Special Virtue: Megaliths in the Neolithic Landscapes of Wales, Oxford.

Dann, G. M. S., and Jacobson, J. K. S. (2003)
"Tourism Smellscapes", in: *Tourism Geographies* 5, pp. 3–25.

Domino, G. (1989)
"Synaesthesia and Creativity in Fine Arts Students: An Empirical Look", in: *Creativity Research Journal* 2, pp. 17–29.

Exon, S., Gaffney, C. F., Woodward, A., and Yorston, R. (2000)
Stonehenge Landscapes: Journeys Through Real-and-Imagined Worlds, Oxford.

Farnell, B. (1999)
"Moving Bodies, Acting Selves", in: *Annual Review of Anthropology* 28, pp. 341–373.

Flanagn, J. R., and Beltzner, M. A. (2000)
"Independence of Perceptual and Sensorimotor Predictions in the Size-Weight Iillusion", in: *Nature Neuroscience* 3, pp. 737–741.

Frieman, C., and Gillings, M. (2007)
"Seeing is Perceiving?", *World Archaeology* 39, pp. 4–16.

Gaffney, V., and Stančič, Z. (1991)
GIS Approaches to Regional Analysis: A Case Study of the Island of Hvar, Ljubljana.

Gaffney, V., Stančič, Z., and Watson, H. (1996)
"Moving from Catchments to Cognition: Tentative Steps Towards a Larger Archaeological Context for GIS." in: M. Aldenderfer and H. D. G. Maschner (eds.), *Anthropology, Space and Geographic Information Systems*, New York.

Galton, F. (1880)
Visualised Numerals, in: *Nature* 22, pp. 494–495.

García Sanjuan, L., Metcalfe-Wood, S., Rivera Jiménez, T., and Wheatley, D. (2006)
"Análisis de pautas de visibilidad en la distribución de monumentos megalítos de Sierra Morena occidental", in: I. Grau Mira (ed.) *La aplicación de los SIG en la arqueología del paisaje*, Alicante, pp. 181–200.

García Sanjuan, L., and Wheatley, D. (eds.) (2002)
Mapping the Future of the Past, Seville.

Gibson, J. J. (1977)
"The Theory of Affordances", in: *Perceiving, Acting and Knowing: Toward an Ecological Psychology*, pp. 67–82.

Gibson, J. J. (1979)
The Ecological Approach to Visual Perception, Boston.

Gidlow, J. (2000)
"Archaeological Computing and Disciplinary Theory", in: G. Lock and K. Brown (eds.), *On the Theory and Practice of Archaeological Computing*, Oxford, pp. 23–30.

Gillings, M., Mattingly, D., and Van Dalen, J. (eds.) (1999)
Geographic Information Systems and Landscape Archaeology, Oxford.

Gillings, M., and Wheatley, D. (2001)
"Seeing is Not Believing: Unresolved Issues in Archaeological Visibility Analysis", in: B. Slapsak (ed.), *On the Good Use of Geographic Information Systems in Archaeological Landscape Studies*, Brussels, pp. 25–36.

Grau Mira, I. (ed.) (2006)
La aplicación de los SIG en la arqueología del paisaje, Alicante.

Grün, A., Sauerbier, M., and Lambers, K. (2003)
"Visualisation and GIS-based Analysis of the Nasca Geoglyphs", in: M. A. S. Doerr (ed.), *The Digital Heritage of Archaeology – Proceedings of the 30th CAA Conference, Heraklion, Crete, April 2002*, Athens, pp. 161–167.

Hall, E. T. (1966)
The Hidden Dimension, Garden City, N.Y.

Hamilakis, Y., Pluciennik, M., and Tarlow, S. (2002)
Thinking Through the Body: Archaeologies of Corporeality, New York, London.

Haraway, D. J. (1991)
Simians, Cyborgs, and Women: The Reinvention of Nature, New York.

Harley, J. B., and Woodward, D. (1987)
The History of Cartography. Vol. 1: Cartography in Pre-Historic Ancient and Medieval Europe and the Mediterranean, Chicago, London.

Higuchi, T. (1988)
The Visual and Spatial Structure of Landscape, Massachusetts.

Hillier, B., and Hanson, J. (1984)
The Social Logic of Space, Cambridge, MA.

Hodder, I. (2001)
Archaeological Theory Today, Cambridge, MA.

Horowitz, W. (1998)
Mesopotamian Cosmic Geography, Winona Lake, Ind.

Huggett, J. (2004)
"Archaeology and the New Technological Fetishism", in: *Archeologia e Calcolatori* 15, pp. 81–92.

Hunt, E. D. (1992)
"Upgrading Site-Catchment Analyses With the Use of GIS: Investigating the Settlement Patterns of Horticulturalists", in: *World Archaeology* 24, pp. 283–309.

Ingold, T. (2000)
The Perception of the Environment: Essays in Livelihood, Dwelling and Skill, London.

Johnson, I., and North, M. (eds.) (1997)
Archaeological Applications of GIS: Proceedings of Colloquium II UISPP, XIIIth Congress, Forli, Italy, September 1996, Sydney.

Johnson, M. (1999)
Archaeological Theory: An Introduction, Oxford, UK.

Jones, A. (2001)
Archaeological Theory and Scientific Practice, Cambridge, MA.

Kvamme, K. L. (1983)
A Manual for Predictive Site Location Models: Examples from the Grand Junction District, Colorado, Colorado, Grand Junction District.

Kvamme, K. L. (1989)
"Geographical Information Systems in Regional Archaeological Research and Data Management", in: M. B. Schiffer (ed.), *Archaeological Method and Theory*, Tuscon, Arizona, pp. 139–203.

Lawrence, D. L., and Low, S. M. (1990)
"The Built Environment and Spatial Form", in: *Annual Review of Anthropology* 19, pp. 453–505.

Llobera, M. (1996)
"Exploring the Topography of Mind: GIS, Social Space and Archaeology", in: *Antiquity* 70, pp. 612–622.

Llobera, M. (1999)
Landscapes of Experiences in Stone: Notes on a Humanistic Use of a Geographic Information System (GIS) to Study Ancient Landscapes, Oxford.

Llobera, M. (2003)
"Extending GIS-based Visual Analysis: The Concept of Visualscapes", in: *International Journal of Geographical Information Science* 17, pp. 25–48.

Lock, G. R. (ed.) (2000)
Beyond the Map: Archaeology and Spatial Technologies, Amsterdam.

Lock, G. R., and Stančič, Z. (eds.) (1995)
Archaeology and Geographical Information Systems: A European Perspective, London.

Maschner, H. D. G. (ed.) (1996)
New Methods, Old Problems: Geographical Information Systems in Modern Archaeological Research, Carbondale, Ilinois.

McGurk, H., and MacDonald, J. (1976)
"Hearing Lips and Seeing Voices", in: *Nature* 264, pp. 746–748.

Meece, S. (2006)
"A Bird's Eye View – of a Leopard's Spots. The Çatalhöyük 'Map' and the Development of Cartographic Representation in Prehistory", in: *Anatolian Studies* 56, pp. 1–16.

Mellaart, J. (1967)
Çatal Hüyük: A Neolithic Town in Anatolia, London.

Mlekuz, D. (2004)
"Listening to Landscapes: Modelling Past Soundscapes in GIS", in: *Internet Archaeology* 16, http://intarch.ac.uk/journal/issue16/mlekuz_index.html (12 May 2012).

Moore, J. D. (1996)
"The Archaeology of Plazas and the Proxemics of Ritual: Three Andean Traditions", in: *American Anthropologist* 98, pp. 789–802.

Nielson, J. M. (1947)
"Sensory Perception Through Vision, a Synesthesia. Report of Case", in: *Bulletin of the Los Angeles Neurological Society* 12, p. 195.

Paliou, E. (2009)
The Visual Consumption of Mural Painting in Late Bronze Age Akrotiri (Thera, Greece): A Computational Approach to Visibility Analysis in Three-Dimensional Built Environments, Southampton (PhD thesis, unpublished).

Paliou, E., and Wheatley, D. (2007)
"Integrating Spatial Analysis and 3D Modelling Approaches to the Study of Visual Space: Late Bronze Age Akrotiri", in: *The World is in Your Eyes – Proceedings of the XXXIII Computer Applications in Archaeology Conference, 21–24 March 2005*, Tomar, Portugal, pp. 375–386.

Ramachandran, V. S., and Hubbard, E. M. (2001a)
"Psychophysical Investigations into the Neural Basis of Synaesthesia", in: *Proceedings. Biological Sciences / The Royal Society* 268, pp. 979–983.

Ramachandran, V. S., and Hubbard, E. M. (2001b)
"Synaesthesia –A Window into Perception, Thought and Language", in: *Journal of Consciousness Studies* 8, pp. 3–34.

Simner, J. (2007)
"Beyond Perception: Synaesthesia as a Psycholinguistic Phenomenon", in: *Trends in Cognitive Sciences* 11, pp. 23–29.

Simner, J. (2010)
"Defining Synaesthesia", in: *British Journal of Psychology* , pp.1–15.

Simner, J., Harrold, J., Creed, H., Monro, L., and Foulkes, L. (2009)
"Early Detection of Markers for Synaesthesia in Childhood Populations", in: *Brain: A Journal of Neurology* 132, pp. 57–64.

Simner, J., Mulvenna, C., Sagiv, N., Tsakanikos, E., Witherby, S. A., Fraser, C., Scott, K., and Ward, J. (2006)
"Synaesthesia: The Prevalence of Atypical Cross-Modal Experiences", in: *Perception* 35, pp. 1024–1033.

Skcatcs, R. (2010)
An Archaeology of the Senses: Prehistoric Malta, Oxford.

Stavroulaki, G., and Peponis, J. (2005)
"Seen in a Different Light. Icons in Byzantine Museums and Churches", in: Nes, A. (ed.), *Proceedings. 5th International Symposium on Space Syntax*, Delft. http://www.spacesyntax.tudelft.nl/media/longpapers2/giannastavroulaki.pdf (27 May 2012).

Stein, B. E., and Meredith, M. A. (1993)
The Merging of the Senses, Cambridge, MA.

Thomas, J. (1991)
Rethinking the Neolithic, Cambridge.

Thomas, J. (1993)
"The Politics of Vision and the Archaeologies of Landscape", in: B. Bender (ed.), *Landscape, Politics and Perspectives*. Oxford, pp. 19–48.

Thomas, J. (1996)
Time, Culture and Identity: An Interpretive Archaeology, London.

Thomas, J. (1999)
Understanding the Neolithic, London.

Thomas, J. (2001)
"Archaeologies of Place and Landscape", in: I. Hodder (ed.) *Archaeological Theory Today*, Cambridge, pp. 165–186.

Tilley, C. (1994)
A Phenomenology of Landscape: Places, Paths and Monuments, Oxford.

Trick, S. (2004)
"Bringing it All Back Home: The Practical Visual Environments of Southeast European Tells", in: *Internet Archaeology* 16, http://intarch.ac.uk/journal.issue16/trick_index.html (15 May 2012).

Trigger, B. (1989)
A History of Archaeological Thought, Cambridge.

Turner, A., Doxa, M., O'Sullivan, D., and Penn, A. (2001)
"From Isovists to Visibility Graphs: A Methodology for the Analysis of Architectural Space", in: *Environment and Planning B: Planning and Design* 28, pp. 103–121.

Von Däniken, E. (1998)
Arrival of the Gods: Revealing the Alien Landing Sites at Nazca, Shaftesbury.

Watson, A., Keating, D. (1999)
"Architecture and Sound: An Acoustic Analysis of Megalithic Monuments in Prehistoric Britain", in: *Antiquity* 73, pp. 325–336.

Watson, O. M., and Graves, T. D. (1966)
"Quantitative Research in Proxemic Behavior", in: *American Anthropologist* 68, pp. 971–985.

Westscott, K. L., and Brandon, R. J. (eds.) (2000)
Practical Applications of GIS for Archaeologists: A Predictive Modeling Kit, London.

Wheatley, D., and Gillings, M. (2000)
"Vision, Perception and GIS: Developing Enriched Approaches to the Study of Archaeological Visibility", in: G. R. Lock (ed.), *Beyond the Map: Archaeology and Spatial Technologies*, NATO Science Series A: Life Sciences vol 321, pp. 1–27 Amsterdam.

Wheatley, D., and Gillings, M. (2002)
Spatial Technology and Archaeology: A Guide to the Archaeological Applications of GIS, London.

Wheeler, R. H., and Cutsforth, T. D. (1922)
The Synaesthesia of a Blind Subject With Comparative Data from an Asynaesthetic Blind Subject, Eugene.

Constantinos Papadopoulos, Graeme Earl

Formal three-dimensional computational analyses of archaeological spaces

Abstract

This paper focuses on the use of formal three-dimensional computational analyses of archaeological spaces as a means to enhance archaeological interpretations, which are usually constrained by the nature of the archaeological record and the methodologies employed during all stages of knowledge production. The first part of this chapter concentrates on the potential of lighting analysis to identify the impact that illumination has on the perception of a given environment and task performance. The second part explores built space, focussing on patterns of visibility, based on texture viewsheds methodology. All the examples presented in this paper come from three different types of spaces in Minoan Crete (a house, a workshop and a burial building), providing valuable information about different aspects of everyday life in 3000–1600 BCE. Formal visibility and lighting analysis techniques, based on three-dimensional computer graphic simulations, provide a synthetic understanding of the potentials of these spaces, stimulating discussion of visual perception, as well as of a broader spectrum of senses.

1 Introduction

It is common practice within interpretations of archaeologically attested environments to develop spatially-contingent conclusions. Thus, in discussing motion within space one might consider a series of rooms acting so as to direct movement, to focus attention, and to provide sensations of enclosure and control. Such interpretations commonly derive from experience of the surviving spaces, examination of correlating what are perhaps better preserved environments, and consultation of plans and elevations. Computer graphic simulation has built on the potential of conventional painted and drawn reconstructions to provide access to hypothesised three-dimensional environments. These in turn stimulate critique and an emotional or purely functional engagement with visualised spaces (Earl et al., in press; Beale et al. 2010).

More recent developments in computational practice have made available easily accessible tools that can formalise the interaction with these simulations. Thus, architectural design software enables calculation of exact movements and transformations of natural light around built spaces and landscapes and the impact of varying forms of artificial illumination. Alongside this, formal analyses of visibility enable the practicalities of the illumination of a given space to be compared to the potentials afforded by movement around it for viewing given locations. Together these formal methods provide a counterpart to less formalised modes of visual interpretation.

In this paper we concentrate on the potentials of formal lighting analysis to identify the illumination that has an impact on the perception of a given environment. We highlight the

importance of virtual constructions (for the use of this term cf. Papadopoulos and Kefalaki 2010) in archaeological research, especially concerning the estimation of lighting values in ancient structures and the importance of natural and flame light in domestic, religious and working spaces. We then consider ways of exploring the visibility of the space as a whole, and in the context of the available light and of computer graphic visual simulations of the environment as it is perceived. All the examples that will be presented below come from Minoan Crete, with attention focussed not on the palatial structures that characterise many studies in the area, but rather on three different types of spaces: houses, workrooms and burial buildings, which provide valuable information about private life, working conditions and religion respectively. We leave for a later publication considerations of what the subsequent perception of digital objects within these simulated environments might mean in archaeological terms.

2 Illumination of computer graphic simulations

The interaction between people and objects in space is fundamentally mediated by light. As these relationships are at the core of what archaeological practice seeks to do, so must illumination be a fundamental factor in understanding past societies. Contemporary Western lifestyles are based on the ubiquity of artificial illumination and constructed landscapes conditioned to available sunlight, to the extent that these have become an accepted background to our daily lives. In the past, evidence for artificial illumination suggests that it required greater effort to create and deploy, and was more variable and generally less successful in providing functionally useful illumination. Nevertheless, natural sunlight coupled with this variety of flame lights facilitated aspects of daily routine, including work and rituals (Parisinou 2007). Light enables agents to extract valuable information from their environment, while eliminating visual discomfort and also causing diverse experiences, attitudes and expectations (Boyce 2003).

In modern architectural design light is closely related to the proposed activities associated with specific spatial orientations. In archaeologically defined environments it is similarly important to distinguish well-lit and darker areas and to consider the potential activities in each case. Visualising and analysing the illumination of particular areas and structures can therefore contribute to the development of hypotheses of functional use, and an evaluation of their impact. Furthermore, light is a crucial factor in providing the character peculiar to a given environment, defining to a great extent the ways in which it is perceived. In exploring such information we do not underestimate that visual acuity – comfort and discomfort – and task performance are influenced by many physical and social variables, and not solely by the amount of light in an environment. Similarly we do not associate given perceptual stimuli such as colour and form with emotional, aesthetic responses. Rather, the analysis of the lighting and the simulation of its impact within a given context is

considered to be an additional data type inherent in the archaeological record, but rarely exposed for analysis.

As already indicated in numerous finds from prehistory, the role of illumination in ancient structures was of great concern. People were producing terracotta lamps, either to use them in areas such as storerooms and workshops or for various activities, such as gatherings and rituals. In addition, sunlight had an integral role in these practices. Both uses are documented in ancient literature, inscriptions, presentations of light on pottery and sculpture as well as physical remains found in several excavations, either in private houses, working areas or sanctuaries. However, the understanding of illumination in pre-historic times is more complicated, since physical remains are far less in quantity and pres-ervation in comparison to subsequent eras, and written sources do not exist to provide an indication of people's intentions.

Apart from the physical construction of ancient structures, we are limited in our options for finding reliable means for estimating the contribution of illumination to people's lives. In most cases, it is impractical to build replicas of such physical construc-tions due to the high quality and quantity of construction materials to be employed, the skills that modern workmen need to construct the buildings using the methods of the past, the high level of scientific expertise required, and consequently the greater cost involved. Three-dimensional computer models can be used to replicate many of these components, but with reduced overheads in some areas. It is still essential that simulated buildings con-form to appropriate structural principles and precedents, and that the attendant light sources interact physically with the materials employed. However, the cost of physical labour and materials is translated into one of modelling, architectural expertise and hard-ware and software resources. In addition such virtual buildings make possible infinite var-iety and hence a potentially broader and better examination, interpretation and narration of the past.

Computer-based visual simulation of past environments takes one of two broadly divergent approaches. The first uses geometry, textures and simple, multiple light sources to replicate the visual appearance of a real environment. The modelling process is struc-tured around an expected visual product. This is the approach common to film and televi-sion graphics. In our own workflow and that employed in architectural design the empha-sis is on physical realism (Earl et al., forthcoming a). In a physically real simulation the pattern of light, colour and shade observed is a function of the input-simulated light energy and the properties of the objects with which it interacts. Such an approach requires greatly increased computational resources and also more detailed knowledge of the input data. For example, few archaeological simulations make use of physically accurate properties, since research regarding combustible materials is still in preliminary stages and remains quite problematic, especially for specific fuels such as wood.

3 Previous work

Much of the work in physically accurate simulation of ancient lighting has been undertaken by Chalmers (2002) and Devlin (2001; 2002). They examined the realistic visualisation of archaeological site computer graphic simulation based on experimental archaeology and physics. In addition, Ioannis Roussos (2003a; 2003b), working in the same group, made a comprehensive study of small-scale flames and different fuel types, using his own scientific and psychophysical investigations. Other work in the domain includes that by Sundstedt on the ancient Egyptian temple of Kalabsha (Sundstedt et al. 2004), Masuda and Yamada (2004) on Sunlight Illumination Simulation in Fugoppe Cave and Eva Zányi (2007) on flame illumination of Byzantine Art in Cyprus. Most of this work focused on the perceptual differences of archaeological sites lit by different types of lighting. It did not focus on the ability of formal lighting analysis to calculate the amount of light in an ancient environment and to understand the intended content of an environment on this basis.

A pioneering paper that considers ancient lighting in terms of energy transmitted to given locations is Dawson et al. (2007; cf. also Dawson and Levy 2005). They not only simulated flame light sources, but also used the results to interpret the archaeology of Arctic dwellings on the basis of the tasks that may have been performed in their interior. Our work on the computer graphic simulation and lighting study of the Minoan cemetery at Phourni, Crete (Papadopoulos 2010; Papadopoulos and Earl 2009; see below) built on this. This work produced a series of alternative computer graphic simulations and considered how these may have affected the perception of the sites in conjunction with the lighting values obtained. It also used these values for natural and flame light to interpret the archaeology of the site and discuss theoretical issues regarding death management in Minoan Crete. The work at Zominthos' ceramics workshop (Papadopoulos and Sakellarakis 2013; see below) followed the same principles. Here the lighting analysis rejected the initial interpretation of the room as a workshop.

Happa's work for Panagia Angeloktisti (2009) includes accurate incorporation of Image-Based Lighting, High Dynamic Range Environment Maps of photographs and interpolated spectrophotometer data collected on site. His STAR paper presented in VAST2009 (2009) also comprises a summary of virtual construction and illumination studies completed to date, mainly regarding the use of modelling tools, technical approaches and methodologies. In CAA2010 Dobbins and Gruber (2013a, 2013b) presented a virtual presentation of the Drinking Contest at Antioch and also of the House of the Faun in Pompeii. In both projects, they simulated how light shifted throughout the hours of the day or days of the year, to observe when mosaics would have been exposed to direct sunlight or were in the shade, trying to consider the impact on how we perceive the artworks within the buildings in contrast when they are displayed in museum exhibitions. In VAST2010 Callet and Dumazet (2010) presented a paper about natural lighting in Notre Dame Cathedral in Paris, considering its influence on gilts and polychromy. This research, mainly based on

spectral simulation, helped towards a further understanding of what could be the medieval design of interior lighting schemes. The authors (Earl et al., forthcoming a) have also worked on the lighting analysis of the Basilica Portuense at Portus, discussing both the functional and metaphysical role of illumination. Lastly, Frischer and Fillwalk, in CAA2012 (forthcoming), presented a lighting simulation for the path of the sun on any time and day of the year 130 CE at Hadrian's Villa, Italy. They particularly focused on the solar alignments affecting the design and orientation of the Temple of Apollo in the Accademia and the lower rotunda of Roccabruna.

4 Lighting study one: the Minoan cemetery at Phourni – Burial Building 19

Contemporary and archaeological evidence suggests that light is of great significance in religious contexts, with its symbolism pervading the geography of sacred landscapes. It is for this reason that a lighting study was undertaken at the Minoan cemetery at Phourni. Existing theories relating the orientation of the buildings and natural illumination to the perception of life and death by the living were critically examined as part of a broader examination of the role that natural and flame light might have played during specific funerary rites.

The position of the sun and hence the natural illumination of the buildings at Phourni is a function of the orientation of the structures towards north, their geographic location, and the date and time. It is widely accepted that the orientation of the structures had some connection with specific beliefs about the dead. For example, the east-facing tombs may be closely related to the rising sun, as this could only have entered the interior on particular days of the year. However, a definitive answer remains elusive (Blomberg and Henriksson 2002). The purpose of the computer-based simulation of Phourni was therefore to examine the impact of natural and flame light in the interior of the burial structures and to discuss its impact when, for example, corpses were admitted into the tombs, or when post-funerary or other rituals were taking place.

The ground plan of BB19 is rectangular externally and apsidal internally, with its apse on the east side (fig. 1). Most of the walls, except for the west, are unusually thick for the size of the building, and also reinforced by a huge monolith at the south side and southeast corner. However, the structure, as it is today, does not exceed a height of one metre, having a doorway, c. 0.8m wide, at the northwest corner. The plan of the structure is broadly representative of the architectural features of other well-known house tombs of the period. These were intended to copy the houses of the living, and hence to serve as "houses for the dead" (Soles 1992).

The most controversial issue concerning the original form of Burial Building 19 is the way that it was roofed. In 1994, Maggidis, drawing on his study of the assemblage, and following the excavator's observation regarding the construction of the east wall with stones

forming a slight overhang (Sakellarakis and Sakellaraki 1976), published a hypothetical illustration of the building (Maggidis 1994). The roof was presented as a semi-vault, based on the north, south and east walls, and closed on the west side by a thin, vertical west wall. The idea of a semi-vault, although peculiar, cannot be totally rejected, since there is no direct evidence to suggest any alternative. Due to the absence of relevant data suggesting possible roofing techniques, it was decided to construct several alternative versions of this structure (fig. 2). Although they do not have any impact on the available space in the burial building, they affect not only the visual perception of the structure, but the lighting as well, as the height and the materials of the building change.

5 Results

The software employed in this and the subsequent analyses was 3ds Max Design. This includes a set of lighting analysis tools tailored to the needs of architects and lighting designers. The tools available allow a simulation to be produced of a given environment in which energy is accurately conserved. In other words, as light from the sun or other luminaires enters the scene it has a specific energy which can only decrease as it is progressively reflected by and refracted through the objects, people and architectural features that it encounters. Lighting analysis provides metrics for the amount of light arriving at a given point in space (the illuminance measured in lux and correlated to the human perception of what is commonly called brightness) and for the amount of light reflected back from it (the luminance measured in candelas per square metre). The difference between these will be a function of the incident direction and wavelength of light and the properties of the material it encounters. The direct illuminance can be calculated for objects in the path of light sources such as a wall in direct sunlight. The indirect illuminance can be calculated for objects that are not directly illuminated, receiving the energy bounced off one or more intermediate surfaces.

For a lighting analysis to be accurate there are a number of key requirements. First, the geometry used must be carefully and accurately produced and must conform to a number of technical norms. Second, the orientation and location of natural and artificial luminaires must be correct. Where scenes take account of natural lighting this will include values impacted by atmospheric effects such as low-level cloud. Third, the energy and distribution pattern produced by the luminaires must match those in the real world. Fourth, the quality of the lighting solution produced by the computer must be high. Approximation is a necessary factor in the simulation of light transport, as any given scene would under normal conditions contain far more photons than could ever be directly simulated. The means of approximation chosen and the quality parameters associated with it have a direct impact on the physical accuracy of the lighting analysis. For this reason we are increasingly using the University of Southampton's Iridis3 supercomputer and high performance workstations to

generate simulations, particularly where it is necessary to consider a number of geometric and lighting permutations. At the time of writing Iridis3 is the fastest Windows computer in Europe, with up to 8000 cores available for processing. In our experiments we have identified considerable variations in lighting simulation outcomes as a consequence of changed indirect illumination settings. These do not define a linear relationship, however, as they are entirely subject to the material and geometric properties present in the scene. We opt for using the most detailed options whenever possible.

The final impact on lighting analysis results from the surface materials used. These must as closely as possible mimic the interaction between light and the real-world material they represent. For example, a darker coloured material will contribute less indirect illumination to a scene than a lighter material. It will have no impact on the direct illumination. A material with a glossy finish will contribute more to the indirect illumination than a matte finish. A rubber object will contribute more light to the scene than a leather one. An opaque object will contribute more light energy than a transparent one, if the transparency allows the light to escape from the area of the analysis. The impact of this material variation will be evidenced in the changing illuminance values associated with objects receiving lighting bounced off the object with the given material, and in the varying luminance value directly observed of the object itself. In designing modern buildings the architect has the benefit of a host of available luminaire types, which include experimentally derived energy and distribution values. In an archaeological context we are dependent upon more sporadic capture of such data and on the *ad hoc* modification of tools and resources designed for architects. Thankfully there is increasing work in this area for artificial luminaires. In the case of natural lighting the existing standards for dealing with sunlight and skylight (e.g. the *Commission Internationale de l'Éclairage* (CIE) sky models) provide an effective framework, coupled with tools for calculating ancient sun positions via astronomical ephemeris tools.

At Phourni the results clearly demonstrate the potential of this lighting analysis approach. The southwest orientation of BB19 suggests that during the morning hours of the months considered as part of the analysis (July and October) its interior is weakly lit, with the maximum amount of illuminance in most of the cases under fifty. During the afternoon, it is illuminated by direct and indirect light, which significantly increases the interior illuminance values by more than five hundred per cent. It is also interesting that although the solstices and equinoxes tested do not present any features suggesting that these dates may have been considered to be 'times of the dead' (Goodison 2001), sunlight penetrates directly into the interior during specific hours of the day, especially between three and six in the afternoon.

Although it is not feasible to draw a definite conclusion from these results, it can be supposed that as it is the case of regular tombs, it may have been an important time of the day, for either the dead or the living. However, the fact that direct light enters BB19 and the other tomb modelled, Tholos C, at different times of the day is indicative not only of the different orientation of the structures, but of its relation to symbolic aspects of beliefs about

Figure 1 | Burial Building 19 in its current state of preservation from the North West.

Figure 2 | One of a number of hypothetical constructions of Burial Building 19, which presents the only method of construction of a vaulted roof in order for it to be stable. View from the South West. The exterior is rectangular, the interior forms a semi-vault and the gap between the two is filled up with a large amount of earth and stones. The west wall does not exceed 1 metre.

death and the afterlife. Although these beliefs are unknown to us, it is feasible to associate them with the careful treatment of the body during primary burials, suggesting that after death and before decomposition, individuals may not have been considered to have gone from the world (Parker 1999). Thus, the rising sun entering into the tomb may have been indicative of a life force which helped them in some way. On the other hand, as is the case with Burial Building 19, the light of sunset entering into the structure, which was probably used as an ossuary rather than a tomb, as well as the subsequent gradual increase in darkness, may have symbolised the passing of time and the ending of life. The results from the lighting study do not on their own provide any direct evidence for a different use of Building 19 other than as a tomb. They can, however, be used to facilitate a useful discussion about any potential connection of sunrise and sunset with construction decisions, linked to the use and the probable meaning of the burial buildings.

Since considerable uncertainty remains about the original architectural form of the building, there are concomitant uncertainties relating to the lighting analysis. The illumination of the interior is increased or reduced depending on the architectural features that are added or removed. However, according to the lighting analysis values the amount of light entering the tomb seems enough for such a small place for most hours of the day, and

Figure 3 | The interior of Burial Building 19 during its first phase on 30th July 2007 at 3 p.m., lit by direct and indirect sunlight through the doorway and the roof. Illuminance values exceed 600 lux (red colour).

suggests an intention to create a building to be used not as a tomb, but to facilitate the better organisation of the ritualised secondary treatment of the dead (Papadatos 1999). It is not possible to reliably assess how the lighting in the interior was changing when more depositions and offerings were introduced, as certain aspects of rituals change very quickly, and in non-linear directions, sometimes leaving no visible mark. However, the accumulation of the depositions at the entrance gradually reduced the amount of light reaching the interior, although this remained well lit during most of the daytime. As can be clearly seen in the lighting analysis images, the luminance values have been significantly reduced in comparison to the first phase, during which the interior was receiving values of more than 400–500 lux (figs. 3 and 4a, b). However, the latter could not have any impact on the various practices taking place in the interior, as the lighting values are at an average level by modern standards, which may suggest that flame lighting was only needed early in the morning and during the night (fig. 5). However, ritual fires or other ceremonies under flame illumination cannot be excluded (Papadopoulos and Earl 2009; Papadopoulos 2010).

Figure 4a | Second phase of Burial Building 19. First Row: 30th July 2007 at 7 a.m. Rendered output indicates almost absolute darkness during the tested date. Luminance values not exceeding 50 cd/m². Second Row: 30th July 2007 at 12 p.m. Lighting values range between 0 to 200 cd/m2 in lower and upper parts of the burial building accordingly.

6 Lighting study two: Kommos, a Minoan harbour – the North House

The Hilltop houses at the Minoan harbour of Kommos were virtually constructed with a particular emphasis on House N. This is a two-storeyed structure, and the largest residence excavated on the hilltop. The house is characterised by an orderly plan with a consistent orientation of the walls to the cardinal compass points and with spacious interior areas. All exterior facades have been traced, the only uncertain one being on the north. It is the largest known Late Minoan house on the hill at Kommos, and is also one of the better built and apparently more prosperous houses in that area of the settlement (Shaw and Shaw 1996).

Although the primary focus for this case study was to graphically simulate the Hilltop houses according to the excavated data and similar archaeological correlates, it was also interesting to examine the lighting conditions under which the inhabitants were preparing food, sleeping, receiving visitors and to discuss to what extent there are similarities and dif-

Figure 4b | Third Row: 30th July 2007 at 3 p.m. Lighting values range between 50 to 300 cd/m² in lower and upper parts of the burial building accordingly, while values exceed 600 cd/m² at the area close to the opening. Fourth Row: 30th July 2007 at 6 p.m. Luminance values in cd/m².

Figure 5 | Torch with intensity of 1500 candelas providing flame light of approximately 100 cd/m² on 30th October 2007 at 7a.m. First phase of Burial Building 19.

ferences in comparison to modern practices, indicating how superficial our interpretations may become when they are solely based on contemporary comparators.

Polythyra and light-wells in Minoan architecture created a distinct contrast between light and shadow, whilst the variety of colour and decorative schemes produced a feeling of constant motion. The contribution of light is at its most apparent in Minoan palatial structures, which contrast considerably with domestic spaces. The information we have concerning urban settlements and consequently domestic spaces mainly derives from the archaeological remains, supplemented by several depictions in art. Houses were two- or three-storey buildings, with most of the windows on the upper storeys, ostensibly for security and privacy purposes. Depending on the use of each room, there are varying features such as hearths and benches, coupled with light sources that correspond to functional interpretations of spatial practice based on the material culture. Thus, the largest room is usually the primary living space of each household. The smallest rooms seem predominantly to be used for storage and usually have only small openings for ventilation, with indirect illumination provided by the adjacent rooms. Similarly, the rooms used for industrial activities seem to have enough openings to provide light for practical purposes and to facilitate air circulation.

The lighting values obtained for the North House at Kommos seem to match those expected of a domestic space. The areas such as N16, identified as being where most of the everyday activities were taking place, such as food preparation and consumption, are well lit through doors and windows (figs. 6 and 7). Where necessary the amount of available light can be increased by using portable lighting devices, such as olive oil lamps. Storage rooms, such as room N1 and Area 18, have small openings, presumably to allow air circulation whilst restricting the impact of direct and bright indirect illumination on the goods stored (figs. 8 and 9). Similarly, areas that have been characterised as sleeping quarters are usually made of solid walls which do not allow any direct illumination. The indirect light coming from neighbouring openings can be considered enough for the activities taking place there and again additional light can be provided by lamps or torches. Lastly, the hearth in the main room (N17) not only provided warmth but also light during night hours and on cloudy days (fig. 10).

7 Lighting study three: the 'Ceramics Workshop' at Zominthos

Zominthos is located in the mountains of central Crete. It was discovered in 1982 as part of an excavation which is still in progress by Efi Sapouna-Sakellarakis. A monumental Central Building that covers an area of 1,600 square metres, developed from the 17th century onward, has been revealed. The structures are well preserved and some walls still stand at a height of 2.2 metres (Sakellarakis and Panagiotopoulos 2006). The purpose of this case study was to construct virtually a room unearthed at the northwest corner of the Central

Figure 6 | Room N16 in the North House, Kommos Hilltop Houses. The finds indicate that food preparation and consumption was taking place in this room.

Figure 7 | Lighting analysis of Room N16 in the North House, Kommos Hilltop Houses. The values on 21st March 2010 at 3 p.m. indicate that light entering this area was sufficient for carrying out domestic activities.

Figure 8 | Lighting analysis in a storage area, North House, Kommos Hilltop Houses. The values on 21st March 2010 at 3 p.m. suggest that light entering this area was insufficient for carrying out any activities requiring detailed near sight. It is appropriate for such spaces to have low lighting values, as this may have helped the preservation of the various goods kept there.

Figure 9 | Area 18 in the North House, Kommos Hilltop Houses. The space behind the staircase that led to the second floor might have been used for storing goods.

Figure 10 | Room N17 in the North House, Kommos Hilltop Houses. This is the largest room of the house. The hearth at the centre indicates that most of the activities were taking place in this room.

Building, Room 13, which has been identified as a Ceramics Workshop (fig. 11). It defined a 15 square metre area that contained more than 250 vessels for everyday use, some bronze and stone tools, a basin in the middle of the room and a potter's wheel. Ceramics had been placed on benches running along the northern and southern walls, some of which were found in situ. Some of them may have been positioned on wooden shelves along the walls, as indicated by the great quantity of carbonised wood unearthed. Although Room 13 has provided a range of features which indicate its use as a ceramics workshop, there is one peculiar characteristic: although the walls are preserved to a significant height, no window was revealed. This is in comparison to known windows in the structure in the adjacent Rooms 14 and 15, as well as in Rooms 8 and 9 on the facade of the building. Thus, an illumination study was defined to reveal the extent to which an apparently weakly lit space could be used as a working area.

According to several ethnographic comparators from regions of Crete and mainland Greece with a strong tradition in pottery making, potters' workshops should be illuminated by sufficient sunlight to facilitate the production of ceramics. In Margarites for example, a small village to the east of Rethymno, ceramics workshops used to have at least one large window and a door, which remained open during the production of pots. During the study it becomes apparent that every single working space should have enough light to assist people's work. When natural light is not adequate, flame illumination can be used to increase the lighting levels. However, the kind of light that is produced from flame sources, such as a candle or an oil lamp, is a combination of light and shadows. The study identified that this flickering, variable illumination hinders any work which requires absolute control of the product created. The possibility of the flickering providing an enhanced appreciation of the subtle morphology of the ceramics when produced was not supported ethnographically.

The level of preservation of the main walls in Room 13 is exceptional for such a structure, leaving no room for hypotheses about the preservation of any openings in them. However, small window openings may be hypothesised to have existed in the upper courses of

Figure 11 | Aerial View of the 'Ceramics Workshop'.

the walls which do not survive intact. It is not impossible to have had small openings facili-
tating the illumination and ventilation of the interior here. For this reason, several struc-
tural models were produced in order to provide a reliable illumination study regarding the
impact that this unusual absence of windows may have (fig. 12). Small windows were con-
structed in the east and west walls of the room, corresponding to those found in rooms 7
and 8, and 14, 15. In addition, oblong windows were created in the north wall, and various
alternatives were examined with the partition wall that divides Rooms 13 and 14.

The absence of windows was initially explained by the excavator, based on the fact that
clay is a very fragile material and, as a consequence, a ceramics workshop should not be
overlit or have constant air circulation, since clay can easily become dry and useless. He also
supported this idea by stating that the windows in the adjacent rooms may have provided
sufficient light to aid a potter's work. Although it was impossible to test this idea physically,
since the structures are not fully preserved, the computer graphic simulation produced pro-
vided the chance for a further analysis of this dataset. The results of the lighting study
undertaken indicate that no light could enter the room through nearby openings, as the
values obtained do not exceed 40–50 lux in the spring and summer months (fig. 13). With
windows in the north, east and west walls there is increased illumination ranging from 0 to
70 lux (fig. 14). However, none of them seem to have facilitated the diffusion of light to a
sufficient extent to consider these alternatives a solution to the problematic aspects of the
dataset. The walls' thickness, which at some parts exceeds one metre, seems to have pre-
vented the significant ingress of daylight to the interior. Flame illumination was also tested
(fig. 15), although as discussed this was discouraged, since modern potters argued that the
existence of flames in a dark room produces irregular shadows which confuse the potters
about the actual form and shape of the vessel produced.

Through this illumination study, which would have been impractical by other means,
it was proven that neither the light coming from adjacent openings nor the addition of
hypothetical windows can be considered sufficient to consider this area a continuous work-
ing space. The initial interpretation has to be re-evaluated based on the archaeological finds,
ethnographic correlates and the results of the lighting analysis (Papadopoulos and Sakella-

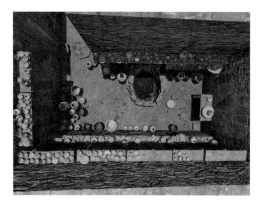

Figure 12 | 3D graphic simulation of the 'Ceramics Workshop'.

Figure 13 | Light meters indicating the amount of incident light (illuminance) entered in Room 13 from the openings of the adjacent rooms. Left: 21st December 2010 at 9 a.m., Right: 21st March 2010 at 12 p.m.

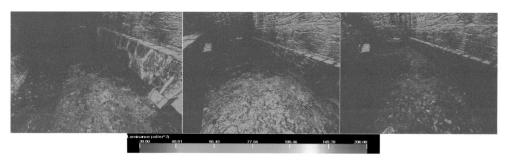

Figure 14 | Lighting analysis with luminance values not exceeding 70 cd/m² (left-right): window on the north side, window on the east side, window on the west side. The test date is 21. 6. 2009 at 12 p.m.

rakis 2013). The latter may suggest that Room 13 was a room for storing and drying the vessels that were produced somewhere else in the Central Building and most probably outside this room, where a kiln and more than 100 vessels were found. It is possible that, as is the case with traditional Cretan potters, a small shack was constructed with perishable materials in the vicinity of Room 13. This could then have been used as the potter's working space, providing direct access to the kiln, natural resources and sunlight.

Figure 15 | The 'Ceramics Workshop' under the light of three olive oil lamps. Lamps provide local illumination, while creating irregular shadows, which may confuse the potter in the production process.

8 Discussion

Computer methodologies provide valuable tools for exploring the complexities that the archaeological record presents. The illumination of an ancient interior space can only be examined via physical reconstruction and experimental archaeology, and through formal lighting analysis within a computer graphic simulation. These two methods necessarily work in parallel. A physical construction is often expensive and requires a broad range of construction expertise. It also requires the production of one or a small number of variations on any given variable. However, the physical simulations provide a useful source of lighting information and crucial data to enable direct comparisons to be made with the lighting simulation. This approach has proved successful in our work at Çatalhöyük, where the initial computer simulations were calibrated against lighting data and polynomial texture maps gathered in a physically constructed 'experimental house' on site (Earl et al., forthcoming a; Earl et al. 2010). For lighting analysis of this kind to develop there must continue to be experimental archaeology to provide the necessary luminaire and material information. Similarly the construction of computer models requires detailed input from architectural and engineering experts in order that the geometry produced is physically and culturally accurate.

The three lighting examples presented, from three different contexts, clearly show that, depending on the use of each building or area, distinct lighting conditions are needed in order to facilitate the activities that take place in them. It may not be possible to give definitive answers, but the various results provide invaluable stimuli, which can be used as a fertile field for discussion. There has been some criticism of the use of contemporary lighting metrics in the calculation of suitability for specific tasks. Dawson et al. (2007) did not define new luminaire light distributions or spectra for their light sources and instead

used a standard modern luminaire. We agree that this may not have significantly impacted their results. Their use of standard CIE and other tables alongside ethnographic data for evaluation of the capacity to perform given tasks is more problematic (e.g. Woodson 1992). Again Dawson identifies the problems with these data and covers the implications for their use in great detail. The use of such metrics carries with it problematic issues of essentialism in terms of perception, but we would argue that these are in any case at the heart of such analyses, and indeed in much archaeological writing relating to the senses.

However, it should be argued that the interpretive process that usually follows an archaeological research project may embroil or oversimplify past reality. Social factors may be misinterpreted because of our own social criteria, cultural traditions may be misunderstood due to our modern westernised way of thinking, values and world views, and structural remnants may be considered self-explanatory evidence of the various processes that have taken place. As a fundamental feature of our archaeological practice we always try to use well documented correlates with a definite resemblance to our primary datasets. In this way we aim to approach the past more closely. Still, in the work described here we have drawn back from the use of formal metrics, and our interpretations instead draw explicitly from contemporary personal experience in physically constructed ancient and modern environments, and on ethnographic data. We consider this interaction between formal methods and lived experience to be a fundamental aspect of archaeological practice. However, we acknowledge the value that such standard measures of recommended lighting conditions offer as a structure for interpretation.

The three studies demonstrate that the possibility of consistent variance of parameters within computer graphic simulations, as opposed to physical environments, enables crucial sensitivity analysis to be undertaken. This testing allows lighting and visibility analyses and visual representations of spaces to be validated, both qualitatively and quantitatively. Whether through hand modelling of varying geometry, batch-processed variation of parameters or through the use of procedural modelling (Haegler et al. 2009; Müller et al. 2006), such sensitivity analysis is a crucial component. The impact of portable material culture such as blinds and screens, the varied location and intensity of artificial luminaires, different colour and intensity perception in humans, and the orientation of people, colourful fabrics and furniture all play a role in the pattern of light and shade. However, with every additional parameter introduced, the calculations required in producing comprehensive analyses increase by an order of magnitude, hence requiring increased use of Iridis3 in our further work in this domain. Such a need for parameterisation will also feature in the next section as we consider the ways in which we can supplement the formal analysis of lighting with the formal analysis of visibility.

9 Visibility in computer graphic simulations

In the second part of this paper we explore a companion method for formal analysis of these Minoan built structures. Whilst lighting studies provide an indication of the types of activity that could be performed in given locations and the relationship between form and perception, they do not provide an analogue to the sense of space typically defined in architectural studies of surviving built environments. In a context such as Herculaneum, where significant proportions of the built architecture survive, it may be possible to develop interpretations that draw directly from experience of the environment. As one moves further from this degree of preservation the extent to which one may talk about spatial sensations such as enclosure and transition is reduced, or at least rendered more complex. Despite this, studies continue to develop spatial interpretations on the basis of data that are themselves divorced from the forms they represent: namely the plan and elevation. In this section we will consider an alternative means for approaching the question of built space focused on patterns of visibility.

Formal visibility methods attempt to sample the visibility of a space or landscape. In GIS this accounts for the changing convex topography, but not enclosed and concave surfaces. Other approaches such as that defined here can account for visibility in built environments that elicit all of the complexity seen in the lighting studies above. In combination these methods make possible a summary of a space that is at once about the potentials of movement and sight, and the influences upon it imposed by structural form and illumination. Both approaches are also based in tradition and vocabulary associated with the production of engaging visuals, and hence we are able to intermingle the creative, inherently subjective processes of modelling with the metrics of formal spatial analysis.

10 Texture viewsheds

The texture viewsheds methodology was introduced in Earl (2005). The technique is based on the texture-baking algorithms common to computer games production. For the purposes of analysis this algorithm is used to define a metric for visibility for all surfaces within a 3D environment, including the distance from which the surface is viewed, the angle of view and the overall degree of visibility. The paper drew a great deal from the increasing overlap between GIS and computer graphic approaches. In essence the texture viewshed approach thus combined the formal raster mathematical components of GIS with the geometric capabilities of modelling software such as 3ds max. This same combination of techniques was employed by Paliou and Wheatley (2007) for the study of Akrotiri. They fall within a wide range of techniques for mathematically summarising the built environment, including Benedikt (1979) and Yang et al. (2007). Cf. Paliou et al. (2011) for detailed coverage.

Since this initial publication the texture viewsheds approach has developed in two directions. First, there has been a realisation that approaches so dependent on modelled geometry must take account of the uncertainties inherent in it. An approach to undertaking a sensitivity analysis of this geometry, analogous to the production of fuzzy and probabilistic viewsheds in GIS, was outlined in Paliou et al. (2011). In this approach consistent variation is introduced in duplicates of the geometry underlying the analysis. This is produced manually and the visibility products then compared. This method provides a great deal of control over the construction of models. However, this is necessarily limited by modelling resources in terms of the scope of variation. As defined above, the variation in lighting values for reconstructed archaeological environments is considerable, even given relatively subtle changes in model morphology. For this reason we have instead proposed a method employing procedural modelling tools to define variability in object components.

The second departure from the method outlined in Earl (2005) has been a move away from GIS-based analyses towards image-processing tools. The technique has moved from raster calculation in ArcGIS to an approach based around the established and robust VIPS framework (Martinez and Cupitt 2005; Cupitt and Martinez 1996). The overall technique remains computationally intensive in the production of graphical outputs and has therefore been optimised for processing on Iridis3.

11 Visibility study: Kommos, a Minoan Harbour – the North House

The lighting study of the North House described above identified functional zones on the basis of material culture and the pattern of light and shade observed within this building. Through the calculation of texture viewsheds we have attempted to correlate the morphology of the scene to the pattern of illumination.

The texture viewshed approach uses a moving omnidirectional light source to simulate the monocular vision of a single observer able to look in any direction. The pattern of visibility for this observer is then calculated by capturing the illumination values for all surfaces within the model. As the omnidirectional light provides the only illumination within the analysis and no indirect illumination calculations are made, those areas that have an illumination value greater than zero must be visible to the observer. The surface materials used for the lighting analysis of the North House were replaced by a simple shader with no reflectivity and even shading between vertices. As the shading model used in the calculation generates a linear fall-off from a value of 255 at a point perpendicular to the observer position to a value of 0 at a point parallel to it, it was also possible to identify the angle of view to provide a more nuanced indication of visibility (Earl 2005). Furthermore, by limiting the exigent light via a photometric web distribution the technique enables particular angles of inclination to be isolated (Paliou et al. 2011). For the analyses presented below the resulting light maps were reclassified to create a binary texture viewshed (Earl 2005), where

the pixels mapped to each geometric object were reclassified to values of 1 for visible and 0 for invisible.

The North House analysis began by defining the range of these potential observer positions within the house. By carrying out the analysis for multiple observer positions a summary of the whole space is defined. In this case study rooms N16 and N17 were examined, with observers placed at one-metre intervals throughout the rooms. Two observer heights of 1.1m and 1.6m were specified to include observers at seating and standing heights (fig. 16). This generated a sample of 48 viewer locations. In other studies we have undertaken much denser observer samples (Earl 2005), but this was not considered necessary here as the focus was on the comparison with lighting analysis.

The model of the North House was modified to a limited degree to suit the needs of the methodology. As the texture viewsheds approach relies on the automatic unwrapping of planar surface lighting maps from geometry, it assists in post-processing if the geometry corresponds only to the areas visible to a potential observer. In other words it must be a water-tight model in which there are no overlapping meshes and redundant faces have been removed. As this modelling requirement also matches that imposed by accurate calculations of indirect illumination, it did not require a great deal of modification. Secondly, since the lighting maps are scale-independent, it is preferable for the individual geometric components to be similar in size. Again this does not present modelling difficulties, and the results below have in any case been standardised by object area.

Texture viewsheds were produced at a resolution of 1024×1024 pixels for the 60 objects in Rooms 16 and 17 of the North House model, based on a total of 2880 unwrapped lighting maps. This produced an average sample resolution of c.4 pixels/ cm² of real-world object space. The maps were converted to binary maps showing visible and invisible components and then combined to produce texture viewsheds. The histograms of these were stretched uniformly according to the maximum visibility within the scene to enable optimum interactive display to be achieved in the viewport. The analyses below are based on the original data. Figure 17 shows a view of Wall 3 in Room 17. Figure 18 shows the binary texture viewshed for this wall and Figure 19 shows the texture viewshed mapped back onto the geometry in the scene.

12 Results

When all texture viewsheds were mapped back onto the model of the North House, it became clear that there were very different patterns of visibility within the building. By replacing the textures used for analysis with the texture viewsheds it was possible to identify patterns in visibility by moving around the structure (fig. 20). In particular there was considerable influence of the supporting beams and the doorways in Room N17 on the visibility in that space and the connected side spaces. Based on the observers within Rooms N16 and

N17, the other storage spaces were not well integrated visually and the influence of varying heights of doorways and tight corners was considerable.

The metric data support these qualitative assessments of the remapped texture viewsheds. Room N16, which was interpreted as having a habitual domestic function, had a reasonable level of visual integration (table 1). Whilst the sample size was low in this case study there was good visibility of most parts of the room from both within and without. The more central, communal Room N17 had even higher levels of all round visibility (table 2) and was more tightly integrated into Room N16. Whilst Room N16 had an average of 26 % of objects viewed by observers in Rooms N16 and N17, Room N17 had 48 %. This implies that the latter was a considerably more prominent space, whether when standing or sitting. There are two potential factors that may have skewed these data. First, objects with larger surface areas may as a consequence become more prominent. In fact a comparison of the percentage of observers seeing each of the main wall and floor objects, compared to the observer density for the object, suggested that there was no simple correlation (table 4). Second, the number and location of observers in each room does not define the pattern.

In addition to general patterns there were distinct variations between comparable areas in the rooms, suggesting that there may have been areas more suited to particular forms of activity that require prominence, or from where it was important to be able to see the remainder of the house. Further lighting studies may assist in understanding these distinct areas. Whilst additional work remains to be completed, and in particular the incorporation of a larger density of samples and of probabilistic geometry, the results to date imply a differential sense of prominence between these two spaces.

13 Conclusions

The integration of formal visibility and lighting analysis methods has identified a number of points of interest to archaeologists studying the Minoan built environment. In the case of the North House at Kommos the integration of visibility and lighting analysis with visual analysis provided by rendered graphics has produced a synthetic understanding of the potentials of this space. Whilst this example provides only a relatively low-resolution case study, it is clear that the combination of methods merits further work. The ability to repurpose geometry produced for any one of the three approaches for use in the other two is extremely powerful, and in future work we aim to simplify further the modelling and analytical steps involved. We are also further exploring the possibilities for procedural modification of geometry as a means to qualify the impact of modelling decisions on the qualitative and quantitative outcomes.

The analyses defined above are clearly biased towards visual components of perception (for a critique on the dominance of vision in spatial analyses see Wheatley, this volume). Whilst such studies stimulate interpretation of a broader spectrum of senses (see for

example Dawson et al. 2007's discussion of touch), vision remains predominant. Archaeology has always used a range of visual genres as interpretive aids. Sight is considered the sense of science (Classen 1993) and ocularcentrism is usually privileged above other approaches (Jay 1996; MacGregor 1999). It is characteristic therefore that the three case studies under examination are all based on the assumption that visual perception would have been the critical sensory engagement of the Minoans. Although there are several attempts to consider other senses in archaeological contexts, both on a theoretical level and by technical means (Chalmers and Zányi 2009), the results remain limited. Only hearing has been introduced consistently in the realm of archaeological interpretation, although the outcomes have been challenged (Scarre and Lawson 2006).

As Paliou mentions in this volume, when space is studied only in two dimensions, certain social meanings remain under-appreciated and/or non-percept. Two-dimensional approaches of studying space fail to consider fundamental elements that might have influenced perception and human behaviour, thus limiting the interpretations to the relation between spatial configurations and human movement. To that we could add that two-dimensionality does not only pose problems for the interpretation of human-space relationship, since it is an issue ingrained in archaeological practice. In archaeology, we are used to producing two-dimensional realities, since the conventional recording mechanisms employed in excavations turn three-dimensional space into two-dimensional constructions (e.g. architectural drawings, photography, text). In other words, our work as archaeologists, or in this case as archaeological computing specialists, is based on the paradox that the material world has to be flattened in order to fit into the various methodologies employed, while three-dimensional computer graphic simulations are produced by using this two-dimensional information as a basis. In this process however, various perceptual, physiological and technical factors affect the course of interpretation, visualisation and reconstruction, therefore distorting the actual three-dimensional properties of the real world, leaving information behind, while adding others that might have never existed.

However, even three-dimensional approaches have certain drawbacks, since they tend to neglect other factors that played an essential role in the perception of a given environment. For example, to what extent could a formal multisensory analysis have provided a different perception of Burial Building 19? Could Zominthos' potter have been able to see by touch rather than vision, therefore invalidating our interpretation? Would the results have been different regarding the visibility of the Theran mural paintings or the interpretation of San Vitale (Paliou, this volume) if formal lighting analysis was incorporated (for the interpretation of ecclesiastical spaces based on the simulation of light, cf. Earl et al., forthcoming a)?

It seems likely that buildings and landscape design have been commonly influenced by the sensorium, but interpretation of them does not require an adherence to visual dominance or indeed to the active participation of all five traditional senses in a given encounter in space (Classen 1993). The factor that Minoans might have ranked the senses differently or developed diverse sensoriums should not be underestimated. Especially in the case of

Table 1 | Percentage of observers in Rooms N16 and N17 viewing objects in Room N16.

Object	Observers (%)	Object	Observers (%)
Roof Beams3	88	Internal Door1	0
Wall3	77	Internal Door2	0
Ground Floor	71	Internal Door3	0
Wall7	71	Roof Beams1	0
Wall1	63	Roof Beams2	0
Wall2	58	Roof Beams4	0
Roof	40	Supporting Beam1	0
Wall4	33	Wall5	0
Roof Beams5	19	Wall6	0
External Door	4	Window	0

Table 2 | Percentage of observers in Rooms N16 and N17 viewing objects in Room N17.

Object	Observers (%)	Object	Observers (%)
Roof Beams1	90	Supporting Beams4	50
Wall2	77	Supporting Beams3	48
Ground Floor	71	Wall1	48
Wall3	67	Roof Beams5	46
Wall5	67	Roof	40
Wall4	65	Roof Beams6	35
Roof Beams2	63	Supporting Beams2	35
Roof Beams3	54	External Window2	15
Roof Beams4	54	External Window1	10
Roof Beams7	54	External Door	6
Supporting Beams1	54	Internal Window	0

the 'ceramics workshop' at Zominthos, it might be argued that touch may have facilitated or indeed directed the potter's work, suggesting that a functional argument derived from lighting analysis must consider that pottery making may have been possible under dim or even flickering flame light. Such approaches cannot provide definitive answers. Although they encourage a further engagement and discussion of the datasets, they can be equally criticised for their tendency to pivot on philosophical rather than tangible arguments. For now we are content to continue exploring one or two aspects of perception as a means to critique the broader, socially contingent nature of space. Furthermore, we believe that an integrated approach that allows the creation of visual simulations, the analysis of potential visibility and the qualification of the lighting in space has much to recommend it.

Table 3 | Comparison of percentage of observers seeing each of the main wall and floor objects compared to the observer density for the object. Note: there is no correlation between surface area of object and prominence of objects.

Object	Observers per m²	Observers (%)
Rest Walls1	2.6	81
Room 17 Wall2	1.09	77
Room 16 Wall3	7.4	77
Ground Floor	0.13	71
Room16 Wall7	3.09	71
Roof	0.23	67
Room 17 Wall3	0.52	67
Rest Walls6	1.28	67
Room17 Wall5	1.39	67
Rest Walls3	2.91	67
Room17 Wall4	2.38	65
Room16 Wall1	0.44	63
Rest Walls2	2.33	58
Room16 Wall2	2.55	58
Rest Walls8	3.11	58
Rest Walls4	1.08	54
Rest Walls5	0.42	52
Rest Walls7	3.43	50
Room17 Wall1	0.31	48
Rooms16 and 17 Roof	0.25	40

Figure 16 | View into N17 showing the paths taken by the observers.

Figure 17 | View from N16 into N17 showing Wall 3.

Figure 18 | Binary texture viewshed for Wall 3.

Figure 19 | Wall 3 in model showing unwrapped texture viewshed.

Figure 20 | Looking back from N17 into N16.

Bibliographical references

Beale, G., and Earle, G.P. (2010)
"The Herculaneum Amazon: Sculptural Polychromy, Digital Simulation and Context", in: A. Moore, G. Taylor, E. Harris, P. Girdwood, and L. Shipley (eds.), *Conference Proceedings, TRAC 2009*, pp. 31–40.

Benedikt, M.L. (1979)
"To Take Hold of Space: Isovist Fields", in: *Environment and Planning B: Planning and Design* 6, pp. 47–65.

Blomberg, M., and Henriksson, G. (2003)
"Literary and Archaeoastronomical Evidence for the Origins of the Hellenic Calendar in the Aegean Bronze Age", in: A. Maravelia, (ed.), *Ad Astra per Aspera et per Ludum European Archaeoastronomy and the Orientation of the Monuments in the Mediterranean Basin. Papers from Session I.13, held at the European Association of Archaeologists Eighth Annual Meeting in Thessaloniki 2002, BAR International Series 1154*, Oxford, pp. 53–70.

Boyce, R. P. (2003)
Human Factors in Lighting, London.

Callet, P., and Dumazet, S. (2010)
"Natural Lighting, Gilts and Polychromy of Notre-Dame de Paris Cathedral", in: A. Artusi, M. Joly-Parvex, G. Lucet, A. Ribes, and D. Pitzalis (eds.), *Conference Proceedings, 11th VAST International Symposium on Virtual Reality, Archaeology and Cultural Heritage*, pp. 63–70.

Chalmers, A., and Zányi, E. (2009)
"Real Virtuality: Emerging Technology for Virtually Recreating Reality", in: *Becta*, http://www.becta.org.uk (14 February 2011).

Chalmers, A. (2002)
"Very Realistic Graphics for Visualising Archaeological Site Reconstructions", in: *Conference Proceedings, 18th Spring Conference on Computer Graphics*, New York, pp. 7–12.

Classen, C. (1993)
Worlds of Sense: Exploring the Senses in History and Across Cultures, London.

Cupitt, J., and Martinez, K. (1996)
"VIPS: An Image Processing System for Large Images", in: *Conference Proceedings, IST/SPIE Symposium. Electronic Imaging: Science and Technology, 2663, Very High Resolution and Quality Imaging*, pp. 19–28.

Dawson, P., Levy, R., Gardner, D., and Walls, M. (2007)
"Simulating the Behaviour of Light Inside Arctic Dwellings: Implications for Assessing the Role of Vision in Task Performance", in: *World Archaeology* 39, 1, pp. 17–35.

Dawson, P., and Levy, R. (2005)
"Explore the Ideological Dimensions of Thule Whalebone Architecture in Arctic Canada", in: *Internet Archaeology* 18, 1, http://intarch.ac.uk/journal/issue18/ (21 April 2013).

Devlin, K., and Chalmers, A. (2001)
"Realistic Visualisation of the Pompeii Frescoes", in: A. Chalmers, and V. Lalioti (eds.), *Conference Proceedings, 1st International Conference on Computer Graphics, Virtual Reality and Visualisation, AFRIGRAPH*, pp. 43–47.

Devlin, K., Chalmers, A., and Brown, D. (2002)
"Predictive Lighting and Perception in Archaeological Representations", in: *Conference Proceedings, UNESCO World Heritage in the Digital Age, 30th Anniversary Digital Congress.*

Dobbins, J., and Gruber, E. (2013a)
"Illuminating Historical Architecture: The House of the Drinking Contest at Antioch", in: F. Contreras, M. Farjas, and F.J. Melero (eds.), *CAA 2010 Fusion of Cultures. Proceedings of the 38th Annual Conference on Computer Applications and Quantitative Methods in Archaeology, Granada, Spain, April 2010. BAR International Series 2494*, Oxford.

Dobbins, J., and Gruber, E. (2013b)
"Modeling Hypotheses in Pompeian Archaeology: The House of the Faun", in: F. Contreras, M. Farjas, and F.J. Melero (eds.), *CAA 2010 Fusion of Cultures. Proceedings of the 38th Annual Conference on Computer Applications and Quantitative Methods in Archaeology, Granada, Spain, April 2010. BAR International Series 2494*, Oxford, pp. 77–84.

Earl, G., Porcelli, V., Papadopoulos, C., Beale, G., Harrison, M., Pagi, H., and S. Keay (forthcoming a)
"Formal and Informal Analysis of Rendered Space: The Basilica Portuense", in: A. Bevan and M. Lake (eds.), *Computational Approaches to Archaeological Spaces*, Walnut Creek.

Earl, G.P., Keay, S.J., and Beale, G. (in press)
"Archaeological Computing for Recording and Presentation of Roman Portus", in: S.J. Keay and L. Paroli (eds.), *Workshop Proceedings, The First Portus Workshop, Rome, March 2008*, British School at Rome.

Earl, G.P., Martinez, K., and Malzbender, T. (2010)
"Archaeological Applications of Polynomial Texture Mapping: Analysis, Conservation and Representation", in: *Journal of Archaeological Science XXX*, pp. 1–11.

Frischer, B., and Fillwalk, J. (forthcoming)
"The Digital Hadrian's Villa Project: Virtual World Technology as an Aid to Finding Alignments between Built and Celestial Features", in: *Conference Proceedings, XXXX Computer Applications and Quantitative Methods in Archaeology 2012.*

Goodison, L. (2001)
"From Tholos Tomb to Throne Room: Perceptions of the Sun in Minoan Ritual", in: R. Laffineur and R. Hägg (eds.), *Conference Proceedings, Aegaeum 22 POTNIA, Deities and Religion in the Aegean Bronze Age, The 8th International Aegean Conference*, pp. 77–88.

Haegler, S., Müller, P., and Van Gool, L. (2009)
"Procedural Modeling for Digital Cultural Heritage", in: *EURASIP Journal on Image and Video Processing.* http://jivp.eurasipjournals.com/content/2009/1/852392/ (21 April 2012).

Happa, J. et al. (2009a)
"The Virtual Reconstruction and Daylight Illumination of the Panagia Angeloktisti", in: K. Debattista, C. Perlingieri, D. Pitzalis, and S. Spina (eds.), *Conference Proceedings, 10th VAST International Symposium on Virtual Reality, Archaeology and Cultural Heritage*, pp. 49–56.

Happa, J. et al. (2009b)
"Illuminating the Past – State of the Art", in: K. Debattista, C. Perlingieri, D. Pitzalis, and S. Spina (eds.), *Conference Proceedings, 10th VAST International Symposium on Virtual Reality, Archaeology and Cultural Heritage*, pp. 155–182.

Jay, M. (1996)
"Vision in Context: Reflections and Refractions", in: T. Brennan and M. Jay (eds.), *Vision in Context: Historical and Contemporary Perspectives on Sight*, London, pp. 1–12.

Maggidis, C. (1994)
Burial Building 19 at Archanes: A Study of Prepalatial and Early Protopalatial Funerary Architecture and Ritual, University of Pennsylvania (PhD thesis).

MacGregor, C. (1999)
"Making Sense of the Past in the Present: A Sensory Analysis of Carved Stone Balls", in: *World Archaeology* 31, 2, pp. 258–271.

Martinez, K., and Cupitt, J. (2005)
"VIPS – a Highly Tuned Image Processing Software Architecture", in: *Conference Proceedings, IEEE International Conference on Image Processing* 2, Genova, pp. 574–577.

Masuda, T., and Yamada, Y. (2004)
"Sunlight Illumination Simulation for Archaeological Investigation – Case Study of the Fugoppe Cave", in: *Conference Proceedings, 10th International Conference on Virtual Systems and MultiMedia*. http://www.cvl.iis.u-tokyo.ac.jp/papers/all/687.pdf (21 April 2012).

Müller, P., Vereenooghe, T., Wonka, P., Paap, I., and Van Gool, L. (2006)
"Procedural 3D Reconstruction of Puuc Buildings in Xkipché", in: M. Ioannides, D. Arnold, F. Niccolucci, and K. Mania (eds.), *Conference Proceedings, 7th VAST International Symposium on Virtual Reality, Archaeology and Cultural Heritage 2006*, Baltimore, Maryland, pp. 139–146.

Paliou, E., Wheatley, D., and Earl, G. P. (2011)
"Three-dimensional Visibility Analysis of Architectural Spaces: Iconography and Visibility of the Wall Paintings of Xeste 3 (Late Bronze Age Akrotiri)", in: *Journal of Archaeological Science* 38, pp. 375–386.

Paliou, E., and Wheatley, D. (2007)
"Integrating Spatial Analysis and 3D Modelling Approaches to the Study of Visual Space: Late Bronze Age Akrotiri", in: *Conference Proceedings, The XXXIII CAA 2005: Computer Applications and Quantitative Methods in Archaeology, International Conference, The World is in Your Eyes*, pp. 307–312.

Papadatos, Y. (1999)
Mortuary Practices and their Importance for the Reconstruction of Society and Life in Prepalatial Crete: The Evidence from Tholos Tomb G, in Archanes-Phourni, University of Sheffield (PhD thesis).

Papadopoulos, C., and Sakellarakis, Y. (2013)
"Virtual Windows to the Past: Reconstructing the 'Ceramics Workshop' at Zominthos, Crete", in: F. Contreras, M. Farjas, and F.J. Melero (eds.), *CAA 2010 Fusion of Cultures. Proceedings of the 38th Annual Conference on Computer Applications and Quantitative Methods in Archaeology, Granada, Spain, April 2010. BAR International Series 2494*, Oxford, pp. 47–54.

Papadopoulos, C. (2010)
Death Management and Virtual Pursuits: A Virtual Reconstruction of the Minoan Cemetery at Phourni, Archanes, Examining the Use of Tholos Tomb C and Burial Building 19 and the Role of Illumination, in Relation to Mortuary Practices and the Perception of Life and Death by the Living, BAR International Series 2082, Oxford.

Papadopoulos, C., and Earl, G. (2009)
"Structural and Lighting Models for the Minoan Cemetery at Phourni, Crete", in: K. Debattista, C. Perlingieri, D. Pitzalis, and S. Spina (eds.), *Conference Proceedings, 10th VAST International Symposium on Virtual Reality, Archaeology and Cultural Heritage*, pp. 57–64.

Parisinou, E. (2007)
"Lighting Dark Rooms: Some Thoughts about the Use of Space in Early Greek Domestic Architecture", in: R. Westgate, N. Fisher, and J. Whitley (eds.), *Conference Proceedings, Building Communities: House, Settlement and Society in the Aegean and beyond*, British School at Athens Studies 15, pp. 213–223.

Parker, M. P. (1999)
The Archaeology of Death and Burial, Great Britain.

Roussos, I. (2003a)
Image Based Flame Lighting, University of Bristol, (PhD thesis).

Roussos, I. (2003b)
"High Fidelity Lighting of Knossos", in: D. Arnold, A. Chalmers, and F. Niccolucci (eds.), *Conference Proceedings, 4th VAST International Symposium on Virtual Reality, Archaeology and Intelligent Cultural Heritage 2003*, pp. 47–56.

Sakellarakis, Y., and Panagiotopoulos, D. (2006)
"Minoan Zominthos", in: E. Gavrilaki and Y. Tzifopoulos (eds.), *Conference Proceedings, O Mylopotamos apo tin Archaiotita os Simera. Perivallon, Archaiologia, Istoria, Laografia, Koinoniologia, Rethymno*, pp. 47–75.

Sakellarakis, Y., and Sapouna-Sakellaraki, E. (1976)
"Anaskafh Archanon", in: *Praktika ths en Athinais Arxaiologikhs Etaireias*, pp. 351–385.

Sakellarakis, Y., and Sapouna-Sakellaraki, E. (1997)
Archanes: Minoan Crete in a New Light, vol. 1–2, Athens.

Scarre, C., and Lawson, G. (eds.) (2006)
Archaeoacoustics, Cambridge.

Shaw, J., and Shaw, M. (1996)
Kommos I: The Kommos Region and Houses of the Minoan Town, Princeton.

Soles, J. (1992)
The Prepalatial Cemeteries at Mochlos and Gournia and the House Tombs of Bronze Age Crete, Hesperia Supplements 24, New Jersey, American School of Classical Studies at Athens.

Sundstedt, V. Chalmers, and A. Martinez, P. (2004)
"High Fidelity Reconstruction of the Ancient Egyptian Temple of Kalabsha", in: *Conference Proceedings, 3rd International Conference on Computer Graphics, Virtual Reality, Visualisation and Interaction in Africa*, pp. 107–113.

Trigger, G. B. (2006)
A History of Archaeological Thought, Cambridge, MA.

Woodson, W. (1992)
Human Factors Design Handbook: Information and Guidelines for the Design of Systems, Facilities, Equipment, and Products for Human Use, 2nd edition, New York.

Yang, P.P.J, Putra, S.Y., and Li, W. (2007)
"Viewsphere: A GIS-based 3D Visibility Analysis for Urban Design Evaluation", in: *Planning and Design: Environment and Planning B* 34, 6, pp. 971–992.

Zacharias J. (2001)
"Pedestrian Behavior and Perception in Urban Walking Environments", in: *Journal of Planning Literature*, 16, 1, pp. 3–18.

Zányi, E. (2007)
"High Dynamic Range Display of Authentically Illuminated Byzantine Art from Cyprus", in: D. Arnold, F. Niccolucci, A. Chalmers (eds.), *Conference Proceedings, 8th VAST International Symposium on Virtual Reality, Archaeology and Cultural Heritage 2007*. pp. 87–92.

Kevin D. Fisher

Investigating monumental social space in Late Bronze Age Cyprus: an integrative approach

Abstract

The Late Bronze Age on Cyprus (c. 1650–1100 BCE) saw the appearance of monumental buildings that came to play an important role in changing patterns of social interaction and reproduction. Although these buildings often shared similarities in overall plan and the use of common design elements, I argue that the process of placemaking resulted in considerable variation in both their spatial configuration and the design of contexts for particular social interactions. Through its design and use in daily practice and social occasions, each monumental building developed its own biography and sense of place, ensuring that the experiences of its occupants and visitors were, in many ways, unique. I investigate this through a comparative study of two court-centred buildings, Building X from Kalavasos-*Ayios Dhimitrios* and Building II from Alassa-*Paliotaverna*. I apply an integrative approach that acknowledges the agency of both builder and building, combining access analysis with an examination of how built environments encode and nonverbally communicate meanings to those who used them.

1 Introduction

In contrast to its better-known neighbours in the eastern Mediterranean and Near East, the island of Cyprus is remarkable for the late development of many of the traditional hallmarks of state-level "civilization". It was only during the transition to the Late Bronze Age (LBA or Late Cypriot [LC] period, c. 1650–1100 BCE) that we see the widespread emergence of institutionalized social hierarchies, specialized systems of production and exchange, and international relations. At the same time, Cyprus witnessed the appearance of monumental buildings and new types of domestic and funerary architecture, followed soon after by the first cities. While these changes to the island's built environment are typically seen as by-products of demographic and politico-economic processes, I have argued, rather, that they represent acts of placemaking and played an active and vital role in the profound social transformations of the LC period (cf. Fisher 2013, in press). In particular, elites erected monumental buildings that became not only indelible landmarks, but also the primary arenas in which LC sociopolitical dynamics were enacted (Fisher 2009a).

Under the long-established influence of traditional art-historical perspectives, studies of Cypriot monumental buildings have tended to be descriptive, often focusing on their stylistic elements (usually as a means of attributing foreign influences) and technical aspects of their construction. Influenced by processual approaches in archaeology, the late 1980s and early 1990s brought attempts to see these buildings (and settlements more generally) from a functionalist perspective, emphasizing their role in local and regional systems of production and exchange. More recently, however, some scholars have adopted agent-

centred approaches that recognize the role of the LC built environment in social repro-
duction (Bolger 2003; Knapp 2008; 2009; Manning 1998; Smith 2009). Knapp (2008,
p. 211–249) certainly goes the furthest in this direction, acknowledging how the perform-
ances and experiences that occurred in monumental structures helped LC people to make
sense of their world. Nevertheless, these accounts do not address how monumental build-
ings structure movement and influence behavior through the design and elaboration of
particular contexts for specific types of social interaction. A further issue with many recent
accounts of LC architecture is an emphasis on the standardization of architectural forms
as one of its defining traits (e.g. Bolger 2003, p. 43, 49; Knapp 2008, p. 209; Wright 1992,
p. 211: "Π-shaped" buildings; cf. Negbi 2005).

In spite of superficial similarities in overall plan and the use of common elements
such as ashlar (cut stone) masonry, I argue that the process of placemaking resulted in con-
siderable variation in both spatial configuration and the design of contexts for particular
social interactions among LC monumental buildings – even among buildings regarded as
being of the same type. Through its design and use in daily practice and ritual occasion,
each monumental building developed its own biography and sense of place, ensuring that
the experiences of its occupants and visitors were, in many ways, unique. I investigate this
dynamic using an integrative approach that combines the topological emphasis of access
analysis with a focus on how built environments encode and nonverbally communicate
meanings to users.

I begin by outlining the theoretical underpinnings and methods of this integrative
approach before applying it to an analysis of social space in two court-centred monumental
buildings from the island's LC IIC–IIIA urban *floruit* (c. 1340–1100 BCE): Building X at
Kalavasos-*Ayios Dhimitrios* and Building II at Alassa-*Paliotaverna*.

2 An integrative approach

I take an approach to analyzing social space that acknowledges the agency of both people
and the built environments they construct and inhabit. This approach takes a cue from
Giddens (1984) and related social theorists, who argue that it is through practice, or the rou-
tinized actions of knowledgeable agents, that the structural properties of societies are pro-
duced and, at the same time, reproduced or transformed. As the primary contexts in which
practice is enacted, built environments are both product and producer of social life. I see the
design, construction and use of these contexts as acts of placemaking. This implies a dis-
tinction between space and place, something now widely accepted across the social sciences
(Feld and Basso 1996; Low and Lawrence-Zúñiga 2003; Preucel and Meskell 2004; Tuan
1977). While space generally refers to the static, physical setting in which everything occurs,
place is the dynamic, socially-constructed and meaningful context of human action and
experience. But how do places influence social action and interaction?

In their landmark review of built environment studies, Lawrence and Low (1990, p. 482–491) argued the need for approaches that integrate the social production of built form and its impact on social action with insights gained from environmental psychology and symbolic approaches that emphasize the role of built form in the communication of meaning. I have developed such an integrative approach by combining the topological emphasis of access analysis with a focus on how built environments transmit meanings through nonverbal communication. Its aim is to determine the types of social interaction that might take place in particular contexts, thereby fleshing out and re-populating past built environments. I have discussed this approach in detail elsewhere (Fisher 2007, chapters 4–5; 2009b) and provide only a brief summary here.

Social interaction requires the co-presence of individuals (Giddens 1984, p. 64–73; Goffman 1963, p. 17–18). In recognizing different types of interaction, Erving Goffman (1963, p. 18–24) distinguished between transitory *gatherings* in which two or more individuals are momentarily in one another's presence, and *social occasions*, which are undertakings or events that also involve co-present individuals, but which are bounded in time and space and often facilitated by fixed equipment. Occasions range from some of the more routine aspects of daily life (e.g. the regular preparation and consumption of a meal), while others are more formally defined in terms of time, space and participants. In order to identify likely contexts for social occasions, it is necessary first to understand how a building structures movement and encounter among its occupants and between occupants and visitors. Access analysis, derived from space syntax, achieves this by determining how individual spaces are integrated into the overall spatial configuration (Hillier and Hanson 1984; Hillier, this volume). It involves translating a building into a graph in which each room or space is represented as a circle, with direct access between rooms represented as lines linking the circles together. The spaces can be 'justified' by lining them up in levels according to their depth from the point of origin, resulting in a j-graph (e.g. see fig. 4). From this, one can measure *integration*, or how accessible each space is from any other point in the structure; *control*, or the degree of control a space exercises over its immediate neighbours; and *depth*, or how many spaces one would move through to arrive at another space, usually from outside the building (cf. Hillier and Hanson 1984, p. 143–175).[1] Access analysis allows us to

1 Integration is expressed here as *relative asymmetry* (RA), a measure of how accessible a space is from any other space in the structure. To calculate it, one must first calculate *mean depth* (MD), which measures how deep the space is, relative to the other spaces in the building: MD = the cumulative depth of each space/p-1, where p is the number of points in the system (see Hillier this volume). Then, RA = 2(MD-1)/k-2, where k is the number of spaces in the system. RA values are standardized to provide a value between 0 and 1, with a higher score indicating less accessibility or integration. They are then converted to *real relative asymmetry* (RRA) values by dividing them by their D-value (cf. Hillier and Hanson 1984, table 3) in order to allow comparisons between systems with different numbers of spaces. RRA scores can be classified as high, medium, or low by dividing a ranked set into thirds, while keeping equal RRA scores within the same category (Note that in some recent applications of space syntax, integration is measured as the reciprocal of RRA). Control is expressed as a *control value* (CV), the degree of control a space exercises over its immediate neighbours. Each space in the building is assigned a value of 1, which is

see pathways movement through a structure, providing insight into potential locations for interaction between inhabitants and visitors. Unfortunately, however, the topological emphasis of this method obscures or ignores elements of built environment, including everything from the size and shape of a room, to its contents and décor, that encode and communicate meanings that can profoundly influence human behavior (Bechtel 1997; Hall 1966; Stokols and Altman 1987; cf. Fisher 2007, chapter 3 for a summary).

Amos Rapoport's (1990) nonverbal communication approach provides a comprehensive framework for examining this phenomenon. It is based on the premise that built forms are created to provide cues to users that inform them of proper or expected behavior (fig. 1). These meanings are encoded in fixed-feature elements such as walls and floors, semifixed-feature elements such as furnishings and other artifacts, and nonfixed-feature elements including the physical and verbal expressions of the building's occupants and users. They are then communicated to the users of a space, potentially influencing their actions and interactions. Redundancy in meanings across these elements increases the likelihood that the message will be properly understood, although it by no means guarantees either comprehension or compliance. In order to investigate this phenomenon, I recorded the size and relative convexity ('squareness') for each space in the buildings examined below, as well as the locations and characteristics of various features and artifacts, such as masonry, doorways, hearths, wells and benches. To this we can add insights gained from Hall's (1966) research on *proxemics*, the study of people's use of space as an aspect of culture (table 1). It is especially useful in illuminating the relationship between interpersonal spacing and human sensory perception during social interaction and can suggest a range of distances at which certain types of social interaction might take place (cf. Wheatley, this volume). Taken together, the syntactic and architectural properties of each space allow one to determine its potential to host social interaction and whether that interaction would more likely be public-inclusive or private-exclusive in nature (table 2).

While many senses are engaged in wayfinding and the perception of cues during interaction, vision is perhaps the easiest to assess in many archaeological contexts (cf. Wheatley, this volume, for a full discussion of vision and its relationship with other senses). We can begin to capture something of the visual experience of significant spaces or movement through built space using the concept of the *isovist*, defined as the set of all points visible from a particular vantage point in space (Benedikt 1979, p. 47). Given the limitations of representing a three-dimensional phenomenon in two dimensions, these appear as polygons. It is possible to increase the analytical power of an isovist by coding it with a series of concentric circles representing Hall's proxemic thresholds (e.g. see fig. 8). The isovist can also

equally divided among each of the neighbouring spaces to which it has direct access. These are then totaled for each space, and the higher the number, the more control the space exerts over adjoining spaces. Control values can also be ranked, with values of 1.0 or less being "low", while values > 1.0 but = 2.0 are "medium", and those > 2.0 are "high".

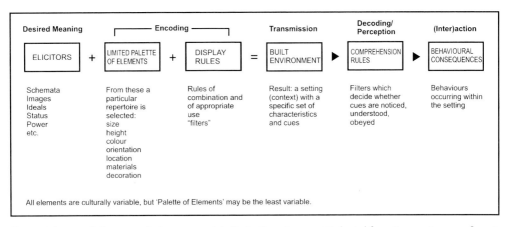

Figure 1 | A nonverbal communication approach to the built environment (adapted from Rapoport, p. 199, fig. 17).

Table 1 | Proxemic distances and corresponding effects on perception (based on Hall 1966, p. 116–129).

Proxemic Threshold	Intimate	Personal	Social (Near Phase)	Social (Far Phase)	Public (Near Phase)	Public (Far Phase)
Distance	0–0.45 m	>0.45–1.2 m	>1.2–2.15 m	>2.15–3.65 m	>3.65–7.6 m	>7.6 m
Touch	Can touch easily; accidental contact is possible	Can reach out and grasp extremity at near phase; cannot touch beyond c. 0.75 m	2 people can pass an object back and forth by both stretching (up to c. 3 m).			
Oral/Aural	Soft voice; intimate style Conventional modified voice; casual or consultive style		Loud voice used when speaking to group Full public-speaking voice; frozen style			
Detailed Vision (Foveal)	Details of eyes, pores on face, finest hairs visible; vision can be distorted or blurred	Details of face clearly visible	Can see head hair clearly; wear on clothing apparent	Fine lines of face fade; lip movement seen clearly	Eye colour not discernable; smile vs. scowl visible	Difficult to see eyes or subtle expressions
60° Scanning Vision	1/3 of face; some distortion	Takes in upper body	Upper body and gestures	Whole seated body visible Whole body has space around it in viewshed; postural communication becomes important		
200° Peripheral Vision	Head against background visible	Head and shoulders visible	Whole body visible	Other people seen if present Other people become important in vision		

Table 2 | Architectural and syntactic correlates of public-inclusive and private-exclusive social interactions.

"PUBLIC" – INCLUSIVE OCCASIONS

- Medium to high CV

- Low RRA

- High convexity score (>0.6) and area >12 m² (space will be large and tend toward square)

- Generally low depth measure (i.e. space is shallow or close to exterior), but if depth measure is high, the space will likely be on a major axial route

- Space is more likely to contain important fixed- or semifixed-feature elements (e.g., ashlar masonry; formal hearths, etc.)

- Likely to have wider doorways

"PRIVATE" – EXCLUSIVE OCCASIONS

- Low CV (space is less subject to intrusion)

- Medium-High RRA (space is not easily accessible/not well integrated)

- Generally high convexity, although size is not an important factor

- Likely to have high depth measure

- Likely to have more narrow doorways

be expanded to include all the points visible from a particular space, or what I call an *isovist field* (e.g. see fig. 3; cf. Batty 2001; Benedikt 1979). It can also be modified to include only a subset of points, or *viewshed*, which indicates what is visible from the perspective of the viewer facing a particular direction (cf. Fisher 2009a, p. 448–51; e.g. cf. fig. 5). Recent advances in 3D modeling and visualization hold the promise of significantly advancing this kind of approach and our ability to understand how people perceived and experienced past built environments (e.g. Paliou et al. 2011; Paliou, this volume; Papadopoulos and Earl, this volume).

The integrative approach outlined here provides a means of investigating the materiality of past built environments, allowing significant insights into the relationship between people and the places in which they lived, as well as the wider social implications of this relationship. The dynamics of this relationship were enacted at multiple spatial scales, from the body itself, through individual buildings and their constituent parts, to various levels of community. In what follows I will apply the integrative approach to two ostensibly similar monumental buildings from the island's Late Bronze Age.

3 A tale of two buildings

This period culminated in what some scholars see as the emergence of state-level socio-political organization on the island (cf. Knapp 2008, p. 144–159 for a full discussion). Whether this took the form of a centralized, island-wide polity or a series of regional polities (or vacillated between these forms), it is clear that emerging inequalities gave way to social hierarchies as elites institutionalized their power through intensified control over increasingly centralized systems of production and exchange, legitimized through ideological means (Knapp 1988). At the same time, society became increasingly heterarchical as various collectivities emerged in the context of new social, economic and political networks and opportunities (Keswani 1996; 2004, p. 154–57). New urban environments were both product and producer of these transformations. The earliest cities were founded during a formative "Proto-urban" phase (Middle Cypriot [MC] III–Late Cypriot I; c. 1750–1450 BCE), which also saw the construction of the first monumental buildings – a series of forts, which appear in the northern and eastern parts of the island (cf. Fortin 1981).

This was followed by a fully-urban phase during the 14th through early 12th centuries BCE (LC II–IIIA periods) that witnessed the (re)construction, 'urbanization' and monumentalisation of a number of settlements. If the admittedly limited exposures at sites such as Enkomi and Kalavasos-*Ayios Dhimitrios* are any indication, the design and construction of the new urban centres involved the architectural definition of the majority of space within the urban areas. New monumental buildings, often built at least partially of ashlar masonry, were an integral part of these new urban landscapes and potent materializations of elite power and control over human and material resources. In the fully-urban phase of the Late Bronze Age, these buildings came to replace the funerary realm as the primary venues in which social dynamics were enacted. Whatever other practical and symbolic functions they may have had, I have argued that the capacity to provide appropriate contexts for social interactions that could emphasize or downplay social distance was, ultimately, their main purpose (Fisher 2009a).

The Ashlar Building at Maroni-*Vournes*, Building X at Kalavasos-*Ayios Dhimitiros*, and Building II at Alassa-*Paliotaverna* were all built during this fully-urban period. Each has been described as the administrative centre or focus of power for both its site and the wider region (Cadogan 1996, p. 18; Hadjisavvas 2000, p. 396; South 1992, p. 195). These buildings share a number of general similarities suitable for this role, including large size, the extensive use of ashlar construction; location within a distinct administrative or elite sector of their respective sites; a layout based on units or wings arranged around a large central hall or court; and the provision of large-scale production facilities (at least at Maroni and Kalavasos), monumental storage facilities, and spaces suitable for public-inclusive social interactions up through the far phase of public distance as well as private-exclusive interactions. Hadjisavvas (2000, p. 388) has suggested that, with these shared characteristics, the three buildings could justify a "special classification". In the following, I will limit my dis-

cussion to the two buildings that share the most formal similarity – those at Kalavasos and Alassa.

In spite of this general formal similarity, I will show how each building incorporated architectural elements in distinct ways, materializing different approaches to the expression of monumentality and the control of movement and occupant-visitor interaction. Not only would users have experienced each building differently, but each structure developed a unique biography through its construction and use. It is important to note that neither of these buildings has been fully published. Much of the following is based on various preliminary reports and my own observations from site visits.

4 Building X at Kalavasos-*Ayios Dhimitrios*

The site of Kalavasos-*Ayios Dhimitrios* is located in south-central Cyprus in the Vasilikos River valley about 3.5 km from the Mediterranean coast. Excavations there, directed by Alison South, were initiated in 1979 in advance of the construction of the new Nicosia-Limassol highway, which cuts through the centre of the site (South et al. 1989, fig. 2). This work continued until 1996, revealing an important urban centre that reached its zenith during the LC IIC period (c. 1340–1190 BCE). Excavations in several areas of the 11.5 ha site recovered the remains of various buildings and roads that are largely oriented to the northwest, indicating that much of the city was laid out on a preconceived plan (South 1996, p. 41; Wright 1992, p. 115).

Located in the north-eastern "administrative" area, Building X is by far the largest and most elaborate building yet found at the site (fig. 2). Sometime in the mid-LC IIC, it was reconstructed (I would say monumentalized) with the addition of various types of ashlar masonry (South 1997, p. 173). It is a multifunctional complex, with evidence for economic production, storage and administration on the first floor, as well as a now-missing upper floor that may have been residential space. It lies at the end of the city's main north-south road, which widens as it approaches the building, taking on something of the appearance of a processional way. Not coincidentally, a series of elite chamber tombs, some of which were still in use during Building X's occupation, were found in the road as it comes to an end between Buildings XII and XV (South 2000). Looking northward, their backdrop is the southwest corner of Building X, which has the most elaborate form of ashlar masonry, a shell-wall consisting of a plinth of long rectangular blocks with drafted margins, surmounted by an orthostat of taller blocks, also with drafted margins. This, in turn, would have been topped by a superstructure of plastered mudbrick (South 1984, p. 19).

The core of the building is square (30.5 × 30.5 m) and is conceived on a tripartite plan with three parallel sectors along the front. An additional sector or annex runs transversely across the north end, bringing the total north-south length to 35–37 m. The main entrance is from the south, leading through a vestibule (Room 154) into a large central court (Room

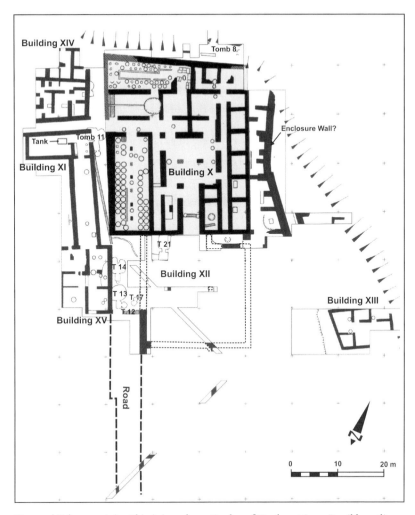

Figure 2 | Kalavasos-*Ayios Dhimitrios*, schematic plan of Northeast Area. Possible outline of Building XII shown based on robber's trenches (modified from plan provided by A. South).

157). The central unit and its associated rooms are flanked by long hallways that provided access on the east to a series of small rooms and, on the west, a massive storeroom (discussed further below). In the northwest corner of the building were facilities for the production and storage of olive oil. In the detailed plan provided (fig. 3), I have indicated doorways to each of the rooms along the east of Hallway 158. While the doorways are not preserved, it is unlikely that the hallway would have run nearly the entire length of the building if not to provide access to these rooms, with the doorway preserved in the west wall of Room 171 providing a precedent for this arrangement.

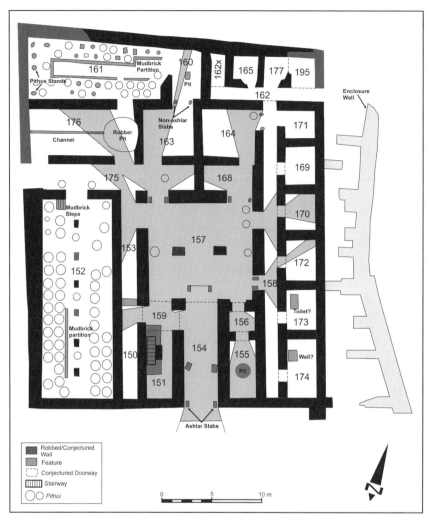

Figure 3 | Kalavasos-*Ayios Dhimitrios*, Building X schematic plan showing isovist field from central court (drawn by author based on schematic plan provided by A. South).

Syntactically, Building X is quite shallow; no room is more than three levels deep from the carrier, and someone entering from the outside is never more than one level away from a space that controls access to several other spaces (e.g. Rooms 157, 162, 158 and 175 [fig. 4]). Indeed, nearly every room in the building is directly accessible from one of the primary access spaces: the central court, Hallways 162 and 158 in the east, and Hallway 175 in the northwest. It is clear that Building X was purposefully designed to facilitate the circulation of traffic throughout its ground floor.

Not surprisingly, the central court would have played an important role in structuring daily practice and is well suited to hosting public-inclusive social interactions. It is the most

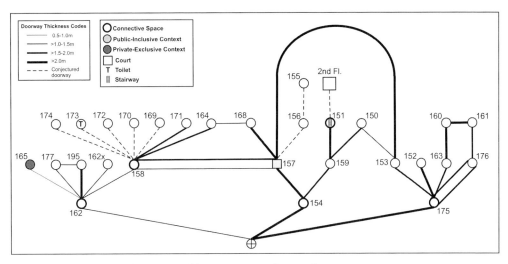

Figure 4 | Kalavasos-*Ayios Dhimitrios*, Building X access graph (j-graph).

integrated space in the building (RRA score of 0.52), has a medium control value (1.78) and is on the axial route from the building's main entrance (table 3). Covering an area of 97.5 m², it is the second largest room in the building and is nearly square, having a relative convexity measure of 0.87. The central court has an extensive isovist field that penetrates into several of the surrounding parts of sections of the building (fig. 3). In terms of fixed- and semifixed-feature elements, the walls of this room, at least on the north, east and west sides were likely faced with ashlar blocks, although smaller and less elaborate than those along the building's west wall. Currently, however, only a few such blocks remain *in situ*. The pebble floor is of a type normally found in outdoor spaces elsewhere in the city, leading South (1984, p. 22) to suggest that the court was an open area. A large ashlar block was set into the floor of the east part of the court, while a large pit with ashlar fragments located in the same position on the west side of the court undoubtedly held an identical block. These blocks were likely bases for columns that formed a portico, in which one half of the court (or the east and west sides) may have been covered by a roof.

The main entry to Building X was through an impressive vestibule or entry hall (Room 154), although it is unclear precisely how this articulated with Building XII, a partially-excavated structure immediately south of Building X (South 1991, p. 136–7). Building XII appears to have been a pillared hall or court of ashlar construction, although much of the masonry was robbed-out in antiquity. Wall trenches where ashlar blocks probably stood appear to adjoin the south wall of Building X, suggesting that one may have had to enter Room 154 through Building XII. In any case, the elaborate entry hall to Building X was characterized by pairs of inset ashlar blocks that marked the entry and the mid-point of the room. While South (1984, p. 20–21) suggests that these blocks might have supported a stone or wooden threshold slab, it is more likely, given the underlying foundation layer of

Table 3 | Kalavasos-*Ayios Dhimitrios,* Building X ranking of key syntactic and architectural properties. Darker shaded cells indicate private-exclusive spaces; lighter shaded cells indicate public-inclusive spaces.

CV Rank			RRA Rank			Depth Rank	
Room	CV		Room	RRA		Room	Depth
169	0,IIII	low	157	0,5171	low	154	1
170	0,IIII	low	158	0,5579	low	162	1
171	0,IIII	low	154	0,5715	low	175	1
172	0,IIII	low	162	0,5852	low	152	2
173	0,IIII	low	Carrier	0,5852	low	153	2
174	0,IIII	low	153	0,6532	low	157	2
165	0,1667	low	175	0,7212	low	158	2
162x	0,1667	low	156	0,8709	low	159	2
152	0,2000	low	159	0,9117	low	163	2
155	0,5000	low	164	0,9117	low	165	2
2nd Floor	0,5000	low	168	0,9117	low	176	2
164	0,6111	low	150	0,9390	medium	177	2
150	0,6667	low	169	0,9390	medium	195	2
177	0,6667	low	170	0,9390	medium	162x	2
195	0,6667	low	171	0,9390	medium	150	3
163	0,7000	low	172	0,9390	medium	151	3
168	0,7000	low	173	0,9390	medium	156	3
176	0,7000	low	174	0,9390	medium	160	3
Carrier	0,7000	low	177	0,9526	medium	161	3
154	0,8667	low	195	0,9526	medium	164	3
153	0,9000	low	165	0,9662	high	168	3
160	1,0000	low	162x	0,9662	high	169	3
161	1,0000	low	163	1,0614	high	170	3
156	1,2000	medium	176	1,0614	high	171	3
151	1,3333	medium	152	1,1022	high	172	3
159	1,3333	medium	155	1,2519	high	173	3
157	1,7778	medium	151	1,2655	high	174	3
175	2,6667	high	160	1,4016	high	155	4
162	3,4444	high	161	1,4016	high	2nd Floor	4
158	6,8667	high	2nd Floor	1,6466	high	Carrier	na

Relative Convexity Rank			Total Door Width Rank		Mean Door Width	
Room	Area m2	Rel.Conv.	Room	Total Width	Room	Mean Width
158	36,82	0,05	165	1,00	165	1,00
162	13,38	0,11	162x	1,20	162x	1,20
175	39,72	0,15	171	1,60	177	1,23
153	16,64	0,15	177	2,45	162	1,37
150	14,72	0,17	152	2,50	150	1,55
154	33,64	0,31	151	3,00	171	1,60
152	135,45	0,36	150	3,10	158	1,61
162x	3,84	0,38	164	3,40	164	1,70
161	67,58	0,38	195	3,45	195	1,73
176	46,64	0,42	168	3,85	153	1,77
151	20,36	0,43	161	3,90	176	1,85
174	16,52	0,47	163	3,95	168	1,93
168	12,50	0,48	160	4,20	161	1,95
155	16,24	0,48	153	5,30	163	1,98
160	14,01	0,62	176	5,55	175	2,01
156	4,95	0,65	159	6,55	160	2,10
159	9,50	0,66	Carrier	6,90	157	2,15
172	11,20	0,70	158	8,05	159	2,18
169	10,08	0,78	154	8,15	Carrier	2,30
173	10,08	0,78	162	8,20	152	2,50
164	22,79	0,81	157	10,75	154	2,72
170	9,66	0,81	175	12,05	151	3,00
157	97,52	0,87	155	?	155	?
163	22,50	0,90	156	?	156	?
165	5,63	0,90	169	?	169	?
195	4,40	0,91	170	?	170	?
171	7,84	1,00	172	?	172	?
177	4,20	1,00	173	?	173	?
2nd Floor	na	na	174	?	174	?
Carrier	na	na	2nd Floor	?	2nd Floor	?

rubble, that these blocks were meant to be visible and that they were actually the terminals of some kind of wooden (or perhaps even ashlar) threshold. The north end of the entry hall was further distinguished by steps leading up to the slightly higher elevation of the court, and this transition was also marked by a pair of smaller ashlar slabs. A line of charcoal ran between the two slabs (South, 1984, p. 21), suggesting that they were ends of what may have been another wooden threshold. These thresholds clearly marked the significance of movement into (or out of) the court. They also served as nonverbal cues that funneled both the movement and viewsheds of visitors toward the court, gradually revealing this impressive monumental space as one moved forward (fig. 5). The entry hall likely served as a liminal space between the commonly accessible space of the outside of the building (or, possibly, Building XII) and the ideologically-charged space of the elaborate central court – the physical and symbolic heart of the building. It is significant that similar sets of ashlar blocks flanked other doorways into the court, including the south entry on the eastern wall and the east and west entries along the northern wall. The central hall was clearly a space within which gatherings would have occurred in the course of daily practice, but there is some circumstantial evidence for its use in important public-inclusive occasions.

In nearby Room 173, which was paved with irregular, uncut stones, a deep, rectangular shaft was discovered that may have been a latrine (cf. South 2008, fig. LXIIa). Within its fill was a deposit that contained, in addition to numerous botanical remains, 4.5 kg of animal bones, including large numbers of meat-bearing joints of sheep and goats, single bones from a pig and a cattle- or equid-sized creature, birds, fish and rodents (South 2008, p. 311). Associated ceramic remains consist of at least 85 vessels with Mycenaean vessels and local Mycenaean imitations comprising at least 62 % of the assemblage, and the imports making up about 75 % of that amount (South and Russell 1993, p. 306). Open forms such as cups and shallow bowls were predominant in the assemblage. While a few vessels are complete, most are broken but easily restorable (with joins being found at distinctly different depths), suggesting that the material was deposited over a short period of time (South 1988, p. 228). I suggest that this deposit represents the remains of a feasting event that likely took place in the central court and that the vessels may have been broken in an act of conspicuous consumption that must have ended the occasion (cf. South 2008, p. 312). The role of feasting in the negotiation of social relations and development of power is well established (e.g. Bray 2003; Dietler and Hayden 2001; Wright 2004), and it is clear that it was an integral part of the social lives of LC elites (Fisher 2009a; Steel 2004).

The central court provided a suitably impressive context for such an event, during which as many as 180 seated guests could participate.[2] The size of this space would have

2 Room capacity is a function of its area, and I calculate maximum occupancy based on modern architectural standards for density of people seated on benches or chairs (1.9 persons/m^2) and standing in a group situation of "normal spacing" (3.4 persons/m^2) (Neufert and Neufert 2000, p. 16–17; cf. Fisher 2007a, p. 101–102). The maximum seated capacity is 185 persons, but allowance is made for the presence of the large columns.

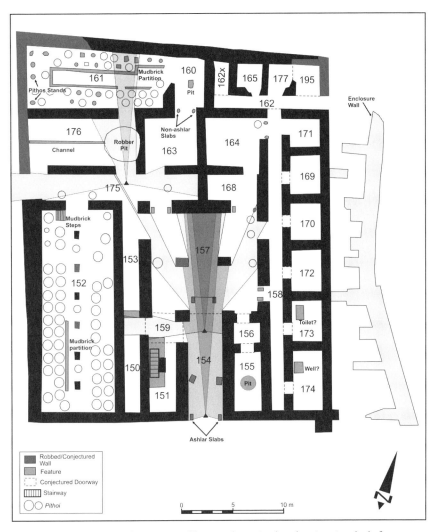

Figure 5 | Kalavasos-*Ayios Dhimitrios*, Building X schematic plan showing viewsheds from two points in Room 154 as one moves toward the central court; and from Room 175 though to Room 161.

permitted interactions up to the far phase of public distance. Interestingly, the central court is the only space in the building with the characteristics suitable for public-inclusion occasions. Adjoining rooms with lower control values, such as Rooms 164 and 168 to the north or 156 and 155 to the south, might have been employed during these occasions if contexts were needed for interactions that required more exclusivity and less chance of interruption. While there is no direct evidence for food preparation within the building, South (1988, p. 227) suggests that the space between the east wall of Building X and the enclosure wall, with its pebble floors and drains, might have served as kitchen space.

In addition to the social occasions held within the central court, I would argue that some visitors were also expected to see Room 152 – the Pithos Hall. This monumental space was an immense rectangular hall that occupied the entire southwest corner of the building. It is the largest room in Building X (135 m²) and, as noted above, has the most elaborate type of ashlar masonry along its west wall. The south wall, which was robbed of its ashlar facing, was probably similarly constructed, while the remaining walls were constructed with well-built rubble socles (South 1984, p. 22). Six monolithic ashlar columns that were a minimum of 2.5 m high (only four of which are partly extant) were aligned on the longitudinal axis of the room and supported its roof.

While architecturally impressive, the most striking feature of this hall was its contents. It was filled with over 50 massive *pithoi* (ceramic storage jars), most standing in rows running the length of the hall, while six others were sunk into the ground between the columns and in the northeast corner, with their rims at floor level. These vessels were typically ovoid or piriform in shape, ranging from 1.5–2.0 m in height with rim diameters of 0.50–0.68 m (Keswani 1989, p. 17–18). Most of the pithoi stood on regularly-spaced flat stones, their bases still found *in situ* (South 1984, p. 19). They had a combined capacity of c. 33,500 litres and gas-chromatography analysis indicates that many (if not all) of them contained olive oil (South 1989, p. 321). The single entrance to the Pithos Hall results in the room being poorly integrated into the overall plan, making it clear that control over access to this room and its valuable contents was a priority.

The view into the Pithos Hall from this entrance in the north wall (from Hall 175) would have been an impressive one, enhanced by the symmetry of the room and arrangement of the ashlar columns and rows of pithoi along the hall's longitudinal axis. In describing this sort of arrangement, Keswani (1989, p. 16–17) notes that, "when intact, each individual vessel would have been extremely imposing in appearance; grouped together, they must have conveyed a tremendous impression of agricultural wealth." I suggest that these "mega-pithoi" (Keswani 1989, p. 17) were monumental objects in their own right and symbolic not only of the wealth represented by their contents, but also of the highly skilled labor required to produce them and the ability of Building X's occupants to control such labour (or at least procure its products). Contemporary ethnographic studies indicate that these hand-made vessels were likely products of a highly specialized craft based on the inter-generational transmission of traditional skills (Keswani 1989, p. 17). Their immense size and weight (especially once full) meant that they were probably rarely, if ever, moved, lending them a sort of permanence that was hardly less than that embodied by the massive ashlar blocks and columns. The few large pithoi placed in the central court (whatever their contents, if any) carried this iconic function into a highly visible space, serving as a constant reminder of the economic power of Building X's occupants. These pithoi were placed so as to be within the viewshed of someone about to enter the central court from Room 154 (cf. fig. 5). It is not surprising that two pithoi (although smaller than the largest examples) also flanked the doorway to the Pithos Hall itself, rendering this

entrance clearly visible to anyone in Hallway 175, while also symbolizing the Pithos Hall's valuable contents. I would go so far as to say that the "mega-pithoi" were an important expression of LC elite identity.

The adjoining production and storage facilities in the northeast corner of the building were also impressive. Room 176, across Hall 175 from the Pithos Hall, appears to have been used for the production of olive oil. It is probable that the large robber pit at the east of this room was occupied by a massive stone collection/settling tank, similar to that found set into the floor of Room 185 in nearby Building XI (South 1992, p. 137–139; 1997, p. 154). Using the tank in Building XI as an analogy, it is likely that the Room 176 tank was carved from a single block of calcareous sandstone (of the same type used for the most the building's ashlar masonry) weighing some 2.6 tons and with a capacity in the 2000 litre range (South 1992, p. 137; 1996, p. 43). Gas chromatography analysis of the Building XI tank shows that it contained olive oil (Keswani 1992, p. 141–144). Adjoining this room on the north was another storage hall, somewhat less grand than the Pithos Hall, but nevertheless remarkable. It contained an estimated 46–50 pithoi, mostly of smaller size than those in the Pithos Hall (Keswani 1989, p. 15–16; South 1991, p. 132). Like the Pithos Hall, the low control value (1.0) and high RRA score (1.40) of this room suggest a concern for the security of its contents.

It is notable that Rooms 176 and 161 were separated by an elaborate ashlar wall (similar to that along the west side of the Pithos Hall) that had a doorway at its east end. It is also significant that this doorway is aligned with the east doorway along the south wall. Given the location of the tank and the fact that pithoi blocked direct access from Room 176 into Room 161, it is highly unlikely that these doorways were meant to facilitate movement from Hall 175 through to Room 161. I would argue instead that these doorways were aligned so as to permit a viewshed from the south doorway looking northward that took in the tank as well as a portion of four rows of the large pithoi framed by the ashlar masonry (cf. fig. 5).

Given its singular size, monumental construction and finds of five clay cylinders inscribed with Cypro-Minoan characters (cf. Porada 1989, p. 33–37; Masson 1989, p. 38–40), it is clear that Building X was the administrative centre of Kalavasos-*Ayios Dhimitrios*. The facilities in the western part of Building X suggest that it was designed in part to allow the production and storage of olive oil. More importantly, however, the fixed- and semifixed-feature elements of these spaces were purposefully created to provide visitors, as well as those who worked in the facilities, with an indelible reminder of the power of Building X's occupants. This dynamic was also materialized in the syntactic and architectural properties of the main entrance and the central court. The court played an essential role in structuring daily practice within the building, while sometimes hosting important public-inclusive social occasions such as ceremonial feasting that also brought together occupants and visitors. A plan based around a central court is but one of several common features which Building X shared with the slightly larger Building II from Alassa-*Paliotaverna*. Yet, in spite of some general similarities in these aspects, a detailed spatial analysis of Build-

ing II reveals important differences that speak to the somewhat different intentions of its builders.

5 Building II at Alassa-*Paliotaverna*

The site of Alassa is located in south-western Cyprus about 10 km north of Episkopi (ancient Kourion) and is situated in a triangle of land bordered by the Kouris River on the west, the Limnatis River on the east and the foothills of the Troodos Mountains on the north (Hadjisavvas 1986, fig. 1). In response to the threat of flooding from the construction of the Kouris Dam, the Department of Antiquities undertook a survey in the area in 1983 (Hadjisavvas 1986, p. 63). The resulting investigations revealed a LC site that extended across the *Paliotaverna* and *Pano Mandilaris* localities, an area of around 12.5 ha (Knapp 1997, table 2; cf. Hadjisavvas 2000, p. 393, who estimates the site size at 50 ha). Excavations during the 1990s at *Paliotaverna*, the upper part of the settlement, revealed a group of three large buildings, two of which were built wholly or partially of ashlar masonry (Hadjisavvas 1994). Two monumental buildings were built on the same orientation, separated by a 4.3 m wide street (fig. 6). Building I was severely damaged by ploughing (Hadjisavvas 1994, p. 107), but appears to have been a rectangular columned hall. Immediately to the north (upslope), across the street, excavators recovered a massive building constructed entirely of ashlar masonry. Building II is a square, Π-shaped building, measuring 37.7 m per side, and designed around a large central court open on its east end. It is clear that a major leveling operation took place in order to prepare the site for the construction of this edifice, including the excavation of the upper slope of the hill and the elevation of the lower slope (Hadjisavvas 2003a, p. 434). A smaller (ca. 25 × 16 m) three-room building on a different orientation, known as Building III, was excavated about 20 m to the east. Finds of pithos sherds and a wine press suggest that this may have been a production and storage annex to Building II (Hadjisavvas 2001a; Steel 2003–2004, p. 96–97).

Building II is the largest and most architecturally elaborate building yet found from the LCII–IIIA period. Nearly all the masonry is of the most elaborate form of ashlar construction with a plinth (built as a shell around a rubble core) surmounted by a wall of large orthostats (also of shell construction), both of which had blocks decorated with drafted margins. This was topped by a mudbrick superstructure, and traces of red pigment were noted on some examples (Hadjisavvas 2003a, p. 434). Many of the plinth blocks and some of the orthostats (particularly on the outer walls) also retained their lifting bosses as decorative elements. Hadjisavvas (2003a, p. 436) argues that its original construction dates to the LC IIC (specifically the 14th century BCE) and that, near the end of the LC IIC or early LC IIIA, the North Wing storage hall was added and the South Wing was remodeled. A Medieval period re-occupation of the West Wing and part of the central court has rendered identification of the function of rooms in that part of the building "impossible", although it is clear that the

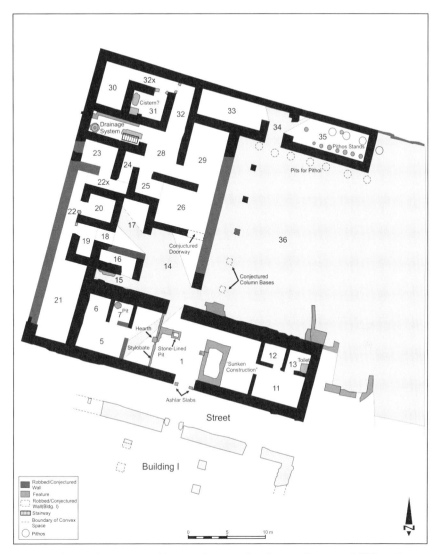

Figure 6 | Alassa-*Paliotaverna*, Building II schematic plan showing the isovist field from the central court (Room 36). The southern extent of the isovist field beyond Building II is unclear (drawn by author based on Hadjisavvas 2003b, fig. 4).

northwest part of the building housed a sophisticated drainage system (Hadjisavvas 2003a, p. 434–435). The South Wing, after the late LC IIC or LC IIIA renovation, had a symmetrical interior structure with a large central hall and smaller rooms at the east and west ends. The walls of Building II were certainly large enough to support at least one additional story (probably the living quarters; cf. Hadjisavvas 2000, p. 396), and it is likely that there was a stairway and possible lightwell in Room 27 (Hadjisavvas and Hadjisavva 1997, p. 146).

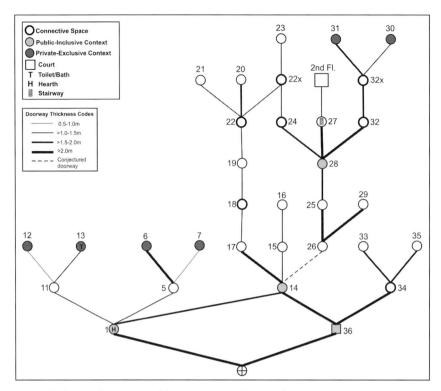

Figure 7 | Alassa-*Paliotaverna*, Building II access graph (j-graph).

The access graph (fig. 7) indicates that the various wings of Building II are not well integrated. The West Wing, which contains most of the rooms in the building, is quite deep, with three rooms at a depth of 8 from the carrier (table 4). In addition, there are only two circulation rings in the whole building, one entirely within the West Wing and one that links the central court with the west and south wings. Both of these rings link up at Room 14, which is also a space of convergence for the two axial paths that penetrate into the building from the carrier. One could enter Building II either at the South Wing, off the street, or through the east side of the central court, which appears to have been largely open.

While it is uncertain whether the east opening of the court (Room 36) was intended as the main entrance to Building II, it would have provided a most impressive viewshed for those approaching the building from that direction. The nature of the space in front of the court (i.e., immediately to the east) is not discussed in the published reports, although a small scale plan of the excavation area suggests that this would have been a relatively open space (Hadjisavvas 2003a, fig. 2). Some effort was made to enclose it on the north with a line of ashlar blocks, some with drafted margins, that continues eastward for a few metres along the bedrock cut just north of Building II's north façade. There is also what may have

been a wall at the south end of this "forecourt" projecting some 5 m perpendicular from the centre of the east wall of the south wing.

The court itself is by far the largest space in the building (399 m²), and indeed the largest space of any building from this period on Cyprus. The impressiveness of this monumental space was enhanced by a portico that ran along at least part of its west wall. Two massive ashlar blocks were set into the floor, aligned along the west end of the court, probably serving as column bases. A third was likely robbed from a pit located to the south along this same line and at the same interval of spacing, and it is likely that two other similar, but now missing, blocks on the same alignment would have completed the portico. The court had the architectural and syntactic characteristics suitable for public-inclusive social occasions and could have accommodated a maximum of 758–1356 people, depending on whether they were seated or standing and not including the space of the "forecourt" to the east. This space would permit interactions through to the far phase of public distance. Given the sheer monumentality of this space, one might expect that it served as a venue for occasions in which large groups of people might witness some form of performance or ritual that may have been theatrical in nature. As Hall (1966, p. 125) notes, voice and movement must be amplified or exaggerated to be perceived at such public distances. Compared with the central court in Building X at Kalavasos, Alassa's court was poorly integrated into the overall plan (1.07 RRA compared with 0.51 for Building X; cf. table 4). In addition, the isovist field from Building II's central court does not penetrate very deeply into the adjoining parts of the building or cover much area beyond the court itself (fig. 6).

Unfortunately, the published materials offer little to shed light on the use of the space, except perhaps the pithoi that were reportedly found in various pits in the courtyard (Hadjisavvas 2003a, p. 435). Given their role as containers for produce (solid or liquid), one might suggest that the distribution of such foodstuffs, perhaps in a feasting context, took place on these public-inclusive occasions. It is possible that up to seven of the large pithoi may have lined the northern part of the court, partially sunken into the series of pits along the north wall. As I argued above for the central court in Building X at Kalavasos, these monumental storage containers were important expressions of elite identity (whether or not they actually contained anything) and their presence in a highly visible space like the central court, backgrounded by impressive ashlar masonry, served as a reminder of the economic power of Building II's occupants. Some examples from Alassa had the added feature of a clay band impressed with scenes of hunting/combat or sitting griffons (Hadjisavvas 2001b, p. 213). This band was made of fine clay that was much lighter in color than the pithos itself and, although the details of the impression may not have been clear beyond a few metres away, the band itself would have been visible at a considerable distance. This would be an important consideration in such a large space, which probably held public-inclusive social occasions.

The pithoi lining the court's north wall were also representative of the larger number of pithoi stored on the other side of that wall in Rooms 35 and 33. The remains of at least

Table 4 | Alassa-*Paliotaverna*, Building II ranking of key syntactic and architectural properties. Darker shaded cells indicate private-exclusive spaces; lighter shaded cells indicate public-inclusive spaces.

CV Rank			RRA Rank			Depth Rank	
Room	CV		Room	RRA		Room	Depth
20	0,2500	low	14	0,8004	low	1	1
21	0,2500	low	26	0,8906	low	36	1
6	0,3333	low	25	0,9583	low	5	2
7	0,3333	low	1	1,0033	low	11	2
12	0,3333	low	17	1,0033	low	14	2
13	0,3333	low	28	1,0259	low	34	2
23	0,3333	low	36	1,0710	low	6	3
29	0,3333	low	15	1,1386	low	7	3
30	0,3333	low	18	1,2063	low	12	3
31	0,3333	low	24	1,2288	low	13	3
33	0,3333	low	29	1,2513	low	15	3
35	0,3333	low	19	1,2739	medium	17	3
16	0,5000	low	5	1,3190	medium	26	3
2nd Fl.	0,5000	low	11	1,3190	medium	33	3
24	0,5833	low	32	1,3190	medium	35	3
25	0,5833	low	22	1,3416	medium	16	4
32	0,5833	low	27	1,3641	medium	18	4
Carrier	0,5833	low	34	1,3866	medium	25	4
17	0,7000	low	22x	1,4317	medium	29	4
19	0,7500	low	16	1,4994	medium	19	5
18	1,0000	low	Carrier	1,5975	medium	28	5
36	1,0333	medium	32x	1,6346	medium	22	6
15	1,2000	medium	6	1,6798	high	24	6
27	1,2500	medium	7	1,6798	high	27	6
1	1,3667	medium	12	1,6798	high	32	6
26	1,7000	medium	13	1,6798	high	20	7
22x	1,7500	medium	20	1,7023	high	21	7
14	1,9167	medium	21	1,7023	high	22x	7
28	2,0000	medium	2nd Fl.	1,7249	high	2nd Fl.	7
5	2,2500	high	33	1,7474	high	32x	7
11	2,2500	high	35	1,7474	high	23	8
34	2,3333	high	23	1,7925	high	30	8
32x	2,5000	high	30	1,9954	high	31	8
22	2,8333	high	31	1,9954	high	Carrier	na

Relative Convexity Rank			Total Door Width Rank		Mean Door Width Rank	
Room	Area (m2)	Rel.Conv.	Room	Total Width	Room	M Width
22	13,20	0,11	5	0,95	5	0,95
15	3,68	0,17	7	0,95	7	0,95
22x	6,78	0,21	12	0,95	12	0,95
32x	8,68	0,23	13	1,05	13	1,05
24	6,24	0,23	21	1,25	11	1,07
16	5,52	0,26	16	1,30	15	1,23
27	15,40	0,31	30	1,40	19	1,25
35	30,87	0,32	23	1,50	21	1,25
32	12,40	0,32	20	1,55	22	1,28
33	27,72	0,36	31	1,55	16	1,30
21	37,50	0,38	35	1,60	22x	1,32
1	119,70	0,41	33	1,70	18	1,40
19	6,30	0,49	27	2,00	30	1,40
18	3,24	0,56	15	2,45	24	1,43
17	19,89	0,58	19	2,50	23	1,50
23	12,42	0,59	29	2,75	32x	1,53
34	12,15	0,60	18	2,80	20	1,55
30	18,59	0,60	24	2,85	31	1,55
26	30,10	0,61	11	3,20	35	1,60
25	6,46	0,65	17	3,70	33	1,70
29	35,41	0,66	25	3,70	34	1,80
5	21,95	0,68	32	3,80	28	1,84
11	22,43	0,68	22x	3,95	17	1,85
31	12,00	0,75	32x	4,60	25	1,85
20	10,08	0,78	26	4,85	1	1,88
36	398,72	0,79	22	5,10	32	1,90
28	20,00	0,80	34	5,40	14	1,94
14	60,20	0,81	1	5,65	27	2,00
12	5,85	0,87	28	7,35	26	2,43
13	5,98	0,88	14	7,75	29	2,75
7	5,41	0,98	Carrier	22,65	36	8,20
6	7,84	1,00	36	24,60	Carrier	11,33
2nd Fl.	na	na	6	?	6	?
Carrier	na	na	2nd Fl.	?	2nd Fl.	?

16 large pithoi were found in these rooms on stone stands or in circular depressions in the floor (Hadjisavvas 2003a, p. 434). The North Wing was essentially a monumental storage hall but, in contrast to the Pithos Hall from Building X, it was longer, more narrow, and subdivided into two rooms entered from a paved central hallway (Room 34) that provided access to the main court. It was also much smaller than Building X's Pithos Hall, although one should bear in mind that the space between the bedrock cut and the north façade was also used for storage, as well as Building III (Hadjisavvas 2001b, p. 62). The width of the doorway (2.1 m) makes the presence of a door less likely, suggesting that this hallway was meant to be visible from the court. The interior doorways of the north wing are much narrower (1.6–1.7 m wide), but would still have allowed for the placement or removal of the large pithoi.

As noted above, there appears to have been a deliberate effort to isolate the central court from the rest of the building; especially from the South Wing. The main entrance to the South Wing was off the street between Buildings I and II and was centrally placed along its south wall. At 2.65 m wide, this entrance was much wider than the typical doorway in Building II (mean width of 1.62 m) and was flanked by two square ashlar slabs embedded in the floor. The slabs are reminiscent of those employed in Building X at Kalavasos to mark the entries or boundaries of particularly important spaces. It is no coincidence that the single largest ashlar block in the building (nearly 5 m long) was placed where it would be clearly visible, along the south façade, with its east end forming the west door jamb.

This doorway provided access to Room 1, which is the largest interior space in Building II (120 m²). It contains a number of distinctive fixed-feature elements including a monumental hearth. This is a large square block (0.65 m per side) surrounded by mudbricks on three sides, leaving the east side open (Hadjisavvas and Hadjisavva 1997, p. 145). It was built into the centre of a narrow (0.3 m wide) stylobate of ashlar blocks that ran along the building's north-south axis between the north and south walls of the room. A number of fragments of slender semi-circular ashlar pillars with drafted margins were found in association with this feature, some with traces of mortises cut on their flat backs indicating attachment to the wall, probably at each end of the stylobate (Hadjisavvas 1994, p. 110). Other pillars may have been freestanding on the stylobate (Hadjisavvas and Hadjisavva 1997, p. 145). A perpendicular line of narrow ashlar blocks embedded in the floor ran eastward from the stylobate, ending in a small (c. 70 × 40 cm), but deep rectangular pit, the top of which was outlined with ashlar masonry. The function of this feature is unclear, although it may have been used to receive libations (e.g. Davis 2008; Hägg 1990).

The other significant feature in the room is a large "sunken rectangular construction" just to the east of the entry, measuring 3.25 × 5.25 m. This feature was stone-lined and extended down 1.86 m to bedrock. Nothing was found in its excavation to suggest the function of this feature, although the excavator suggests that the nearest parallels are the *kouloures* of the Minoan palaces (Hadjisavvas and Hadjisavva 1997, p. 145). This seems unlikely, however, given that the *kouloures* are centuries earlier, circular, and not typically

found within the palace buildings themselves. A much closer parallel would seem to be the LC IIB Basin Building from Maroni-*Vournes* (cf. Cadogan 1986, p. 40–42). If this feature did hold water, it would have made for a more impressive display of control over this valuable resource than a mere well, and could have been used for ritual purposes.

Room 1 has a highly symmetrical design, with the stylobate and rectangular pit on the west side providing a mirror image to the space taken up by the sunken rectangular feature to the east. In addition, both installations are equidistant from the room's end walls. Only the entry to Room 14 in the north wall is not placed symmetrically, although it is apparent that the occupants of Building II did not wish the occasions in Room 1 to be directly accessible or visible to the "public" space of the central court. Only a narrow view into Room 1 is possible from the court, and one would have to be standing in the doorway between the court and Room 14 to take advantage of it (fig. 6). Given its size and formality, as well as the presence of several unique architectural features, it is clear that Room 1 played a very important role in social interactions within Building II. It is also evident that the largest (and therefore most impressive) ashlar blocks in the south wing were used on the interior faces of the north and south walls and the exterior face of the south wall of Room 1. The syntactic properties of Room 1, including a low RRA score (1.00) and a medium control value (1.37), suggest its potential use for public-inclusive social interactions. The somewhat low relative convexity score (0.41) is offset by the room's large width and does not diminish its capacity to host public-inclusive occasions.

The nature of these social occasions can only be guessed at from the available data, although, given the nature of its fixed-feature elements, it is tempting to suggest a ritual-ceremonial function for this space. Hadjisavvas (1996, p. 32) suggests that the South Wing was a "cult place", given the central hearth flanked by pilasters and the find of a bathtub in Room 13. Neither of these features, however, is definitively cultic in nature. The presence of a formal central hearth could suggest that Room 1 played host to feasting events, as proposed for broadly similar hearth-rooms at Enkomi and other sites (Fisher 2009a). I have discussed elsewhere the ideological importance of formal/monumental hearths as symbolizing control over fire as an element of transformation (Fisher 2008, p. 96–97). The hearth was likely the (a?) focal point of interactions in Room 1 and is set in a unique and particularly elaborate context that would have influenced the nature of interactions in and around it. The presence of the stylobate and columns suggests that the primary interaction took place in front of it (i.e. to the east) or at least that the majority of participants were meant to occupy the area between the stylobate and the large sunken feature. While Room 1 could hold a maximum of 227 to 407 people (depending on whether seated or standing and not modified for the area occupied by the large sunken feature), the area between the stylobate and the large sunken feature (c. 6.5×7 m) could have accommodated a maximum of only about 87 to 155 people, suggesting more exclusive social occasions than those held in the central court. This smaller space could accommodate social interactions up to the near phase of public distance. It is interesting, however, that the distance from the hearth to the

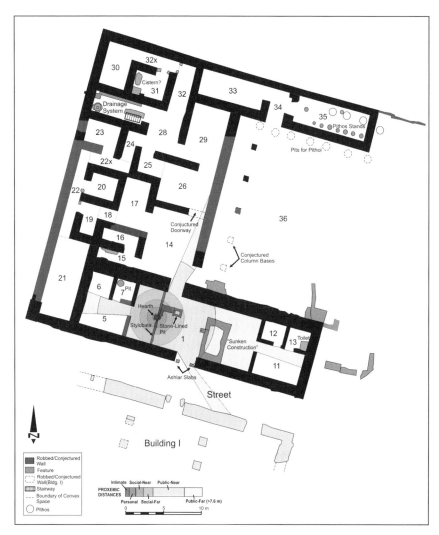

Figure 8 | Alassa-*Paliotaverna*, Building II schematic plan with isovist centred on Room 1 hearth, coded for proxemic distances.

north, south and west walls of the room, and out to the eastern edge of the small rectangular pit, coincides quite closely with the limit of the social proxemic threshold (table 1), suggesting scope for a more personal level of interaction within that area (fig. 8). It is also possible that only certain (probably higher-status) actors were permitted to occupy the space to the west of the stylobate ("behind" the hearth). In such a case, the stylobate and the slender columns it supported created a physical and, probably, social barrier that still allowed these individuals and their various forms verbal and nonverbal communication (gestures, clothing, personal adornment, etc.) to be perceived by the other participants.

It is unclear if all the architectural features of Room 1 were employed during the same ceremonial occasions, or if they were used in temporally discrete events. Nearly identical sets of smaller rooms at either end of the South Wing could have been used as ancillary spaces during these occasions or could have been appropriate contexts for separate private-exclusive occasions. Given that the entrance to Building I across the street is the same size as, and directly aligned with, the main entrance to Room 1, and is similarly flanked by two stone slabs, I suggest that this hall might have sometimes been used during social occasions associated with those taking place in Room 1.

6 Discussion

Broad similarities in form and material among the two buildings discussed here suggest the existence of common cultural ideas regarding the materialization of monumentality and the "proper" form that a LC monumental building should have. We might see this as an underlying "genotype" (Hillier and Hanson 1984; Hillier 1996) or in terms of the structural properties of social systems that, according to Giddens (1984, p. 17), make it possible for similar social practices to exist across various spans of space and time and which give systemic form to these practices. This is manifested in Rapoport's culturally contingent "limited palette of elements" and "display rules", which are combined in the creation of built environments (fig. 1). While these elements are a key part of placemaking, I would argue that, in terms of creating a place laden with meaning, sensory experience and memory, it is also necessary to take into account the idiosyncratic aspects of a building's fixed-, semifixed-, and nonfixed-feature elements. Generalizations about these buildings as a type overlook important differences that affect how people experienced them and are referenced in the formation of group and individual identities.

The process of constructing one of these buildings undoubtedly involved decisions made by a number of stakeholders, including the "rulers" themselves (whether they exercised power locally or otherwise), designers, bureaucrats, and various craftspeople and laborers, while taking into account available material and human resources and whether or not there was pre-existing architecture that had to be incorporated in some way (Fisher 2009a, p. 189, 198; Locock 1994, p. 5; Markus 1993, p. 23; cf. Letesson's discussion of building vs. architecture, this volume). Yet, as Rapoport (1990, p. 15–16, 21) argues regarding a building's meaning, it is the occupants' and users' meanings that are most significant, and these are generated in part through *personalization* as these people take possession of a place and complete or change it. Personalization is therefore a form of territorial marking by the owners or occupants of a space that encodes messages regarding their identity (Brown 1987, p. 519–521). We might see these buildings, or at least particular parts of them, as the *primary territories* of the main occupants – spaces that were used by them on a relatively permanent basis and central to their day-to-day lives (Altman 1975,

p. 111–114). Such spaces tend to have markers more closely reflective of the central values and personal qualities of the occupants (Brown 1987). In this way, individual monumental buildings were "phenotypes" – the heterogeneous physical expressions of an underlying genotype (Hillier and Hanson 1984; Hillier 1996; Letesson, this volume; van Nes, this volume).

Manifestations of these processes include significant differences in overall spatial configuration and the arrangement of spaces for public-inclusive interactions between the two buildings. While Building X at Kalavasos exhibits a highly integrated plan, Building II's configuration is poorly integrated, with distinct wings that are not easily accessible from one another. Both buildings have multiple large halls or courts suitable for public-inclusive social occasions, with adjoining spaces suited for more private-exclusive interactions, although the arrangement of these spaces varies considerably. The central court in Building X is fully enclosed and has a ceremonial entry hall and yet plays a significant role in structuring movement and interaction in the building. The much larger central court of Building II at Alassa is completely open on one end, while being poorly integrated with the rest of the building. As suggested above, this immense space was likely intended for large-scale public-inclusive occasions that would have involved a broader constituency of LC society. It could have been what Altman (1975, p. 114–118) refers to as a *secondary territory*, accessible to a wider range of users, although regular occupants often exert some degree of control over who can enter the space and their expected behavior (cf. Lawrence's [1990] discussion of "collective" spaces). Room 1 in Building II likely held higher-level and more controlled public-inclusive occasions, while the pillared hall of Building I across the street may have had a similar function for yet another level of guest or particular type of interaction. Building XII at Kalavasos, which may have directly adjoined the front of Building X, and also appears to have been a large pillared hall, could have fulfilled a similar role, playing host to a more inclusive group of visitors who might not have been invited to occasions held in the central court. This "filtering" or classification of visitors through the provision of multiple venues for public-inclusive occasions is a feature of most LC monumental buildings, although it was manifested differently in each case (Fisher 2007; 2009b).

In terms of the placement of fixed-feature elements, I would also draw attention to differences in the use of ashlar masonry between buildings. I have argued elsewhere that types of ashlar masonry with greater degrees of elaboration tended to be employed in highly visible contexts or those in which important public-inclusive occasions might have taken place (Fisher 2009a). Ashlar masonry represented more than just elite control over material and human resources, symbolizing the seeming permanence of the inequalities that restricted its use. By the time the buildings at Kalavasos and Alassa were constructed, ashlar masonry had become an important part of the identities of urban elites. Building II is built almost entirely of the most elaborate type of ashlar masonry, with a plinth of large blocks topped by a course of orthostat blocks (all with drafted margins). By contrast, this type of masonry is used more strategically in Building X, particularly for the south and west

walls of the Pithos Hall. Less elaborate types of ashlar masonry were used in Building X's central court. Ashlar masonry was not only used for walls, but also for other fixed-feature elements that were unique to each building, including the columns in the Pithos Hall of Building X and the monumental hearth and stylobate of Room 1 in Building II.

Some of these idiosyncrasies were undoubtedly due in part to the economic and human resources available to the owners and designers of each building and the practical needs of accommodating differing social interactions and economic activities. I would argue, however, that they are also due to personalization and the desire on the part of ruling elites to create a highly *imageable* monument (cf. Lynch 1960, p. 9) that did not simply materialize their power, but could play a central role in forging a distinct identity at the personal, group and wider community levels. It is clear that, in spite of overarching cultural similarities, there was wide scope for variation in monumental placemaking regarding the "display rules" by which Rapoport's "palette of elements" could be combined (fig. 1). On the one hand, therefore, common design elements among these buildings provided cues ensuring that people were aware of expected behavior in particular settings (although whether or not they chose to act accordingly is another matter). On the other hand, decision-making by various stakeholders regarding spatial configuration and room form, construction and renovation materials and methods, and the placement of permanent features and mobile furnishings, ensured that occupants and visitors would have experienced each of these monuments quite differently (cf. also Barrett 2001; Hendon 2003, p. 278–9; Isbell 2000, p. 258; Rodman 1992). The nonfixed-feature elements of the buildings' occupants and users, including their shifting spatial relations (Hall's proxemics), bodily movements, nonverbal expressions such as clothing, body modification and adornment, and emotive state also contributed to this difference.

It is the experience of these fixed-, semifixed- and nonfixed-feature elements in the course of daily practice and periodic social occasions that forms the basis of distinct individual and group identities. It is also what created a *sense of place* among those who lived in, visited or otherwise used these monumental buildings. Lynch (1981, p. 131–132) defines this as 'the extent to which a person can recognize or recall a place as being distinct from other places – as having a vivid, or unique, or at least a particular, character of its own'. This highlights the recursive relationship between people and place, which Basso (1996) refers to as *inter-animation*. As places animate the ideas or feelings of the people who interact with them, these same ideas and feelings animate the places on which people have focused attention. The unique material and (micro)historical circumstances within which each building was created meant that, like other human and material actors, it had (and continues to have) a unique biography (Kopytoff 1986) or "life-history" constituted in the meanings accumulated over the duration of its existence, as well as the memories of it held by its human occupants (Düring 2005; Hendon 2003, p. 276; Pred 1990; Tringham 1995).

On one level, the monumental buildings of LBA Cyprus are symbols of conspicuous consumption, marking the efforts of emergent and established elites to demonstrate their

control over human and material resources (Trigger 1990). As I have tried to demonstrate, however, this only tells part of the story of the vital role these buildings played in the transformation of LC society. Rather, it was through the dynamic interplay of symbolically-laden architectural elements, furnishings and artifacts in the context of daily practice and ritual performance that monumental spaces were imbued with meaning. I have tried to show how we might start to investigate this process using an integrative approach that acknowledges the agency of those who created and used LC monumental buildings and the agency of the buildings themselves. Indeed, these places were active participants in the actions and occasions through which power and identity were negotiated and materialized, and social lives were (re)produced.

Bibliographical references

Altman, I. (1975)
The Environment and Social Behavior: Privacy, Personal Space, Territory, Crowding, Monterey, Calif.

Barrett, J. C. (2001)
"Agency, the Duality of Structure, and the Problem of the Archaeological Record", in: Hodder, Ian (ed.), *Archaeological Theory Today*, Cambridge, UK, pp. 141–164.

Basso, K. H. (1996)
"Wisdom Sits in Places: Notes on a Western Apache Landscape", in: Steven Feld and Keith H. Basso (eds.), *Senses of Place,* Santa Fe, N.M., pp. 53–90.

Batty, M. (2001)
"Exploring Isovist Fields: Space and Shape in Architectural and Urban Morphology", in: *Environment and Planning B. Planning and Design* 28, pp. 123–150.

Bechtel, R. B. (1997)
Environment and Behaviour: An Introduction, London.

Benedikt, M. L. (1979)
"To Take Hold of Space: Isovists and Isovist Fields", in: *Environment and Planning B. Planning and Design* 6, pp. 47–65.

Bolger, D. R. (2003)
Gender in Ancient Cyprus: Narratives of Social Change on a Mediterranean Island, Walnut Creek, CA.

Bray, T. L. (ed.) (2003)
The Archaeology and Politics of Food and Feasting in Early States and Empires, New York.

Brown, B. B. (1987)
"Territoriality", in: Daniel Stokols and Irwin Altman (eds.), *Handbook of Environmental Psychology,* New York, pp. 505–531.

Cadogan, G. (1996)
"Maroni: Change in Late Bronze Age Cyprus", in: Paul Åström and Ellen Herscher (eds.), *Late Bronze Age Settlement in Cyprus: Function and Relationship*, Jönsered, pp. 15–22.

Cadogan, G. (1986)
"Maroni II", in: *Report of the Department of Antiquities, Cyprus*, pp. 40–44.

Davis, B. (2008)
"Feasting in Cyprus: A View from Kalavasos", in: Louise Hitchcock, Robert Laffineur, and Janice L. Crowley (eds.), *Dais: The Aegean Feast. Proceedings of the 12th International Aegean Conference. 12e Rencontre Égéenne Internationale, University of Melbourne, Centre for Classics and Archaeology, 25–29 March 2008*, Liège, pp. 47–55.

Dietler, M., and Hayden, B. (eds.) (2001)
Feasts: Archaeological and Ethnographic Perspectives on Food, Politics, and Power, Washington, D.C.

Düring, Bleda S. (2005)
"Building Continuity in the Central Anatolian Neolithic: Exploring the Meaning of Buildings at Aşikli höyük and Çatalhöyük", in: *Journal of Mediterranean Archaeology* 18, no. 1, pp. 3–29.

Feld, S., and Basso, K. H. (eds.) (1996)
Senses of Place, Santa Fe, N.M.

Fisher, K. D. (2007)
Building Power: Monumental Architecture, Place and Social Interaction in Late Bronze Age Cyprus, Toronto.

Fisher, K. D. (2008)
"The Aegeanization of Cyprus at the End of the Bronze Age: An Architectural Perspective", in: Timothy P. Harrison (ed.), *Cyprus, the Sea Peoples and the Eastern Mediterranean: Regional Perspectives of Continuity and Change. Special Issue of Scripta Mediterranea XVII–XVIII*, Toronto, pp. 81–103.

Fisher, K. D. (2009a)
"Elite Place-Making and Social Interaction in the Late Cypriot Bronze Age", in: *Journal of Mediterranean Archaeology* 22, 2, pp. 183–209.

Fisher, K. D. (2009b)
"Placing Social Interaction: An Integrative Approach to Analyzing Past Built Environments", in: *Journal of Anthropological Archaeology* 28, 4, pp. 439–457.

Fisher, K. D. (2013, in press)
"Rethinking the Late Cypriot Built Environment: Households and Communities as Places of Social Transformation", in: A. B. Knapp and P. van Dommelen (eds.), *The Cambridge Prehistory of the Bronze and Iron Age Mediterranean*, Cambridge.

Fortin, M. (1981)
Military Architecture in Cyprus during the Second Millennium B.C., London.

Giddens, A. (1984)
The Constitution of Society: Introduction of the Theory of Structuration, Berkeley.

Goffman, E. (1963)
Behavior in Public Places: Notes on the Social Organization of Gatherings, New York.

Hadjisavvas, S. (1986)
"Alassa. A New Late Cypriote Site", in: *Report of the Department of Antiquities*, Cyprus, pp. 62–67.

Hadjisavvas, S. (1994)
"Alassa Archaeological Project 1991–1993", in: *Report of the Department of Antiquities*, Cyprus, pp. 107–114.

Hadjisavvas, S. (1996)
"Alassa: A Regional Centre of Alasia?", in: Paul Åström and Ellen Herscher (eds.), *Late Bronze Age Settlement in Cyprus: Function and Relationship*, Jönsered, pp. 23–38.

Hadjisavvas, S. (2000)
"Ashlar Buildings and their Role in Late Bronze Age Cyprus", in: G. C. Ioannides and S. A. Hadjistellis (eds.), *Acts of the Third International Congress of Cypriot Studies*, Nicosia, pp. 387–398.

Hadjisavvas, S. (2001a)
"Seal Impressed Pithoi Fragments from Alassa: Some Preliminary Thoughts", in: P. M. Fischer (ed.), *Contributions to the Archaeology and History of the Bronze and Iron Ages in the Eastern Mediterranean: Studies in Honour of Paul Åström*, Vienna, pp. 61–67.

Hadjisavvas, S. (2001b)
"Crete and Cyprus: Religion and Script", in: *Kreta und Zypern: Religion und Schrift: Von der Frühgeschichte bis zum Ende der archaischen Zeit: Tagung, 26.–28. 2. 1999, Ohlstadt/Oberbayern, Germany*, Altenburg, pp. 205–231.

Hadjisavvas, S. (2003a)
"Dating Alassa", in: Manfred Bietak (ed.), *The Synchronisation of Civilisations in the Eastern Mediterranean in the Second Millennium B.C.: Proceedings of the SCIEM 2000-EuroConference, Haindorf, 2nd of May–7th of May 2001 II*, Vienna, pp. 431–436.

Hadjisavvas, S. (2003b)
"Ashlar Buildings", in: S. Hadjisavvas (ed.), *From Ishtar to Aphrodite. 3200 Years of Cypriot Hellenism: Treasures from the Museums of Cyprus*, New York, pp. 31–34.

Hall, E. T. (1966)
The Hidden Dimension, Garden City, N.Y.

Hadjisavvas, S., and Hadjisavva, I. (1997)
"Aegean Influence at Alassa", in: Kypros. Tmema Archaioteton (ed.), *Proceedings of the International Archaeological Conference: Cyprus and the Aegean in Antiquity: From the Prehistoric Period to the 7th Century A.D. Nicosia 8–10 December 1995*, Nicosia, pp. 143–148.

Hägg, R. (1990)
"The Role of Libations in Mycenaean Ceremony and Cult", in: R. Hägg and G. C. Nordquist (eds.), *Celebrations of Death and Divinity in the Bronze Age Argolid. Proceedings of the Sixth International Symposium at the Swedish Institute at Athens, 11–13 June, 1988*, Stockholm, pp. 177–184.

Hendon, J. A. (2003)
"Feasting at Home: Community and House Solidarity Among the Maya of Southeastern Mesoamerica", in: Tamara L. Bray (ed.), *The Archaeology and Politics of Food and Feasting in Early States and Empires*, New York, pp. 203–234.

Hillier, B., and Hanson, J. (1984)
The Social Logic of Space, Cambridge.

Hillier, B. (1996)
Space is the Machine. A Configurational Theory of Architecture, Cambridge.

Isbell, W. H. (2000)
"What We Should Be Studying: The 'Imagined Community' and the 'National Community'", in: Jason Yaeger and Marcello A. Canuto (eds.), *The Archaeology of Communities: A New World Perspective*, London, New York, pp. 243–266.

Keswani, P. (1989)
"The Pithoi and Other Plain Ware Vessels", in: A. K. South, P. Russell, P. S. Keswani, and L. Courtois (eds.), *Vasilikos Valley Project. Ceramics, Objects, Tombs, Specialist Studies 3, Kalavasos-Ayios Dhimitrios II*, Gothenburg, pp. 12–21.

Keswani, P. (1992)
"Gas Chromatography Analyses of Pithoi from Kalavasos *Ayios Dhimitrios*: A Preliminary Report", in: A. South (ed.), "Kalavasos-Ayios Dhimitrios 1991", *Report of the Department of Antiquities*, Cyprus, pp. 141–145.

Keswani, P. (1996)
"Hierarchies, Heterarchies, and Urbanization Processes: The View from Bronze Age Cyprus", in: *Journal of Mediterranean Archaeology* 9, pp. 211–250.

Keswani, P. (2004)
Mortuary Ritual and Society in Bronze Age Cyprus, London.

Knapp, A. B. (1988)
"Ideology, Archaeology and Polity", in: *Man* 23, 1, pp. 133–163.

Knapp, A. B. (1997)
The Archaeology of Late Bronze Age Cypriot Society: The Study of Settlement, Survey and Landscape, Glasgow.

Knapp, A. B. (2008)
Prehistoric and Protohistoric Cyprus: Identity, Insularity, and Connectivity, Oxford, New York.

Knapp, A. B. (2009)
"Monumental Architecture, Identity and Memory", in: Apostolos Kyriatsoulis (ed.), *Proceedings of the Symposium: Bronze Age Architectural Traditions in the Eastern Mediterranean: Diffusion and Diversity (Gasteig, Munich, 7–8 May, 2008)*, Weilheim, pp. 47–59.

Kopytoff, I. (1986)
"Cultural Biography of Things: Commoditization as Process", in: Arjun Appadurai (ed.), *The Social Life of Things: Commodities in Cultural Perspective*, Cambridge, New York, pp. 64–94.

Lawrence, D. L., and Low, S. M. (1990)
"The Built Environment and Spatial Form", in: *Annual Review of Anthropology* 19, pp. 453–505.

Lawrence, R. J. (1990)
"Public, Collective and Private Space: A Study of Urban Housing in Switzerland", in: Susan Kent (ed.), *Domestic Architecture and the Use of Space: An Interdisciplinary Cross-Cultural Study,* Cambridge (UK), New York, pp. 73–91.

Locock, M. (ed.) (1994)
Meaningful Architecture: Social Interpretations of Buildings, Aldershot (UK).

Low, S. M., and Lawrence-Zúñiga, D. (eds.) (2003)
The Anthropology of Space and Place: Locating Culture, Malden, MA.

Lynch, K. (1960)
The Image of the City, Cambridge, Mass.

Lynch, K. (1981)
Good City Form, Cambridge, Mass.

Manning, S. W. (1998)
"Changing Pasts and Socio-Political Cognition in Late Bronze Age Cyprus", in: *World Archaeology* 30, pp. 39–58.

Markus, T. A. (1993)
Buildings and Power: Freedom and Control in the Origin of Modern Building Types, London, New York.

Masson, E. (1989)
"Vestiges écrits trouvés sur le site de Kalavasos-*Ayios Dhimitrios*", in: A. K. South, P. Russell, P. S. Keswani, and L. Courtois (eds.), *Vasilikos Valley Project. Ceramics, Objects, Tombs, Specialist Studies 3, Kalavasos-Ayios Dhimitrios II,* Gothenburg, pp. 38–40.

Negbi, O. (2005)
"Urbanism on Late Bronze Age Cyprus: LC II in Retrospect", in: *Bulletin of the American Schools of Oriental Research* 337, pp. 1–45.

Neufert, E., and Neufert, P. (2000)
Architects' Data, Oxford.

Paliou, E., Wheatley, D., and Earl, G. (2011)
"Three-Dimensional Visibility Analysis of Architectural Spaces: Iconography and Visibility of the Wall Paintings of Xeste 3 (late Bronze Age Akrotiri)", in: *Journal of Archaeological Science* 38, 2, pp. 375–386.

Porada, E. (1989)
"Cylinder and Stamp Seals", in: A. K. South, P. Russell, P. S. and Keswani (eds.), *Vasilikos Valley Project 3: Kalavasos-Ayios Dhimitrios II (Ceramic, Objects, Tombs, Specialist Studies),* Gothenburg, pp. 33–37.

Pred, A. (1990)
Making Histories and Constructing Human Geographies: The Local Transformation of Practice, Power Relations, and Consciousness, Boulder.

Preucel, R.W., and Meskell, L. (2004)
"Places", in: L. Meskell and R.W. Preucel (eds.), *A Companion to Social Archaeology*, Malden, MA, pp. 215–229.

Rapoport, A. (1990)
The Meaning of the Built Environment: A Nonverbal Communication Approach, Tucson.

Rodman, M. C. (1992)
"Empowering Place: Multilocality and Multivocality", in: *American Anthropologist* 94, 3, pp. 640–656.

Smith, J. S. (2009)
Art and Society in Cyprus from the Bronze Age into the Iron Age, Oxford, New York.

South, A. K. (1984)
"Kalavasos-*Ayios Dhimitrios* 1984", in: *Report of the Department of Antiquities*, Cyprus, pp. 14–41.

South, A. K. (1988)
"Kalavasos-*Ayios Dhimitrios* 1987: An Important Ceramic Group from Building X", in: *Report of the Department of Antiquities*, Cyprus, pp. 223–228.

South, A. K. (1989)
"From Copper to Kingship: Aspects of Bronze Age Society Viewed from the Vasilikos Valley", in: E. J. Peltenburg (ed.), *Early Society in Cyprus*, Edinburgh, pp. 315–324.

South, A. K. (1991)
"Kalavasos-*Ayios Dhimitrios* 1990", in: *Report of the Department of Antiquities*, Cyprus, pp. 131–139.

South, A. K. (1992)
"Kalavasos-*Ayios Dhimitrios* 1991", in: *Report of the Department of Antiquities*, Cyprus, pp. 133–146.

South, A. K. (1996)
"Kalavasos-*Ayios Dhimitrios* and the Organization of Late Bronze Age Cyprus", in: Paul Åström and Ellen Herscher (eds.), *Late Bronze Age Settlement in Cyprus: Function and Relationship*, Jönsered, pp. 39–49.

South, A. K. (1997)
"Kalavasos-*Ayios Dhimitrios* 1992–1996", in: *Report of the Department of Antiquities*, Cyprus, pp. 151–175.

South, A. K. (2000)
"Late Bronze Age Burials at Kalavasos *Ayios Dhimitrios*", in: G. C. Ioannides and S. A. Hadjistellis (eds.), *Acts of the Third International Congress of Cypriot Studies*, Nicosia, pp. 345–364.

South, A. K. (2008)
"Feasting in Cyprus: A View from Kalavasos", in: Louise Hitchcock, Robert Laffineur, and Janice L. Crowley (eds.), *Dais: The Aegean Feast. Proceedings of the 12th International Aegean Conference. 12e Rencontre Égéenne Internationale, University of Melbourne, Centre for Classics and Archaeology, 25–29 March 2008*, Liège, pp. 309–315.

South, A. K., and Russell, P. (1993)
"Mycenaean Pottery and Social Hierarchy at Kalavasos-*Ayios Dhimitrios*", in: C. Zerner (ed.), *Wace and Blegen: Pottery as Evidence for Trade in the Aegean Bronze Age, 1939–1989: Proceedings of the International Conference Held at the American School of Classical Studies at Athens, December 2–3, 1989*, Amsterdam, pp. 303–310.

South, A. K., Russell, P., Keswani, P., and Courtois, L. (1989)
Vasilikos Valley Project. Ceramics, Objects, Tombs, Specialist Studies 3, Kalavasos-Ayios Dhimitrios II, Gothenburg.

Steel, L. (2003–4)
"Archaeology in Cyprus 1997–2002", in: *Archaeological Reports* 50, pp. 93–111.

Steel, L. (2004)
"A Goodly Feast ... a Cup of Mellow Wine: Feasting in Bronze Age Cyprus", in: James C. Wright (ed.), *The Mycenaean Feast*, Princeton, New Jersey, pp. 161–180.

Stokols, D., and Altman, I. (eds.) (1987)
Handbook of Environmental Psychology, New York.

Trigger, B. (1990)
"Monumental Architecture: A Thermodynamic Explanation of Symbolic Behavior", in: *World Archaeology* 22, 2, pp. 119–132.

Tringham, R. (1995)
"Archaeological Houses, Households, Housework and the Home", in: D. N. Benjamin (ed.), *The Home: Words, Interpretations, Meanings and Environments*, Aldershot (UK), pp. 79–107.

Tuan, Y. (1977)
Space and Place: The Perspective of Experience, Minneapolis.

Wright, G. R. H. (1992)
Ancient Building in Cyprus, Leiden, New York.

Wright, J. C. (ed.) (2004)
The Mycenaean Feast, Princeton, New Jersey.

Piraye Hacıgüzeller, Ulrich Thaler

Three tales of two cities?
A comparative analysis of topological, visual and metric properties of archaeological space in Malia and Pylos

Abstract

Topological and visual analyses in the space syntax tradition on the one hand and GIS-based spatial analyses on the other have started out on very different trajectories, not only in the scope of applications but also in their underlying premises; the Euclidian metric basis of the latter, for instance, stands in stark contrast to the idea of a configurational topology which forms the basis of traditional space syntax. More recently, there has been a notable convergence both in analytical scope and in the form of software implementations; this has not been paralleled, however, by comparable efforts in terms of explicitly comparative or even integrative studies, a gap we seek to (begin to) address in the present paper on the basis of parallel analyses of topological, visual and metric properties for two case studies. The purpose of this exercise is threefold: Firstly, comparisons of the respective analytical results will aid an appreciation of the strengths and potential weaknesses of specific approaches as well as an identification of both complementary and alternative techniques, but will ultimately also help to gain a reliable basis for future integrative work. Secondly, and more specifically, GIS-based metric integration analysis will be introduced and 'field-tested' in comparison with conventional space syntax analyses, from which it derives – in a first step towards a more integrated perspective – part of its inspiration. Thirdly and no less importantly, we seek to contribute to a better understanding of the archaeological contexts under discussion, i.e. the Middle Bronze Age Building A of Quartier Mu at Malia on Crete and the Late Bronze Age palace of Pylos at Ano Englianos in Messenia.

1 Introduction

Analysis of topological, visual and metric properties of spatial settings has seen numerous applications in archaeology in recent years, particularly in the form of space syntax analysis and GIS-based techniques since the 1980s and 1990s respectively. Despite their common interest in the spatiality of past human life and the search for a multi-faceted, empirical framework for studying this particular domain, space syntax and GIS techniques in archaeology long constituted distinct fields of research.

This could be seen to be due, in part, to the disciplinary history of both approaches outside archaeology. One of the most notable differences in this regard lies in the fact that GIS was conceived as a technology more than anything else, coming into existence without any particular theoretical basis and thus not depending on any specific epistemology – its positivist branding today is largely explicable through its eventual adoption by spatial-analytical geography in the 1970s and 1980s (Pickles 1995; Schuurman 2000; Kwan 2004; Harvey et al. 2005; Sheppard 2005; Leszczynski 2009; Hacıgüzeller 2012a; 2012b; cf. Wheatley, this volume) –, whereas the main advocates of space syntax have proposed and continue to advocate it as an encompassing theoretical framework (e.g. Hillier 1999,

p. 165; 2008). However, the latter position has found little support in archaeology and related disciplines such as social anthropology, where such theoretical aspirations have been mostly either ignored in favour of a 'toolbox' approach – which as with GIS allows for the methodology's use in different theoretical frameworks – or even severely criticized (cf. Leach 1978; Batty 2004, p. 3; Thaler 2005, p. 324; Dafinger 2010, p. 125–127, 134–140). In acknowledgment of this previous reception, but also in order to facilitate an integrative discussion together with other approaches (cf. Thaler 2006, p. 93–100; Dafinger 2010, esp. p. 137), space syntax will be consciously taken as a methodology 'only' in this paper.

It would appear, given this common methodological stance, that the reasons for the separateness of space syntax and GIS-based studies in archaeological practice may more plausibly be identified in both technical issues, i.e. in particular the software employed in analysis, and differences of resolution, i.e. the scale of contexts commonly studied through either set of techniques. It deserves particular attention, therefore, that it is precisely in these two respects that a remarkable convergence can be noted in recent years: archaeological GIS, for example, is to some degree experiencing a 'scaling down', which in terms of resolution brings it closer to the traditional remit of space syntax studies. While the landscape level is still most commonly focused upon (Wheatley 2004; cf. Wheatley and Gillings 2002; Conolly and Lake 2006), there have been a small number of promising applications on the architectural scale as well. Cost-distance (Hacıgüzeller 2008) and 3D visual analysis (Paliou 2008; Paliou et al. 2011) at the building level have demonstrated how current GIS technology permits a study of phenomenological and cognitive properties of buildings through a detailed study of their configurational properties.[1] In terms of software applications, space syntax techniques have been incorporated as add-ons within a GIS environment in several instances, and GIS has also served as a digital cartographic platform in which to import space syntax results (cf., e.g., Turner 2007a). Perhaps most important of all is that recent versions of Depthmap as the software mainstay of current space syntax work have come to include GIS-like features; it is now possible to enter non-spatial data in the database tables provided by the software and, much as in any GIS software, these database tables are linked to the spatial features represented (Turner 2007b).

1 We would like to thank the participants of the workshop "Spatial analysis of past built environments" for their valuable comments as well as their encouraging feedback and likewise express our gratitude to the organizers of the workshop for providing an intellectually stimulating environment for discussion. Piraye Hacıgüzeller would like to thank Bourses d'Excellence Wallonie-Bruxelles International (WBI) for their support, which has made this research possible. Ulrich Thaler gratefully acknowledges the support of the Graduiertenkolleg "Formen von Prestige in Kulturen des Altertums" at Ludwigs-Maximilians-Universität München.
There has been a noteworthy parallel trend in GIS studies of modern urban environments since the early 2000s, which strongly suggests that, in the future, traditional GIS analysis may be accompanied by a new set of techniques on an architectural and urban scale stemming from an interest in configurational properties of space (metric, visual and topological), which is in its turn informed by space syntax approaches (Ratti 2004, p. 12; cf. Jiang and Claramunt 2002; Ratti 2002).

All these trends mean that archaeologists studying ancient built environments have an increasing number of analytical approaches and – potentially complementary or possibly alternative – techniques at their disposal, often at the push of a button.[2] What is therefore needed at this point is a sound body of comparative research in which different techniques are applied to specific test cases. To contribute to such a body of research is the main aim of this paper, and for this purpose, the analyses for each of the case studies will be followed by separate discussions on interpretative archaeological aspects and the comparison of analytical results from different approaches.

A further and related aim is to view the performance and results of an innovative GIS-based technique of metric analysis, which is first introduced in this study (for a related approach cf. Hacıgüzeller 2008), against the results of 'tried-and-tested' topological and visual space syntax analysis, which follow a deliberately conservative line (cf. Thaler 2005, p. 326), in order to better appreciate the potential as well as potential problems of the new approach. The latter differs from metric analysis conducted within a space syntax framework, as will be explained in more detail in the methodology section, in being raster-based and, concomitantly, allowing the researcher to take into consideration differences of elevation in architectural systems, as represented by, for example, stairs or ramps. Thanks to the spatio-statistical, data management and cartographic tools provided by GIS software, this technique also allows the manipulation of metric configurational results in a statistically and visually informed manner (cf. Gil et al. 2007, p. 16).

As a final point, which brings us back to the distinction between archaeological interpretations and methodological comparisons, we also hope to offer a meaningful contribution to a better archaeological understanding of the buildings which form our case studies, Building A of Middle Bronze Age Malia on Crete (fig. 1) and the Late Bronze Age palace of Pylos at Ano Englianos in Messenia (fig. 2), as well as the social phenomena they bear silent witness to. If not for that hope ... why bother?

2 Methodology

2.1 Topological properties

The topological analysis here presented follows a mostly conservative space syntax methodology. Space syntax has been applied in numerous archaeological studies (cf. Cutting 2003, p. 5–7; Thaler 2005, p. 324–326) ever since its first systematic formulation in

2 It should be noted that the availability of a technique through its implementation in computer software is of little if any help without an appropriate familiarity with the technique itself; it is generally advisable to watch the spell-checker of your word-processing software closely, but this necessitates a basic grasp of orthography and grammar – spatial analysis software is no different.

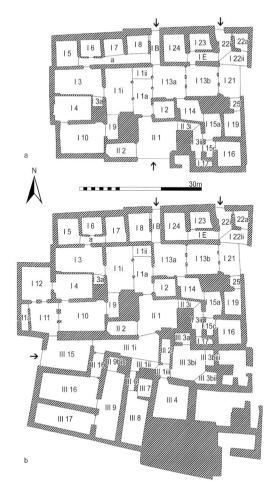

Figure 1 | Malia, Quartier Mu, Building A: a) plan of phase 1 with room numbers, points of access indicated by arrows; b) plan of phase 2 with room numbers, points of access indicated by arrows.

the mid-1980s (Hillier and Hanson 1984),[3] but still retains a certain 'exoticism' in the field. Bill Hillier's (this volume) introductory article sets out the basics of the methodology as well as a number of central concepts. Several of these will be employed in this paper, such as integration as a normalized measure and the most commonly used spatial indicator of topological properties, the notion of global and local qualities and effects, the distinction between the convex[4] and the axial break-up of a building as the basis for parallel

3 Hillier et al. (1976) deal with 'generative syntaxes' only, not the analytical methodology, under the heading of 'space syntax', whereas Hillier et al. (1983) offer a first brief overview of what is today commonly referred to as 'space syntax'.

4 A convex space is defined, in strict terms, as an area in which each point is visible from each other point. For practical purposes, these more or less equate with rooms within a building, while courts often need to be subdivided into several units. Ultimately, what constitutes a convex space is a matter of resolution – each impediment to sight, e.g. a column, pilaster or convexly curving wall, would demand a subdivision of a given space. A slightly

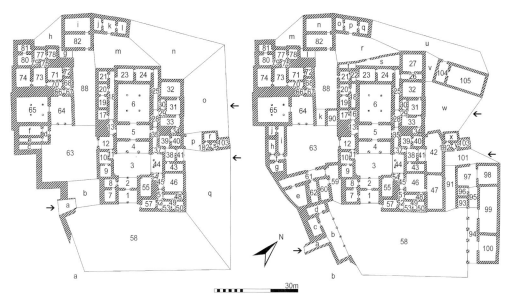

Figure 2 | Pylos, palace: a) plan of earlier building state with room numbers, points of access indicated by arrows; b) plan of later building state with room numbers, points of access indicated by arrows.

analyses,[5] the differentiation between a-, b-, c- and d-type spaces and the mapping of integration cores, with the reader being referred to Hillier's paper for an introduction. Some specifics as well as some additional concepts and a few points of departure, however, necessitate brief comment:

In purely practical terms, the term 'j-graph' will here be used more narrowly to refer to a justified graph which takes the carrier space, i.e. the outside of a building, as its root space. A 'global' analysis of integration will take into account each spatial unit's relationship with each other space in the entire building; in a 'local' analysis, relationships with immediate and mediate neighbours up to a step-depth, i.e. a radius of 3, are taken into account. Cores of integration, both convex and axial, are defined conventionally as the 10 % most integrated units, e.g. the 6 most integrated convex spaces out of a total of 56.

more intuitive form of break-up has been termed 'semi-convex' elsewhere by one of the authors (Thaler 2005, p. 327; 2009, p. 27); this term, however, is dropped here in acknowledgment of the fact that in many published analyses 'convex' is not entirely convex (cf., as arbitrarily chosen examples, Hillier and Hanson 1984, p. 168–169 fig. 103–104 [cf. Hanson (1998, p. 41 fig. 1.19) for a different break-up of the same complex]; Hanson 1998, p. 34 fig. 1.14, p. 93 fig. 3.6) – with good reason.

5 For the analyses in this study, both convex and axial break-ups were hand-drawn. Although Depthmap features a reduction from an all-line to fewest-line axial map (Turner et al. 2005; Turner 2007b, p. 46), drawing by hand was preferred, amongst other reasons, because it allowed the inclusion of columns as visually non-permeable structures without having to include a topological ring around each individual column; this was felt to be the most adequate representation, but is incompatible with the reduction algorithm used by Depthmap.

Two additional types of areas, i.e. sets of convex spaces, are mapped in the following analyses, areas of primary access and areas of primary control; neither are commonly used in space syntax work in precisely the present form,[6] but both follow a very basic topological principle: they allocate individual spaces – and, consequently, areas within a building complex – to one of a given set of root spaces according to closest proximity in terms of step-depth. The root spaces for mapping areas of primary access are, as the designation indicates, those convex spaces which permit access to the building complex, i.e. entrances. The root spaces for mapping areas of primary control are an ultimately arbitrary, but meaningfully chosen set of convex spaces. In the current study, spaces are chosen which are termed 'primary integrators' and characterized, in the first instance, by their local integration surpassing that of all immediate neighbours; as a second criterion applied to the resulting subset of spaces, only those spaces are considered 'primary integrators' which display absolute values of local integration falling within the top 5% of all convex spaces. Other criteria could also be chosen, and it is not co-incidental that the above-stated criteria single out, in the present analysis, the main courts of the respective building.

A further but unavoidable element of arbitrariness is encountered wherever archaeological sources indicate the former presence of rooms, but do not inform us of their exact layout, specifically the position of doors. In this case, substitute spaces are included in the analysed plans in an approximation of the likely original layout; these placeholders restore or approximate, if used in moderation, the original 'balance' of the topological system as a whole and thus allow its meaningful analysis, e.g. the calculation of average values of integration.[7] In the present study, this is relevant in the case of the palace of Pylos,[8] where, for instance, the neighbours of room 82 are omitted from most published plans (e.g. Blegen and Rawson 1966, key plan), although their existence seems indubitable (cf. Blegen and Lang 1963, p. 157; Blegen and Rawson 1966, p. 289–291; Blegen et al. 1973, p. 44 fig. 311; Kilian 1987, fig. 2; Thaler 2009, p. 64–65). The more general difficulty of arriving at the unambiguous plans needed for the types of formal spatial analyses here discussed is illustrated yet more clearly, in the case of Building A at Malia, by the different representations of the building even within the present volume (cf. Letesson, this volume), with yet another set of plans found in McEnroe's (2010, p. 64 fig. 6.15–6.16) recent study of

6 Hanson (2000, p. 108–110) uses an approach closely comparable to mapping areas of primary access.

7 The values of specific spatial indicators calculated for the substitute spaces individually are, of course, largely meaningless. Nevertheless, any consideration of the balance of a built structure should leave us in no doubt that the suggestion to systematically exclude rooms which are not clearly definable in archaeological terms (van Dyke 1999, p. 467) is inevitably counterproductive (cf. Thaler 2005, p. 326). What, however, constitutes a 'moderate' use of substitute spaces remains a matter of personal judgement, both on the part of the researcher performing the analysis and those wishing to evaluate it.

8 Substitute spaces and, more generally, additions to the preserved built structures are not specifically marked in the plans reproduced here in order not to overcomplicate the latter. For an overview of additions cf. Thaler (2005, p. 325 fig. 141) and for a detailed discussion of the earlier and later state of the building cf. Thaler (2009, p. 56–70).

Minoan architecture. In the specific case, such inconsistencies can hardly be avoided until a final and detailed publication of the architecture of Building A is available (cf. Poursat 2012, p. 177), but they highlight the necessity to carefully examine all available information in the preparation of plans for analysis. For Pylos, a general discussion of the plans is set out elsewhere (Thaler 2009, p. 56–70) in greater detail than would be possible in the present context.

As stated at the outset of this methodological introduction – and as the reader will hopefully agree on the basis of the above remarks – space syntax is applied in this paper in a largely conservative fashion, which necessitates a further comment on the reason for this choice and on a difficulty not arising from but related to it: studies of contemporary architecture in the space syntax tradition regularly rely on comparing analytical results with real-life observations, e.g. of human movement in the architectural contexts under analysis, a luxury which archaeological contexts do not afford the researcher. Therefore, it seems highly advisable for the latter to concentrate on those space syntax methods and indicators which have most consistently produced meaningful results in studies of present-day contexts (cf. Thaler 2005, p. 326), integration in particular. This, however, means that 'unresolved issues' of the space syntax mainstream could potentially prove particularly problematic for archaeological applications. Since integration is a normalized measure, i.e. one not directly obtained from the topological graph, but one transformed to allow comparison between systems of different sizes, normalization is probably the most important issue in this respect. Although alternatives to integration as commonly defined, i.e. as the reciprocal of real relative asymmetry (Hillier and Hanson 1984, p. 109–113; Peponis et al. 1997, p. 771), have been suggested (Teklenburg et al. 1993; Livesey and Donegan 2003), these are most often tacitly ignored and rarely is a comparative discussion even attempted,[9] let alone brought to a satisfactory conclusion. In the topological analyses presented here, the standard definition of integration is employed – in the hope, however, that in future its use will either be based on more than a tacit consensus or abandoned if comparative studies suggest a more reliable alternative.

2.2 Visual properties

Visual graph analysis (VGA) as implemented in Turner's Depthmap software (Turner 2001; 2004; 2007b) goes one step beyond 'classic' topological space syntax analysis in that it develops a sensitivity for metric properties; the size of a room within a given building will

9 Sailer (2010, p. 129–132) is a noteworthy exception; the alternative normalization of axial maps she arrives at (Sailer 2010, p. 130–131, p. 132 fig. 5–12) is, however, too specifically geared to analysing office buildings to be used in the present study.

influence its visual integration.[10] In many other respects, as Hillier (this volume) clearly illustrates, it represents a direct continuation of traditional space syntax, in which a new type of node and a new type of link are introduced,[11] while the methodological apparatus is retained. Amongst other things, this means VGA continues to use[12] formulae of normalization previously established for topological analysis and, again and perhaps even more so than in topological analysis, the issue of normalization may prove problematic, as indicated by Turner in the handbook for an early version of the software: "Not enough work has been done at the time of writing to see [...] if any normalisation of depth is a sensible idea for such [i.e. visibility] graphs" (Turner 2004, p. 15). While a previous study had noted "preliminary evidence" that traditional normalization, particularly using the P-value (Hillier and Hanson 1984, p. 113–114 incl. table 4), "may be a valid method to overcome the problem of size" (de Arruda Campos and Fong 2003, p. 35.9) and while it could be claimed that meaningful results of numerous analyses conducted since provide empirical confirmation of the 'sensibility' of normalization, we are not aware of a theoretical solution to the issue; indeed, it has been suggested recently that normalized indicators for VGA should not be used in the analysis of complex buildings and that mean path lengths could be referred to in their stead (Sailer 2010, p. 132–133). In the present study, integration as a normalized indicator is employed, but the main focus is on the interpretation of the resulting maps rather than on specific numerical values – a visual approach to visual integration, as it were.[13] Still, the choice of relying on integration in VGA follows mainly from the idea of following the common practice of studies of modern contexts as explained in the section on topological methodology, and the reader should be aware of potential problems. Brief mention is also made of visual connectivity, a more basic characteristic, which only takes into account immediate intervisibility and is defined as the number of other grid points visible from any given grid point (Turner 2004, p. 10).

10 Cf. Turner (2001, p. 31.8), who suggests entropy as a topological measure to counter this area dependence, also noting, however, that both entropy and relativized entropy lead to interpretative problems of their own (Turner 2004, p. 15). In the present study, which combines VGA with both topological and metric analysis, no need was felt to render VGA more 'topological', and area dependence is considered a strength as much as a weakness of visual integration; entropy or relativized entropy are therefore not employed.

11 The nodes or spatial units can be understood either as locations, in which case "a graph edge connects vertices representing mutually visible locations" (Turner 2001, p. 31.1) or as 'isovists', in which case "a spatial network is [...] calculated from overlap" (Turner 2007b, p. 43). The latter definition illustrates even more clearly the close connection with axial and, if adjacency is substituted for overlap, convex space syntax analysis; the former definition is more closely comparable to the way space is represented through square raster cells in GIS analysis.

12 More precisely: Depthmap continues to offer and researchers commonly make use of this offer.

13 Based on the output of Depthmap 8.15.00c, maps resulting from normalization by D- and P-value were visually identical; both were also found closely similar to those resulting from normalization by the formula suggested by Teklenburg et al. (1993) and comparable in general terms if not in all specifics to maps of mean depth (i.e. mean path length). Where numerical values for visual integration are given below, these represent Depthmap's output for P-value normalization.

Agent-based analysis, in which agents navigate through a layout by reference to their direct visual field, from which they pick a random direction after a given set of steps, was conducted as an adjunct to visual analysis. Since the main focus of this study is on comparison of 'traditional' space syntax with GIS approaches, only this most basic form of agents provided by Depthmap was employed, which has been found in present-day studies to produce good correlations with observed movement in some contexts (Penn and Turner 2002a; 2002b; cf. Turner 2007c, 166–167). Default settings of the software were used unless otherwise noted, with the exception of the length of analysis and the time individual agents remained in the system, both of which were stepped up by a factor of 10 to better capture long-term patterns.

As to the underlying plans, which again include the substitute spaces introduced for topological analysis, VGA was initially conducted both on the basis of an eye-level plan excluding and a floor-level plan including built features such as benches (cf. Hillier, this volume). Their inclusion, however, was found to have little impact on the results, which is perhaps less than surprising since the few indisputable built features are almost all 'wall-hugging'; therefore, the results presented here for VGA are based on one version of the plans only, viz. those plans not including built features. Agent-based analysis, on the other hand, relies on the plans including built features, since, as in the metric analysis discussed below, these have to be subtracted from the surface available to human movement even where they do not impede sight.

Two distinct problems in relation to the plans arose from the sensitivity of both VGA and agent-based analysis to the size of individual spaces. The first of these resulted from gaps or uncertainties in the data available on the outer limits of one of the complexes under analysis, the palace of Pylos. In this case, the comparative analysis of alternative reconstructions provides a satisfactory solution for VGA, as will be explained in section 4.1.2. below. The other problem was encountered in trying to apply agent-based analysis in Pylos and closely corresponded to problems also encountered in studies of present-day contexts which include large open spaces (Turner 2007c, p. 165–166, p. 169–170). Efforts to counter this through tweaking the representation of the spatial layout, e.g. by reducing courts to either passages linking the doors of buildings or even to a more arbitrary set of corridors either following main axes or hugging the walls between doors, did not lead to satisfactory results. Occlusion-driven agents, which form a more recent development not taken into consideration here, may well produce more meaningful results (Turner 2007c, p. 175–178).

2.3 Metric properties

GIS-based metric integration analysis is an innovative technique, methodological details of which are presented in Appendix 1; in this section the focus is on the way in which the correlation between average metric distance (AMD) and standard deviation of metric distance

(STMD) values can be interpreted in terms of configuration, the main analytical approach in this study. Before moving on to a more detailed discussion of this particular approach, however, two issues which are significant for the rest of the paper need further clarification. The first of these is the 'metric cost-of-passage surface' created to model architectural space through the steps explained in Appendix 1. Subsequent to acquiring the surface, the standard GIS-based cost-of-passage analyses, which are mainly applied at a landscape level, become applicable on an architectural scale. Note that cost-of-passage analyses typically include least-cost paths and cost-distance allocations (cf. Burrough and McDonnell 1998; Wheatley and Gillings 2002; Conolly and Lake 2006), both of which have been conducted for the case studies of Malia and Pylos. Secondly, 'metric integration core' is a term that essentially refers to an area comprising raster cells with AMD values that fall within a value class which starts from the minimum AMD value and has a width of one standard deviation of the AMD value distribution. The term is used frequently in the metric analyses presented later in this article. The core has been used as a means of comparing integration of different spatial systems in the analysis below.

Returning to the correlation of AMD and STMD values, a summary of the interpretative scheme used for the correlation of these values is presented in table 1. These configurational interpretations are based on whether or not observed AMD and STMD values are higher or lower than their expected values, calculated on the premise that in permeable systems, AMD and STMD values will be in direct correlation with one another.[14] Permeable systems will in essence comprise a globally central core (with low AMD and STMD values), a periphery (with high AMD and STMD values) and intermediate areas with varying degrees of centrality and peripherality (with medium AMD and STMD values). Accordingly, for each spatial system examined here, the minimum and maximum observed AMD and STMD values are taken as the start and end points of a line which represents the expected linear correlation between the two variables. And it is on the basis of this line that expected values are estimated and compared to the observed values (i.e. values extracted from the GIS map) in order to assess whether or not the figures observed are either lower or higher than what is expected.

As indicated in table 1, one of the possibilities for the correlation of AMD and STMD values is that they both stay low. In this case, the metric distance values for a given cell location do not vary much, remaining low overall and thus pointing to the centrality of the raster cell location within the entire spatial system. A second possibility is that for a given raster cell the AMD values may stay low while the standard deviation values are relatively high. This particular combination can be taken as an indication for raster cells which are central to a significantly large part of the system whilst being far away from relatively large

14 Further research on metric integration analysis should preferably be aimed at clarifying such issues by applying the technique on purely geometric (e.g. square, rectangular, circular etc.) and thus perfectly permeable spatial systems, to examine the 'behaviour' of different geometric shapes in terms of AMD-STMD correlation.

Table 1 | Configurational interpretation of correlations between AMD and STMD values.

		Standard Deviation of Metric Distance	
		Low	High
Average Metric Distance	Low	Central for the entire spatial system (i.e. globally central)	Centre of a possible sub-system (i.e. locally central)
	High	Peripheral; connected to the rest of the spatial system through metrically long sequence of spaces that are mostly narrow and/or constitute tree-like topological structure	Peripheral; but if found close to local centers (i.e. low AMD, high STMD), possibly part of a sub-system

areas too; this would be the reason why metric integration values vary considerably, while AMD values remain low. The combination is likely to point to a relatively peripheral locale serving as the centre of a *large* subsystem (term henceforth used interchangeably with 'spatial cluster' and 'compartment'), of which the relative size (i.e. largeness or smallness) is assessed in relation to the entire building size. Another possible combination is high AMD values accompanied by relatively low STMD values. This combination can indicate a metrically isolated raster cell in the entire spatial system; at a more local level, the combination indicates that very few cells are close to the cell under observation. Raster cells with this particular combination of AMD and STMD values exhibit low variations of metric distance values because a substantial amount of the other raster cells in the spatial system is relatively far away. In fact, the combination indicates that the raster cell connects to the rest of the system through a metrically long sequence of spaces. The difference between the 'ordinary' peripheral cells and this particular type – reflected by low STMD values – is the relative (metric) narrowness and/or tree-like topological configuration of the spaces that need to be traversed to reach the latter. Both qualities will have an impact on STMD values, rendering them lower than expected. Regarding the tree-like configuration, note that high AMD and low STMD raster cells are often located towards the end of topologically long branches with many b-type spaces. From a cognitive perspective, areas exhibiting this particular AMD and STMD correlation may indeed be those perceived as distant or inaccessible, a property suggested as being also indicated by low axial integration (Sailer 2010, p. 98). Lastly, there are those cells with both high AMD and STMD values which are simply peripheral within the spatial system as listed in table 1. In certain cases these areas may be part of a subsystem if they are found close to raster cells with low AMD and high STMD values, which in fact would be the centre of such subsystems as discussed above.

Finally, two additional points have to be made concerning metric analysis. Firstly, the interpretations presented in table 1 are preliminary and may possibly entail equifinality issues which may have been overlooked here because of the limited number of case studies. In other words, other configurational properties may also provide explanations for the particular correlations of AMD and STMD values set out in table 1. Future applications in other

architectural systems will certainly enrich our knowledge on the issue. Secondly, identification of spatial clusters using the framework presented here is very much affected by a subsystem's size in relation to the entire spatial system as well as the degree to which it is peripheral (i.e. its distance to the centre of the system). In terms of size, a small spatial cluster within a large spatial system may easily be missed, a phenomenon observed for Building A and the Palace of Pylos. Besides, spatial clusters closer to the centre of a spatial system are more difficult to identify with this approach than those at the periphery. This is because a subsystem at the centre would typically have low AMD and STMD values, which render it globally central. As a result, any spatial cluster at the centre would unavoidably be missed, and the area will be interpreted as the centre of the entire system rather than being a globally central subsystem. Further research on GIS-based metric integration analysis would be most rewarding in further clarifying such issues.

3 First case study: Malia

3.1 Analysis

3.1.1 Topological properties

Previous work on Maliote architecture in the vein of space syntax analysis comprises a study by Romanou (2007), whose thoughts on the use of genotypes are of great methodological interest, as well as Letesson's (2009, this volume) studies on the configurational variation within Cretan Bronze Age architecture and an article of much more limited scope by Thaler (2002). The Middle Minoan II complex of Quartier Mu, with its exceptional preservation, offers a subject for consideration for both Romanou (2007) and Letesson (this volume), who deal with the 'house-workshops' and Buildings A and B respectively. Our focus here is more specifically on Building A only, the central and largest building of Quartier Mu.

Building A is surrounded by nine other buildings, five of which are identified as house-workshops. As there is no consensus about space use in Quartier Mu, varying interpretations have attributed different functions to Building A, mostly emphasizing a combination of ceremonial, storage, residential and administrative practices (Poursat 1983; 1987; 1995; 1996; Poursat and Knappett 2005; cf. Schoep 2002). For topological as well as for other forms of spatial analysis, it represents one of those particularly promising cases where archaeology can distinguish the plan of a building in two different phases, and we can thus trace the effects of its transformation through time.

In the case of Building A this transformation is quite drastic in terms of size, converting a former 35-room into a 56-room structure, but, at least at first sight, changes in spatial characteristics seem less dramatic. The convex integration core (fig. 3) in the earlier phase is formed by an east-west axis of spaces consisting, in decreasing order of integration, of

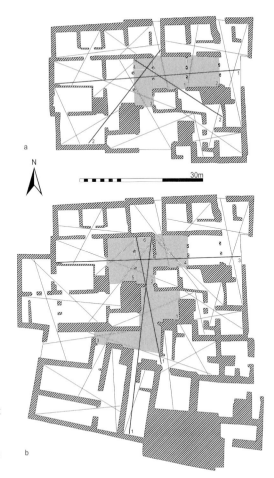

Figure 3 | Malia, Quartier Mu, Building A:
a) plan of phase 1 with convex integration core
indicated in light grey, axial break-up in grey and
axial integration core in black, numbers denote rank
order; b) plan of phase 2 with convex integration
core indicated in light grey, axial break-up in grey
and axial integration core in black, numbers denote
rank order.

I 13a, *I 13b*, *I 1a* and *I 1ii*, which remains part of the core when a second, north-south axis develops due to the extension of the building, with the core now including spaces *II 1*, *I 1a*, *III 1i*, *I 13a*, *I 1i* and *I 1ii*. A look at axial integration confirms this: the longest and most integrated line of the earlier phase, which passes from *I 3* through to *I 21* on the west-east axis, is relegated to third place in the later phase by two lines falling on the north-south axis, although it still shows a considerably higher integration than any line outside this core of three (fig. 3). The two north-south lines both cover spaces *I 1Iii*, *I 1a*, *II a*, *III 1i* and *III 1ii* along with, in one case, *III 6* and *III 8* and, in the other, *III 1iii*.[15]

15 It would be tempting to replace the two lines on the north-south axis with a single line, but if both the northeastern segment of the ring of spaces *I 1i*, *I 1ii* and *I 1a* and spaces *III 6* and *III 8* are to be covered by the longest feasible lines, both lines are needed. If the shorter one is omitted, which still leaves a fully connected system, the remaining line continues to show a higher integration than the line on the west-east axis.

a

N

30m

b

Figure 4 | Malia, Quartier Mu, Building A:
a) plan of phase 1 with areas of primary access
highlighted; b) plan of phase 2 with areas of primary
access highlighted.

The boundary between areas of primary access (fig. 4) for the northern and north-eastern entrance is hardly shifted at all as a result of the re-modelling. Moreover, the north entrance remains, as in the first phase, a clear second to the south – or later west – entrance in terms of the number of rooms to which it provides topologically shortest access paths. Still, the northern access point does, hardly surprisingly, gain some ground towards the south, as the southern access point is shifted to the south-west. However, as in the changes described before, this one, too, appears to be a mere function of the enlargement of the building, more specifically in this case of the exclusive addition of rooms to its southern and not its northern part, rather than a reflection of any change in its underlying organizational logic.

At first glance, one might assume the same about changes in general integration values. Average convex integration drops moderately from 0.87 to 0.72 globally and 1.15 to 1.06 locally, and the integration of the carrier space, i.e. the integration of the building with its surroundings, from 1.34 to 1.10; if, in a comparative exercise, average integration is cal-

culated for the northern part only of the building in its later state as a subsystem, i.e. with rooms I 11, I 11a and I 12 as the only additions, the resulting values of 0.70 for global and 1.05 for local integration match those of the entire system very closely; integration of the carrier cannot be meaningfully calculated for this subsystem. Changes in axial integration between the earlier and later phase are even less pronounced than those in the convex analysis, with the average falling from 1.33 to 1.25[16] globally and the axial integration of the carrier from 1.51 to 1.46, while average local axial integration remains almost stable with an earlier value of 1.53 and a later one of 1.52. For the northern part of Building A, axial integration shows an average of 1.28 globally and 1.48 locally. Overall, the values remain high; since in larger systems the movement-related axial system tends to assume greater importance,[17] the stability in axial integration deserves particular emphasis, considering the substantial enlargement of Building A. Furthermore, the high integration values for the carrier, which takes fourth and fifth rank respectively in the convex break-up of the first and second phase, are particularly noteworthy: this building is perfectly suited to communicating with its surroundings.

Yet if we take a closer look at possible reasons for the moderate loss of convex integration that we do observe, in particular by tracing the ringy and tree-like elements of the earlier and later j-graph (fig. 5) through a count of space-types a, b, c and d, we come upon one element of change that does appear significant and that does seem to relate to a meaningful change in the organizational properties of Building A. In the first phase, c-type spaces, i.e. spaces on a ring, are most common with a remarkable 49 % of the total, followed by the dead-end a-type at 37 %, cut-link b-type spaces at a rather low 9 % and the rare d-type connectors between rings at 6 %. In stark contrast, 71 % of all spaces are of 'branchy' types in the second phase, with a-type spaces at now 39 % the most common; indeed, even the formerly relatively sparsely represented b-type spaces at 32 % very clearly outnumber both ringy types, with c-type now at only 21 % and d-type spaces at 7 %. That this is no coincidence becomes obvious if we take another look at the plans: not only are all the additions to the south, e.g. the suite of rooms *III 10* to *III 17*, tree-like in structure, but also seemingly minor local changes in the older part of the building, most notably the blocking of doors between *I 13b* and *I E*, and probably between *I 8* and *a*, serve to break up former rings and create tree-like elements. It therefore appears that, in the later phase, we are witnessing a compartmentalization of the building, which appears to be deliberate, since it is partly effected through the walling-up of doors; while still very well integrated with its surroundings and providing good internal communication, Building A is now divided into more clearly delineated sections which can be more easily sealed off from one another.

16 This, however, is, at least partly, a function of the representation of the main north-south axis by two lines. If the shorter of these is omitted, axial integration shows a slightly more pronounced decline to an average of 1.16.
17 Cf. Hillier (1996, p. 132) on the correspondence between axiality and movement as well as the convex articulation of space and "'static' behaviours" and Turner's (2007c, p. 163–164, p. 177) emphatic statements on the role of axiality in larger systems, particularly settlements.

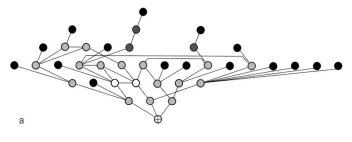

a

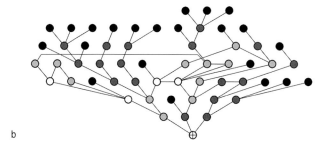

b

Figure 5 | Malia, Quartier Mu, Building A: a) j-graph of phase 1 with a-type spaces indicated in solid black, b-type by dark grey fill, c-type by light grey, d-type by white and the carrier space by a cross; b) j-graph of phase 2 with a-type spaces indicated in solid black, b-type by dark grey fill, c-type by light grey, d-type by white and the carrier space by a cross.

3.1.2 Visual properties

The results of VGA accord well with what was suggested above on the basis of the topo-logical study. The visually most integrated area (fig. 6a, 6c) in the first building phase is part of the central group or row of spaces, i.e. the axis running west-east from *I 1i* to *I21*; more specifically, visual integration is at its highest in the western part of this axis includ-ing *I 1i*, *I 1ii*, *I 1a* and *I 13a*. These spaces, as previously stated, also form the convex inte-gration core, i.e. topological and visual integration correlate well, although *I 13a* as the topologically most integrated convex space is somewhat less integrated visually than the other three spaces. This may reflect, to some degree, the influence of a short north-south 'axis' of relatively high visual integration reaching south into *II 1*. This axis, as also seen in the convex and axial analysis, becomes more pronounced in the second phase, when a sec-ond core zone of visual integration forms at its southern end in *III 1i* and *III 1ii*. In this southern core zone integration values even slightly surpass those of the northern one, which is now more narrowly confined to spaces *I 1a* and *I 1ii*. Interestingly, in terms of the more basic characteristic of visual connectivity (fig. 6b, 6d), the northern core zone remains more prominent, which reflects the fact that it is there that the main west-east and north-south axis intersect in light-well *I 1a*. More generally, both axes and also the shift from one west-east axis to two intersecting axes emerge yet more clearly in the mapping of visual connectivity than they do in the visual integration map. The drop in average visual integration from 0.65 to 0.41, on the other hand, can be seen to further reflect the afore-

Figure 6 | Malia, Quartier Mu, Building A: a) plan of phase 1 with visual integration indicated by shading (lighter shading denotes higher integration); b) plan of phase 1 with visual connectivity indicated by shading (lighter shading denotes higher connectivity); c) plan of phase 2 with visual integration indicated by shading (lighter shading denotes higher integration); d) plan of phase 2 with visual connectivity indicated by shading (lighter shading denotes higher connectivity).

mentioned tendency to compartmentalize the building while maintaining high overall topological integration.

A further and vivid confirmation of the importance of the main integrative axes of Building A is provided by an agent-based analysis of its plan, which was performed using a deliberately fine grid of points spaced only approximately 16 cm apart, since it was felt that the detail of Building A's plan could not be adequately represented at a scale that approximates raster width to the length of a human step. To counter the resulting divergence from the human scale (cf. Turner 2007c, p. 171), the field of view and the number of steps before a turn decision were raised significantly after an initial analysis performed at Depthmap's

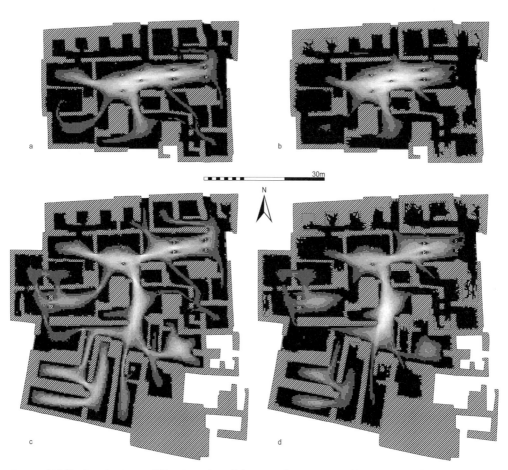

Figure 7 | Malia, Quartier Mu, Building A: a) plan of phase 1 with gate counts of agents with default field of view and number of steps before decision (lighter shading denotes higher density of movement); b) plan of phase 1 with gate counts of agents with increased field of view and number of steps before decision (lighter shading denotes higher density of movement); c) plan of phase 2 with gate counts of agents with default field of view and number of steps before decision (lighter shading denotes higher density of movement); d) plan of phase 2 with gate counts of agents with increased field of view and number of steps before decision (lighter shading denotes higher density of movement).

standard settings.[18] The first analysis (fig. 7a, 7c) picked up both the mono-axial core of the first and the bi-axial core of the second phase, but also a few less frequented, but still discernible subsidiary routes including the loops through rooms *II 1, I 1a, I 13a, I 14, I 15 a, II 3ii* and *II 3i* in both and through rooms *I 11, I 12, I 4* and *I 10* in the later phase only. The second analysis (fig. 7b, 7d), with larger fields of vision and less frequent turns, showed an even stronger concentration of movement on the main axes. This effect is most pronounced in

18 From 15 to 45 for field of view and from 3 to 10 for steps before turn decision.

the map for the first phase, where apart from the dominant west-east axis only the emergent north-south axis is discernible at all against a background of low movement density. In the map for the later phase, it is particularly noteworthy that movement of agents is most intensive in *II 1*, i.e. in the space that connects the visually most integrated areas. In either version of the analysis and either phase, it is furthermore conspicuous how little movement is attracted by the storerooms in the north of the building, particularly the group of rooms *I 5*, *I 6* and *I 7*, despite their topological proximity to the most integrated parts of the building. The significance of this observation is not quite clear, although the contrast to previously discussed aspects, where observations on visual properties were more easily correlated with topological results, is of some interest.

3.1.3 Metric properties

In the first phase, large areas of Building A have directly correlating AMD and STMD values (fig. 8a, 8b). As explained previously, low AMD and STMD values indicate centrality to the entire system, and this is the case for *I 13a* and the light-well *I 1a* in particular, but also for *I 1i*, *I 1ii*, *I 2*, *I 14* and *II 1*. In the first phase system, AMD and STMD values range from 8.4 m to 19.2 m and 3.6 m to 6.9 m respectively, while the globally central areas listed above have values of 8.4 m to 10.7 m and 3.6 to 5.0 m respectively. Note that these areas constitute the metric integration core together with *I 13b*. With 10.6 m as AMD and 5.5 m as STMD, *I 13b* is more of a locally central area than the rest of the core; moving further eastward this local centrality phenomenon becomes even more emphasized in *I 21*, where relatively low AMD values (13.3 m–13.6 m) coincide with high STMD values (6.4 m–6.6 m). As such, *I 21* may have been a local centre connecting rooms to its north (*I 22–I 24*) with those to its south (*I 19* and *I 25*) and west (*I 13b*), perhaps facilitating their use as a subsystem. In general the first phase building is fairly permeable, with directly correlating AMD and STMD values in many parts including the western part of *I 3*, *I 4–I 10*, *I 15*, *I 17*, *I 23*, *I 24*, and *II 2*, where *I 4* is the most isolated area; for these rooms AMD and STMD values range from 15.8 m to 19.2 m, and from 6.1 m to 6.9 m respectively.

The metric integration core covers 83.1 m² of the 248.9 m² system in the first phase, comprising 33% of it. The metric allocation of areas to the entrances shows that the two north entrances are the closest for 52% of the building (the north entrance 28%, the northeast entrance 24%), while the south entrance is the closest entrance for 48% of it (fig. 9a). Importantly, the areas allocated to the northeast entrance match exactly with the subsystem indicated above, with *I 21* as the local centre.

In the second phase the metric integration core enlarges and shifts to the south (i.e. from the area in between *I 1a* and *I 13a* to the area in between *I 1a* and *II 1*); both is to be expected given the extension of the system towards the same direction. The AMD and

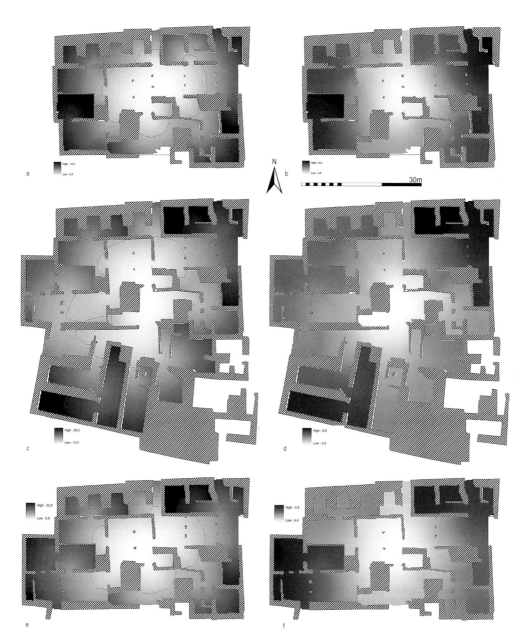

Figure 8 | Malia, Quartier Mu, Building A: a) AMD map of phase 1; b) STMD map of phase 1; c) AMD map of phase 2; d) STMD map of phase 2; e) AMD map of phase 2 (northern subsystem); f) STMD map of phase 2 (northern subsystem). The border of the metric integration core for each case is shown by a solid black line.

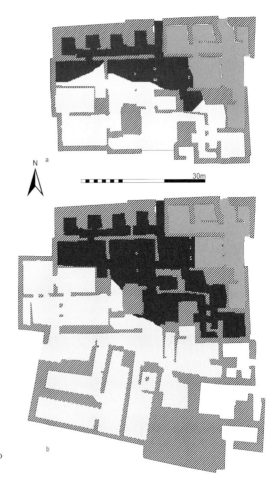

Figure 9 | Malia, Quartier Mu, Building A:
a) metric allocation map of phase 1 showing areas
allocated to three different entrances; b) metric
allocation map of phase 2 showing areas allocated to
three different entrances.

STMD values range from 12.0 m to 28.0 m and 4.9 m to 9.9 m respectively in this phase
(fig. 8c, 8d). The globally central area mainly comprises *II 1* and *I 1a*, but also *I 2*, *II 2* and
III 1, where AMD values range between 12.0 m and 13.3 m and STMD values between 4.9 m
and 5.8 m. Besides these globally central areas, the metric integration core also includes *I 1i*,
I 1ii, *I 9*, *I 10*, *I 13b* and the eastern part of *III 15* with low AMD (14.1 m–15.8 m) but relatively
high STMD (6.5 m–7.2 m) values, and as such they have local centrality properties. Beyond
the metric integration core a similar trend continues: at the south of *I 4*, *I 11*, the southeast
of *I 12*, *I 13b*, *I 14*, and the west of *III 15* and *III 16*, *I 21*, *I 22*, *I E* and *I 25*, a combination of low
AMD (15.8 m–21.3 m) and relatively high STMD (7.2 m–9.4 m) values can be observed,
pointing to varying degrees of local centrality.

There are three spatial clusters at the periphery of the building during the second
phase: First, in the western part, the loop through *I 4*, *I 10–I 12* is a spatial cluster with the
opening between *I 4* and *I 10* at its centre (if we take the northern part of the second phase

building as a subsystem, the spatial cluster comprising *I 4, I 10–I 12* stands out more distinctly [fig. 8e, 8f]). Second, to the northeast, as in the first phase, *I 21, I 13b, I 19, I 22, I 22a, I 23, I 24*, and *I 25* constitute a spatial cluster with *I 21* as the centre. And third, to the southwest *III 9, III 16* and *III 17* form a cluster with the opening between *III 9* and *III 16* as its centre. In large parts of the building (comprising *I 5, I 7, I 16, I 17*, the western part of *II 2, III 3, III 4, III 7* and *III 8*) there is either a combination of relatively high AMD (15.7 m–19.6 m) and low STMD (5.2 m–7.0 m) values, or high AMD (19.0 m–22.3 m) and relatively low STMD (6.9 m–7.9 m) values. These spaces are likely to have this particular combination of AMD and STMD values not only because of their peripherality. As discussed previously in the methodology section, the correlation also has to do with being located at the end of long branches of the tree-like elements (*I 5* and *I 7*), forming narrow spaces themselves (*II 2* and *III 8*), being accessed through narrow spaces (*I 16, I 17* and *III 7*) or a combination of one or more of these configurational properties. Note, however, that for none of these spaces the trend is strong and, as such, they can be considered simply peripheral in a largely permeable system in terms of metric distance.

In the second phase, the metric integration core increases in absolute size to 124.5 m², but with the entire system expanding to 438.4 m² the core comes to comprise only 28 % of it, pointing to a slightly less integrated system than the first one. The allocation of areas to entrances shows a possible increase in the importance of the south entrance that shifts to the west in the second phase. This southwest entrance is the closest entrance for 54 % of the building now (fig. 9b), while the north entrance is now the closest entrance for 33 % of the entire system, which is also an increase compared with the first phase. The northeast entrance, on the other hand, is the closest entrance for the same area as for the first system, which constitutes 13 % of the second phase building; the area allocated to the northeast entrance in the second phase is in fact the spatial cluster with *I 21* at its centre, a compartment which can be identified clearly in both phases of Building A.

3.2 Interpretation

3.2.1 Archaeological interpretation

The major architectural change in Building A in the second phase is the addition of two rooms (*I 11* and *I 12*) to the west, and a series of spaces (section *III*) to the south. Additionally, the accesses between *I 7* and *I 8*, and *I E* and *I 13b* were sealed in the second phase, as were two out of three openings between column bases separating *I 1a* and *I 1ii* from *I 13a* (Daux 1967, p. 882; Poursat 1992). All three analyses – topological, visual and metric – point to the well-integrated nature of the building in both phases; while integration values decline in the second phase – a phenomenon which can *largely* (cf. section 3.2.2) be explained through compartmentalization – a high degree of overall integration is main-

tained. In fact, the sustained high integration, increasing compartmentalization and architectural modifications along with the largely unaltered plan of the northern part comprise a dialectical existence of change and continuity embodied in Building A at Middle Bronze Age Malia.

Specifically, *I 13b* is no longer as central in the second phase as it was in the first in terms of convex integration. The same observation can be made for *I 1i*, *I 3*, *I 13a*, *I 13b* and *I 21*; *I 13a*, *I 13b*, and *I 14*; and *I 1i* and *I 13a* in terms of axial, metric and visual integration values respectively. Spaces *I 1a*, *I 1ii*, *I 13a* and *I 13b* may deserve particular attention here as they comprise a 'Minoan hall'[19] in the first phase, which may have had ceremonial and/or communal significance (Poursat 1992, p. 41; cf. Marinatos and Hägg 1986) as part of or beyond the daily routine. Hall *I 13* (*I 13a* and *b*) is less integrated in the second phase, as indicated by the topological, visual and metric analyses. Moreover, the same hall is not readily accessible from the southwest entrance, whereas in the first phase the south entrance would have been an easy way to access it through a large paved vestibule and portico,[20] which in its context may have been considered prestigious. In fact, a later hall (comprising *I 10–I 12*) with pier-and-door partitions in the western part of Building A may have created a second phase alternative for some of the practices that originally took place in the first phase Minoan Hall. Note that, in the second phase, it is this new hall which becomes easily accessible through the southwest entrance preceded by a sandstone pavement ('*Trottoir Ouest*', cf. Poursat and Darcque 1990, p. 910) running along the western façade of the building, comparable to the paved entrance of the first phase building. While spaces *I 10–I 12* do not qualify as a Minoan Hall from a strictly typological point of view (lacking column bases and a light-well), it is noteworthy that spaces *I 10* and *I 11* have visual and metric properties comparable to those of *I 13a* and *I 13b* in the first phase.

A result shared by all three analyses is that they pick up *I 1a*, *II 1* and *III 1* (*i* and *ii*) and *I 1i*'s east as the centre of the building for the second phase and *I 1i*, *I 1a* and *13a*[21] for the first. For the second phase it is worth noting that all the stairs leading to the first floor of the building (i.e. *I A*, *II A*, *II B*, *III A* and *III B*) open onto this central zone. As such, it would be there that the daily buzz in Building A would be, provided enough people were present. It

19 Although the 'Minoan hall' as typologically defined (cf. Driessen 1982, p. 29) is not necessarily a category that immediately reflects the 'realities' of the Cretan Bronze Age, it is perhaps of significance to underline that spaces *I 1a*, *I 1ii*, *I 13a* and *I 13b* no longer constitute a Minoan Hall in the second phase, as two of the three openings between the column bases that separate *I 1a* and *I 1ii*, and *I 13a* were blocked.

20 This first phase vestibule becomes space *II 1* of the second phase system. The paved portico mentioned was incorporated into the second phase building and can still be traced through the paved areas in spaces *II 1*, *III 1* and *III 2* (Poursat 1992, p. 42–43).

21 Space *I 13b* appears as one of the better integrated spaces in all analyses except for the visual one, a reason why it has not been included here. Another reason is the metric analysis according to which *I 13b* has local centrality properties, unlike the rest of the metric integration core, which is globally central.

would be a place where people moving from one compartment of the building to the other, or coming from or going upstairs would pass and encounter one another.

Compartmentalization is another common conclusion reached by topological, visual and metric analysis. Through metric integration analysis three clusters can be identified: *I 4*, *I 10–I 12*; *III 9*, *III 16* and *III 17*; and *I 13b*, *I 19*, *I 21–I 25*. Given the existence of a 'lustral basin'[22] at the basement level underneath the ground floor space *I 4*, the first cluster is likely to have had some cultic significance. For the second compartment, the existence of benches in *III 16* may signify storage practices, and given that it was found empty during excavations it is possible that this cluster had already been abandoned at the time of the final destruction by fire. The other compartment which was found empty, *I 13b*, *I 19*, *I 21–I 25*, is likely to have also been abandoned at the time of the final destruction by fire if not during the entire second phase. In the first phase, however, it may have been a context for culinary practices considering the 'troughs' found *in situ* in *I 19* (Poursat 1992, p. 47)[23] and possible storage spaces to the north, *I 23* and *I 24*.

As mentioned previously in the methodology section, metric analysis failed to identify some of the obvious spatial clusters in Building A, *I 5–I 7* (perhaps also including *I 3*) being one of them. With several storage vessels found *in situ* in these rooms (Poursat and Knappett 2005, p. 158–160), there is barely any doubt that this cluster was used for storage, particularly in the second phase and probably in the first one, too. Spaces *I 14–I 17* and *II 3* form another one of those unidentified possible spatial clusters which may have been used for culinary practices in the second phase, considering the *in situ* storage vessels found in *I 16* (Poursat and Knappett 2005, p. 161) as well as the troughs in *I 15* (Poursat 1992, p. 47); this area may have been rearranged in the second phase, perhaps restoring the practices which had taken place in *I 13b*, *I 19*, *I 21–I 25* during the first phase.

From these results, we can say that in the second phase building practices similar to those performed during the first phase found new locales. In fact, the architectural history of Building A shows us a glimpse of the delicate balance between change and continuity in this particular social context, i.e. how change came without denying traditions and habits in a context where traditions and habits did not exclude change. The second phase Building A, with its central zone interfacing between different compartments and floors, appears to be a place where people would continually encounter one another, witness what others were doing and (tacitly) negotiate their social roles. It is a place that could facilitate intense social interaction, awareness (cf. Thrift 2008, p. 6–7) and memory

22 For a recent overview of this particular type of architectural space referred to as lustral basins (or *adyton*, see Marinatos 1993, p. 77–87) and often interpreted as baths or cult rooms in Cretan Bronze Age studies, cf. McEnroe (2010) with references. For further information on the lustral basin in Building A cf. Poursat (1992, p. 37–38).

23 What is referred to here as a trough is commonly known as *gournes* (Greek) or *auge* (French) in Cretan Bronze Age studies. These are stone blocks with single or double cavities of uncertain use (cf. Treuil, 1971; Begg 1975, p. 28 for further explanation).

building; a context where tensions could rapidly emerge through the co-presence of ambi-
tious, competitive actors and where strong social bonds could be (re-)produced through
cooperative attitudes.

3.2.2 Comparison of analytical results

The results of topological, visual and metric analysis significantly agree with one another, as
was mentioned in the previous section. All three point to well-integrated systems in both
phases, while integration values slightly decline for the second phase. Yet do the similar
trends in global integration values relate to the same aspects of configuration?

Since the integration value trends for the first and second phase systems largely
match, and a numerical comparison is not possible due to the differences in calculation
methods, the inclusion of analytical results for the north wing (sectors *I* and *II*; henceforth
referred to as 'north wing system') as a subsystem of the second phase is of particular inter-
est in a comparative discussion. As summarized in table 2, axial, visual and metric global
integration values for the three systems follow a very similar trend: the north wing system is
slightly less integrated than the first phase, whereas the second phase is the least inte-
grated. However, it appears that average global convex integration values are the 'odd ones
out' in this context, given that the values for the north wing system are much lower than
those of the first phase and slightly lower than those of the second phase system. One pos-
sible explanation of this pattern could be sought in the topological depth of new tree-like
compartments in the second phase and north wing systems, calculated in relation to the
'main' rings. To be more specific: Each of the three systems under consideration has
relatively lengthy rings running through several topologically well-integrated spaces.[24] The
second phase and north wing rings, however, differ from the first phase one in that relatively
large numbers of deep topological branches comprising the compartments connect to
these rings in both systems.[25] Therefore, although the question would need further exam-
ination before any conclusive answer can be put forward, the trend of average global convex
integration values may be explained by the existence of these deep compartments in
relation to the rings in the second phase and north wing systems – a configurational prop-
erty not prominent in the first phase. As such, average global convex integration values in
this particular context may be a reflection of a particular compartmentalization phenom-

24 These rings are as follows:
Ring 1: corridor *a*, *I B*, *I 13a*, *I 1a*, *I 1i* and *I 3* (first phase system).
Ring 2: *I 13a*, *I 14*, *I 15a* (and *I 15c*), *II 3ii*, *II 3i*, *II 1* and *I 1a* (first and second phase and the north wing systems).
Ring 3: *III 15*, *III 1i*, *II 1*, *I 1a*, *I 1i*, *I 9*, *I 10* and *I 11* (second phase system).
25 E.g. *III 10*, *III 16*, *III 9* and *III 17*, which connect to *III 1i*; and *I 13b*, *I 21*, *I 22ii*, *I 22i* and *I 23* (or *I 24*), which con-
nect to *I 13a*. Note that in the first phase system the single comparably deep compartment is formed by *I 9*, *I 10* and
I 4, which is connected to *I 1i*.

Table 2 | (Average) global integration values for the three systems.

	Average Convex	Average Axial	Average Visual	Metric
1st Phase	0.87	1.33	0.65	33%
2nd Phase	0.72	1.25	0.41	28%
2nd Phase (North)	0.70	1.28	0.52	32%

enon that involves deep tree-like elements, a property other global integration values are not necessarily sensitive to.

Note that allocation of areas to 'source points' (or 'root spaces' using space syntax terminology) by metric and topological analysis provides very similar results in Building A. For example, both techniques assign spaces *I 19*, *I 21–I 24* to the northeast entrance. In both phases space *I 13b*, the locally central part of the metric integration core (cf. section 3.1.3), is assigned to the northeast entrance by metric allocation, although not by topological allocation; the result may be another indication of the ambiguous or multi-'functional' nature of *I 13b*: as mentioned earlier, this particular space appears as part of the metric integration core with local centrality properties, while it is also part of hall *I 13* and spatial cluster *I 19*, *I 21–I 24*. It is worth noting that metric allocation, unlike topological allocation, does not require the ascription of entire rooms to specific areas, but affords the researcher the possibility of making distinctions within rooms. For example, while the north entrance receives only parts of *I 1a*, *I 1i*, *I 3* and *I 4* in the first phase metrically, spaces *I 3* and *I 3a* are assigned to the north entrance and *I 1a* and *I 1i* remain with the south entrance in the corresponding topological mapping. Another difference between topological and metric allocation results is that in the second phase space *II 1*, one of the more central parts of the building, is assigned to the north entrance metrically and the southwest entrance topologically. At any rate, there is considerable agreement between the two techniques, which offer possible alternatives to one another.

4 Second case study: Pylos

4.1 Analysis

4.1.1 Topological properties

As in the case of Building A at Malia, the palace of Pylos (Blegen and Rawson 1966), which served as the centre of a Late Bronze Age state as evidenced by the Linear B tablets found in its archive rooms, provides a particularly promising context for topological studies and other analyses of configuration because of our ability to distinguish an earlier and later building state, as was first coherently set out by Wright (1984), with later

additional discussions by Nelson (2001, p. 207–216) and Thaler (2009, p. 56–70). Space syntax analyses of the palace were undertaken relatively early on by Lane (1993, p. 28–32, pl.s 3–4),[26] who, however, based his work on topological graphs which did not capture the building in its entirety in either phase, and later by Thaler (2005; 2009, p. 56–83), whose main results are summarized here.[27]

An almost inescapable starting point for the topological analysis of the Pylian palace is the assumption that changes to the palace consistently served to "restrict access and circulation" (Shelmerdine 1987, p. 564), which has long been taken as one of several architectural reflections of a long-term economic decline and sometimes even been associated with fortificatory intentions (Deger-Jalkotzy 1995, p. 370; Shelmerdine 1998, p. 87). The assumption that circulation was restricted fails to find corroboration in topological analysis, as average convex integration is only marginally lower at 0.70 in the later than in the earlier building state at 0.72, and the same is true for axial integration with an average of 1.01 for the first and 0.96 for the second building state.[28] Integration of the complex with the exterior as a topological measure of ease of access, on the other hand, does experience a more noticeable decrease from 0.84 to 0.69 for the convex and 1.27 to 1.11 for the axial break-up;[29] however, both measures of integration for the carrier space remain close to the average integration of the building complex even in the second phase, thus belying any fortificatory intent and suggesting that the observable changes may be better understood in the context of functional and potentially social differentiation. Partly, this seems to take the form of effectively channelling movement within and particularly into the palace, which will need to be discussed in more detail, but is already hinted at by the increase in proportion of spaces of type b, 29 % in the earlier and 38 % in the later building state, and the concomitant decrease of d-type ring-connectors, 18 % and 9 % respectively.

Generally, a higher degree of spatial differentiation in the later building state, in terms of circulation within the palace complex as well as access from outside, is particularly evident in the case of the major courts, particularly courts 58 and 63. While both form part of

26 We would like to thank Louise Hitchcock for pointing out to us an even earlier application of a space syntax approach to the analysis of Pylos by Yiannouli (1992), to whose unpublished PhD thesis we unfortunately did not have access at the time of writing.

27 To ensure consistency, analyses which had previously been carried out manually (Thaler 2001) or with the older UCL Macintosh-Bundle (Thaler 2005; 2009) were reworked with Depthmap 8.15.00c. The underlying ground plans are, except for the omission of staircases, the same as in the two latter studies, which revise the architectural discussion in the first in some details. Results, however, remain consistent.

28 With regard to the issue of normalization (cf. section 2.1), it is well worth noting that results are reversed for both the convex and axial analyses if the normalization formula suggested by Teklenburg et al. (1993) is applied instead of the standard one, although the differences in integration values remain minimal (cf. Thaler 2009, p. 71–72).

29 For technical reasons, the axial carrier was represented by a frame of four interconnected axes and its integration was calculated as the average value for these four spatial units in Thaler (2009, p. 73), resulting in values of 1.15 and 0.90 for the earlier and later state respectively. The present analysis uses Depthmap's link-functionality to render the axial carrier as a single spatial unit, which results in the higher values given here.

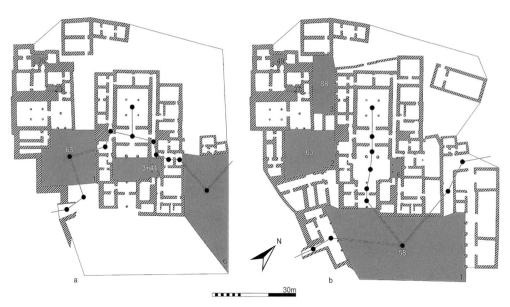

Figure 10 | Pylos, palace: a) plan of earlier building state with topologically shortest routes to throne room *6* indicated and peaks of local integration highlighted in grey with local integration ranks inscribed in black; b) plan of later building state with topologically shortest routes to throne room *6* indicated and peaks of local integration highlighted in grey with local integration ranks inscribed in black.

an undifferentiated ring of hypaethral spaces in the earlier building state and are, at a low depth of 2 and 3 steps respectively, easily reached from the outside, they come to fulfil distinctly different roles in the later building state. At a topological depth of 6 steps from the outside and no longer part of the shortest topological route to the throne room (fig. 10), court *63* is of little importance for access to the palace; its integration value of 1.17, however, the maximum value for the complex, demonstrates that it forms the single most important node of internal communication. Court *58*, on the other hand, with a noticeably lower, though still high global integration value of 0.92, retains a comparatively low depth of 3 and forms, in the later state, the point where the shortest topological access paths to the throne room converge. This offers a first indication of this court's role as the most important interface between the palace and the outside in official matters.

Court *58*'s importance as an interface, for which it is well suited as the space with both the highest local integration and the highest number of immediate neighbours, becomes clearer still by mapping the areas most closely associated with each of the three main courts, which takes into account court *88* alongside courts *58* and *63* (fig. 11a). All three are not only peaks of local integration, i.e. more highly integrated at radius 3 than any adjoining space, but also the three spaces with the highest absolute values of local integration in the complex and thus identified as primary integrators (fig. 10). In this map of primary control, both the palace archive consisting of rooms *7* and *8* and the Northeastern Building – recently and

Figure 11 | Pylos, palace: a) plan of later building state with areas of primary control indicated by shading; b) plan of later building state with areas of primary access indicated by shading.

convincingly re-interpreted as a clearing house functioning within the redistributive palatial economy (Flouda 2000, p. 215; Bendall 2003, p. 181) – fall within the area of primary control of court *58*, thus confirming its role as an interface for official visitors to the palace.

In addition, the mapping of areas of primary control shows court *88* as the centre of an area which overlaps almost perfectly with the area most easily accessible from the outside through space *w*. This is particularly noteworthy since *w* is the one entrance to the palace that bypasses court *58* and also the one from which the complex as a whole, i.e. beyond this area of primary access (fig. 11b), appears deepest and least accessible; the latter is illustrated by a comparison of j-graphs for this northern and the two southern access points (fig. 12). Since the area controlled by *88* and accessible via *w* encompasses most of the palace's store-rooms, notably the oil and wine magazines and the main pantries, Kilian's impressionistic and perhaps anachronistically phrased, but highly perceptive identification of a 'trades-man's entrance' (Kilian 1984, p. 43: "Lieferanteneingang"; Kilian 1987, p. 207: "entrée des fournisseurs") at the back of the palace is clearly confirmed as a prime example of the above-mentioned efficient channelling of access to the palace. As such it forms the direct counterpart to the shifting of shortest topological paths to the throne room, previously alluded to in discussing court *58*: while these paths use side entrances of the Main Building in the earlier building state, they come to coincide with what architectural elaboration and the parallel contexts at the palatial sites of Mycenae and Tiryns lead us to identify as the canonical access route through spaces *1* to *5*, i.e. the propylon and megaron court and then the porch and vestibule of the megaron, into room *6*, i.e. the throne room, the importance

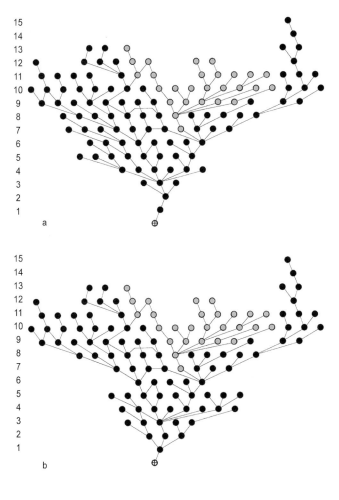

15
14
13
12
11
10
9
8
7
6
5
4
3
2
1

a ⊕

15
14
13
12
11
10
9
8
7
6
5
4
3
2
1

b ⊕

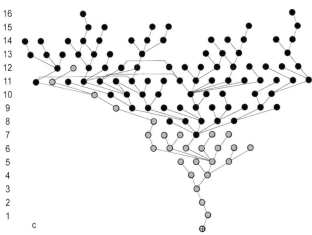

16
15
14
13
12
11
10
9
8
7
6
5
4
3
2
1

c ⊕

Figure 12 | Pylos, palace: a) j-graph of later building state for access through space *a* only, topological depth indicated on the left, area of primary access through *w* in grey and carrier space by a cross; b) j-graph of later building state for access through space *101* only, topological depth indicated on the left, area of primary access through *w* in grey and carrier space by a cross; c) j-graph of later building state for access through space *w* only, topological depth indicated on the left, area of primary access through *w* in grey and carrier space by a cross.

of which is reflected by its being the most integrated a-type space in the Main Building. In this latter instance, it is conceivable that social customs assured a similar 'channelling' in the earlier building state, but it is only in the later one that it becomes 'inscribed' in the architectural layout of the palace. More generally, none of the elements of spatial differentiation here described for the later building state are evident in the earlier. In particular, the integrated economic unit at the back of the palace is only made possible through a reconfiguration of access to rooms at the Main Building's western corner.

4.1.2 Visual properties

As in the case of Malia, some of the tendencies observed in topological analysis are further illustrated by the results of VGA (fig. 13).[30] The first and – given the sensitivity of visual analysis to the size of spaces – most obvious of these is the great importance of the major courts as main foci of integration, clearly observable in both building states; but the visual analysis helps to add an interesting nuance here: in both the earlier and later state, the hypaethral areas around the back of the Main Building are noticeably less integrated than corresponding frontal areas, corroborating the identification of a 'back area' of the palace complex. Front and back are at first identified intuitively on the basis of the orientation of entrances to the major buildings, most notably the propylon of the Main Building and porch 64 of the Southwestern Building.

It should be stressed, however, that this could, in principle, be an analytical artefact to some extent, since the exact limits and, consequently, the size of specific courts are often difficult to ascertain and thus have to be set with some degree of arbitrariness; since this has a bearing both on VGA results – illustrated most clearly by a map of visual connectivity for the later state (fig. 14), in which the large court 58 could not stand out more clearly – and on the results of metric analysis set out below, some explanatory comment is needed here: the southwestern limit of the complex is defined by terrace walls and thus secure; the northeastern limit, where the ground continues as a plateau of comparable level, is approximated for the first building state by a line including the northeastern wall of a small outbuilding identified as part of the palace proper and for the later state by a serious of outbuildings on the northeastern edge of the complex and should thus be fairly reliable. The northwestern and southeastern limits provide the real challenge, since these are decisive for the size of 'frontal' and 'back' courts, but more difficult to delineate archaeologically

30 It should be noted, however, that in the case of Pylos even more than in the Maliote example, this may be partly due to the researcher's view being guided to some extent by expectations resulting from the topological analysis previously conducted, particularly since the latter was repeated in several versions with corroborative results (cf. above, footnote 27). This problem may be compounded by the fact that the grid point is an intuitively much less meaningful unit of analysis than the convex space which so closely approximates what is more commonly called a 'room', a unit of analysis that we almost automatically 'think back to'.

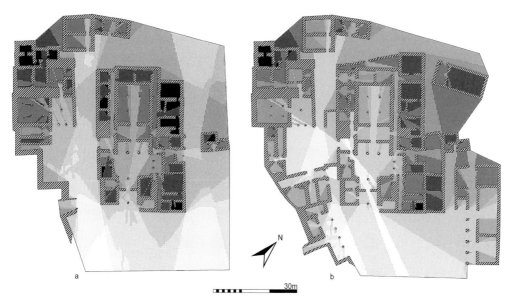

Figure 13 | Pylos, palace: a) plan of earlier building state with visual integration indicated by shading (lighter shading denotes higher integration); b) plan of later building state with visual integration indicated by shading (lighter shading denotes higher integration).

than those just discussed. In the northwest, the scarp of the plateau is relatively steep, so even allowing for some erosion, as the plans analysed here do (cf., e.g., Blegen et al. 1973, fig. 302), we should not expect spaces much wider than what is preserved today; in the southeast, however, where the edge of a very incompletely preserved stucco floor in court *58* abutted the Main Building, there is a gentler slope today with two less pronounced scarps, rendering an estimate of the court's original size much more difficult. For the later state, it was assumed to extend slightly beyond the southeastern edge of room *100* of the Northeastern Building, which, however, is itself reconstructed rather than preserved,[31] and a comparable extent is thought likely for the earlier state.

To see how much this might influence the outcome of visual analysis, a trial run was undertaken with a plan of the earlier building phase in which the southeastern extent of court *58* was reduced by approximately half (fig. 15).[32] This did indeed attenuate the predominance, in terms of visual integration, of frontal hypaethral space over back areas to some extent, but by no means neutralize it. As this is most effectively explicable by the

31 Room *100* is reconstructed slightly wider along its northwest-southeast axis in the present plans than in most other published plans (e.g. Blegen and Rawson 1966, key plan) to allow for an even spacing of the pillars suggested in Westerburg's (2001) inspiring discussion of the original layout of the Northeastern Building.
32 This brings it in rough correspondence with the southern corner of the – *nota bene* – earlier Building X, a position which seems, if anything, even more arbitrary, but is probably still the most reliable minimum estimate available.

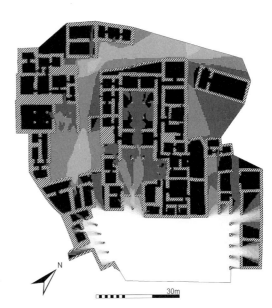

Figure 14 | Pylos, palace, plan of later building state with visual connectivity indicated by shading (lighter shading denotes higher connectivity).

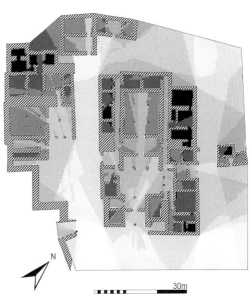

Figure 15 | Pylos, palace, alternative plan of earlier building state (reduced size of court 58) with visual integration indicated by shading (lighter shading denotes higher integration).

aforementioned orientation of main entrances to the major buildings, the intuitive first identification of front and back is clearly corroborated by the analytical results.

Still, VGA should and does offer more than this, if we look more closely at those courts and particularly at court 58, previously identified as the main interface between the building complex and its carrier space in the later building state. It is the concomitant channelling of access to the throne room towards the canonical route which is also reflected in visual inte-

gration analysis. Whereas in the earlier state the most visually integrated sections of court 58 are lateral ones which connect to other open-air spaces on the ring around the Main Building, a central core zone of visual integration within the court, which is focussed and thus focuses the visitor on the propylon, is observable in the later building state. This is perhaps the most noteworthy result of visual analysis and nicely parallels Kilian's earlier observation on how the width of the propylon in comparison to the widths, less by half, of ramps 59 and 91 helped to orientate visitors towards what is here termed the canonical access route (Kilian 1984, p. 43). While the most highly integrated area within the Main Building is linked with the connection of courts 3 and 63 in the later building state – partly apparently a result of eliminating porch 41 as an alternative 'attractor' by walling off court 42 –, the main axis of the megaron is now characterized by higher integration relative to its surroundings than previously[33] and thus provides, to a certain degree, a continuation of the visual focus on the canonical access route.

A brief remark needs to be addressed to absolute values for visual integration, the average of which is almost twice as high in the earlier phase at 0.62 as it is in the later one at 0.33. Is circulation restricted after all, as was suggested in the hypothesis of an economic decline? There is good reason not to consider the results of visual analysis evidence for this, but to place much more weight on the evidence of topological analysis discussed before. The reason for this lies in the fact that a simple characteristic of the earlier layout accounts much more effectively for high visual integration than any socio-historical narrative: where the later building state has courts hemmed in and separated from one another by suites of rooms, the earlier one has a large undifferentiated ring of hypaethral space, which is characterized by high visual integration in almost the same way as, for example, a football pitch is. To better illustrate this, it is worth contrasting visual integration for the entire complex with visual integration of the Main Building considered on its own; the latter shows an average of 0.48 for the earlier and 0.42 for the later layout and thus a much less pronounced decrease. Nevertheless, the loss of visual integration must have made itself felt for visitors to the palace, but in all plausibility much less as a restriction of circulation than by reduced intelligibility of a complex which is still well integrated topologically. This would, of course, only add to the effect of visual channelling towards specific routes, such as the canonical access route to the throne room: the relatively high visual integration of this route must have made it all the more conspicuous when other sight-lines were cut short.

Agent-based analysis in the form outlined in the methodology section has, unfortunately, little to contribute in the case of Pylos (fig. 16). The sheer size of courts compared to indoor spaces and again of court 58 in particular offers an inescapable attraction to agents of the standard direct perception type (Turner 2007c, p. 172), as Turner also notes in a com-

33 In absolute terms the main axis of the megaron is less integrated in the later state than in the earlier, but this has to be seen against the background of the lower average of visual integration values in the later building state (cf. below, next paragraph).

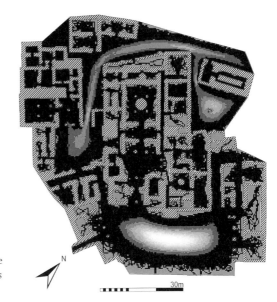

Figure 16 | Pylos, palace, plan of later building state with gate counts of agents (lighter shading denotes higher density of movement).

parable case study: "their direct perception leads them towards open spaces" (Turner 2007c, p. 169). To emphasize the positive, we may take this as further strong corroboration of the overarching importance of the Pylian courts as primary integrators of movement within the palace complex.

4.1.3 Metric properties

For the first phase of the Palace of Pylos, spaces *2, 3* and *4* and a large surrounding area (particularly spaces *8, 10, 11, 12, 37, 38, 44*) have low AMD and STMD values and, as such, would be the central area for the entire spatial system in terms of metric distance (fig. 17a, 17b). In a system where AMD values range between 37.1 m and 83.4 m and STMD values between 14.6 m and 28.7 m, these areas with AMD values ranging from 37.2 m to 39.2 m and STMD values ranging from 14.6 m to 16.2 m stand out as globally central. Note that despite being at the periphery of the metric integration core (where AMD values range between 37.2 m and 44.9 m), areas to the southwest (court *63*) and northeast (space *41, p*) of the Main Building are to a certain extent globally central, with relatively low AMD (43 m, 39.7 m, 41.6 m respectively) and STMD (19.1 m, 16.5 m, 17.4 m respectively) values. The southeastern part of the core, however, is not globally central, where spaces *1* and the northwestern part of court *58* (with AMD values of 39.2 m and 42.1 m respectively) have relatively high STMD values (18.2 m and 22.1 m), pointing to a locally central area.

Another potentially important property of the spatial system in this phase is that there is a considerable difference between the respective trends of AMD and STMD values for the

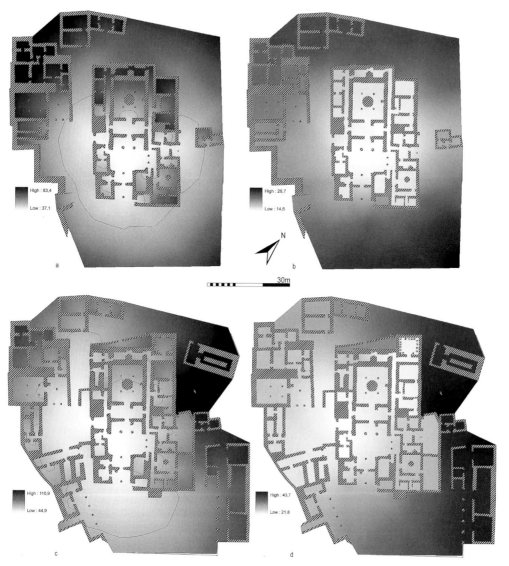

Figure 17 | Pylos, palace: a) AMD map of the earlier building state; b) STMD map of the earlier building state; c) AMD map of the later building state; d) STMD map of the later building state. The border of the metric integration core for each case is shown by a solid line.

areas within the Main Building: the latter – being low and almost uniform (from 14.7 m to 16.5 m) – are certainly not directly correlated with the patterning of AMD values ranging from low to relatively high numbers (from 37.2 m to 64.5 m). In fact, the cause of this pattern is found in the metrically isolated areas in the Main Building (spaces *19, 20, 21, 23, 24, 32, 33, 34, 50, 53*) with low AMD and high STMD values, as they are connected to the rest of

the building by narrow corridors (*13, 25, 28, 35, 45, 48, 49, 51*). Note that spaces *64* to *81* in the Southwestern Building have AMD values ranging from medium (46.8 m) to high (83.2 m). Although there is largely a direct correlation between medium AMD and STMD values in this building, simply indicating the relatively peripheral nature of these areas, the high AMD values of the westernmost spaces (*77, 78, 79, 80, 81*), between 73 m and 83.2 m, do not directly correlate with the relatively low STMD values ranging between 22.9 m to 23.2 m. The high AMD and low STMD values for these areas, again, should be explained through the narrow corridors (such as *70* and *75*) that link them to the rest of the system as well as the tree-like topological organization of the area. The spaces around the Main Building – including the structure to the northwest (*82, i, j, k, l*) – seem mainly peripheral, with high AMD values in relatively direct correlation to high STMD values.

If one takes the relative increase in the metric integration core's size as an indication of a metrically better integrated system, then the second phase complex appears to be better integrated than the first. While the size of the spatial system considered for the metric analysis increases a mere 7 % in the second phase (from 5768 m² to 6194 m²), the size of the metric integration core experiences a more significant increase from 1237 m² (21 % of the entire spatial system) for the first phase to 1951 m² (31 % of the entire spatial system) for the second. Here, centrality is a phenomenon that does not exclusively characterize spaces *2, 3* and *4*, but also spaces to the west of these, concentrating partially on court *63*. As fig. 17c shows, the metric integration core includes courts *63* and *88*, parts of court *58* as well as large parts of the Main Building. As for the first phase, the northwestern part of court *58*, which is picked up as part of the metric integration core, is perhaps the least globally central part of the entire core, potentially being central only to the court itself and the immediate surroundings. The larger second phase complex has higher AMD values for the metric integration core than its smaller first phase counterpart; these values range between 44.9 m and 59.7 m. Moreover, the second phase AMD and STMD values both have generally wider ranges than the first phase values, viz. 44.9 m–110.8 m and 21.8 m–43.68 m respectively. Therefore, we can say that the second phase system is only *contextually/locally* better integrated, while the local centrality has a considerable impact on the global integration index. In other words, better integration properties would be relevant only for those actors involved in the set of activities that entailed circulation between the Main Building and the areas south, southwest and west of it rather than those walking from one side of the complex to another; the latter would experience the later building state as the metrically less integrated one.

Combinations of relatively high AMD and low STMD values occur in many spaces, including those in the eastern (*38–43, 46–50, 53*) and northern parts (*27, 32*) of the Main Building as well as spaces in the Southwestern Building (*77, 78, 79, 80, 81*), as in the first phase. It is noteworthy that despite the increase in the size of the area considered for the metric analysis of the second phase, the AMD value in one of the more isolated parts of the spatial system, space *81*, increases by 3 metres only (from 83 m to 86 m). This fairly negli-

gible increase is at odds with the more significant augmentation for the spatial system and is another indicator of the better-integrated nature of the second phase Main Building and the areas south, southwest and west of it. For the northern, northeastern and eastern parts of the system (spaces 91, 94–100, 101, 102, 103, 104, 105, u, v, w, x, y), however, corresponding trends of AMD and STMD values point to the peripheral character of these areas. Hence, these parts appear to have been almost left out in the second phase while the rest of the system operates more in unison.[34]

Results provided by least-cost path analysis and cost-allocation elucidate further the configurational changes of the second phase in the Pylos case. Firstly, the first phase features least-cost paths leading from the south (a) and northeast (q) access points to the throne room (space 6), passing through the entrances on two of the Main Building's sides (spaces 12 and 41 – fig. 18a, 18b). In the second phase, however, movement towards the throne room is clearly channelled into a route passing through spaces 1 to 5 (fig. 18c, 18d). Secondly, the allocation of areas to the three large courts (58, 63 and 88 – fig. 19a, 19b) and the access points (a, q/101 and o/w – fig. 19c, 19d) reveals that the construction of spaces 42 and 47 at the northeast of the Main Building influenced the role of court 58 and access point q/101 in the second phase. In fact, court 58 appears to be the closest court for 40 % of the spatial system in the first phase, while in the second the percentage decreases to 36 %. Similarly, access point q at the northeast of the spatial system is the closest entrance/exit for 30 % of the spatial system in the first phase while access point 101 at the same location serves only 17 % of the system in the second phase. Thirdly, court 88 starts to serve the northwest part of the Main Building during the second phase as the closest large open space, resulting from the openings set within the southwest walls of spaces 21 and 22.

4.2 Interpretation

4.2.1 Archaeological interpretation

The conclusion that, from the perspective of metric analysis, the later building state appears to be, in terms of the size of the integration core, the more highly integrated system when compared to the earlier one leads us back to the oft-cited hypothesis that an economic decline was reflected in architectural changes to the palace of Pylos, which the topological analysis took as its point of departure: while in topological terms integration remained fairly stable

34 Note that, despite the obvious existence of spatial clusters to the west (spaces 64 to 81) and northwest (space 82, n, o, p, q) of the Main Building, metric integration analysis was unable to pick centres for these individual buildings (which would typically have low AMD and high STMD values) and as such identify these spaces as spatial clusters. Although future research should elaborate on this issue, as discussed in the methodology section, this phenomenon is likely to be related to the small size of these clusters in relation to the entire spatial system considered for the analysis.

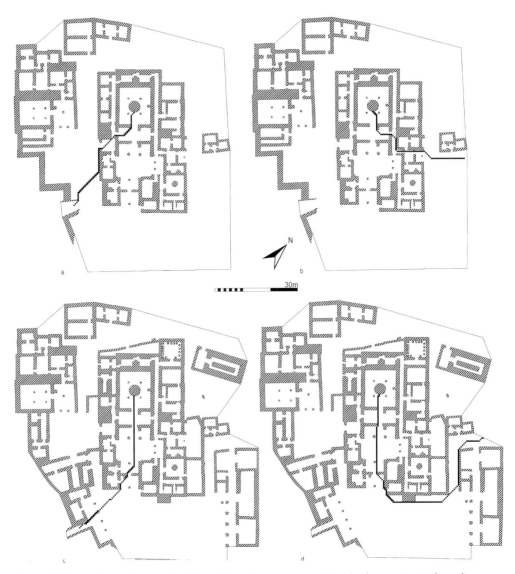

Figure 18 | Pylos, palace a) least-cost path from the southern access point to the throne room in the earlier building state; b) least-cost path from the northeastern access point to the throne room in the earlier building state; c) least-cost path from the southern access point to the throne room in the later building state; d) least-cost path from the northeastern access point to the throne room in the later building state.

and the analysis thus suggested that internal circulation was not restricted in the later state, as advocates of the hypothesis of economic decline assumed,[35] metric analysis can be seen to

35 The lower average visual integration in the later state will be commented on in the subsequent comparative section.

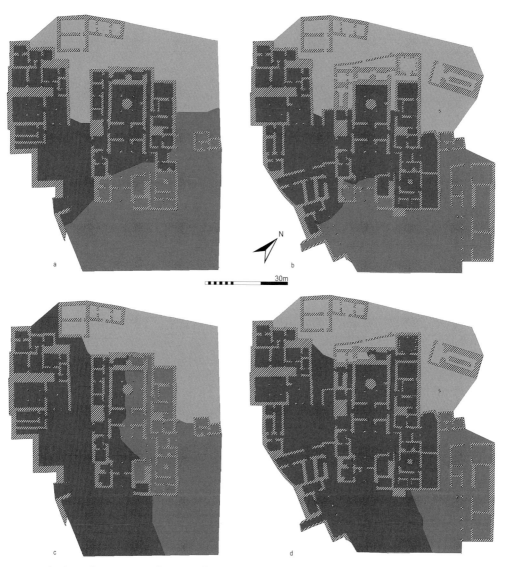

Figure 19 | Pylos, palace a) metric allocation of areas to the main courts in the earlier building state; b) metric allocation of areas to the main courts in the later building state; c) metric allocation of areas to the access points in the earlier building state; d) metric allocation of areas to the access points in the later building state.

contradict the underlying assumptions of the decline hypothesis even more clearly. Since recent studies suggest that the hypothesis also fails to account for a variety of other observations (Bendall 2003, esp. p. 225–226; Thaler 2006), we will not discuss it further here.

Focussing instead on the positive results of the analyses set out above, two keywords may guide a new understanding of changes to the palatial architecture of Pylos, both of

which have already occurred in the analytical section: differentiation and channelling. Since it is, ultimately, one aspect among others of functional and social differentiation, we will look at the channelling or focussing of access on specific routes first: official visitors enter the palace through either staircase *a* or space *101* in the later state and can only reach the inner sections via court *58*. Several observations may suggest a further differentiation between those coming to the palace in political or religious matters, on the one hand, and in official economic matters, on the other, although this partly transcends what can be demonstrated analytically: staircase *a*, with which we may associate the former group of visitors and which is the only entrance for which we have clear evidence of monumental elaboration, is oriented towards the propylon and thus directs visitors to the canonical route to the Megaron. Space *101*, by contrast, is closely linked with the Northeastern Building, which most probably functioned as a clearing house and could even be entered from *101* without first entering court *58*; there is also little doubt that space *101* was approached along the same street across the plateau of Ano Englianos as court *w*, the third point of access, which gave access to the economic unit at the back of the palace. While it thus seems plausible that both *101* and *w* provided access for visitors in economic matters, there are, again, also important contrasts: the store-rooms in the economic unit, on the one hand, to which 'tradesman's entrance' *w* gave access were used, as far as we know, to stock wine, oil and pottery, i.e. bulk goods,[36] of which at least a high proportion was destined for consumption within the palace (Whitelaw 2001, p. 54). The Northeastern Building, on the other hand, which was accessed through *101*, presumably dealt in goods to be redistributed – as accords well with its position on the fringes of the palaces, particularly in terms of AMD and STMD –, partly at least more costly goods and, quite importantly, goods closely monitored and recorded in detail by the palace administration. It therefore makes good sense, with regard to *101*, to speak of traffic in official economic matters in order to differentiate it from the delivery of supplies through *w*.

The economic unit itself exemplifies differentiation not only in terms of access, but also internal organization, since it forms an internally coherent subsystem set apart in topological and functional terms from the rest of the palace in a back section of the complex; in metric terms, too, at least a part of the unit is identifiable as isolated from the complex as a whole. It should not need stressing that both the visitors and 'residents' of this area would have been socially distinct from those in other parts of the palace, at least in the roles they fulfilled in specific contexts. Another functional area can be seen in the 'interface zone' focussed on the frontal court *58* and encompassing the remaining two points of access *a* and *101* as well as both the Northeastern Building and the palace archive. This is captured most effectively in the metric allocation of areas to courts (fig. 19a, 19b), which clearly sets

36 The term 'bulk goods' is here used merely to denote goods which arrived or at least were stored and presumably consumed at the palace in large quantities; specifically, nothing is implied as to the status of foodstuffs as staples or otherwise (cf. Palmer 1994, p. 132).

apart both the economic unit and the interface zone from the core of the palace; the latter encompassed all possible and plausible 'halls of state', i.e. throne room *6* as well as rooms *46* and *65*, and was focussed on court *63* as the main integrator of internal circulation in topological and, in conjunction with court *3* and *88*, also in metric terms.

While court *63*, despite this overarching importance for internal circulation, did not fall on any of the main access routes into the palace discussed above, yet another form of socio-spatial differentiation ascribes it a clearly defined place with regard to rights of access, the importance of which for Mycenaean architecture has been rightly stressed in recent years (e.g. Wright 1994, esp. p. 51, 60). While this is only hinted at in formal analyses of the palace's layout such as the ones presented here, it is strongly corroborated by both comparison with the linear court sequence of the highly elaborate palace at Tiryns and the study of Pylian pantry inventories. With reference to both its topological characteristics and the associable drinking vessels (Bendall 2004, p. 112–124; Thaler 2005, p. 332; 2006, p. 98, 105; 2007, p. 302), it occupies a middle position between outer court *58* and an inner area, identified as either the megaron (Bendall 2004, p. 122–123) or the megaron court *3* (Thaler 2006, p. 98), indicating a three-tiered hierarchy of participants in palatial feasts. That corresponding distinctions of rights of access associated with specific courts were also in effect in the everyday use of the palace is not only suggested by comparisons with neighbouring cultures (Thaler 2007, p. 305), but also by the light which the results discussed above relating to both the economic unit and the interface zone shed on the general importance of such distinctions.

After these extensive comments on the later building state, only one thing needs to be stressed with regard to the earlier one: none of the above is apparent in the earlier building state – all of the above results from changes to the palace and its architecture during, roughly, the 13th century, although the possibility should again be noted that, in some instances, social conventions may have anticipated elements that were later embodied architecturally. Unless we assume, as seems possible given the available evidence for the relative recency of the megaron palace as an architectural type (e.g. Maran 2001), that the earlier building state represents a monumentalized version of smaller prototypes such as Mansion I at the Menelaion (Catling 2009, p. 23–32), which proved functionally inadequate to the needs of the Pylian polity and had to be modified accordingly, the conclusion seems almost inescapable, as indeed the proponents of the decline hypothesis were right to point out, that these architectural changes reflect political or economic and thus ultimately social changes. Continued territorial expansion of the Pylian polity during the 13th century or a rise in importance of palatial feasts as occasions of the re-constitution of palatial society have been suggested elsewhere as possible explanations (Thaler 2006, p. 107–108), but other hypotheses could certainly be added, and this is not the place to try to settle the issue. However, it may well be helpful to point out a common denominator of both of the above and other plausible scenarios: the spatial differentiation of the palace, e.g. into distinct functional sectors to which different social groups would have had differential access, as

well as the channelling of visitors towards specific routes, may well reflect efforts to manage visitors who would have come to and entered the palace or parts of the palace in noticeably larger, rather than smaller, numbers in the later stages of the palace's existence than they previously did.

4.2.2 Comparison of analytical results

Taking a step back again from archaeological interpretation to evaluate how and what specific forms of analysis contribute to it, the first thing that captures our attention is the remarkably close correspondence in the results of several topological and metric analyses: shortest topological routes to the throne room (fig. 10) are virtually identical to least-cost paths determined metrically (fig. 18) and the attribution of areas of control to the main courts, particularly for the later building state, for which it could be meaningfully interpreted, differs little between its topological (fig. 11b) and metric version (fig. 19b), the main difference lying in the latter's ascribing what appears as a 'contested' zone between courts 58 and 63 in the former to court 63 exclusively. This difference, of course, is easily explicable since metric analysis does not allow an in-between position in the way topological maps do, which also explains the more noticeable differences between the topological and metric mapping of primary access: in both cases, entrances *a* and *101* share the control of access to court 58, but only in the topological perspective does this by necessity mean that they share control of access to areas beyond court 58.

This could be taken to suggest that topological analysis may provide a 'cost-effective'[37] substitute for metric analysis in some contexts, whereas metric analysis may provide a sharper resolution where ambiguities arise from pure topology; ambiguities in the available data, on the other hand, such as, in the present case, both the exact position of the point of access associated with space *w* and more generally the exact metric dimensions of the hypaethral spaces, may suggest topology as the more robust approach for some archaeological contexts. Alternatively, the different approaches, rather than judging their respective merits for specific contexts, can be taken as complementary perspectives: the topological mapping of primary access for the later building state allows us to appreciate court 58's role as an interface, and the metric perspective may reflect the overarching significance of staircase *a* as the main entrance to the palace.

The generally close correspondence as well as the explicability of divergences among these analyses is, of course, contingent upon the fact that the very same phenomena are

37 What is subjectively perceived as 'cost-effective' will to some degree depend, of course, on how well one is personally acquainted with specific approaches as well as the corresponding computer software. Yet the fact that topological analysis is quite feasible in many contexts without the aid of a computer may be considered a more objective criterion here; topological allocation to entrances, for example, requires no other computational 'features' than the ability to count.

approached in very similar manner; therefore, we next need to consider less similar approaches and their results. Here again, there are a number of clear parallels, e.g. with regard to the focussing of access on the canonical route to the throne room between, on the one hand, visual analysis and, on the other, the topological and metric observations discussed above. Another parallel, in this case between topology and metric study, can be seen in the identification of distinct zones, most notably with respect to the absence of such zones in the earlier building state and the presence of the economic unit in the later. Despite not delineating a fully congruent area, but rather a noticeably smaller one than, for example, topological mapping of primary access suggests for the economic unit, metric observations on the peripheral nature of the area of the Wine Magazine, which comprises rooms *104* and *105*, can be seen to capture a corresponding trend in the development of this area of the palace. This confirmation is particularly helpful, since analysis of AMD and STMD values does not, in contrast to both the topological and metric mapping of, for instance, areas of primary control, need to rely on the prior definition or designation of a set of root spaces. In the present case, however, visual analysis in turn provides corroboration of the focus on courts as root spaces. The independence from pre-defined root spaces or comparable categories is especially important in the case of the negative evidence for the earlier building state, which naturally cannot be ascribed to a 'wrong choice' of root spaces where none are used. Topological and metric allocation mapping and their interpretation, on the other hand, do offer a richer and more varied, albeit perhaps more easily disputed picture, as evidenced by the identification of the 'interface zone' in the later state.

While these results can easily be understood as complementary, there is one point in which topological, visual and metric analysis would appear, at first sight at least, to contradict one another, viz. the issue of the overall integration of the palace in the earlier and later building state: topology suggests stability, visual analysis – although there are specific reasons for this which we have discussed – a pronounced loss, and metric analysis an increase in overall integration, at least in contextual terms, i.e. in the form of a wider distribution of relatively highly connected areas. Several observations may help to reconcile these perspectives: the loss of visual integration, although mostly explicable as an effect of the sensitivity of visual integration to surface area, in conjunction with the breaking-up of the earlier undifferentiated ring of large hypaethral spaces, may well be explained as a further aspect of the channelling documented not least in the visual integration map itself; if channelling occurs, the whole complex need not be intelligible for a visitor as a visually integrated system, but only specific routes. Topological or metric integration, on the other hand, should more effectively describe the ease with which those who relied on their knowledge rather than their spontaneous understanding of the architectural context could move within it; maintaining or increasing these could be as important for the efficient functioning of the palace architecture as its growing functional differentiation. Still, the divergence in analytical results between topological and metric integration may need further discussion. The

key to this may lie in the fact that, on the one hand, topological analyses in the space syntax tradition conceive of the 'integration' of a building as a normalized measure, thus relying on absolute values for the purpose of inter-building comparison, whereas, on the other hand, the metric analysis outlined in this study uses the relative proportion of raster cells that fall within the core in order to compare 'integration' between buildings, where inclusion in the core is based on a cell's low AMD value in relation to the distribution of AMD values for the individual building. The latter approach is not only valid in its own terms, but certainly also a helpful complement to the way the topological approach conceptualizes integration. However, it may ultimately preclude direct comparison with integration as a normalized topological measure, for which a normalized version of, as it were, an 'average AMD', i.e. an AMD calculated not for specific raster cells, but for the system as a whole, might be needed.[38] But if topological and metric integration should capture, as was suggested for visual integration, different spatial qualities of the system under study, comparative studies of present-day contexts may be necessary to clarify this issue.

5 Future perspectives

As stated at the outset, one of the aims of this study is to contribute to a body of comparative research into the results of topological, visual and metric configurational analyses in archaeology. Taking into account its immediate results, it seems fair to say that it also offers a clear illustration of the need for further comparative work in this vein, if future students of the archaeologically preserved built environment are to make informed methodological choices: in many instances, specific results could not be compared immediately in the form of the data-output of the respective analyses, but only in mediate form, i.e. once an initial interpretation of these results had taken place. While this does offer useful controls to see whether different strands of analysis and argument can support the same interpretations, the more compelling results of parallel analysis may still be seen in those cases where more direct comparisons of results are possible at the data level. Examples of the latter in the present study include the topological and metric definition of shortest paths between two spaces and of allocation of areas to root spaces. Since these, however, have already been commented on in the comparative discussions, merely a short note of encouragement will be added here: since topological allocation, i.e. the mapping of areas of primary control and access, and determination of individual path lengths does not require large computational effort, but hardly more than the ability to count doors, it may form an easily accomplished and – as we hope to have shown above – worthwhile adjunct to any metric study of such properties.

38 Sailer's (2010, p. 132) suggestion to normalize metric distance by division by the square root of the surface area of the system could prove helpful. It should be noted, however, that the metric distances she works with are based on a spatial representation derived from the axial break-up and not the cost-of-passage surface used in this study.

Still, the question remains open how other forms of analysis might be conducted in a way that allows similarly direct comparisons between topological, visual and metric perspectives, and this leads, if we return to the notion of space syntax and GIS research as two distinct traditions in archaeology, to the question of what one might learn from the other. Here, we simply want to highlight one aspect of each which may bear further scrutiny with regard to its high potential utility to the other.

One of the long-established key aspects of space syntax is the conceptualization of integration as a normalized measure which allows for the easy comparability of this decisive spatial characteristic between systems of different sizes and dissimilar layouts. Metric integration study, as outlined here as a new approach within GIS-based archaeological research, approaches the phenomenon of the overall integration of a building in a distinctly different manner by comparing the surface area of its metric integration core, which is based on a statistically defined size class of AMD values, to the surface area of the entire spatial system. As a result it mainly captures the 'distributedness', rather than the 'degree' of integration within a system. While this forms a reliable basis for meaningful interpretations, as we have seen, it could well prove a worthwhile pursuit to complement this approach by the introduction of a normalized measure of integration. If space syntax, however, is to provide the model for this, the as yet unresolved issues concerning different formulae for normalization within space syntax need bearing in mind (cf. section 2.1).

A major strength of GIS methodology and software, on the other hand, is the multiple possibilities for manipulating the primary data.[39] From a statistical point of view, GIS can be used to define a core area of integration on the basis of size classes of integration values. For instance, in the metric study set out here the histogram and standard deviation of AMD value distribution was employed to delineate an integration core. A corresponding approach could offer a more inherently meaningful substitute for the simple 10% rule applied in determining topological integration cores. Comparison with GIS studies could thus inspire a more statistically-minded space syntax approach. In practical rather than conceptual terms, too, GIS software will, despite the ingenuity and effort of the space syntax community, often offer more effective ways of managing data generated in space syntax software such as Depthmap than the latter can offer itself; following the previous remarks on metric and topological integration cores, the GIS-based derivation of the map of the integration core from VGA data generated in Depthmap would be a promising example.[40]

The possibility of manipulating space syntax data in a GIS environment also leads to a final perspective which we wish to mention, one not concerned with comparison or selective adoption, but with the integration of topological, visual and metric analyses: map-alge-

39 Cf. Gil et al. (2007) for an explanation of the Confeego tool set, which serves as a plug-in for the MapInfo Professional software and was created on the basis of similar premises regarding the benefits of using GIS to further process space syntax results. Cf. also Jiang and Claramunt 2002.

40 While recent versions of Depthmap include more GIS-like features themselves, they also offer the option of exporting data in a GIS format (e.g. MapInfo's *.mif).

bra functionalities in GIS software could be used to create not merely an overlay of maps of different spatial properties, but to merge these into a single representation. Provided that issues of normalization can be solved adequately, incorporating data on convex, visual and metric integration into a meta-mapping of cumulative integration appears the most promising option that springs to mind. As stated at the beginning, however, the availability of an analytical methodology at the press of a button should not be mistaken for the advisability of pushing that button. Rather it presents a reason for methodological reflection, to which we hope to have contributed in this paper from a comparative perspective – a comparative perspective which we consider a necessary precursor to and precondition for even the idea of merging analytical techniques.

Appendix 1
Metric integration analysis: a methodological description

What is referred to as metric integration (or metric) analysis in this study is an original technique anchored in GIS-based[41] cost-distance analysis carried out with raster datasets. Considering absolute distance as a configurational measure is not new and has been highlighted by space syntax theory, which cautioned against its positively misleading character at the 'non-local level' (Hillier and Penn 2004, p. 505–506; Hillier et al. 2007). It is indeed possible within the current set of space syntax techniques to calculate metric integration or metric (mean) step depth values by using a weighted visibility graph (Turner 2004, p. 13), or through segment representation of space (cf. Sailer 2010, p. 70–71, fig. 3–2). The methodological framework of GIS-based metric integration analysis comes particularly close to the first of these space syntax techniques, since both measure metric distances across a surface (i.e. a cost-distance surface) or a pseudo-surface (i.e. a two-dimensional space tessellated into a dense grid) respectively rather than along a line, as segment representation does. Despite these similarities, the GIS-based methodological framework presented here deviates from the weighed visibility graph analysis conducted in Depthmap on three principal points. The primary difference is that a GIS-based metric integration analysis affords a consideration of topographic variability in buildings, i.e. it can be employed to take into account the existence of stairs, ramps etc. Secondly, it enables calculation of varied statistical measures[42] such as those that correspond to space syntax's mean depth (which is referred to as average metric distance [AMD] here) as well as the standard deviation of metric distance values (STMD). Furthermore, metric integration analysis allows for plotting AMD value distributions for spatial systems as a histogram and provides statistical qualities of the

41 The analyses presented here are conducted with the commercial GIS software package ArcGIS 9.2 (ESRI).
42 Regarding spatio-statistical applications, the new statistical tools added to Depthmap software explore statistical avenues similar to the ones presented here (cf. Turner 2007b).

distribution. This particular quality of the GIS-based technique can assist the interpretation process in various ways, including definition of a main integration core in a statistically-informed manner, as illustrated above for the Malia and Pylos cases. And thirdly, although not exemplified in this study, the raster-based modelling in GIS affords modelling attractors in the built environment by assigning low cost-of-passage values to the areas surrounding these attractors.[43]

As for the methodological particularities of the metric integration analysis, the technique is based on a binary conceptualization of the built environment as comprised of two material categories: those that do and those that do not block human movement. The first step in creating such a binary model is to vectorize all features that allow movement (floor surfaces, ramps, stairs etc.). At this stage of the modelling process, it is of capital importance to vectorize inclined (stairs, ramps) and flat surfaces as separate polygons. At a later stage, a column for entering cost-of-passage values for each polygon is created in the attribute table of the spatial database. In this column, each polygon representing an approximately flat surface is assigned '1' as cost-of-passage value, which results in taking cost-distance as equal to the metric distance for these cells. Stairs and ramps, on the other hand, are assigned a value in accordance with their slope. For this study the length of inclined surfaces has been taken as $1/\cos(\alpha)$, where α is the angle of inclination. As such, the cost-of-passage for the inclined surfaces is rendered equal to the length of the inclined surface.[44] The following step performs a 'vector-raster' conversion in order to transfer the digitized polygon features into a raster surface on the basis of the cost-distance values assigned to respective polygons. The newly created raster surface constitutes the cost-of-passage surface used for metric integration analysis (fig. 20a).

In order to calculate AMD and STMD values based on this cost-distance surface, a two-dimensional point cloud is created (fig. 20b), in which each point serves as a source (i.e. starting) point for the cost-distance analysis. This can in fact be compared to the way in which Depthmap software conducts VGA, which is "the analysis of the visual relationships of (potentially humanly occupied) points in space to each other" (see Turner 2007b, p. 45).

Note that a dense point cloud with points located in relative proximity to one another will give more robust results while calculating AMD and STMD values. On the other hand,

43 See also Stahle et al. (2007) for an overview of the Place Syntax plug-in for the GIS software MapInfo, where attractors are also modelled but as part of the axial representation.

44 In this study, the inclination angle for ramps and stairs has been uniformly taken as 30 degrees, which led to the cost-of-passage being calculated as 1.155 at these locations. The reason for using a uniform value for all the inclined surfaces was the limited availability of architectural information with regard to the inclination of these surfaces and number of steps for the stairs. What is more, the direction of movement is not considered in these analyses, as metric distance is inherently isotropic (cf. Conolly and Lake 2006, p. 215). It is acknowledged here that analysing time and energy expenditure while circulating within the architectural systems would be (given that it is human-oriented) a more appropriate approach than analysing the metric distance traversed. At this preliminary stage of metric integration analysis, however, only isotropic metric cost is employed, leaving the use of anisotropic types of costs to future studies.

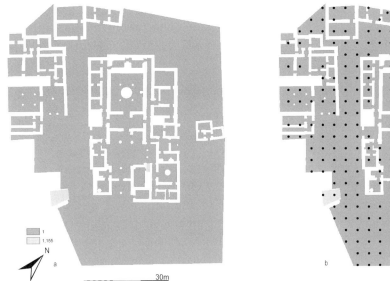

Figure 20 | Pylos, palace a) the cost-of-passage surface of the earlier building state; b) a two-dimension point cloud overlaid on the cost-of-passage surface of the earlier building state.

such small distances between points will automatically increase the amount of time required to complete the analysis (at least when the analysis is conducted manually rather than with the help of a computer script). For example, for a 60 m² spatial system, creating a two-dimensional point cloud with 10 cm intervals will result in 6000 points. If we consider that cost-distance analysis should be conducted for each of these points in order to calculate the AMD and STMD values, we can anticipate how time-consuming such an analysis could potentially be. For the analysis in this paper, Building A features a 1 m-by-1 m and the Palace of Pylos a 4 m-by-4 m point-cloud.[45,46]

After cost-distance analyses have been conducted for each of the point cloud components, the cost-distance rasters are put into the 'Cell Statistics', whereby the average metric distance value for each raster cell location is calculated. The result is a new raster surface

45 One of the future research directions for metric integration analysis is to assess the relationship between the selected point-distance for the point-cloud and the changing accuracy of the results. Preliminary observations revealed that although, to a certain extent, the accuracy of the AMD values keeps on increasing with decreasing point distance, at some point the decrease stops affecting the results. This observation strongly supports the existence of an optimum point-distance to conduct metric integration analysis with. The way in which this optimum value varies with size and shape of the spatial system requires future in-depth study.

46 An easy way to create two-dimensional point clouds is to resample the cost-of-passage surface to a specific raster cell size which is equal to the point-distance decided on. Subsequently a 'Raster to Point' conversion can be applied whereby GIS software creates a set of point features located at the centre of the raster cells. Then each of these points – whose distance to other points is equal to the edge length of the raster cell – can be used as a source point for cost-distance analysis.

which has the AMD values for each cell across the entire spatial system. Similarly, through 'Cell Statistics' a new raster surface can be created which has the STMD values for each raster cell location.

Appendix 2
A note on Akrotiri's West House and upper storeys

In the above, we have limited our comparative study to two sites only, not only in an effort to keep the text at a readable length, but also and more importantly because of our particular familiarity with these two sites and our conviction that familiarity with the archaeological details of the context under study is essential. Ultimately, in our opinion, it outweighs purely methodological competence in its importance for meaningful spatial analyses, although both are undoubtedly necessary preconditions. Still, we undertook further ana-lyses in the preparation of this paper and would briefly like to discuss one of these for the sake of its particular methodological interest: the combined convex and visual analysis[47] of the West House in the early Late Bronze Age settlement of Akrotiri on the island of Thera (Palyvou 2005, p. 46–54).[48] The importance of the West House lies, firstly, in the unusual completeness of its preservation, with not only the ground floor, but also the complete first and parts of the second floor uncovered by archaeological excavations, and, secondly, in the fact that the layout of the ground floor, in most other cases all that is preserved archaeologi-cally, differs radically both from that of the first floor and the building as a whole (cf. Thaler 2002, p. 114).

 The former is almost entirely linear – if represented without the carrier space, i.e. the outside of the building, and the staircase to the upper floor, it is indeed nothing but a line of rooms –, whereas the first floor has one central ring and the whole building three non-trivial rings, two of which intersect and one of which connects the ground and first floor (fig. 21). The most integrated space of the ground floor seen by itself is, obviously, the middle of the line, room 4–1, with an integration value of 0.73, whereas the integration value of 0.38 for the carrier space and thus the integration of the building with the outside is well below the average of 0.49 and even close to the minimum integration of 0.31. For the first floor, which has a noticeably higher overall integration of 0.65, the maximum of inte-gration is the value of 0.91 for room 5–2, where the ring connects with a tree-like element, while again, the integration of the carrier at 0.39 is clearly below average and indeed does

47 The absolute values given in this appendix result from a convex analysis conducted 'manually', i.e. without the help of Depthmap or other specific space syntax software. All values are calculated for the system inclusive of its carrier space, but the designation as most integrated space relies on an alternative calculation without the carrier space where the primary analysis does not yield an unambiguous result. VGA was conducted, as in the other case studies, using Depthmap 8.15.00c.
48 The plans reproduced use Palyvou (2005, p. 47 fig. 46) as a reference.

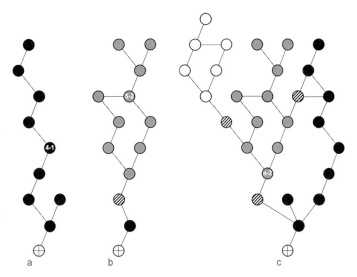

Figure 21 | Akrotiri, West House: a) j-graph of ground floor with ground floor spaces indicated in solid black and the carrier space by a cross; b) j-graph of first floor with ground floor spaces indicated in solid black, first floor by grey fill, stairs by hatching and the carrier space by a cross; c) j-graph of entire building including reconstructed second floor with ground floor spaces indicated in solid black, first floor by grey fill, second floor by white fill, stairs by hatching and the carrier space by a cross.

represent minimum integration. For the building as a whole, however, due to the frontal position of the main staircase, the integration value of 0.56 for the carrier, while still below the average of 0.63, no longer represents one of the lowest values, and the most integrated space at 1.01 is now a flight of the main staircase, *a-2*, i.e. a transitional rather than a use space. Representations of visual integration (fig. 22) confirm these observations, although they also demonstrate that in the total system room *5–2* of the first floor retains its integrative importance. If the visual integration maps for the ground and first floor are set to a common colour scheme, the segregative nature of the former's linear structure becomes yet more clearly visible.

Do these drastic discrepancies between different analyses of the same building or parts thereof mean that computer-aided and more generally formal configurational analyses face problems which should caution against their use in archaeological contexts? Perhaps not entirely surprisingly, we do not think that caution in and towards the use of such analyses should go so far as to refrain from their use entirely. Two main reasons can be given for this position: firstly and quite simply, the problem does not lie in the applied methodology, but in the incompleteness of the archaeological record. Every understanding of the archaeological past which we formulate is based on partial evidence, and the evidence does not become less partial if we discard any particular methodological tool. That formal analyses such as those presented here might in principle even provide a means to approach the problem of incomplete preservation is indicated by Romanou's (2007) study of Maliote architecture. Secondly, and more importantly, the question whether the partial plans we have available for analysis represent meaningful subsystems within a lost overall plan is worth considering. For many buildings – the palace of Pylos being a point in case – the assumption that the upper floor or floors would have been less accessible to visitors provides a plausible, though

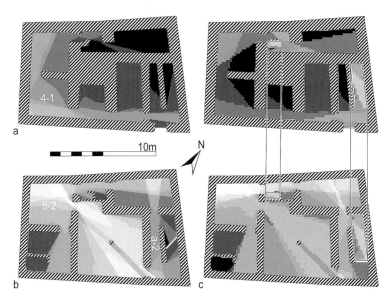

Figure 22 | Akrotiri, West House: a) plan of ground floor with visual integration indicated by shading (lighter shading denotes higher integration, set to the same range of shades as b); b) plan of first floor with visual integration indicated by shading (lighter shading denotes higher integration, set to the same range of shades as a); c) plan of ground floor and first floor with visual integration calculated for both in conjunction indicated by shading (lighter shading denotes higher integration).

ultimately unprovable, reason to accept this premise. In the specific case of the West House, *in situ* finds indicate that the ground floor housed storerooms and workspaces only, whereas the living quarters were upstairs (Palyvou 2005, p. 46–54); this means, although we would obviously miss a lot of information on Akrotirian domestic architecture if the upper floor had not been preserved, that the ground floor does indeed represent a meaningful subsystem. The most important point to be learnt from this is, in our view, that formal configurational analysis will rarely if ever achieve useful results in archaeology if we cannot integrate it with other information, such as the installations and movable finds recovered in the West House. Familiarity with archaeological detail, as stated at the beginning of this appendix, is essential.

Bibliographical references

Batty, Michael (2004)
A New Theory of Space Syntax (CASA working paper 74), http://www.casa.ucl.ac.uk/working_papers/paper75.pdf (10 January 2011).

Begg, Ian (1975)
Minoan Storerooms in the Late Bronze Age, Toronto (PhD thesis).

Bendall, Lisa (2003)
"A Reconsideration of the Northeastern Building at Pylos: Evidence for a Mycenaean Redistributive Center", in: *American Journal of Archaeology* 107, pp. 181–231.

Bendall, Lisa (2004)
"Fit for a King? Hierarchy, Exclusion, Aspiration and Desire in the Social Structure of Mycenaean Banqueting", in: Paul Halstead and John C. Barrett (eds.), *Food, Cuisine and Society in Prehistoric Greece (Sheffield Studies in Aegean Archaeology 5)*, Oxford, pp. 105–135.

Blegen, Carl W., and Lang, Mabel L. (1963)
"The Palace of Nestor Excavations of 1962", in: *American Journal of Archaeology* 67, pp. 156–162.

Blegen, Carl W., and Rawson, Marion (1966)
The Palace of Nestor at Pylos in Western Messenia. Vol. 1: The Buildings and their Contents, Princeton.

Blegen, Carl W., Rawson, Marion, Taylor, William, and Donovan, William P. (1973)
The Palace of Nestor at Pylos in Western Messenia. Vol. 3: Acropolis and Lower Town, Tholoi, Grave Circle, and Chamber Tombs, Discoveries Outside the Citadel, Princeton.

Burrough, Peter A., and McDonnell, Rachael (1998)
Principles of Geographical Information Systems, Oxford.

Catling, Hector W. (2009)
Sparta, Menelaion. Vol. 1: The Bronze Age (British School at Athens Supplementary Vol. 45), Oxford.

Conolly, James, and Lake, Mark (2006)
Geographical Information Systems in Archaeology, Cambridge.

Cutting, Marion (2003)
"The Use of Spatial Analysis to Study Prehistoric Settlement Architecture", in: *Oxford Journal of Archaeology* 22, pp. 1–21.

Dafinger, Andreas (2010)
"Die Durchlässigkeit des Raums: Potenzial und Grenzen des *Space Syntax*-Modells aus sozialanthropologischer Sicht", in: Peter Trebsche, Nils Müller-Scheeßel, and Sabine Reinhold (eds.), *Der gebaute Raum: Bausteine einer Architektursoziologie vormoderner Gesellschaften*, Münster, pp. 123–142.

Daux, Georges (1967)
"Chronique des fouilles 1966. Malia", in: *Bulletin de Correspondance Hellénique* 91, pp. 882–889.

de Arruda Campos, Maria B., and Fong, Polly S.P. (2003)
"A Proposed Methodology to Normalise Total Depth Values When Applying the Visibility Graph Analysis", in: Julienne Hanson (ed.), *4th International Space Syntax Symposium, Conference London, 17–19 June 2003*, pp. 35.1–35.10. http://217.155.65.93:81/symposia/SSS4/fullpapers/35Campos-Fongpaper.pdf (10 January 2011).

Deger-Jalkotzy, Sigrid (1995)
"Mykenische Herrschaftsformen ohne Paläste und die griechische Polis", in: Robert Laffineur and Wolf-Dietrich Niemeier (eds.), *Politeia: Society and State in the Aegean Bronze Age (Aegaeum 12), Conference Heidelberg, 10–13 April 1994*, Liège, pp. 367–377.

Driessen, Jan (1982)
"The Minoan Hall in Domestic Architecture on Crete", in: *Analecta Archaeologica Lovaniensia* 21, 27–92.

Flouda, Georgia S. (2000)
"Inscribed Pylian Nodules. Their Use in the Administration of the Storerooms of the Pylian Palace", in: *Studi Micenei ed Egeo-Anatolici* 42, pp. 213–245.

Gil, Jorge, Stutz, Chris, and Chiaradia, Alain (2007)
"Confeego: Tool Set for Spatial Configuration Studies", in: Alasdair Turner (ed.), *New Developments in Space Syntax Software. Workshop Istanbul, 12 June 2007*, pp. 15–22, http://discovery.ucl.ac.uk/4109/1/4109.pdf (14 January 2011).

Hacıgüzeller, Piraye (2008)
"Modelling Human Circulation in the Minoan Palace at Malia", in: Axel Posluschny, Karsten Lambers, and Irmela Herzog (eds.), *Layers of Perception: Proceedings of the 35th International Conference on Computer Applications and Quantitative Methods in Archaeology (CAA). Conference Berlin, 2–6 April 2005*, pp. 336–341. http://archiv.ub.uni-heidelberg.de/propylaeumdok/volltexte/2010/517/pdf/10_05_haciguezellerf|malia.pdf (7 January 2011).

Hacıgüzeller, Piraye (2012a)
"GIS, Critique, Representation and Beyond", in: *Journal of Social Archaeology* 12, 2, pp. 245–263.

Hacıgüzeller, Piraye (2012b)
Malia Revisited: A GIS-based Functional Analysis of the Pre-, Proto- and Neo-palatial Occupation, Louvain-la-Neuve (PhD thesis).

Hanson, Julienne (1998)
Decoding Homes and Houses, Cambridge.

Hanson, Julienne (2000)
"Urban Transformations: A History of Design Ideas", in: *Urban Design International* 5, pp. 87–122.

Harvey, Francis, Kwan, Mei-Po, and Pavlovskaya, Marianna (2005)
"Introduction: Critical GIS", in: *Cartographica: The International Journal for Geographic Information and Geovisualization* 40, pp. 1–4.

Hillier, Bill (1996)
Space is the Machine: A Configurational Theory of Architecture, Cambridge.

Hillier, Bill (1999)
"Guest Editorial: The Need for Domain Theories", in: *Environment and Planning B* 26, pp. 163–167.

Hillier, Bill (2008)
"Space and Spatiality: What the Built Environment Needs from Social Theory", in: *Building Research and Information* 36, pp. 216–230.

Hillier, Bill, and Hanson, Julienne (1984)
The Social Logic of Space, Cambridge.

Hillier, Bill, Hanson, Julienne, Peponis, John, Hudson, John, and Burdett, Richard (1983)
"Space Syntax: A Different Urban Perspective", in: *The Architects' Journal* 178.48, pp. 47–63.

Hillier, Bill, Leaman, Adrian, Stansall, Paul, and Bedford, Michael (1976)
"Space Syntax", in: *Environment and Planning B* 3, pp. 147–185.

Hillier, Bill, and Penn, Alan (2004)
"Rejoinder to Carlo Ratti", in: *Environment and Planning B* 31, pp. 501–511.

Hillier, Bill, Turner, Alasdair, Yang, Tao, and Park, Hoon-Tae (2007)
"Metric and Topo-Geometric Properties of Urban Street Networks: Some Convergences, Divergences and New Results", in: *Journal of Space Syntax* 1, pp. 258–279. http://joss.bart lett.ucl.ac.uk/index.php/joss/article/view/2 58/pdf_32 (21 January 2011).

Jiang, Bin, and Claramunt, Christophe (2002)
"Integration of Space Syntax into GIS: New Perspectives for Urban Morphology", in: *Transactions in GIS* 6, pp. 295–309.

Kilian, Klaus (1984)
"Pylos – Funktionsanalyse einer Residenz der späten Palastzeit", in: *Archäologisches Korrespondenzblatt* 14, pp. 37–48.

Kilian, Klaus (1987)
"L'architecture des résidences mycéniennes: Origine et extension d'une structure de pouvoir politique pendant l'âge du bronze récent", in: Edmond Lévy (ed.), *Le système palatial en Orient, en Grèce et à Rome. Conference Strasbourg, 19–22 June 1985*, Leiden, pp. 203–217.

Kwan, Mei-Po (2004)
"Beyond Difference: From Canonical Geography to Hybrid Geographies", in: *Annals of the Association of American Geographers* 94, pp. 756–763.

Laffineur, Robert, and Niemeier, Wolf-Dietrich (eds.) (1995)
Politeia: Society and State in the Aegean Bronze Age (Aegaeum 12), Conference Heidelberg, 10–13 April 1994, Liège.

Lane, Michael F. (1993)
On the Structure of Social Space and the Development of Writing, Sheffield (MSc thesis).

Leach, Edmund (1978)
"Does Space Syntax Really 'Constitute the Social'?", in: David R. Green, Colin Haselgrove, and Matthew Spriggs (eds.), *Social Organisation and Settlement: Contributions from Anthropology, Archaeology and Geography (British Archaeological Reports International Series Supplement 47ii)*, Oxford, pp. 385–401.

Leszczynski, Agnieszka (2009)
"Poststructuralism and GIS: Is there a 'Disconnect'?", in: *Environment and Planning D* 27, pp. 581–602.

Letesson, Quentin (2009)
Du phénotype au génotype: analyse de la syntaxe spatiale en architecture minoenne (MMIIIB-LMIB) (Aegis 2), Louvain-la-Neuve.

Livesey, Gillian E., and Donegan, Anthony (2003)
"Addressing Normalisation in the Pursuit of Comparable Integration", in: Julienne Hanson (ed.), *4th International Space Syntax Symposium, Conference London, 17–19 June 2003*, 64.1–64.10. http://217.155.65.93:81/symposia/SSS4/fullpapers/64Livesay-Donegan.pdf (10 January 2011).

Maran, Joseph (2001)
"Zur Frage des Vorgängers des ersten Doppelpalastes von Tiryns", in: Stephanie Böhm and Klaus-Valtin von Eickstedt (eds.), IΘAKH: *Festschrift für Jörg Schäfer zum 75. Geburtstag am 25. April 2001*, Würzburg, pp. 23–29.

Marinatos, Nanno (1993)
Minoan Religion, Columbia.

Marinatos, Nanno, and Hägg, Robin (1986)
"On the Ceremonial Function of the Minoan Polythyron", in: *Opuscula Atheniensia* 16, pp. 57–73.

McEnroe, John C. (2010)
Architecture of Minoan Crete: Constructing Identity in the Aegean Bronze Age, Austin.

Nelson, Michael C. (2001)
The Architecture of Epano Englianos, Greece, Toronto (PhD thesis).

Paliou, Eleftheria (2008)
"An Autonomous Agent Approach to the Investigation of Intra-Site Movement and Visibility: The Visual Consumption of Theran Murals from the Public Spaces of LBA Akrotiri (Thera, Greece)", in: Axel Posluschny, Karsten Lambers, and Irmela Herzog (eds.), *Layers of Perception: Proceedings of the 35th International Conference on Computer Applications and Quantitative Methods in Archaeology (CAA). Conference Berlin, 2–6 April 2005*, pp. 328–335.

Paliou, Eleftheria, Wheatley, David, and Graeme, Earle (2011)
"Three-Dimensional Visibility Analysis of Architectural Spaces: Iconography and Visibility of the Wall Paintings of Xeste 3 (Late Bronze Age Akrotiri)", in: *Journal of Archaeological Science* 38, pp. 375–386.

Palmer, Ruth (1994)
Wine in the Mycenaean Palace Economy (Aegaeum 10), Liège.

Palyvou, Clairy (1987)
"Circulatory Patterns in Minoan Architecture", in: Nanno Marinatos and Robin Hägg (eds.), *The Function of the Minoan Palaces*, Stockholm, pp. 195–203.

Palyvou, Clairy (2005)
Akrotiri Thera: An Architecture of Affluence 3,500 Years Old (INSTAP Prehistory Monograph 15), Philadelphia.

Penn, Alan, and Turner, Alasdair (2002a)
"Space Syntax Based Agent Simulation", in: Michael Schreckenberg and Som D. Sharma (eds.), *Pedestrian and Evacuation Dynamics*, Berlin, pp. 99–114. http://discovery.ucl.ac.uk/75/1/penn-turner-2002_ped.pdf (14 January 2011).

Penn, Alan, and Turner, Alasdair (2002b)
"Encoding Natural Movement as an Agent-Based System: An Investigation into Human Pedestrian Behaviour in the Built Environment", in: *Environment and Planning B* 29, pp. 473–490.

Peponis, John, Wineman, Jean, Rashid, Mahbub, Hong, Kim S., and Bafna, Sonit (1997)
"On the Description of Shape and Spatial Configuration inside Buildings: Convex Partitions and their Local Properties", in: *Environment and Planning B* 24, pp. 761–781.

Pickles, John (1995)
"Representations in an Electronic Age: Geography, GIS and Democracy", in: John Pickles (ed.), *Ground Truth*, New York, pp. 1–30.

Poursat, Jean-Claude (1983)
"Ateliers et sanctuaires à Malia: Nouvelles données sur l'organisation sociale à l' époque des premiers palais", in: Olga Krzyszokowska and Lucia Nixon (eds.), *Minoan Society*, Bristol, pp. 277–281.

Poursat, Jean-Claude (1987)
"Le début de l'époque proto-palatiale à Malia", in: *Eilapini: Tomos timitikos gia ton kathigiti Nikolao Platon*, Heraklion, pp. 461–66.

Poursat, Jean-Claude (1992)
Guide de Malia: Au temps des premiers palais. Le Quartier Mu, Athens.

Poursat, Jean-Claude (1995)
"L'essor du système palatial en Crète: L'état et les artisans", in: Robert Laffineur and Wolf-Dietrich Niemeier (eds.), *Politeia: Society and State in the Aegean Bronze Age (Aegaeum 12), Conference Heidelberg, 10–13 April 1994*, Liège, pp. 185–188.

Poursat, Jean-Claude (1996)
Artisans Minoens: Les maisons-ateliers du Quartier Mu. Fouilles exécutées à Malia. Le Quartier Mu III (Études Crétoises 32), Paris.

Poursat, Jean-Claude (2012)
"The Emergence of Elite Groups at Protopalatial Malia. A Biography of Quartier Mu", in: Ilse Schoep, Peter Tomkins, and Jan Driessen (eds.), *Back to the Beginning: Reassessing Social and Political Complexity on Crete During the Early and Middle Bronze Age*, Oxford, pp. 177–183.

Poursat, Jean-Claude, and Darcque, Pascal (1990)
"Rapports sur les travaux de l'École française en 1989. Malia: Sondages autour du Quartier Mu", in: *Bulletin de Correspondance Hellénique* 114, pp. 908–912.

Poursat, Jean-Claude, and Knappett, Carl (2005)
Fouilles exécutées à Malia: Le Quartier Mu IV. La poterie du Minoen Moyen II: Production et utilisation (Études Crétoises 33), Athens.

Ratti, Carlo (2002)
Urban Analysis for Environmental Prediction, Cambridge (PhD thesis).

Ratti, Carlo (2004)
"Space Syntax: Some Inconsistencies", in: *Environment and Planning B* 31, pp. 487–499.

Romanou, Dorella (2007)
"Residence Design and Variation in Residential Group Structure: A Case Study, Mallia", in: Ruth Westgate, Nicolas R.E. Fisher, and James Whitley (eds.), *Building Communities: House, Settlement and Society in the Aegean and Beyond. Conference Cardiff, 17–21 April 2001*, London, pp. 77–90.

Sailer, Kerstin (2010)
The Space-Organisation Relationship: On the Shape of the Relationship Between Spatial Configuration and Collective Organisational Behaviours, Dresden (PhD thesis).

Schoep, Ilse (2002)
"Social and Political Organization on Crete in the Proto-Palatial Period: The Case of Middle Minoan II Malia", in: *Journal of Mediterranean Archaeology* 15, pp. 101–132.

Schuurman, Nadine (2000)
"Trouble in the Heartland: GIS and its Critics in the 1990s", in: *Progress in Human Geography* 24, pp. 569–590.

Shelmerdine, Cynthia W. (1987)
"Architectural Change and Economic Decline at Pylos", in: *Minos* 20–22, pp. 557–568.

Shelmerdine, Cynthia W. (1998)
"The Palace and its Operations", in: Jack L. Davis (ed.), *Sandy Pylos: An Archaeological History from Nestor to Navarino*, Austin, pp. 81–96.

Sheppard, Eric (2005)
"Knowledge Production through Critical GIS: Genealogy and Prospects", in: *Cartographica* 40, pp. 5–21.

Ståhle, Alexander, Marcus, Lars, and Karlström, Anders (2007)
"Place Syntax Tool – GIS Software for Analysing Geographic Accessibility with Axial Lines", in: Alasdair Turner (ed.), New *Developments in Space Syntax Software. Workshop Istanbul, 12 June 2007*, pp. 35–41. http://discovery.ucl.ac.uk/4109/1/4109.pdf (14 January 2011).

Teklenburg, Jan A.F., Timmermans, Harry J.P., and van Wagenberg, Andreas F. (1993)
"Space Syntax: Standardised Integration Measures and Some Simulations", in: *Environment and Planning B* 20, pp. 347–357.

Thaler, Ulrich (2001)
Communication Breakdown: A Contribution to the Spatial Analysis of the LH III B Palace at Ano Englianos in Western Messenia, Sheffield (MA thesis).

Thaler, Ulrich (2002)
"Open Door Policies? A Spatial Analysis of Neopalatial Domestic Architecture with Special Reference to the Minoan 'Villa'", in: Gergina M. Muskett, Aikaterina Koltsida, and Mercourios Georgiadis (eds.), *SOMA 2001. Symposium on Mediterranean Archaeology (British Archae-*

ological Reports International Series 1040). Conference Liverpool, 23–25 February 2001, Oxford, pp. 112–122.

Thaler, Ulrich (2005)
"Narrative and Syntax: New Perspectives on the Late Bronze Age Palace of Pylos, Greece", in: Akkelies van Nes (ed.), *Space Syntax: 5th International Symposium. Conference Delft, 13–17 June 2005*, Amsterdam, pp. 323–339.

Thaler, Ulrich (2006)
"Constructing and Reconstructing Power: The Palace of Pylos", in: Joseph Maran, Carsten Juwig, Herrmann Schwengel, and Ulrich Thaler (eds.), *Constructing Power – Architecture, Ideology and Social Practice (Geschichte: Forschung und Wissenschaft 19), Conference Heidelberg, 30 June–2 July 2005*, Münster, pp. 93–116.

Thaler, Ulrich (2007)
"Ahhiyawa and Hatti: Palatial Perspectives", in: Sophia Antoniadou and Anthony Pace (eds.), *Mediterranean Crossroads. Conference Athens, 10–13 May 2005*, Athens, pp. 291–323.

Thaler, Ulrich (2009)
Architektur der Macht – Macht der Architektur: Mykenische Paläste als Dokument und Gestaltungsrahmen frühgeschichtlicher Sozialordnung, Heidelberg (PhD thesis).

Thrift, Nigel (2008)
Non-Representational Theory, New York.

Treuil, René (1971)
"Les auges doubles de Malia" in: *Bulletin de Correspondance Hellénique* 95, pp. 13–42.

Turner, Alasdair (2001)
"Depthmap: A Program to Perform Visibility Graph Analysis", in: *Proceedings 3rd International Symposium on Space Syntax, Conference Atlanta, 7–11 May 2011*, pp. 31.1–31.9. http://www.scribd.com/doc/6707121/Depthmap-a-Program-to-Perform-Visibility-Graph-Analysis (15 January 2011).

Turner, Alasdair (2004)
Depthmap 4: A Researcher's Handbook, http://discovery.ucl.ac.uk/2651/1/2651.pdf (14 January 2011).

Turner, Alasdair (ed.) (2007a)
New Developments in Space Syntax Software, Workshop Istanbul, 12 June 2007, http://discovery.ucl.ac.uk/4109/1/4109.pdf (14 January 2011).

Turner, Alasdair (2007b)
"UCL Depthmap 7: From Isovist Analysis to Generic Spatial Network Analysis", in: Alasdair Turner (ed.), *New Developments in Space Syntax Software. Workshop Istanbul, 12 June 2007*, pp. 43–51, http://discovery.ucl.ac.uk/4109/1/4109.pdf (14 January 2011).

Turner, Alasdair (2007c)
"The Ingredients of an Exosomatic Cognitive Map: Isovists, Agents and Axial Lines?", in: Christoph Hölscher, Ruth Conroy Dalton, and Alasdair Turner (eds.), *Space Syntax and Spatial Cognition. Workshop Bremen, 24 September 2006*, Bremen, pp. 163–180.

Turner, Alasdair, Penn, Alan, and Hillier, Bill (2005)
"An Algorithmic Definition of the Axial Map", in: *Environment and Planning B* 32, pp. 425–444.

van Dyke, Ruth M. (1999)
"Space Syntax Analysis at the Chacoan Outlier of Guadalupe", in: *American Antiquity* 64, pp. 461–473.

Westerburg, Jörg (2001)
"Ein Rekonstruktionsvorschlag zum Nordostbau des 'Nestor-Palastes' in Pylos. Die erste Stoa auf dem griechischen Festland", in: *Archäologischer Anzeiger*, pp. 1–12.

Wheatley, David (2004)
"Making Space for an Archaeology of Place", in: *Internet Archaeology* 15, http://intarch.ac.uk/journal/issue15/wheatley_index.html (26 December 2010).

Wheatley, David, and Gillings, Mark (2002)
Spatial Technology and Archaeology: The Archaeological Applications of GIS, London.

Whitelaw, Todd (2001)
"Reading Between the Tablets: Assessing Mycenaean Palatial Involvement in Ceramic Production and Consumption", in: Sophia Voutsaki and John Killen (eds.), *Economy and Politics in the Mycenaean Palace States (Cambridge Philological Society Supplementary Volume 27)*. Conference Cambridge, 1–3 July 1999, Cambridge, pp. 51–79.

Wright, James C. (1984)
"Changes in the Form and Function of the Palace at Pylos", in: Cynthia W. Shelmerdine and Thomas G. Palaima (eds.), *Pylos Comes Alive: Industry and Administration in a Mycenaean Palace*, New York, pp. 19–29.

Wright, James C. (1994)
"The Spatial Configuration of Belief: The Archaeology of MycenaeanRreligion", in: Susan E. Alcock and Robin Osborne (eds.), *Placing the Gods: Sanctuaries and Sacred Space in Ancient Greece*, Oxford, pp. 37–78.

Yiannouli, Eugenia (1992)
Reason in Architecture: The Component of Space: A Study of Domestic and Palatial Building of Bronze Age Greece, Cambridge (PhD thesis).

John Bintliff

Spatial analysis of past built environments:
Houses and society in the Aegean from the Early Iron Age
till the impact of Rome[1]

Abstract

Between ca. 1000 BC, the Early Iron Age, and the Roman Late Republican era ca. 100 BC, domestic life in Greece changed in remarkable ways. On one level we see a process of continual elaboration, confirming Susan Kent's (Kent 1990) generalization that growing complexity in the built environment can form a mirror for that in contemporary social and political life. Yet in parallel we can also see a cycle, beginning with a largely undifferentiated and simple domestic environment matched by the larger residences of an elite, passing through a period when relative equality becomes the norm, then returning to an era where class differences in homes are striking. The Greek house is thus a barometer for the longer-term transformations in social life as a whole.

1 Introduction

As a specialist in material culture, I would like to explore the theme of 'communal values', through the evolution of house and town planning in the Greek city, summarizing recent work by various authors, and using the simplest form of Space Syntax – Access Analysis (Hillier and Hanson 1984; Hillier 1996). The theoretical and more importantly the empirical underpinnings of Space Syntax are elegantly summarized in Bill Hillier's chapter in this volume, while much more sophisticated combinations of built-space investigation where access-analysis is complemented by other methodologies such as viewsheds are to be found in the chapters by Fisher, Hacıgüzeller and Thaler, and Stöger. Nonetheless since this paper is a presentation and discussion of recent work on ancient Greek towns, in which these more elaborate techniques are only just being applied, it seems worthwhile to demonstrate how remarkably effective even access analysis can be when brought together with a rich archaeological, artistic and contemporary literary corpus for relating social change to the dynamics of the built domestic environment.

2 Iron Age beginnings

In the Iron Age we find two recognized settlement types (Snodgrass 1980; 1991; Morris 1991; 2000; Lang 1996; Mazarakis-Ainian 1997). The first is a scattered village plan, such

[1] The analysis in this paper is explored in more detail in Bintliff (2012).

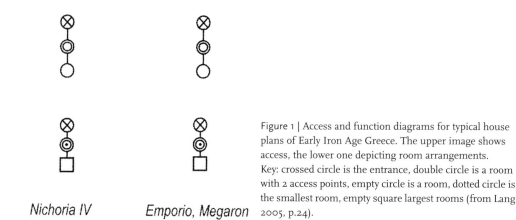

Nichoria IV Emporio, Megaron

Figure 1 | Access and function diagrams for typical house plans of Early Iron Age Greece. The upper image shows access, the lower one depicting room arrangements. Key: crossed circle is the entrance, double circle is a room with 2 access points, empty circle is a room, dotted circle is the smallest room, empty square largest rooms (from Lang 2005, p.24).

as has been excavated underneath the later city of Eretria. Domestic dwellings are dispersed and disorganized with regard to each other. Houses are frequently just a single room, such as was discovered at Old Smyrna. However, several settlements appear to show a chieftain's greathouse/communal focus amidst them. The best-known example is Lefkandi. Lang (2005) has deployed Access Analysis in the typical family home. Movement into and through these houses is extremely basic, a simple sequent access route (fig. 1).

Only the rare chief's house offers slightly more complex internal space, but this also follows a linear progression of rooms. The small scale of the normal dwellings indicates that everyday life was carried out largely outside in communal view, in contrast to the large central rooms of the chieftain's dwellings, assumed to be used for feasts and other communal activities. The majority social group of peasants clearly required no significant differentiated house spaces for their social or economic lifestyle.

The other form of Early Iron Age community can be described as more townlike. This is made up of close clusters of the previously discussed unplanned hamlets, each with their own cemeteries and presumed chiefs (basileis). The best-known examples are Athens and Argos. The multiple foci are assumed to reflect settlements of agglomerated chieftain-centred hamlets, run by a competitive oligarchy.

'Dark Age' society is believed to be dominated by the strong control over peasants by chiefs and a middle class farming group (Morris 1987). The dependence on individual leaders, more 'Big Men' than hereditary aristocratic dynasties, may account for the relative mobility of the smaller of the two settlement forms described above.

Nevertheless, notably towards the end of the protohistoric era, there are occasional experiments with formal planning of such minor communities. One striking example is the site of Vroulia (fig. 2), which although likely to be set out under elite direction, appears in its regimented rows of 'citizen's houses' to reflect the same concepts which were underlying the contemporary rise of the larger city-state or polis as a corporate community of occupants (Lang 1996).

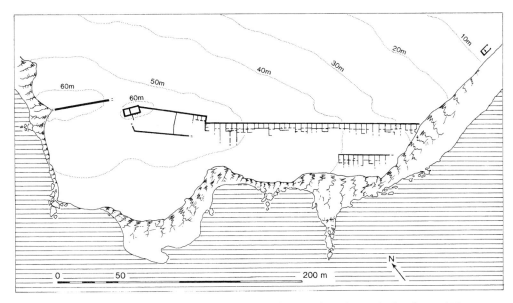

Figure 2 | Plan of the final Iron Age, transitional Archaic settlement of Vroulia on Rhodes (from Whitley 2001, p. 172).

The explosion of city-states across the Aegean between 800 and 500 BC is an extraordinary phenomenon. Hansen (2004) and Ruschenbusch (1985) have shown that the typical polis was surprisingly small, 2000–4000 citizens, arising as nucleated, introverted 'corporate communities' over tiny territories, in which dependent villages and farmsteads clustered around an urban focus, where generally 70 to 80 % of the population resided.

It was the historical geographer Ernst Kirsten (Kirsten 1956; cf. Bintliff 1994), who recognized that this evolution gave birth to the normal Greek polis as a 'village-state' (Dorfstaat), whilst a very small minority of city-states reached far greater population, his 'Megalopoleis', which were territorial states and generally included other towns in their regions or empires. Notable megalopoleis in the Aegean were Athens and Thebes.

3 The Archaic era

The rise of the city-state or polis, out of these fragmented settlements, can in part be accounted for through population growth, creating their fusion into single integrated settlements, but is as much due to major social change, resulting from the decline of the elite grip on the community matched by increasing legal and political rights for all free male citizens. A case can still be made that the broadening of citizen's rights is linked with military reforms, notably the growing centrality of the essentially middle-class citizen-army or hoplite warfare to the city-state. In any case, the Archaic era sees the generalized erosion of

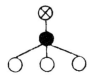

Zagora G

Figure 3 | Access and function diagrams for more elaborate houses at Zagora on Andros, from the transitional Iron Age/Archaic period. The upper image shows access, the lower one depicting room arrangements. Key: crossed circle is the entrance, filled square is the largest room serving as transitional areas; empty circles are rooms, dotted circle is the smallest room (from Lang 2005, p. 24).

the power of the aristocratic basileis in favour of the middle class, and in varying degrees towards the free peasant class. By Classical times, perhaps half of the city-states in the Aegean had adopted what we might term a 'moderate democracy'.

These major sociopolitical changes can be seen in material form when we return to the evidence from private house architecture and town-planning (fig. 3). Already from final Geometric and early Archaic times (the 8th to 7th centuries) we can see the elaboration of family homes, expanding the number of rooms and enclosing partly or wholly the outside working areas, to construct a more focussed, private citizen-family residence reflecting a sense of growing importance for this basic constituent of the emergent city-state or polis. The last phases of the settlement at Zagora on Andros exhibit this trend well, as can be seen both in its increasingly complex plan and in the more elaborate house access diagrams. At first such sprawling room-complexes may represent clusters of related families gaining more privacy, but over time these simplify into the small, more coherent, radially planned regular room-groups arrayed around a private courtyard, which we can later associate with the nuclear or extended citizen family.

However, the remainder, some half of Greek societies, were not to adopt democracy, remaining under aristocrats, even kings, or in a form reminiscent of, and perhaps merely perpetuating, the South Aegean Dark Age model, where a large serf population is dominated by an equally large body of middle and upper class citizens. This latter model is best-known from Thessaly, and from Doric states such as Sparta and the city-states of Dorian Crete. It is of great interest to see what changes in the settlement plan and then in the domestic house occur in these politically conservative 'serf' societies from Archaic into Classical times.

Haggis (2007) has used a detailed regional survey and excavation at the emergent city-state of Azoria in Crete to trace the material evidence for the creation of this distinctive form of Dorian serf-state in Archaic to Classical times. Firstly there is clearly a rise in population and wealth, as well as nucleation into a series of city-state centres. Rich tombs, as generally

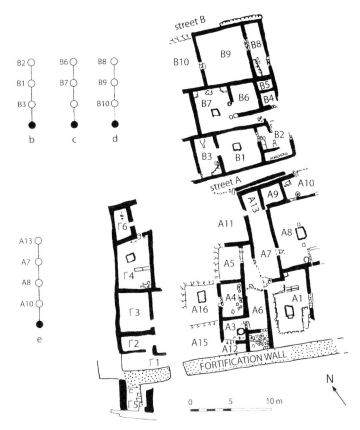

Figure 4 | Typical houses at the Cretan early Hellenistic settlement of Trypetos, Crete. Outside space in the house access diagrams are shown as dark circles, whilst the simple linear sequence of rooms is shown as clear circles (from Westgate 2007, p. 438).

in the Southern Mainland of Greece, decline as prestigious objects are redirected into temple offerings, a sign of the creation of a civic identity and the decline of aristocratic power in favour of a broad middling-citizen community. Yet the similarity to the trajectory leading to Greek democracy is then frozen at this point of evolution. The public monumental city-centre, although including the customarily prominent Agora and major temple, also contains complexes for the storage, preparation and communal consumption of food by the male citizen community (the andreion or syssitia).

At the Cretan town of Trypetos (Westgate 2007) Early Hellenistic private homes show two significant features (fig. 4). On the one hand, the houses are multi-roomed, continuing the trend we witnessed generally from the late Iron Age towards elaboration of the family home. But equally notable is the fact that most houses have simple linear access, being relatively open to the neighbours and the rest of the community.

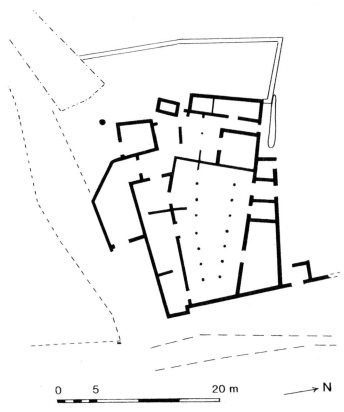

0 5 20 m → N

Figure 5 | Archaic Mansion, Building F from the surroundings of the Athenian Agora (from Whitley 2001, p. 173).

If we compare the indications from Azoria and Trypetos, the growth of family prosperity at least for the citizens, but moderated by the centrality of communal life, appears well expressed in the contemporary designs of private citizen's homes. The diversion of male citizen life into centralized dining complexes in the town freezes the elaboration of the domestic house after its initial unfolding into several spaces, preventing the emergence of a closed and private family focus, and marginalizing the non-adult male members of the citizenry.

Although at one level the rise of the city-state is seen to stimulate an elaboration of typical domestic spaces, whether in rising democracies or in conservative serf-states, at least till the end of Archaic times aristocrats were still dominant in most Greek states. One example of a likely elite mansion is a building discovered on the fringes of the Athenian Agora (fig. 5).

4 The Classical era

In general, by and during Classical times, urban settlements in southern Greece evolve in two ways.

Older settlements simply grew, either through the infilling of former hamlet clusters, or expanding out from single cores (Snodgrass 1991), but organically and with poor articulation. Athens was to contemporaries a notorious example of an unplanned town, except for its public spaces. These focussed on a symbolic communal ritual centre (the Acropolis) and a large open space for public gatherings, enhanced commerce as well as public facilities such as parliament buildings, law courts and city record offices (the Agora).

For these long-established towns, we have too little house evidence to confirm our textual sources, which suggest a likely decline within the moderate to full democracies of large elite dwellings, and a general flattening of house display both externally and internally, conforming to a principle of relative citizen equality. But the limited examples of excavated homes which we do have show a very widespread form, the multi-roomed courtyard house, both in the Aegean non-serf-states and in colonies abroad, which can be read as expressing this concept. Some differences in known examples, such as we see in the next figure (fig. 6), allow us to infer distinctions presumably based on simple relative wealth, between larger and smaller versions of this plan, marking what we might suppose is the typical middle-class version, and the poor in smaller stripped-down versions. Intelligent analysis by Jameson (1990; 1990a) of the most typical scale of courtyard-house, some 200 to 300 square metres in size, suggests that the design was intended for a nuclear family plus a slave or two.

The emphasis is on enhancement of the private citizen family: the front door shuts out the wider community, then (fig. 7) multiple room spaces are radially accessed from the focal enclosed courtyard. This open space appears as a major locale for work, ritual and familial socialization, thus for varied social and economic roles. After lengthy debates on the presence, absence and possible location of 'female quarters', it now seems widely agreed that almost the entire walled house now appears to have become a women's space, contrasted to that of the male, which was the public extramural world of the assembly, law courts, gymnasium etc.

In new planned settlements, of which the best-known architecturally is Olynthus (Cahill 2002), it was possible to underline citizen-equality by the construction in perfect symmetry of apparently uniform house blocks of this single-entrance courtyard type, seen as the materialization of isonomia (citizen equality). Some new towns, such as Piraeus, subordinate the planning of public spaces to the grid of blocks of domestic housing, as if the latter were now the central concept of town organization, followed in second place by good communication infrastructures in and out of town (to facilitate citizen movements to farm-estates forming the town's hinterland or to port facilities).

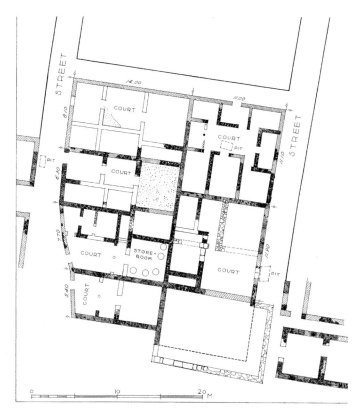

Figure 6 | Classical Houses at the north foot of the Areopagus Hill, Athens.
Each house is identified by its courtyard, showing variability in the size of
small to medium-sized houses (from Tsakirgis 2005, p. 68).

However, inscriptions show that house values range considerably for similarly sized
properties, unsurprisingly affected by more or less desirable locations within the city
(Cahill 2002). Moreover, texts allow us to infer that the very concealed nature of house-in-
ternal arrangements could allow families of wealth and status to advertise themselves away
from the public eye, through luxurious house furnishings, wall-paintings and table-vessels
of precious metal, thereby erecting a parallel value system to the apparent housing democ-
racy. In the same way, town-quarter analysis at Olynthus (Cahill 2002) has made clear that
houses with superficially similar plans could conceal contrasted economies, made clearer
by the study of house contents (in this case differences between streets of artisans and those
of the owners of larger agricultural estates).

The importance of restraint on ostentatious displays of wealth in the city-state can fin-
ally be illustrated by the lack of restrictions when we turn to remoter rural areas far from the
town. In the Athenian village of Atene, the majority of Classical estate-centres are medium
to large establishments, with only a few small 'peasant family farms' (Lohmann 1993).

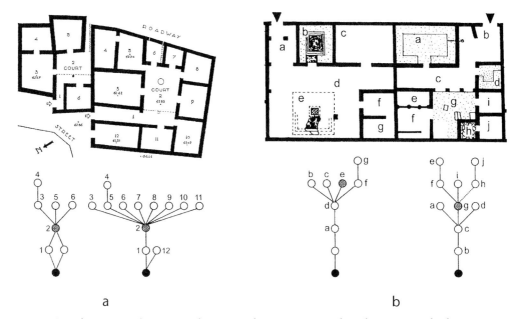

Figure 7 | (a) 5th century BC houses near the Agora, Athens (Houses C and D). (b) Houses at Olynthus, late 5th – early 4th century BC. Outside space in the house access diagrams are shown as dark circles, courtyards as grey circles, and individual roofed rooms as clear circles (from Westgate 2007, p. 425).

Already by late Classical times the decay of community politics was associated by contemporaries (such as Demosthenes) with the urban rich constructing more prestigious townhouses.

5 Hellenistic and Early Roman eras

Alexander the Great's conquests led to the relatively-fixed large kingdoms of Hellenistic times, causing the rapid death of the autonomous city-states and, with it, of the concept of citizen equality. The decline of the democratic city-state is symbolized by changes in the public and private sphere. Public spaces such as the Agora become filled with prestigious monuments to display the acquisition of absolute power by the city's rich, and by external kings and princes. Political activity is increasingly moving to giant palatial complexes at the heart of new large dynastic states, reducing polis politics to local issues. Even these palaces of the Greek dynasts are largely a series of giant reception rooms for hosting social events for the display and negotiation of power, with private accommodation and government offices relegated to the periphery of the plan (Étienne and Müller et al. 2000). This pattern was set early in the originating kingdom for the Hellenistic world, that of Macedon, and is well illustrated by the royal palace of Aegai (fig. 8). Such elite palaces are arguably emulated

Figure 8 | The palace of the kings of Macedon at Aegai-Vergina, 4th century BC (from Étienne et al. 2000, fig. 113).

in the new semi-public form of the homes of the better-off citizens of the Hellenistic world. Not surprisingly early examples of these 'trickle-down' effects are found in the new Macedonian capital city of Pella, where urban mansions with multiple courts, ornamented by columned porticoes (peristyles) and mosaics, have been excavated.

The reduction of a meaningful political role for the average male citizen in the Greek city-state had several effects. Networking with the new powerful elites to whom local power is entrusted by the Hellenistic monarchs, and a concern with advertising and improving family status socially and economically, converts the former closed-in world of the house – the 'oikos' – to a semi-public sphere, at least for the middle to upper classes. The traditional private family courtyard with its radiating rooms is supplemented or replaced by a display court with several reception rooms, often highly decorated. The House of the Mosaics at Eretria (fig. 9) is an early example of this development (Nevett 1999). Peristyles around such courts may be accompanied by fountains and statuary, and these 'display courts' can even be the first complex encountered when coming from the street (fig. 10). The access diagrams for such homes (Westgate 2007) illustrate the marginal location of their private and service rooms, requiring complex indirect pathways to reach them, compared to the directly accessible and focal semi-public visitor-reception court and dining-rooms.

Figure 9 | House of the Mosaics, Eretria, 4th century BC
(from Nevett 1999, p. 109).

0 5 10m

C

0 20 m

Figure 10 | Late Hellenistic houses from Delos. Outside space in the house access diagrams are
shown as dark circles, courtyards as grey circles, and individual roofed rooms as clear circles
(from Westgate 2007, p. 425).

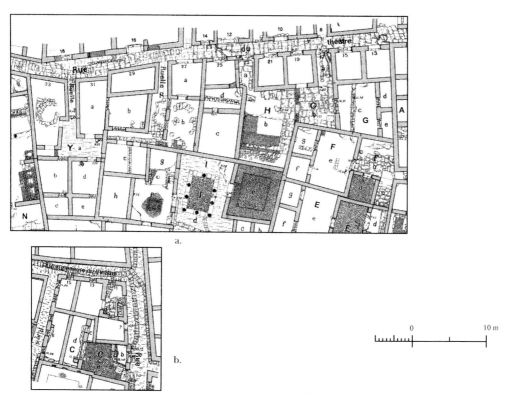

Figure 11 | Mixed housing of all social classes at Late Hellenistic Delos (from Trümper 2005, p. 124).

By the transitional era of the final two centuries BC, between Hellenistic and Roman times, urban fabrics begin to resemble those of many Early Modern European towns, with many gradations along a vast cline from the hyper-rich multi-courted villas, through middle-class traditional-sized homes, then to the lower classes in small to very small apartments or tiny homes, or even above shops, but all living side by side and even in sublet sectors of elaborate house blocks. The cosmopolitan, commercial and one might now reasonably say, 'globalized' port-town of Delos (fig. 11) provides an excellent example of such an urban fabric (Trümper 2005).

However, one more positive sign of social change which is perhaps marked in Roman-era Greek houses is a rise in the status of women: Nevett (1992) has recently interpreted the innovation of double access to houses as marking a relaxation in the seclusion of the family, and especially of women, in Greek society.

Bibliographical references

Bintliff, John (1994)
"Territorial Behaviour and the Natural History of the Greek Polis", in: Eckart Olshausen and Holger Sonnabend (eds.), *Stuttgarter Kolloquium zur Historischen Geographie des Altertums 4*, Amsterdam, pp. 207–249, plates 19–73.

Bintliff, John (2012)
The Complete Archaeology of Greece, Oxford and New York.

Cahill, Nicholas (2002)
Household and City Organization at Olynthus, New Haven and London.

Étienne, Roland, Müller, Christel, and Prost, Francis (2000)
Archéologie Historique de la Grèce Antique, Paris.

Haggis, Donald et al. (2007)
"Excavations at Azoria, 2003–2004, Part 1", in: *Hesperia 76*, pp. 243–321.

Hansen, Mogens (2004)
"The Concept of the Consumption City Applied to the Greek Polis", in: Thomas Nielsen (ed.), *Once Again: Studies in the Ancient Greek Polis*, Stuttgart, pp. 9–47.

Hillier, Bill (1996)
Space is the Machine. A Configurational Theory of Architecture, Cambridge.

Hillier, Bill, and Hanson, Julienne (1984)
The Social Logic of Space, Cambridge.

Jameson, Michael (1990)
"Domestic Space in the Greek City-State", in: Susan Kent (ed.), *Domestic Architecture and the Use of Space*, Cambridge, pp. 92–113.

Jameson, Michael (1990a)
"Private Space and the Greek City", in: Oswyn Murray and Simon Price (eds.), *The Greek City from Homer to Alexander*, Oxford, pp. 171–195.

Kent, Susan (1990)
"Activity Areas and Architecture. An Interdisciplinary View of the Relationship Between the Use of Space and Domestic Built Environments", in: Susan Kent (ed.), *Domestic Architecture and the Use of Space*, Cambridge, pp. 1–8.

Kirsten, Ernst (1956)
Die griechische Polis als historisch-geographisches Problem des Mittelmeerraumes, Bonn.

Lang, Franziska (1996)
Archaische Siedlungen in Griechenland: Struktur und Entwicklung, Berlin.

Lang, Franziska (2005)
"Structural Change in Archaic Greek Housing", in: Bradley Ault and Lisa Nevett (eds.), *Ancient Greek Houses and Households*, Philadelphia, pp. 12–35.

Lohmann, Hans (1993)
Atene. Forschungen zu Siedlungs- und Wirtschaftsstruktur des klassischen Attika, Cologne.

Mazarakis-Ainian, Alexandros (1997)
From Rulers' Dwellings to Temples, Jönsered.

Morris, Ian (1987)
Burial and Ancient Society. The Rise of the Greek City-State, Cambridge.

Morris, Ian (1991)
"The Early Polis as City and State", in: John Rich and Andrew Wallace-Hadrill (eds.), *City and Countryside in the Ancient World*, London, pp. 25–27.

Morris, Ian (2000)
Archaeology as Cultural History, Oxford.

Nevett, Lisa (1999)
House and Society in the Ancient Greek World, Cambridge.

Nevett, Lisa (2002)
"Continuity and Change in Greek Households under Roman Rule", in: Erik Ostenfeld (ed.), *Greek Romans and Roman Greeks*, Aarhus, pp. 81–97.

Ruschenbusch, Eberhard (1985)
"Die Zahl der griechischen Staaten und Arealgröße und Bürgerzahl der 'Normalpolis'", in: *Zeitschrift für Papyrologie und Epigraphik 59*, pp. 253–263.

Snodgrass, Anthony (1980)
Archaic Greece: The Age of Experiment, London.

Snodgrass, Anthony (1991)
"Archaeology and the Study of the Greek City", in: John Rich and Andrew Wallace-Hadrill (eds.), *City and Country in the Ancient World*, London, pp. 1–23.

Snodgrass, Anthony (1993)
"The 'Hoplite Reform' Revisited", in: *Dialogues d'Histoire Ancienne 19*, pp. 47–61.

Trümper, Monika (2005)
"Modest Housing in Late Hellenistic Delos", in: Bradley Ault and Lisa Nevett (eds.), *Ancient Greek Houses and Households*, Philadelphia, pp. 119–139.

Tsakirgis, Barbara (2005)
"Living and Working around the Athenian Agora: A Preliminary Case-Study of Three Houses", in: Bradley Ault and Lisa Nevett (eds.), *Ancient Greek Houses and Households*, Philadelphia, pp. 67–82.

Westgate, Ruth (2007)
"House and Society in Classical and Hellenistic Crete", in: *American Journal of Archaeology 111*, pp. 423–457.

Whitley, James (2001)
The Archaeology of Ancient Greece, Cambridge.

Akkelies van Nes

Indicating street vitality in excavated towns.
Spatial configurative analyses applied to Pompeii

Abstract

The aim of this contribution is to show how it is possible to indicate degrees of street life and economic attractiveness in excavated towns through micro- and macro-spatial configurative analyses. The space syntax method is able to calculate the spatial configuration of built environments and compare it with numerical socio-economic data (Hillier, this volume). It is capable of identifying the spatial features for vital shopping areas, various social classes' spatial preferences when choosing a dwelling area, and the spatial features of the location of various institutional buildings in a contemporary urban context.

At present, research on the urban environment by means of space syntax theory and methods tends to focus on macro-scale spatial conditions. However, the micro-scale aspects should not be neglected. For this purpose, spatial methods were developed and tested out with regard to the topological relationship between private and public space. Issues such as various degrees of inter-visibility between windows and doors, density of entrances, topological depth between private and public space, and degree of constitutedness were taken into account. It became clear that micro-spatial measurements depend on the macro-spatial ones (van Nes and Lopez 2010). Together they offer knowledge about the spatial conditions for different issues, such as vital street life, urban safety, social interactions and their interdependence. Everything seems to depend on various degrees of adjacency, permeability and intervisibility being taken into account on different levels of scale.

When applying these spatial analysis tools on excavated sites, empirical socio-economic knowledge from a modern urban context is required. Then it is possible to derive from the spatial analysis information on street life, poverty and various degrees of social control on excavated sites. Pompeii is one of the best preserved towns from the Roman period and it is used as an example to derive interpretations by means of spatial analysis.

1 Introduction

The Roman town of Pompeii was suddenly buried by an unexpected eruption of the volcano Vesuvius on 24th August 79 AD. About 20,000 inhabitants were living there at that time. The town was buried under a 6-metre layer of volcanic ash, which preserved forever evidence of urban life at that moment almost two thousand years ago. Two thirds of the town are now excavated. Due to its strict orthogonal street grid, it is easy to reconstruct the street structure of the un-excavated parts. A lot has been investigated and written about Pompeii. However, even though there is a wealth of published material, the linkage between various disciplines as well as the linkage between artefacts and their location has not yet been sufficiently established.

From a perspective outside archaeology, urban researchers in the field of space syntax are concerned with the space-society relationship (Hillier, this volume). The focus lies on how activities in society shape the spatial outcome and how this spatial outcome in turn affects human behaviour. The product of this organisational set-up can only be under-

stood from written documents, plans, and, naturally, the spatial organisation of the built environment itself. Conversely, gaining knowledge of human behaviour in built environments requires that human activities in urban space are recorded. An understanding of the relationship between society and its physical product necessitates at least some tools which focus on spatial issues and a consideration of the underlying laws of urban space itself.

From an urban designer's perspective, results from research on built environments are useful to some extent because they enable us to predict future socio-economic consequences of our design proposals. Therefore the space syntax method can give indications of possible effects of spatial changes. Similarly, results from space syntax research in a modern urban context are to some extent useful to archaeologists for understanding past societies by means of spatial analysis. In particular the relationship among the flow of human movement, economic activities and the degree of spatial integration can indicate various degrees of street vitality in excavated towns. Understanding this relationship depends on an accurate reconstruction of the street network of past built environments.

As it is possible to reconstruct Pompeii's entire street network, the Roman town proves an interesting case study for examining social and economic street life in ancient times using spatial analysis. Since many items found in buildings are well preserved, it is possible to identify from an archaeological point of view what kind of function various spaces had in the past. This contribution will focus on how the dispersal of urban functions relates to the spatial configurative analysis of Pompeii's street network. More specifically, the results collated from spatial analysis will be correlated with the location of various building functions as they have been identified by archaeologists.

2 Definition of urban space

The success of space syntax seems to be due to at least two factors: a concise definition of *space* and a high degree of falsifiability and testability. When testing statements or hypotheses, we must be able to determine whether they are true or false. Therefore the concepts used in research have to be well defined for providing reliable scientific explanations and an understanding of how built environments function. The clearly defined spatial notions of the space syntax method have contributed to operational and uniform research methods, which again have contributed to solid, empirically based theories and generalisations on the relationship between society and space.

Hillier distinguishes between *intrinsic* and *extrinsic* properties of space. Extrinsic ones determine how spatial units relate to one another. The configurative laws of space are based on a space's degree of accessibility, permeability, and visibility in relationship to all spaces (Hillier, this volume). When one intends to understand settlements in terms of these laws, they are regarded as sets of *spaces*. Here primarily topological issues become relevant. Volumes, textures and size are not taken into consideration. When regarded in purely extrinsic

terms, spaces are shape-free. It is only their inter-relational aspect or structure that counts here. Each space has one or more functions, either for occupation or movement. Therefore, extrinsic properties of space concern *built form* and their containing *functions* (Marcus 2000, p. 40).

A systematic account of the extrinsic properties of built environments seen as sets of spaces allows the identification of *genotypes* of different settlements. In this respect merely generative processes count. What is important here is to describe the hidden spatial structure of built environments.

While extrinsic properties of space concern invisible, structural relationships, intrinsic properties refer to visible ones. They rely on things we can see, such as the shape, size, and texture, of physical objects (like for example buildings) placed in space (Hillier 1999, p. 1). They consist mostly of geometrical properties and are responsible for the different *phenotype* each settlement has. Describing the intrinsic spatial properties of a built environment is not an abstraction of the meaning and intentions of the physical objects. First and foremost, a physical object's purpose is important at the time it was made. In later contexts it is mostly left out of consideration. In this respect, intrinsic properties of space account for the interrelationship between *built form* and *meaning* (Marcus 2000, p. 40). In research traditions based on urban morphology and place phenomenology concepts of space form part of intrinsic properties of space, viz. they consist of descriptions of building typologies, shape of built volumes, windows, doors, forms of squares etc.

In archaeological research on Pompeii, the phenotype of various artefacts has been extensively recorded. Some examples are the temple of Fortuna Augusta, Capitolium, Temple of Apollo, and the well-preserved villas such as the House of Sallust and the House of the Black Anchor (Zanker 1998). However, the genotype of the various buildings and the city have hardly been taken into account. There has been some space syntax research on buildings and street network over the last 15 years (Laurence 1996; Poehler 2006; Kaiser 2000; Fridell Anter and Weilguni 2003; DeLaine 2004; Newsome 2009). However the linkage between Pompeii's private and public space is not made at all in the analysis of extrinsic properties of space or the genotypes of various streets.

3 The space syntax method applied to excavated towns

When applying space syntax to excavated sites, it is important to clarify the chronological context of the analysis. Often, changes to the street network and buildings through time are layered upon each other (Stöger 2009). Some layers might be lost while others are highly visible. There are several maps of Pompeii's street network. Furthermore, Hans Eschebach and Liselotte Eschebach (Eschebach 1993) recorded every excavated building and carefully plotted their walls and openings on maps. Because of the artefacts found in Pompeii, various functions have been attributed to excavated buildings.

It is easy to identify bakeries, public baths, temples, taverns, wool workshops, smithies, inns, drinking places, and brothels. The presence of shops, however, is difficult to ascertain, since artefacts found inside buildings could be used for private use as well as for sale. In contrast to this approach, Ray Laurence used the length of the streets in metres and divided it by the number of doorways (Laurence 1996, p. 89). In his view this analysis suggests a large number of comings and goings in such streets, which is a condition for micro-scale economic activities.

4 The macro-scale tools

Figure 1 shows how global integration is calculated for a small settlement. As the analyses show, the main street is the most spatially integrated street in terms of the smallest number of direction changes to all other streets. The back street is the most spatially segregated street. Every time people change direction from one street to another, they take a *topological step*. A person has to change direction many times to reach all other streets from the back street. Hence, the back street is topologically *deep*, whereas the main street is topologically *shallow*.

A small settlement can be calculated easily by hand. However, when analysing larger settlements, with more than a hundred thousand street segments, the relationship of a street to all other streets in the network can be calculated using specialised software. Since the space syntax method analyses pure spatial relationships quantitatively, the results can be correlated with numerical statistical data such as pedestrian flow rates, property prices, crime dispersal etc (Hillier, this volume). Hence, the degree of a street network's spatial integration gives an indication of the extent of street life and the location of economic activities.

In excavated towns, spatial analysis results can only be correlated with the location of the various urban functions which have been indicated by the artefacts discovered in buildings. Functions such as public baths, bakeries, taverns, religious buildings and dwellings are easy to identify. The location of shops, however, is difficult to confirm, because artefacts found in the rooms adjacent to the public street can be used privately as well as being offered for sale.

The global and local integration analyses of Pompeii's street network indicate the location of the most important streets. Figure 2 shows a global integration analysis with the location pattern of shops. It suggests how accessible each street is in relation to all the others. The black colour shows the most integrated streets, while the light grey represents the most segregated ones. As research has shown in present-day cities, the most integrated streets have the highest flows of pedestrians. Shops are also located in the most integrated streets (Hillier et al. 1998; van Nes 2005). In Pompeii, the two main streets, Via Stabiana and Via di Nola, have the highest integration values, followed by the Via dell'Abbondanza.

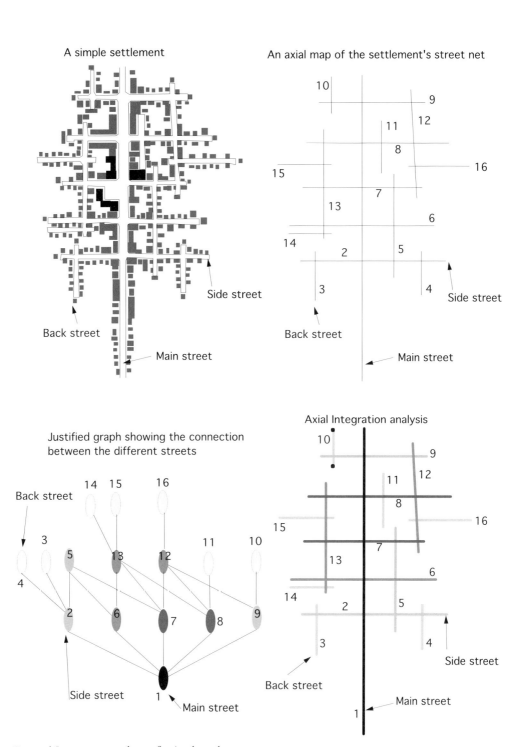

Figure 1 | Space syntax analyses of a simple settlement.

In the local integration analysis, local angular analysis, and isovists analysis, the same integration structure can be seen as in the global integration analysis.

The two highly spatially integrated main streets are planned according to the ideal of Roman city planning, where they are called *decumanus* and *cardus*. Pompeii's oldest urban areas have an organic street network. At the time of the eruption, it was slightly adjusted to the ideal Roman town plan with its strictly orthogonal street pattern.

A two-step analysis shows how much of an area can be reached when changing directions twice from a particular street. When this approach is applied to the two most integrated streets in Pompeii, it shows that all other streets can be reached within two direction changes. Moreover, the density of side streets is very high along the integrated main streets. As was already mentioned, shops are located in the most topologically and metrically central streets in Pompeii, just as they do at present in most cities (van Nes 2005). The black pattern of shops (as indicated by the Eschebachs) corresponds with the integration values of the macro-scale analyses.

A recently developed Space Syntax measure, angular analysis, takes as its basis the angular relationship between streets. Most main routes through and between urban areas consist of long streets ending up at another long street with an angle close to 180 degrees. As expected, the *decumanus* and *cardus* are highlighted more in the angular analyses than in the global integration analyses. The correlation between the location pattern of shops and the occurrence of graffiti on the walls tend to be in streets with a high local angular integration value. It can be presumed that these streets were more frequented than others.

In his book, *Roman Pompeii: Space and Society*, Laurence identified the location of the centres of various local neighbourhoods on the basis of the location of public water fountains and provision of high-quality drinking water (water fountains). He argues that these fountains would have been used by people living in close proximity to them, and they probably functioned as a natural contact point between neighbours (Laurence 1996, p. 98). These water fountains were nearly always located at a street junction. If the water quality is equally distributed around the town, it can be presumed that the locals chose the water fountain in closest proximity to their residence. These locations can be subjected to topological analyses to relate the shortest metrical radiuses to the integration values discussed above. What we find is that the water fountains were located in places with high local integration values and associated with short metrical distances.

Figure 3 shows the location of the various local centres for different neighbourhoods (or *vici*) derived from the spatial topological analyses with a metrical radius of 80 metres. It is not unreasonable to assume that there would be two or three more local centres in the unexcavated areas north of Via dell'Abbondanza. In these unexcavated areas, the structure of the presumed streets has both high integration values and a high density of streets within a short metric distance. In addition, it needs to be pointed out that these unexcavated streets, in terms of point depth and line analyses (as well as axial and segment analyses), suggest that in the unexcavated area in the eastern part of Pompeii lies an important (strong) local centre.

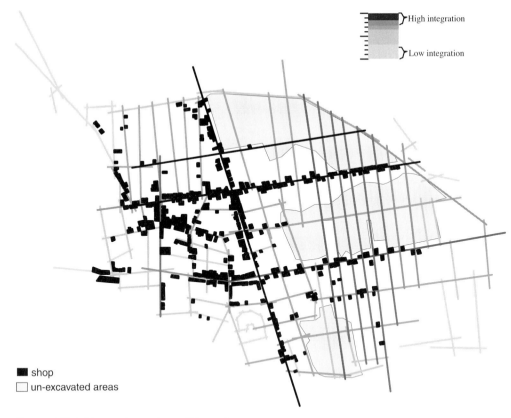

High integration

Low integration

shop

un-excavated areas

Figure 2 | Global integration analyses of Pompeii.

5 The micro-scale tools

Spatially, the focus in the macro-scale analysis is on how one street relates to all others in a city, while the focus in the micro-scale analysis is on the spatial relationship between spaces inside buildings and the streets. More precisely, it aims at defining the interrelationship of buildings or private spaces and adjacent street segments. The focus is on how dwellings relate to the street network, the way building entrances constitute streets, the degree of topological depth from private space to public space, and the intervisibility of doors and houses across streets. As Jane Jacobs and Jan Gehl argue, the existence of many entrances and windows facing a street is a way of ensuring urban liveliness (Jacobs 2000; Gehl 1996). The challenge is to *quantify* these kinds of spatial relationships. What is important here is to measure various degrees of active urban frontages or the relationship between buildings and streets. Only then will it be possible to gain a genuine understanding of the spatial conditions for vital street life and urban safety.

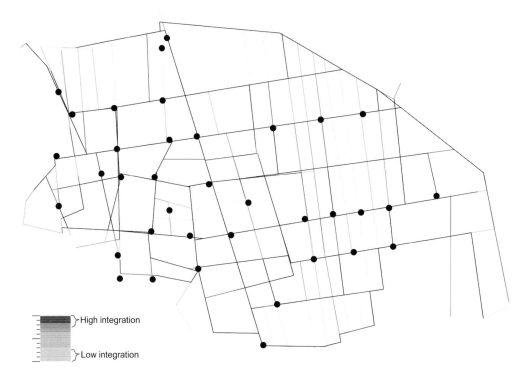

High integration

Low integration

Figure 3 | Angular choice analyses with short metrical radiuses.

Moreover, in a research project on space and crime in Alkmaar and Gouda in the Netherlands, an opportunity was provided to register various spatial relationships between private and public spaces and compare the results with numerical social and economic data in a modern context (López and van Nes 2007). In total 1,168 street segments were observed and twenty-five different spatial features were registered for each segment. The results of the micro-spatial analysis were put in a Statistical Package for the Social Sciences (SPSS) database, together with various macro-scale variables derived from the space syntax analyses of the streets and street network, and the number and characteristics of residential burglaries and thefts from cars for each street segment. This research found that there was a correlation between a street network's spatial structure, the degree of intervisibility of entrances, and the incidence of crime; at the level of generalisation where integration values were high and the intervisibility of entrances was high, crime was low (López and van Nes 2007).

There are several ways of analysing spatial configurative relationships between building entrances and the street network. An easy way is to register the *topological depth* between private and public space. This involves counting the number of semi-private and semi-public spaces a person has to walk through to go from a private space to a public street. If an

entrance is directly connected to a public street, there are no spaces between private and public space and depth is equivalent to zero. If there is a small front garden between the entrance and the public street, the depth value is one, since there is one space between the closed private space and the street. If the entrance is located on the side of the house and it has a front garden or is concealed by hedges or fences, the topological depth of the entrance has a value of two. In other words, the topological steps between the street and the private spaces inside buildings are being counted. In Pompeii the private space was found to be at the main entrance of the buildings.

Each side of a street segment is registered separately. There are many streets where entrances are directly connected to the street on the one side, while there is no entrance on the other side. If the side of a street segment has several depth values between private and public spaces, the average value is used. The diagram in figure 4 (top) illustrates various types of relationship between private and public spaces. The black dots represent the private spaces, while the white dots represent semi-private spaces. Casa di Octavius Quartio and Casa della Venere in Conchiglia are typical Pompeii houses, directly connected to the highly integrated street Via dell'Abbondanza. The main entrances of both houses are between two spaces, where probably shops were located in the past. Even though most of Pompeii's homes housed several families and the garden/courtyard probably functioned as a place for social interaction, they all had one main entrance directly connected to a public street.

A street's degree of *constitutedness* depends on various degrees of adjacency and permeability from buildings to public space. When a building is directly accessible to a street, it *constitutes* the street. Conversely, when all the buildings are adjacent to a street, but the entrances are not directly accessible, then the street is *unconstituted* (Hillier and Hanson 1984, p. 94). A street segment is constituted when only one entrance is directly connected to the street. If the entrance is hidden behind high fences or hedges, has a large front garden, or is located on the side of the building, then the street is defined as unconstituted. The diagram in figure 4 illustrates the differences between constituted and unconstituted streets. The number and density of entrances are not considered in this case. The degree of constitutedness expresses the number of entrances connected to a street divided by the number of buildings located along that street.

As the results from the spatial analyses in Gouda and Alkmaar show, both micro- and macro-spatial variables are highly interdependent for describing an area's degree of liveliness (López and van Nes 2007). When a street segment is on a spatially integrated main route, or close to a main route, more buildings are directly connected to streets, and the entrances on each side of the street are intervisible to one another. Conversely, the further away a street segment is from a main route, the more building entrances are hidden away from streets and the degree of intervisibility between them is lower. These kinds of combination of macro- and micro-spatial conditions influence the degree of street life. The further away from main routes, the more silent street life tends to be. Most micro-spatial

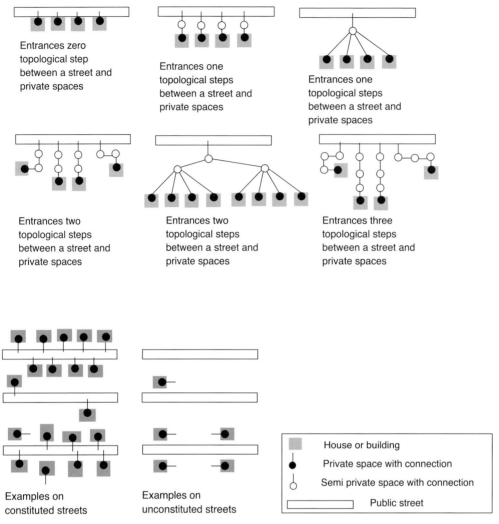

Figure 4 | Diagram showing the topological relationship between private and public space.

variables turn out to be related to the macro-scale variable *local angular analyses*. This variable identifies the main routes through cities and shows strong correlations with the micro-scale variables.

Through the Eschebachs' detailed mapping of buildings and their function, it is possible to carry out the micro-scale spatial analyses in Pompeii in the excavated areas of the city. One result is that all the entrances in the excavated areas are directly connected to the streets. Pompeii has in comparison with more modern European cities a well-connected and well-integrated street network. This might explain why there are almost no entrances hidden away from the public streets. When changing directions twice from Pompeii's main

streets, a person is likely to end up in streets with very few or even no entrances. However, these entrances are still directly connected to the streets.

Figure 5 shows the difference between constituted and unconstituted streets in Pompeii. Unconstituted street segments are marked in grey, while the constituted ones are in black. All the shops are located along the constituted streets. The more entrances are connected to a street, the higher the probability that someone will come out from a private space into public space. However, the high density of entrances connected to a street does not always imply high inter-visibility. There is a distinction in the way entrances *constitute* streets and in the way they are *intervisible* to each other. The way entrances and windows are positioned to each

The density of entrances and degree of intervisibility was recorded separately. Thus, two buildings with two entrances facing each other indicate 100 % intervisibility of doors. Conversely, a street segment with a high density of entrances on only one side of the street segment is defined to be 0 % intervisible. In Pompeii the percentages of the degree of intervisibility of entrances were grouped as 100 %, 50 % and 0 % intervisibility for each street segment. Figure 6 shows some diagrammatic principles on the relationship between intervisibility and density of entrances.

The distinctiveness of this feature can be clarified further with reference to figure 7, which shows an example of a street with low intervisibility and low entrance density (left), and an example of a main street with high intervisibility and high density of entrances (right). The left example is a typical back street with only dwelling entrances (Via del Fuggiaschi), while the right example is Via dell'Abbondanza as a typical main shopping street in Pompeii.

Figure 8 shows the density (above) and degree of intervisibility (below) of entrances in Pompeii. The most integrated streets have the highest inter-visibility and density of entrances. By revealing the degree of constitutedness, it shows that Pompeii also had "silent" side and back streets with no entrances connected to these public spaces. Examples of silent unconstituted streets are Vicolo del Fuggiaschi and Via di Nocura, and examples of lively and constituted streets are Via dell'Abbondanza, Via di Stabia, Via Fortuna and Via di Nola.

A combination of various micro- and macro-spatial measurements makes it possible to capture data for relating the spatial to socio-economic circumstances and to provide an understanding of the spatial conditions for safe and vital urban areas. By the use of Depthmap software, various macro-scale spatial variables can be calculated and visualised. For example, a street with few connections to other streets (macro-scale analysis) can still be full of social activities, provided the street has a high density of entrances and when there is high visibility between public and private spaces (micro-scale analysis). The reverse can be seen in unconstituted streets with a low number of entrances and low inter-visibility, but where the connections to other streets are high. Independently of cultures and architectural styles, micro-spatial measurements make it possible to describe the spatial set-up of built environments at a local level.

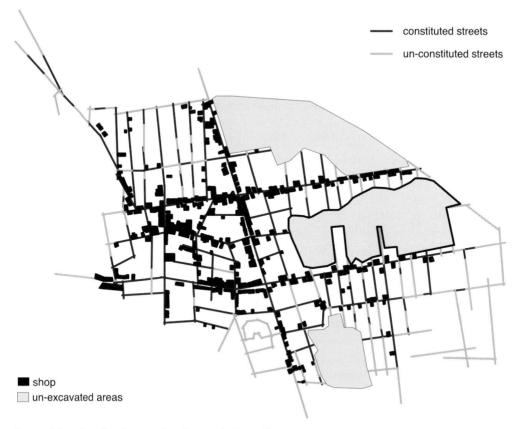

constituted streets

un-constituted streets

shop

un-excavated areas

Figure 5 | Constituted and unconstituted streets in Pompeii.

Drawing on a study of a modern urban context, we find that the further away a street segment is from the main network of routes, the greater the topological depth between private and public space. Along the main routes through urban areas, most entrances are directly connected to the street. When direction is changed twice from the main routes, the average topological depth for entrances is 2, while it is 3 in all street segments that are located more than six topological steps from the main routes. When comparing these data to those derived from Pompeii, we find numerous differences. Pompeii's orthogonal street grid is topologically shallow. By changing direction once from the main routes, which are defined as *cardus* and *decumanus*, most of the town's streets are covered. Therefore, all entrances in Pompeii are directly connected to streets. Furthermore, research has shown that in a modern urban context, the more segregated a street segment is, the more mono-functional the adjacent buildings tend to be. Topologically deeply located street segments usually only have a residential function, since offices, shops, and public buildings tend to locate along the main routes. The semi-private segments are among the topologically dee-

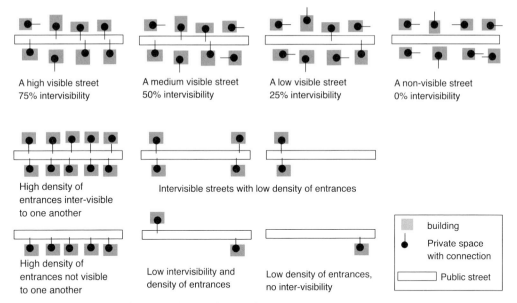

Figure 6 | The principles of intervisibility and density of entrances.

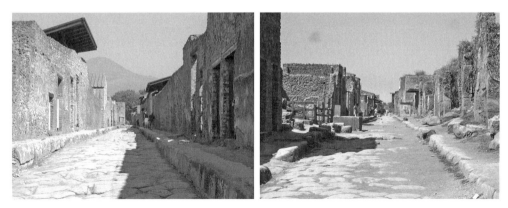

Figure 7 | Example of a side street with low intervisibility and density of entrances (left) and a main street with high intervisibility and density of entrances (right) in Pompeii.

pest and most segregated streets (López and van Nes 2007). In Pompeii entrances to dwellings tend to dominate the side streets, whereas there is a large mix of urban functions along the *cardus* and *decumanus*. Interestingly, the further a street segment is away from the main routes, the lower the values of spatial integration and constitutedness. The unconstituted back alleys tend to be the most segregated street segments.

As the study of street segments in a present urban context clearly shows, the micro-spatial conditions of the street segment are interrelated to the macro-spatial conditions of

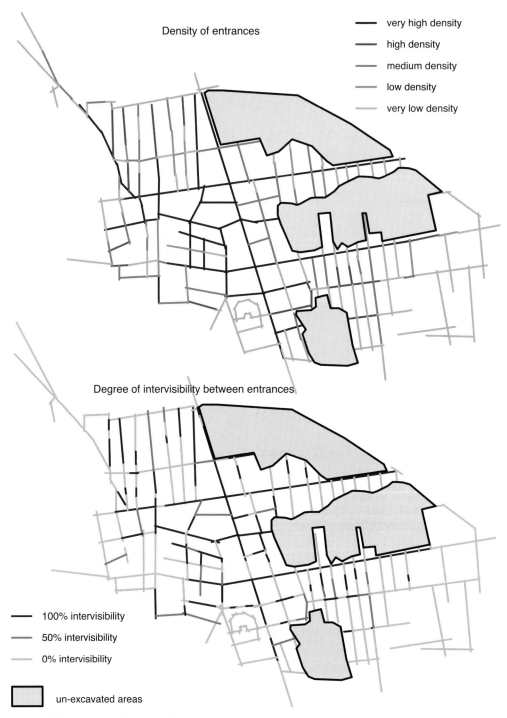

Density of entrances

very high density
high density
medium density
low density
very low density

Degree of intervisibility between entrances

100% intervisibility
50% intervisibility
0% intervisibility

un-excavated areas

Figure 8 | The density and intervisibility of entrances in Pompeii.

the cities' street network (López and van Nes 2007). The definition and operationalisation of the micro-scale conditions is, however, still in a preliminary phase and is an area that needs to be improved upon in the near future. Some concepts, at least, can usefully be introduced in order to describe and analyse the relationship between space and society on an urban micro-scale level for other excavated towns – even where the excavation is not of the scale of that conducted at Pompeii.

6 Findings

How do the spatial analyses of Pompeii contribute to an understanding of the social and economic life in past built environments? By putting all the archaeological data from the Eschebachs and the results from the various spatial analyses in different layers in auto-cad or GIS, it is possible to visualise the correlations between the various data. Moreover, by using SPSS, multi-variable analyses between macro- and micro-spatial parameters and socio-economic data from the past can be carried out. Given the archaeologists' detailed analyses of functions carried out within buildings, the following conclusions can be drawn about space and society in Pompeii.

Shops and bakeries locate in the most integrated streets, with a high number of connections to other streets in a short metrical distance. Moreover, the entrances along these streets are directly connected to the street, have a high density and high degree of intervisibility.

Religious buildings (such as temples) and political institutions locate themselves one topological step (or one direction change) away from the most integrated streets. They are seldom located along or at the end of the integrated main streets. The Temple of Fortuna Augusta is located at one of Pompeii's busiest junctions, which is where Via del Foro and Via del Fortuna cross. The temple's entrance is oriented towards Via del Foro, which is the second best integrated street. In some cases where temples are located along main streets, they can function as a negative generator for the location of shops. The entrances around these buildings have low density, but they still constitute the streets.

Brothels locate in constituted side streets metrically close to the integrated main streets. In contrast, workshops, taverns, and drinking places are located along the main streets and in side streets topologically close to the main streets. Conversely, the public baths, theatres, inns or hotels, sport, and leisure facilities are spread throughout the town's street network.

This pattern has implications for movement within Pompeii. The largest flow of pedestrians, equids or oxen-hauled vehicles was associated with the most integrated streets. Figure 9 shows the traces of 1500 people moving inside Pompeii's public spaces from the agent-based modelling in Depthmap. When we compare figure 9 with the spatial analyses, we see that the highest locally and globally integrated streets (from the macro-scale analy-

Figure 9 | Agent-based modelling of Pompeii's public spaces.

sis) combined with the highest density of entrances (from the micro-scale analysis) are the most frequented urban spaces.

In general, it can be said that the way a society organises its functions spatially and the way its spatial structure affects human behaviour, in terms of the location pattern of its activities, has not changed much in two thousand years. The same tendencies in space and human behaviour can be seen in urban centres in modern cities.

Micro- and macro-spatial relationships play a crucial role in the socio-economic life of human beings in built environments. All these activities depend on how the spatial configuration is on the "plinth" or built-up sides of the street. The street plinth is where the building meets the street. It is at the street plinth that the micro-scale and macro-scale analyses, which determine the degree of liveliness in streets, are interconnected. The micro-spatial structure of the urban street plinth affects the direct interface of public and private life of a built environment's inhabitants and visitors in an informal way. It has always been like this in built environments. Even though Pompeii's street network was planned according to the ancient ideal city type with its strict orthogonal street grid containing two main streets intersecting in the middle, the location process of buildings along streets occurred organically. The most integrated and crowded streets were the most attractive for locating the entrance of an adjacent building. Hence a street network's macro-spatial structure affects the degree of attractiveness for economic and social activities. In Pompeii, most entrances are packed together on the shortest sides of their *insulae* due to high spatial inte-

gration values on the streets on that side. These micro- and macro-spatial conditions made it optimal for the exchange of goods, shopping activities, social interaction, and the vitality of street life in Pompeii's main streets.

Since previous research, analyses, and functional designation of buildings in Pompeii offer a comprehensive set of data of archaeological artefacts, what are then the challenges for the future application of spatial configurative methods on other excavated sites? In the first instance, a reconstruction of a town's street pattern must be available. It is the necessary basis for the macro-scale spatial analysis. This makes it possible to indicate the spatial potential for the degree of street vitality and street life. Secondly, precise mapping of walls and entrances provides the basis for micro-scale spatial analysis. In cases where it is impossible to ascertain a site's street network, micro-scale analysis can to some extent give the spatial indications of how lively or quiet a street probably was in the past. Herculaneum represents a town of this kind, where large parts are still un-excavated. Its twelve excavated street segments show a large variation in inter-visibility, permeability, and adjacency between private and public space on the street plinth level. It is at least a beginning for indicating various degrees of street life in past built environments.

The application of space syntax and the micro-scale tools contributes to understanding how ancient cities functioned and what the relationship is between spatial layout and socio-economic activities. Spatial analysis of the street network gives indications of possible functions in adjacent buildings, where identifiable artefacts are lacking on archaeological sites. Finally the statistical data from the micro- and macro-scale spatial analysis and agent-based modelling can indicate the degree of vitality in shopping streets and where the largest flow of human movement took place in the past.

Bibliographical references

Crane, M. (2009)
"The Medieval Urban 'Movement Economy' Using Space Syntax in the Study of Medieval Towns as Exemplified by the Town of 's-Hertogenbosch, the Netherlands", in: D. Koch, L. Marcus, and J. Steen (eds.), *Proceedings Space Syntax. 7th International Symposium*, Stockholm. http://www.sss7.org/Proceedings/07%20Urban%20Structures%20and%20Spatial%20Distribution/019_Craane.pdf (18 July 2013).

DeLaine, J. (2004)
"Designing for a Market: Medianum Apartments at Ostia", in: *Journal of Roman Archaeology* 17, pp. 146–176.

Eschebach, H. (1970)
Die städtebauliche Entwicklung des antiken Pompeji. Die Baugeschichte der Stabianer Thermen, Heidelberg.

Eschebach, H. (1978)
Pompeji, Leipzig.

Eschebach, L. (1993)
Gebäudeverzeichnis und Stadtplan der antiken Stadt Pompeji, Köln, Weimar, Vienna.

Fridell Anter, K., and Weilguni, M. (2003)
"Public Space in Roman Pompeii", in: G. Malm (ed.), *Towards an Archaeology of Buildings: Contexts and Concepts*, BAR International Series 1186, Oxford, pp. 31–39.

Gehl, J. (1996)
The Life between Buildings: Using Public Space, Copenhagen.

Hillier, B. (1999)
Space as Paradigm for Describing Emergent Structure in Strongly Relational Systems, Lecture notes, Bartlett School of Architecture, UCL, London.

Hillier, B., Penn, A., Banister, D., and Xu, J. (1998)
"Configurational Modelling of Urban Movement Networks", in: *Environment and Planning B: Planning and Design* 25, pp. 25–84.

Hillier, B. and Hanson, J. (1984)
The Social Logic of Space, Cambridge.

Jacobs, J. (2000)
The Death and Life of Great American Cities, London.

Kaiser, A. (2000)
"The Urban Dialogue: An Analysis of the Use of Space in the Roman City of Empúries, Spain", in: *British Archaeological Reports International* Series 901, Oxford, pp. 1–132.

Laurence, R. (1996)
Roman Pompeii: Space and Society, New York.

López, M., and van Nes, A. (2007)
"Space and Crime in Dutch Built Environments. Macro and Micro Spatial Conditions for Residential Burglaries and Thefts from Cars", in: A. S. Kubat (ed.), *Proceedings Space Syntax. 6th International Symposium, Technological University Istanbul*, Istanbul http://www.space syntaxistanbul.itu.edu.tr/papers%5Clongpapers%5C026%20-%20Lopez%20vanNes.pdf (18 July 2013).

Marcus, L. (2000)
Architectural Knowledge and Urban Form. The Functional Performance of Architectural Urbanity, Stockholm (PhD thesis).

van Nes, A., and López, M. (2010)
"Macro and Micro Scale Spatial Variables and the Distribution of Residential Burglaries and Theft from Cars: An Investigation of Space and Crime in the Dutch Cities of Alkmaar and Gouda", in: *Journal of Space Syntax*, Vol. 2, pp. 296–314.

van Nes, A. (2005)
"Typology of Shopping Areas in Amsterdam", in: A. van Nes (ed.), *Proceedings Space Syntax. 5th International Symposium*, Amsterdam.

van Nes, A. (2002)
Road Building and Urban Change. The Effect of Ring Roads on the Dispersal of Shop and Retail in Western European Towns and Cities, Ås (PhD thesis, Agricultural University of Norway).

Newsome, D. J. (2009)
Traffic, Space and Legal Change around the Casa del Marinaio at Pompeii (VII 15.1–2), in: *Babesch* 84, pp. 121–142.

Poehler, E. E. (2006)
"The Circulation of Traffic in Pompeii's Regio VI", in: *Journal of Roman Archaeology* 19, pp. 53–74.

Turner, A. (2004)
Depthmap 4 – A Researcher's Handbook, London.

Stöger, H. (2009)
"Clubs and Lounges at Roman Ostia. The Spatial Organisation of a Boomtown Phenomenon (Space Syntax Applied to the Study of Second Century AD 'Guild Buildings' at a Roman Port Town)", in: D. Koch, L. Marcus, and J. Steen (eds.), *Proceedings Space Syntax. 7th International Symposium* at *KTH*, Stockholm http://sss7.org/Proceedings/03%20Spatial%20Analysis %20and%20Architectural%20Theory/108_Stoeger.pdf (18 July 2013).

Zanker, P. (1998)
Pompeii. Public and Private Life, Harvard.

Hanna Stöger

The spatial signature of an *Insula* neighbourhood of Roman Ostia

Ostia, the harbour city of ancient Rome, is one of the few archaeological sites where the extensive architectural remains allow us to explore the complexity of Roman urban life. Although the site has been attracting widespread research interest, until recently the city's spatial organisation remained a neglected field of study, with only limited attention given to systematic spatial analysis. This chapter concentrates on Ostia's spatial organisation to explore how social processes map into built form, and it applies Space Syntax methods to address questions related to urban development during the second and early third centuries AD. This chapter offers a further context for Space Syntax analysis, detailed applications of which can also be seen in Fisher's, Letesson's and Van Nes' chapters in this volume, while Hillier's chapter provides the theoretical underpinning of Space Syntax and discusses methodological questions.

Space Syntax has been successfully employed in archaeological studies and has helped to redress a conceptual imbalance in archaeological research wherein the highly dynamic space of past urban landscapes has remained predominantly studied from a static position. Space Syntax allows us to pursue methods for the reconstruction of past movement and interaction, employing techniques of analysis that are configurational, dynamic and experiential. This chapter presents and discusses the results of Space Syntax analyses applied to an urban neighbourhood, Insula IV ii, one of Ostia's city street blocks (Stöger 2007; 2011). The topics covered include the spatial organisation of the '*insula* neighbourhood' and the integrative potential of shared activities areas within the Insula (cf. Vaughan et al. 2009 on today's suburban activity centres).

1 The spatial organisation of Insula IV ii

Since Ostia's *insulae* (city blocks) came to light in the large-scale excavations of the late 1930s/early 1940s, they have been widely studied, extending from architectural studies (Boersma 1985; Bauers 1999) to attempts claiming ideological continuity between Roman imperial and Italian fascist architecture (on Calza's influence cf. Kockel 2001, p. 67–72). Earlier work concentrated on typological and cultural-historical explanations (Packer 1971; Pasini 1978), whereas more recent approaches follow advances made in Pompeian studies, partially integrating concepts of today's urban planning and urban geography into archaeological research (Laurence 2007; Jones and Robinson 2007; Ynnilä 2011). With reference to Ostia, these studies incorporate aspects of the *insulae*'s spatial organisation into research

deploying a wider social focus relating to status and ownership (DeLaine 1999; 2004; Gering 2002). Other current approaches examine the infrastructural capacity of *insulae* and value their ability to adapt to dynamic urban processes (Scagliarini Corlàita 1995; Steuernagel 2001); others in turn view particular *insulae* as short-lived material manifestations of architectural dreams, only to be rapidly modified in response to demographic and economic change (Gering 2002).

The current *insula* discussion forms part of a wider discourse on Roman neighbourhoods (Bert Lott 2004) and links up with a comparative archaeological study on neighbourhoods in ancient cities (Smith 2010); Space Syntax methods of spatial analysis add a new perspective to the ongoing discussion, while general trends and problems in the archaeological application of Space Syntax have been discussed thoroughly in several studies (e.g. Thaler 2005, p. 324–326; Cutting 2003). Space Syntax techniques not only provide evidence for the intricate organisation of space within the *insulae*, but also investigate the active role of spatial characteristics. According to Space Syntax theory the spatial structure of the built environment embodies knowledge of social relations (Hillier and Hanson 1984, p. 184–185), whereby space not only assumes a physical location but encodes, communicates and reproduces social meaning (Fisher 2006, p. 124). Insula IV ii serves as a case study, while several other Ostian *insulae* equally warrant a detailed spatial analysis. Still, Insula IV ii is of particular interest, since a number of spatial features consisting of interlinked courtyards make Insula IV ii a very appealing dataset for spatial analysis. A better understanding of the Insula's spatial organisation might allow us to gain insights into the Insula as a lived space.

The Space Syntax analysis builds on an archaeological assessment of the Insula's architectural remains by the author conducted earlier (Stöger 2011, p. 67–158). From this thorough study it was possible to establish that all extant buildings were in use during the early 3rd century AD, forming a simultaneously existing spatial association, which is a crucial requirement for spatial analysis. Earliest levels of occupation have been dated to the Late Republican and Early Imperial periods, while the Insula enjoyed a long period of use, lasting until the 4th/5th centuries AD. Selecting the early 3rd century as a time-slice for analysis places the spatial discussion within two major urban developments: on the one hand Ostia's 2nd century AD urban expansion, which is widely understood as a 'boom-town' phenomenon (Heinzelmann 2002; 2005), and on the other hand Ostia's changing role during the early 3rd century, which saw a transformation from a commercial hub with an outward focus to a 'consumer' city responding to the needs of an increasingly local clientele (Pavolini 2002; Gering 2004, p. 303).

In the following section the Insula's spatial structure will be examined. The first part describes the spatial characteristics which are readily apparent. Next, the Insula's topological and visual patterns are analysed and their spatial relations calculated, using Space Syntax methods; this forms the main part of the analytical approach to the Insula's spatial structure. Finally, a summary of the Insula's spatial organisation will be presented, together

with an evaluation of how it relates to the human use of space and how the Insula functioned as an urban neighbourhood. This will lead to another set of questions related to the position of the Insula within the spatial configuration of the entire city, of which the Insula is a member, as much as it is a unique and distinguishable entity.

2 Insula IVii: location and description

Located on the southern *cardo maximus,* near the Porta Laurentina, but still inside the Late Republican city walls, Insula IV ii enjoyed a position that benefited from the relative proximity to the city centre, as well as from the closeness to the city gate with its connection to the extra-mural areas of Ostia and beyond. Placed at the intersection between the *cardo* and the *Via della Caupona,* a side road south off the *cardo,* the Insula appears well positioned within the urban street network (fig. 1). Towards the east the Insula is delimited by the triangular area of the *Campo della Magna Mater,* one of Ostia's main sanctuaries, dedicated to Cybele, the great mother goddess. The Insula covers a total area of 7321 m² comprising 14 buildings, characterised by diverse land-uses (fig. 2): it represents a built environment that potentially accommodated commercial (shops and storage), industrial (workshops and small scale production), recreational (baths and inns), sacred (*mithraeum*), and communal (open courtyards, entrance passages and portico), as well as habitation space (ground floor and upstairs dwellings) within its confines. These spaces were not only linked functionally, but also through a spatial relationship provided by shared common courtyards.

A number of the Insula's spatial characteristics are readily apparent: commercial space was predominantly located along the street fronts, maximising the potential for interaction at the Insula's interface with public space. Industrial space in contrast reached deeper into the Insula, with the narrow end of the plot along the street front. The southernmost corner of the Insula, the area least accessible, was dedicated to the *Mitreo degli animali*, a cult room serving a limited number of members devoted to the cult of Mithras. Several buildings provided dwelling units at ground floor level, while the majority of habitation spaces were located on the upper floors. The diversity of land-use might have allowed the residents to remain within the boundary of the Insula for most day-to-day activities, while the generously proportioned internal courtyards could have functioned as common areas. The spaciousness of the open areas, which cover about 20 % of the Insula's total terrain, points not only to a generous attitude towards space, but also indicates that numerous activities could have taken place simultaneously within the courtyards.

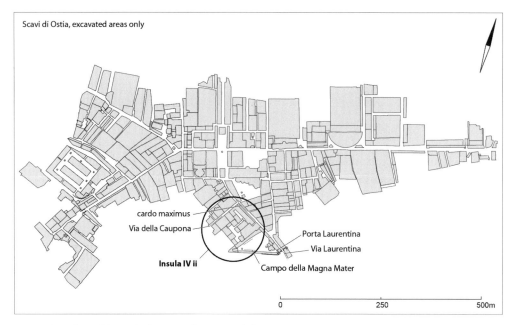

Figure 1 | Insula IV ii located adjacent to the Campo della Magna Mater.

3 A three-way Space Syntax approach to Insula IV ii

The Space Syntax analyses applied to the Insula follow the three-way approach suggested by Hanson (1998, p. 38). Hanson recommends that space should be examined through its three principal aspects: its axial or one-dimensional structure (lines of movement), its convex or two-dimensional organisation (convex spaces such as rooms and buildings) and its visual fields. The three-way approach assures that each type of analysis relates to one aspect of how inhabitants and visitors experienced and used space. Accordingly, the appropriate Space Syntax tools have been applied to the Insula's past built spaces: axial analysis, convex or access analysis and visibility graph analysis (VGA) or isovists (on isovists and visibility graph analysis see Turner et al. (2001), on the theoretical underpinning of Space Syntax analyses see Hillier and Hanson (1984, p. 143–175). The Space Syntax methods have been well explained elsewhere in studies of Pompeian houses and Ostia's *medianum* apartments (Grahame 2000, p. 24–36; DeLaine 2004, p. 157–158). The method therefore requires little comment. All buildings within the Insula have been analysed twice, individually and collectively, forming the Insula's total configuration. Only a small section of the analysis will be reproduced here, concentrating on the Insula's total spatial configuration, examined as a single spatial entity. This should allow us to achieve a better understanding of the functioning of the Insula's collective spatial structure, and will help us to establish to what extent the individual buildings were affected by the larger spatial entity.

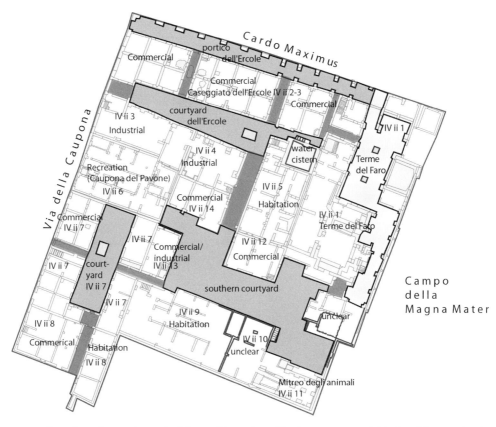

Figure 2 | Insula IV ii comprises 14 buildings with a variety of land-uses: commercial, industrial, recreational (baths and inns), as well as habitation and cultic use (mithraeum).

The Insula consists of 14 individual buildings (fig. 2), which constitute a total of 184 individual spaces, including the outside carrier space, Ostia's street network, counting as one space. Of particular interest are the 'commons', the internal courtyards and passages, which were held in shared use by all buildings within the Insula. These spaces acted as major integrators and distributors, leading movement into and within the Insula, and were essential for providing access to those buildings which were not connected to the exterior public carrier space.

4 Insula IV ii – a reading from access maps and spatial values

Access analysis is a promising starting point for most syntactical analyses (Hillier and Hanson 1984; Hanson 1998; Grahame 2000, p. 29–36). Applied to the Insula's total ground plan, a graph structure (j-graph) was produced, justified with respect to the outside space

Figure 3 | Insula IV ii, topological graph of the total configuration (183 = outside carrier; 42, 105 and 180 = courtyards, 28 = portico).

(fig. 3). The graph is a visual representation of the topological connections between all spaces (rooms and open spaces) and enables us to calculate spatial values (control values and RRA, Real Relative Asymmetry) for comparative quantitative assessment. Control values concern a space and its immediate neighbouring spaces (local), while RRA deals with a certain space and its relationship to all other spaces within the system (global). These measures respond to the Insula's local and global properties and help in assessing the potential of different spaces for interaction between residents and visitors.

The Insula's graph structure can be best described as a broad multiple-entry graph with 28 spaces connected to the outside space, with a total of 10 depth-steps, measured from the outside carrier to the topologically most remote spaces. The mean integration

value (MRRA) for the total graph is 0.937, pointing to a moderately well integrated spatial structure. Mean integration values allow a first hand impression, as they indicate on average how shallow or deep the spaces in the Insula are from one another. This allows us to formulate ideas about the use of space and the potential function of buildings and rooms. A comparison with the mean integration values for the Insula's most integrated building, the *Caseggiato dell'Ercole* (MRRA 0.562) and the least integrated building, the *Mitreo degli animali* (MRRA 1.893), helps us to gain a better perspective of the total structure.

The analytical strategy chosen was to identify the potential 'hotspots' for interaction within the Insula's spatial configuration. From the total configuration (fig. 4) a number of spaces emerge as the areas with the highest levels of integration and control potential. Interesting insights can be gained by correlating the controlling spaces, indicated by control values in excess of 1 (Grahame 2000, p. 33–34), with those spaces with very low RRA values. These range from zero to infinite – the higher the RRA value the more inaccessible a space will be; hence spaces with high levels of global integration are indicated by low RRA (see Grahame 2000, p. 35, 46). The area in which we find the highest consistency between local and global integration potential might point to those spaces by which the Insula was functionally defined (cf. table 1). Within the total configuration these spaces are most notably dedicated to movement and interaction, forming the Insula's interface with visitors: portico 28 and courtyard 42 of the *Caseggiato dell'Ercole*, as well as the outside carrier space 183. Together with the inner courtyards, 105 and 180, these spaces provide the Insula's principal circulation system.

It is worth noting that all spaces which serve a common use are located in the shallower, well integrated parts of the Insula, relatively close to the outside space, mostly 1 to 2 step-depths, but not more than 4 step-depths away from the outside carrier space. In contrast, all spaces which are residential or more private in nature are located in the deeper, less integrated portion of the Insula, at 5 to 10 depth-steps away from the public outside space. This suggests that through its collective structure the Insula was able to generate one feature common to most types of domestic architecture: it incorporates the elementary relation between the inhabitant/resident and the visitor (Hillier and Hanson 1984, p. 183–184). This means that the inhabitant is in the deeper, often less integrated, parts and interfaces with the visitor through the shallower, often well-integrated parts of the Insula. If we take this observation a step further we might be able to suggest that at the collective level the Insula still upheld an inherently domestic structure, while at an individual level a number of buildings had lost their elementary inhabitant/visitor dynamic. This observation seems to receive even more significance when considered within the wider context of the Insula's evolving configuration. In the course of its development the Insula experienced the loss of the *domus*, which constituted the standard domestic building and served as the urban 'base-unit', at least until the earlier Trajanic period (c. 100 AD). Collectively, however, the Insula seems to have retained some characteristics reminiscent of *domus* architecture, such as inner courtyards and a structured access to public space.

Figure 4 | J-graph Insula IV ii represents the topological relationship between all spaces within the Insula, calculated from the outside space (root 183 = outside carrier).

Table 1 | The Insula's 'hotspots': the circulation spaces with highest levels of local and global integration potential (RRA 500–650 = high, 650–950 = moderate, 950 + = low).

Building	Room/ function	No.	Depth	RRA (MRRA 0.937)	Global interaction potential	Local interaction potential	Control Values	Potential presence availability
IV ii 2	Portico	28	1.0	0.622	High	High	7.652	High
IV ii 3	Courtyard	42	2.0	0.558	High	High	7.699	High
IV ii 6	Corridor	86	1.0	0.733	Moderate	Moderate	4.035	Moderate
IV ii 7	Courtyard	105	2.0	0.703	Moderate	High	9.416	Mod/High
common	Southern courtyard	180	4.0	0.617	High	High	5.783	High
common	Outside carrier	183	0.0	0.562	High	High	165.386	High

Next to the Insula's most integrated spaces, the most segregated spaces are equally instructive about the functioning of the configuration (see table 2). As listed in table 2 below, the Terme del Faro's heated pools, 18 and 19, rank very high on the list of the most segregated spaces within the Insula. The heated pools are located eight depth-steps away from the outside space and can only be reached after a sequence of rooms has been crossed; their secluded position seems related to their function and affords higher levels of privacy than other rooms. Two other rooms come into view from the assessment of the collective structure: 143 and 162. Unsurprisingly, the *mithraeum*'s cult room 162 emerges as one of the

Table 2 | The Insula's most segregated spaces with lowest global and local interaction potential.

Building	Room function	No.	Depth	RRA (MRRA 0.937)	Global interaction potential	Local interaction potential	Control Values	Potential Presence availability
IV ii 1	Heated pool	18	8.0	1.693	Low	Low	0.250	Low
IV ii 1	Heated pool	19	8.0	1.693	Low	Low	0.250	Low
IV ii 9	Room	143	10.0	1.851	Low	Low	0.500	Low
IV ii 11	Cult room	162	9.0	1.605	Low	Low	0.500	Low

most segregated rooms within the entire Insula, superseded only by room 143, which is part of Building IVii 9. Room 143 ranks as the most segregated space of the total configuration. It belongs to a range of rooms including 141, 142 and 143. The group is noteworthy since it seems to form a *medianum* apartment located at the Insula's southernmost edge. *Medianum* apartments usually consist of ranges of rooms grouped around a hall or wide corridor (see DeLaine 2004 for a syntactic assessment of Ostia's *medianum* apartments). Facing south, unobstructed by direct neighbours, this range of rooms must have provided an excellent dwelling-unit, appealing to the upper end of the rental market. Its secluded location might have even enhanced the value of the apartment, since its 'remoteness' provided higher levels of privacy than any other ground floor dwelling available within the Insula.

The inner courtyards (42, 180 and 105) play a significant role in channelling movement within the Insula. The southern courtyard 180 is the only one directly connected to all other courts by means of passage corridors. The presence of three courtyards could potentially create a sense of fragmentation within the Insula; this seems, however, balanced by the fact that the southern courtyard acted as a centre for the entire layout. Moreover, the different route options offered by the various passages and courtyards might have helped in counteracting disintegration, since the routes unite the Insula through movement. The wide range of movement choices enabled those who used the Insula, both residents and visitors, to explore the spaces in different ways, generating routes according to specific functional requirements, or simply to stroll through the Insula and go wherever their fancy might take them. One circulation path is of particular interest, since it completely encircled the baths and their associated buildings without passing through outside space, and could therefore run independently of visitor relations. The loop interconnects the baths with the southern courtyard, leading back again into the baths through the central passage and the eastern part of the *Caseggiato dell'Ercole*, thereby creating a 'spatial Insula' within the Insula (see fig. 7 below).

5 The Insula's axial line structure (axial analysis)

To examine the dynamics of the Insula's internal space structure and to systematically investigate movement we need to shift away from access analysis and select Space Syntax techniques specifically suited to capture movement. This also requires a shift from built spaces to open spaces, thus moving away from the Insula's buildings to its open courtyards and passages. A careful look at the Insula's internal space structure already shows that it is distinctly broken up into convex spaces (the courtyards), and into lines (entrance corridors and passages), which interlink the convex spaces (fig. 5).

Before homing in on the Insula's linear space structure, a look at Hillier's findings on the City of London's space structure may be helpful for developing a deeper understanding of the Insula's spatial organisation (cf. Hillier 2007, p. 111–137). Hillier identified two constant spatial properties within the small-scale complexes of the City of London which seem to explain how the supposedly labyrinthine back areas of the City proved to be highly intelligible for those who navigated its spaces. The first property relates to the prevailing movement patterns in which he identified a persistent 'two-line-logic' (Hillier 2007, p. 116–119). In a similar but less intricate way, there is also a 'two-line logic' to movement within the Insula: if one enters the Insula through one of the passage corridors visible from the *cardo maximus*, the next line will take a visitor either out of the back area by leaving the courtyard through the exit on the Via della Caupona, or further into the Insula to some significant spatial event like the next large courtyard, i.e. the southern courtyard. From there, another line would take visitors out of the Insula again by passing through building IV ii 7, reaching the Via della Caupona. This means that wherever one goes within the Insula, there is usually a point from which one can see the point of departure, i.e. the entry into the Insula, and where the next point of aim might be. Hillier contends that this spatial technique has the effect that the back areas become normally and naturally used for movement as part of the urban space pattern, and he adds that there is no inhibition or sense of territorial intrusion in these areas (Hillier 2007, p. 116–118). Whether this holds true for the Insula is difficult to prove, but the ideas are compelling and should be examined in the light of the archaeological evidence, and, above all, put to the test by correlating the Insula's axial line structure and the spatial integration values (RRA) for the courtyards under discussion.

The second spatial property identified by Hillier's study of the City of London concerns how the buildings relate to the open spaces. Hillier observed that almost all buildings opened directly onto the convex spaces (courtyards and squares), and through this practice a close relationship between the residents within the buildings and those outside was created. According to Hillier this kind of direct interfacing engendered a sense of unforced co-presence between people carrying out different activities (2007, p. 118). From Hillier's study it becomes clear that interaction potential is dependent upon a two-way relationship between the linear space structure (movement spaces) and the buildings and squares (convex spaces) relating to it. Can we make similar observations within the Insula? When look-

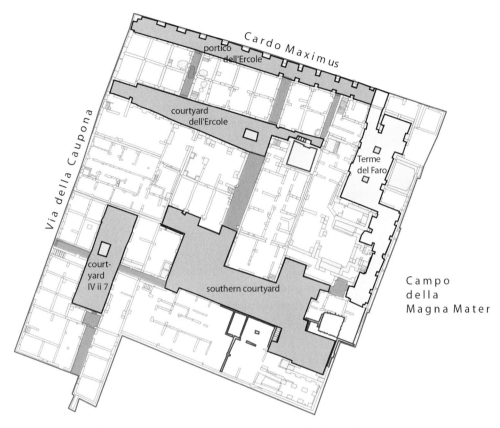

Figure 5 | Insula IVii: courtyards (grey)and passages (darker green) forming axial and convex spaces to serve as the Insula's communication spaces (Terme del Faro in light grey).

ing at the Insula's courtyards we can see that only the southern courtyard was surrounded by individual buildings, while the others were integral parts of buildings (*Caseggiato dell'Ercole* and *Caseggiato IVii 7*). The irregular shape of the southern courtyard suggests that it developed through individual negotiations rather than planned design. In line with Hillier's observations it is worth noting that Buildings IVii 12, 13 and 14 open completely onto the courtyard, and hence provide for the interface described by Hillier as being necessary to produce interaction potential. These observations seem supported by the spatial values that have been calculated for the courtyard and the buildings surrounding it (Buildings IV ii 10, 12 and 14 dedicate high levels of integration and control potential to the southern courtyard. Building IVii 10: RRA 0.725/control values 1.833; Building IVii 12: RRA 0.725/control values 2.583; Building IVii 14: RRA 0.287/control values 3.333). Therefore, the next step is to reconstruct the Insula's line structure, which represents the potential route matrix, and to examine whether the integration values for the lines match the high integration values dedicated to the courtyards.

6 The Insula's axial and visual structure

In conformity with Hanson's three-way approach, as discussed above, the Insula's line structure and its visual fields have been examined, using Space Syntax's axial analysis and visibility graph analysis (VGA).[1] Both are analysis tools specifically designed to capture movement by linking spatial and visual properties. The analysis identifies the most integrated visual lines, calculated for axial integration on the basis of the longest visual lines. This is a two-step process: first, all lines to all lines are calculated (fig. 6); in a second round the fewest longest lines are extracted from the total set and reduced to a representative minimum of lines. The fewest lines embody the Insula's potential route matrix (fig. 7); the latter identifies the Insula's most likely paths of movement, hierarchically ranked and colour-coded (here represented in greyscales only) according to their level of integration with all other lines within the system. The Insula's most integrated line (represented as a dotted line) extends diagonally from the southern courtyard to the baths. The second most integrated line (dotted line) connects the portico to the southern courtyard. Clearly, the southern courtyard comes into view as the converging zone for visual lines from all directions, marking the courtyard as the prime space for movement and social encounter.

The second most integrated line (dotted line) connects from the portico through to the southern courtyard. This line represents the axial connection between outside public space (*cardo maximus*) and the very centre of the Insula. The line proves to be consistent and seems to form part of the 'two-line logic' which appears to be a constant component of the Insula's space structure. The line's counterpart is found in the longest axial line, which connects from the Via della Caupona through Building IVii 7 and all across the southern courtyard. These two lines form the Insula's visual base structure, constituting the root of the Insula's 'two-line logic'. Both lines remained preserved and respected throughout the Insula's development. This is evident from the alignment of the buildings, which safeguard the visual lines, even at all costs, as the passage through Buildings IVii 7, 9 and 13 demonstrates. Interestingly, the lines are also respected by more mundane structures such as the fountains located within the courtyards.

A further level of analysis pertaining to the Insula's visual fields has been applied, the visibility graph analysis (VGA). It is based on visual integration and on a positive correlation between visibility and movement potential (Turner et al. 2001; Hillier and Vaughan 2007). The visibility graph reveals the Insula's visually most integrated spaces (fig. 8), displayed in a ranked order from the most to the least visually integrated spaces (the colour-coded results are represented in greyscale) The southern courtyard emerges as the visually most integrated space, marking the area where the longest visual lines converge as the most inte-

[1] The graphs and analyses were produced with Depthmap 7.12.00d and developed at the VR centre for Built Environment, Bartlett, University College London.

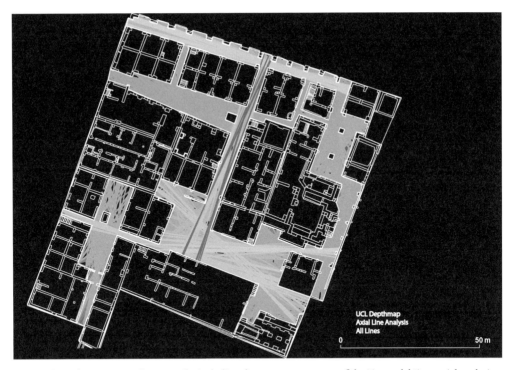

Figure 6 | Insula IVii: internal courtyards, including the movement spaces of the Terme del Faro; axial analysis (all lines) identifies the central passage leading from the portico to the southern courtyard as the visually most integrated space (graphs and analyses produced with Depthmap 7.12.00d; The Bartlett, University College London).

grated zone (see dotted circle). Hence VGA confirms what was identified by the axial line analysis. Both analyses earmark the southern courtyard as the area where movement coming from various directions within the Insula converged; greater density of movement raises co-presence within the southern courtyard, which is an indication of increased potential for social interaction. Finally, agent-based analysis provided by Depthmap (fig. 9) produced a graph showing the movement traces of 50 autonomous agents walking through the Insula driven by visual parameters only. Their random walks take the majority of the agents to the southern courtyard. Hence once again the southern courtyard emerged as the Insula's best place for social interaction.

7 Concluding remarks

In terms of the human use of space the Space Syntax results point to the fact that the Insula was able to draw people in from the street space. However, most importantly, by promoting accessibility to the back part, i.e. the southern courtyard, the Insula's space structure helped

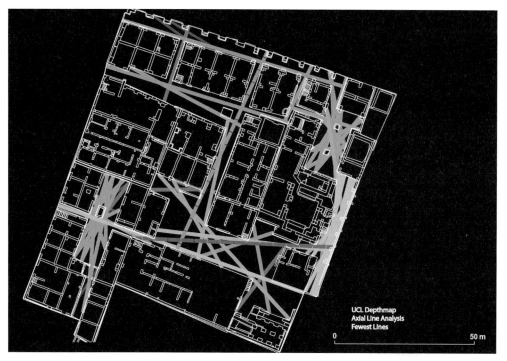

Figure 7 | The Insula's potential route matrix based on the longest and fewest lines; represented in greyscales. The movement spaces of the Terme del Faro are included in the analysis (Depthmap 7.12.00d; The Bartlett, University College London).

in sustaining activities in the back areas. This is even more interesting, since the Insula had clearly defined its commercial front towards the outside through the *Caseggiato dell'Ercole*, with its portico and a shop front taking up almost the entire length of the Insula along the *cardo maximus* (cf. Davis 2009, p. 89–104 for buildings with combined commercial and residential uses). As the spatial organisation of the southern courtyard demonstrates, a lively environment of unforced co-presence is not only dependent on the line structure and the open spaces which constitute the movement spaces, but also requires that the buildings relate to the open spaces by opening onto the spaces, and hence interface in a manner to encourage interaction.

With regard to the Insula's quality as lived space, spatial tools were able to make a valuable contribution in showing that space was designed to promote encounter, and to privilege integration over segregation, which ultimately makes for a better and safer neighbourhood, not only in early 3rd century Ostia. The Insula's integrating capacity seems the key to its long period of occupation. Although composed of individual buildings, the Insula's space structure, its courtyards and passages were still essentially collective and shared by the buildings which composed the group. Its collective space structure seems to have prevented fragmentation into highly individualised luxury architecture, which was the fate of

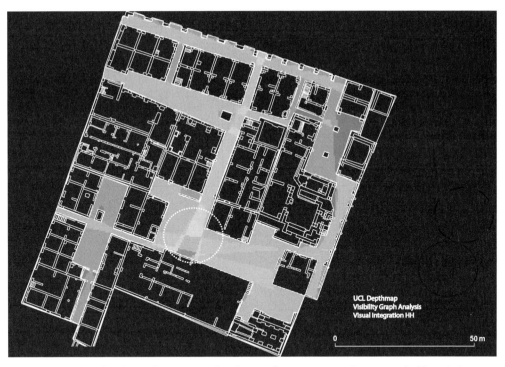

Figure 8 | VGA identifies the southern courtyard as the visually most integrated space (marked by a circle).

most neighbouring *insulae*, as can be seen in the development of the Late Roman *domus*, which affected other Ostian *insulae* during the late Roman period.

This case study of Ostia's Insula IV ii has demonstrated that syntactic and visual tools of spatial analysis can add a valuable dimension to the archaeological assessment of a past built environment. Spatial and visual patterns have been identified which would otherwise not be open to visual inspection by the archaeologists studying the buildings. The real advantage of Space Syntax lies in the fact that the method forces the researcher to understand a building or a group of buildings as a configuration of space, whereby Space Syntax becomes a tool to think with. Since the method is intuitive, it inspires the researcher to experiment at various levels: the technical side of the analyses and the possible interpretations of the results. The syntactic enquiry into the Insula should be further expanded to include various other spatial parameters, such as examining the Insula's total configuration from the perspective of each individual building, or exploring the Insula's visual fields from location to location. Another promising addition to the current analysis should include the streets of the Insula's immediate surroundings into the area defined for analysis. This would give the Insula a buffer zone to counteract possible edge effects, which the immediate boundary of the Insula might exert on the analysis. Moreover, by including a certain amount of street space the effect of the streets on the Insula could be calculated and evalu-

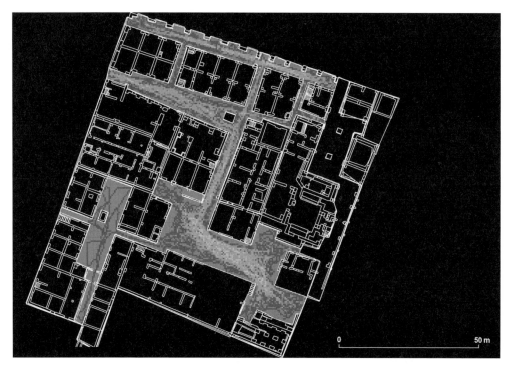

Figure 9 | Agent analysis (preliminary state) movement traces of 50 autonomous agents concentrated in the southern courtyard.

ated. This would no doubt lead to yet another set of questions related to the position of the Insula within the spatial configuration of the entire city and would require a wider analysis of the neighbourhood and the city's street network.

Bibliographical references

Bauers, Nicoline (2001)
"Die Insulae 'dell'Ercole bambino' und 'del soffitto dipinto' in Ostia", in: *Bericht über die 41. Tagung für Ausgrabungswissenschaft und Bauforschung*, Berlin 2000, pp. 67–73.

Bert Lott, John (2004)
The Neighbourhoods of Augustan Rome, Cambridge.

Boersma, Johannes S. (1985)
Amoenissima Civitas: Block V.ii at Ostia: Description and Analysis of its Visible Remains, Assen.

Cutting, Marion (2003)
"The Use of Spatial Analysis to Study Prehistoric Settlement Architecture", in: *Oxford Journal of Archaeology* 22, 1, pp. 1–21.

Davis, Howard (2009)
"The Commercial-Residential Building and Local Urban Form", in: *Urban Morphology* 13, 2, pp. 89–104.

DeLaine, Janet (1999)
"High Status Insula Apartments in Early Imperial Ostia – A Reading", in: S. Mols and C. van der Laan (eds.), *Mededelingen van het Nederlands Instituut te Rome: Antiquity*, Nederlands Instituut te Rome, pp. 175–89.

DeLaine, Janet (2004)
"Designing for a Market: 'Medianum' Apartments at Ostia", in: *Journal of Roman Archaeology* 17, pp. 147–176.

Fisher, Kevin. D. (2006)
"Messages in Stone: Constructing Socio-Political Inequality in Late Bronze Age Cyprus", in: E. C. Robertson, J. D. Seibert, D. C. Fernandez, and M. U. Zender (eds.), *Space and Spatial Analysis in Archaeology*, Calgary, pp. 123–131.

Gering, Axel (2002)
"Die Case a Giardino als unerfüllter Architektentraum: Planung und gewandelte Nutzung einer Luxuswohnanlage im antiken Ostia", in: *Mitteilungen des Deutschen Archäologischen Instituts, Römische Abteilung* 109, pp. 109–140.

Gering, Axel (2004)
"Plätze und Straßensperren an Promenaden: Zum Funktionswandel Ostias in der Spätantike", in: *Mitteilungen des Deutschen Archäologischen Instituts, Römische Abteilung* 111, pp. 299–382.

Grahame, Mark (2000)
Reading Space: Social Interaction and Identity in the Houses of Roman Pompeii: A Syntactical Approach to the Analysis and Interpretation of Built Space, Oxford.

Hanson, Julienne (1998)
Decoding Homes and Houses, Cambridge.

Heinzelmann, Michael (2002)
"Bauboom und urbanistische Defizite – zur städtebaulichen Entwicklung Ostias im 2. Jh.", in: C. Bruun and A. Gallina Zevi (eds.), *Ostia e Portus: Nelle Loro Relazioni con Roma*, Rome, pp. 103–121.

Heinzelmann, Michael (2005)
"Die vermietete Stadt", in: P. Zanker and R. Neudecker (eds.), *Lebenswelten: Bilder und Räume in der römischen Stadt der Kaiserzeit*, Palilia 16, pp. 113–128.

Hillier, Bill (2007, 1st edition 1996)
Space is the Machine, Cambridge.

Hillier, Bill, and Hanson, Julienne (1984)
The Social Logic of Space, Cambridge, New York.

Hillier, Bill, and Vaughan Laura (2007)
"The City as One Thing", in: *Progress in Planning: Special Issue on The Syntax of Segregation, Edited by Laura Vaughan* 67, 3, pp. 205–230.

Jones, Rick, and Robinson, Damian (2007)
"Intensification, Heterogeneity and Power in the Development of Insula VI, 1", in: J. J. Dobbins and J. E. Foss (eds.), *The World of Pompeii*, London, New York, pp. 119–128.

Kockel, Valentin (2001)
"Il palazzo per tutti' La découverte des immeubles locatifs de l'Antiquité et son influence sur l'architecture de la Rome fasciste", in: J.-P. Descoeudres (ed.), *Ostia. Port et porte de la Rome antique*, Genève, pp. 66–73.

Laurence, Ray (2007, 2nd edition)
Roman Pompeii: Space and Society, London, New York.

Meiggs, Russel (1973)
Roman Ostia, Oxford.

Packer, James E. (1971)
"The Insulae of Imperial Ostia", *Memoirs of the American Academy in Rome*, Rome.

Pasini, Francesca (1978)
Ostia Antica. Insule e classi sociali, Rome.

Pavolini, Carlo (2002)
"La trasformazione del ruolo di Ostia nel III secolo D.C.", in: *MEFRA* 114, 1, pp. 325–352.

Scagliarini Corlàita, Daniela (1995)
"La grande insulae di Ostia come integrazione tra edilizia residenziale e infrastrutture urbane", in: G. Cavalieri Manasse and E. Roffia (eds.), *Splendida Civitas Nostra: studi archeologici in onore di Antonio Frova, Studi e ricerche sulla Gallia Cisalpina*, pp. 171–181.

Smith, Michael E. (2010)
"The Archaeological Study of Neighborhoods and Districts in Ancient Cities", *Journal of Anthropological Archaeology*, 29.2, pp. 137–154.

Steuernagel, Dirk (2001)
"Kult und Community: Sacella in den Insulae von Ostia", in: *Mitteilungen des Deutschen Archäologischen Instituts, Römische Abteilung* 108, pp. 41–56.

Stöger, Hanna (2007)
"Roman Ostia: Space Syntax and the Domestication of Space", in: A. Posluschny, K. Lambers, and I. Herzog (eds.), *Layers of Perception, Proceedings of the 35th International Conference on Computer Applications and Quantitative Methods in Archaeology (CAA)*, Berlin, pp. 322–327.

Stöger, Hanna (2011)
Rethinking Ostia: A Spatial Enquiry into the Urban Society of Rome's Imperial Port-Town, Archaeological Studies Leiden University 24, Leiden.

Thaler, Ulrich (2005)
"Narrative and Syntax: New Perspectives on the Late Bronze Age palace of Pylos, Greece", in: A. v. Nes (ed.), *5th International Space Syntax Symposium, Proceedings*, Delft, pp. 323–339.

Turner, A., Doxa, M., O'Sullivan, D., and Penn, A. (2001)
"From Isovists to Visibility Graphs: A Methodology for the Analysis of Architectural Space", in: *Environment and Planning B: Planning and Design* 28, pp. 103–121.

Vaughan, Laura, Jones, Kate, Griffith, Sam, and Mordechai, Haklay (eds.) (2009)
"The Spatial Signature of Suburban 'Active' Centres'", in: D. Koch, L. Marcus, and J. Steen (eds.), *17th International Space Syntax Symposium,* Stockholm, pp. 127.1–127.13.

Ynnilä, Heini (2011)
"Meaningful Insula: Bridging the Gap between Large and Small Case Studies of Urban Living Conditions", in: D. Mladenovic and B. Russel (eds.), *TRAC 2010. Proceedings of the Twentieth Annual Theoretical Roman Archaeology Conference, Oxford 2010,* Oxford, Oaksville, pp. 47–58.

List of contributors

Prof. John Bintliff
Professor of Classical and
Mediterranean Archaeology
Leiden University
The Netherlands
j.l.bintliff@arch.leidenuniv.nl

Dr. Graeme Earl
Senior Lecturer
Archaeological Computing Research Group
Faculty of Humanities
University of Southampton
United Kingdom
graeme.earl@soton.ac.uk

Prof. Kevin D. Fisher
Department of Classical, Near Eastern,
and Religious Studies
University of British Columbia
Canada
kevin.fisher@ubc.ca

Dr. Piraye Hacıgüzeller
Marie Curie Fellow of the Gerda Henkel
Foundation
Institute of Archaeology
University of Oxford
United Kingdom
Department of Archaeology
University of Leuven
Belgium
piraye.haciguzeller@kuleuven.be

Prof. Bill Hillier
Bartlett School of Graduate Studies
University College London
United Kingdom
b.hillier@ucl.ac.uk

Dr. Quentin Letesson
Chargé de recherches F.R.S-FNRS
Aegean Interdisciplinary Studies (AegIS)
Research Group (CEMA/INCAL)
Université Catholique de Louvain
Belgium
Quentin.Letesson@uclouvain.be

Undine Lieberwirth M.A.
Excellence Cluster 264 – Topoi
Free University Berlin
Germany
Undine.Lieberwirth@fu-berlin.de

Dr. Scient. Akkelies van Nes
Assistant Professor
Section spatial planning and strategy
Department of Urbanism
Faculty of Architecture, TU Delft
The Netherlands
A.vanNes@tudelft.nl

Dr. Eleftheria Paliou
Alexander von Humboldt Fellow
Institute of Classical Archaeology
Heidelberg University
Germany
eleftheria.paliou@zaw.uni-heidelberg.de

Constantinos Papadopoulos
Archaeological Computing Research Group
Faculty of Humanities
University of Southampton
United Kingdom
cp5v07@soton.ac.uk

Dr. Silvia Polla
Jun.-Prof. of Archaeoinformatics
Institute of Classical Archaeology
Free University Berlin
Germany
silvia.polla@fu-berlin.de

Ulrich Thaler, MA
German Archaeological Institute
Athens Department
Greece
ulrich.thaler@dainst.de

Dr. Hanna Stöger
Faculty of Archaeology
University of Leiden
The Netherlands
H.Stoger@arch.leidenuniv.nl

Dr. David Wheatley
Senior Lecturer
Archaeological Computing Research Group
Faculty of Humanities
University of Southampton
United Kingdom
dww@soton.ac.uk

About the editors

Eleftheria Paliou studied Archaeology and History of Art at the University of Athens and obtained a MSc in Archaeological Information Systems at the University of York. Her PhD thesis, which was completed at the University of Southampton, examined the communicative potential and social meanings of Theran mural painting in the build environment of Late Bronze Age Akrotiri (Thera, Greece) via the development and application of 3D visibility analysis methods. Her general research interests lie within the fields of Aegean prehistory, historical and prehistoric urban settlement in Mediterranean, landscape archaeology and computational analysis in archaeology (Geographic Information Systems (GIS), 3D modeling, architectural computing). She has been involved in a number of post-doctoral projects as a Junior and Senior Research Fellow at the Topoi Excellence Cluster (Free University, Berlin) and a Marie Curie Experienced Researcher, while currently she holds a Humboldt Fellowship at the University of Heidelberg. In 2012 she became a founding member and deputy chair of CAA GR (Computer applications and quantitative methods in Archaeology – Greek chapter).

Undine Lieberwirth studied Prehistoric Archaeology and Classical Archaeology at the Humboldt-University Berlin and 'GIS and Spatial Analysis in Archaeology' at the University College London. Her Master's thesis dealt with the modelling of archaeological stratigraphy in 3D GIS environments. This topic is also the focus of her PhD thesis specialising in 3D spatial statistics.

She is currently working at the institute for Prehistoric Archaeology at the Free University Berlin as a university lecturer for "GIS Applications in Archaeology" with a focus on methodology which allows participation of students with different archaeological interests. She is also working as a co-ordinator and supervisor for GIS applications and databases in the Excellence Cluster Topoi.

Her research interests are hence methodological approaches in terms of quantitative data documentation (digital 3D documentation), digital field techniques, survey methods and spatial analysis of archaeological data.

Silvia Polla obtained a degree in Classical Archaeology from the University of Trento (Italy) and a PhD from the University of Siena (Italy) within the framework of the International Graduate School "The cultures of the Roman Provinces". Her doctoral thesis analyses the multi-period surface survey pottery record from a Mediterranean micro-region in the Roman *Africa Proconsularis* using an integrated archaeological and archaeometrical approach and GIS-based computational techniques.

Her research focuses on the use of spatial technology for the study of ancient urban and rural socio-economic systems, settlement patterns and infrastructures as well as practices of movement of people and goods at various scales. She has published contributions on Archaeometry and GIS technology in international and peer reviewed Journals and Conference Proceedings. She currently holds the position of Juniorprofessor of Archaeoinformatics at the Institute of Classical Archaeology of the Free University Berlin and is a member of the Excellence Cluster Topoi.